New

F

ils

24 FEB 2010

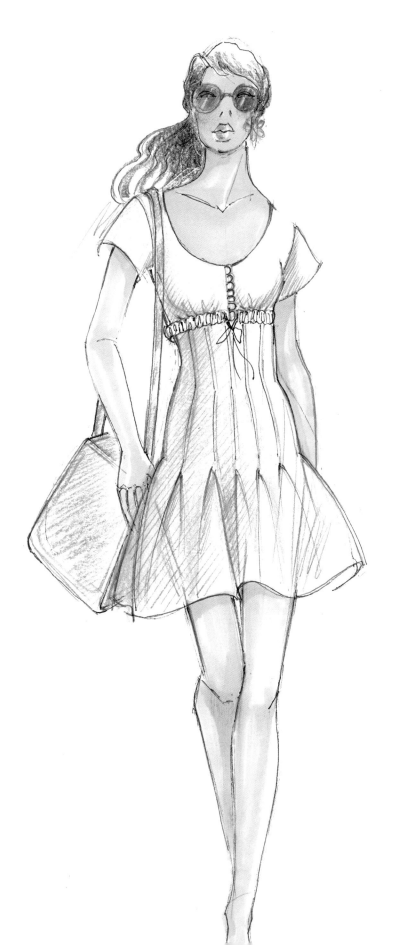

New Encyclopedia of Fashion Details

Patrick John Ireland

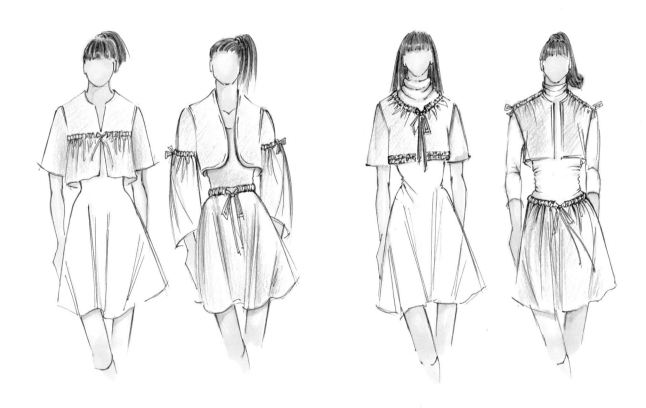

BATSFORD

First published in the United Kingdom in 2008 by
Batsford
10 Southcombe Street
London W14 0RA

An imprint of Anova Books Company Ltd

ISBN-13: 9781906388065

A CIP catalogue record for this book is available from the
British Library.

15 14 13 12 10 09 08
10 9 8 7 6 5 4 3 2 1

Reproduction by Dot Gradations Ltd, UK
Printed and bound by Times, Malaysia

This book can be ordered direct from the publisher at the
website: www.anovabooks.com, or try your local bookshop.

Distributed in the United States and Canada by
Sterling Publishing Co., 387 Park Avenue South,
New York, NY 10016, USA

Contents

Introduction

Planned as a reference for students, it is hoped that this book will be of equal value to the many people who are interested in fashion design. Arranged in alphabetical order, the contents illustrate fashion details and suggest some of the many ways in which they may be used.

Techniques

Throughout the book the drawings vary from line diagrams, showing the development of the use of a design detail, to a variety of fashion sketches using line and tone values to show textures and patterns, and the way in which to indicate the drape and fall of materials, as well as describing how these graphic effects may be achieved. See the figure grid on page 9 for those who may have difficulties in sketching the human figure, especially during their early stages of study.

Design Courses

When working on a design course the student will be required to produce sheets of design sketches when developing ideas. Working drawings and diagrammatic sketches are required for the sample room when cutting the pattern and making a garment. Presentation drawings are needed for exhibitions, competitions and assessments of work. Students are often required to work from design briefs, which are set by the lecturers or manufacturers.

Drawing for Examinations

When answering questions for certain examination papers a sketch or clear diagrammatic drawing is often required, combined with a description of a specific design or detail, such as collars, sleeves, pockets or yokes. The methods illustrated are designed to help the student to cover this requirement.

Reference

These pages are presented for use as a reference to fashion details and decorative effects when designing. They illustrate some of the many ways in which style features, such as tucks, pleats, piping, pockets and collars, may be used in the design of a garment. Many of the design details have been researched from past and current periods of fashion.

Design Development

In the earliest stages of developing a design collection the designer's sketches should be executed quickly, allowing the ideas to flow. At this stage of the design process the drawings need only be drawn as roughs, a method often referred to as 'brainstorming'. Developing ideas in diagrammatic form, known as 'flats', can be effective and will help when you are developing related ideas and building up a unified collection. Illustrated throughout the book are diagrammatic drawings, fashion sketches and presentation illustrations.

Design Sketches

The design sketch can be produced with the aid of a figure template, which enables the designer to produce ideas quickly, relating the proportions, layers and details of the garment design to the figure. When you are more confident at drawing you should develop your skills at sketching freehand.

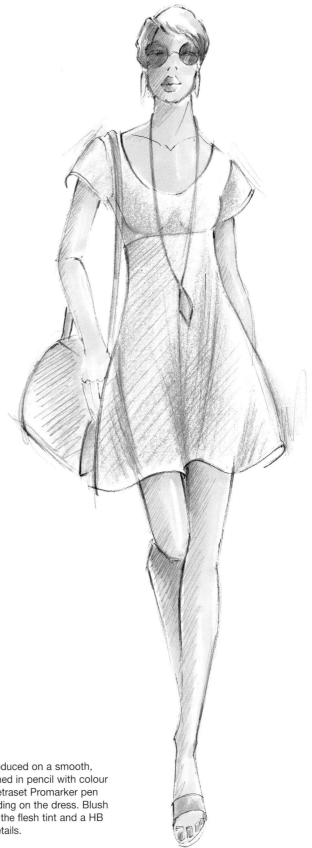

Presentation drawing produced on a smooth, white Bristol card, sketched in pencil with colour added using pale grey Letraset Promarker pen and a soft pencil for shading on the dress. Blush felt-tip pen was used for the flesh tint and a HB pencil for sketching in details.

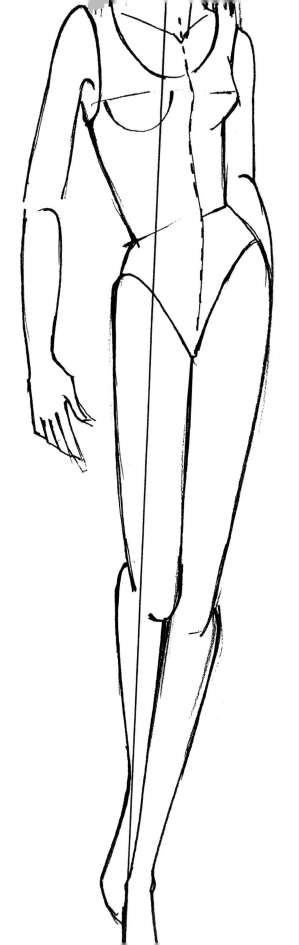

This section is included to help those who may have difficulty, especially in the early stages, in drawing the human figure.

It would be an advantage to attend life-drawing classes and to make a study of anatomy but should this not be possible a figure template can be a useful guide for sketching and developing design ideas. A number of poses are illustrated here.

The average proportions of the figure are 7½–8 heads to the body. Often fashion sketches are stylized and exaggerated when used for presentation and promotion purposes in order to emphasize a fashion image. But when sketching and developing design ideas it is usual to keep the sketches to the average proportions without too much exaggeration, enabling the shape, cut and general design details that relate to the figure to be clearly seen, giving attention to the placing of the collar, pockets, buttons, and so on.

The fashion image suggested is important. This may be projected through the sketch by selecting a suitable pose for the design, such as sporty/casual, elegant/sophisticated. The face and hairstyles need only be suggested but should project an image suitable to the design.

Throughout the book a selection of figures has been illustrated using different techniques, and simple descriptions of the media used have been given. The drawing techniques vary from the diagrammatic to free-style sketches.

Figure Drawing

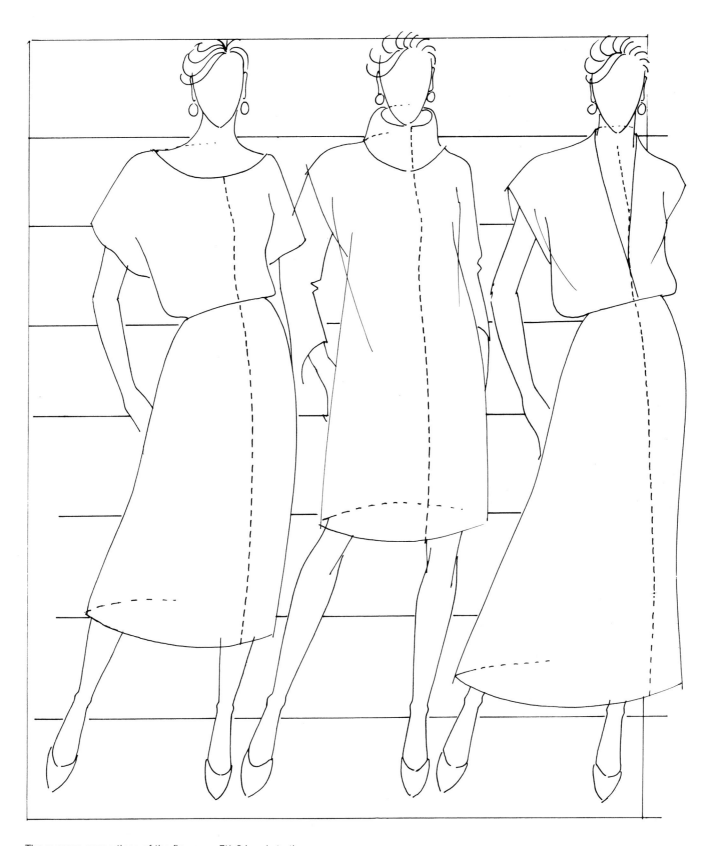

The average proportions of the figure are 7½–8 heads to the
body. The figures in fashion drawing are usually 8–8½.

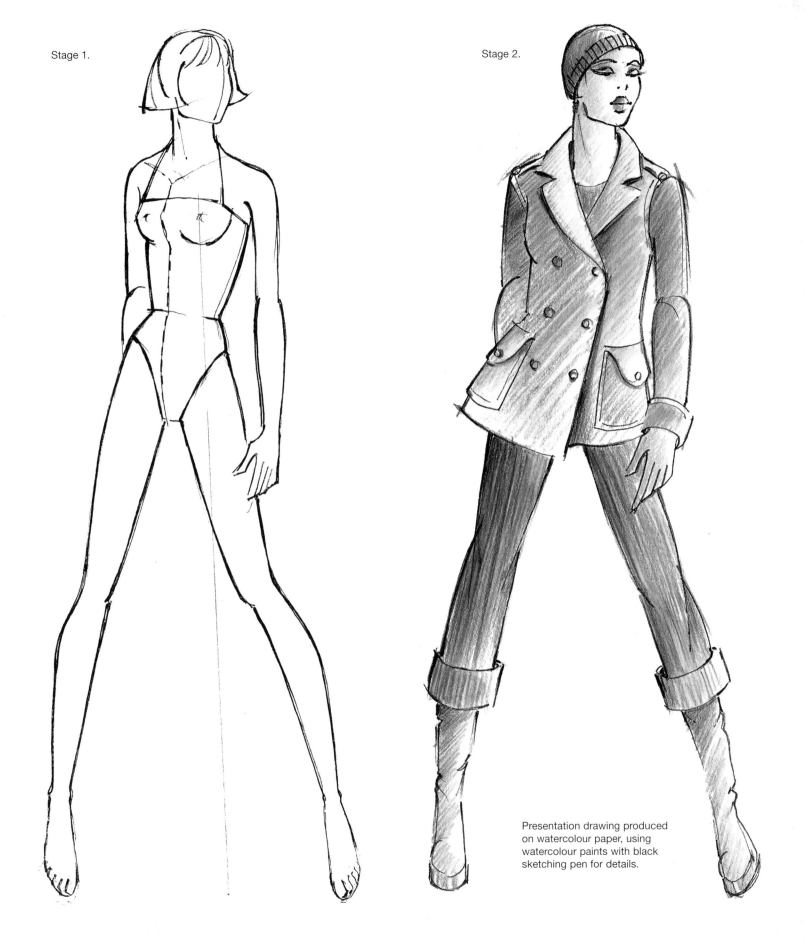

Stage 1.

Stage 2.

Presentation drawing produced
on watercolour paper, using
watercolour paints with black
sketching pen for details.

Stage 1.

Stage 2.

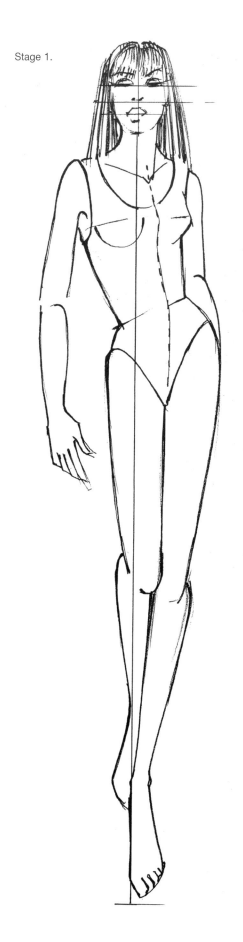

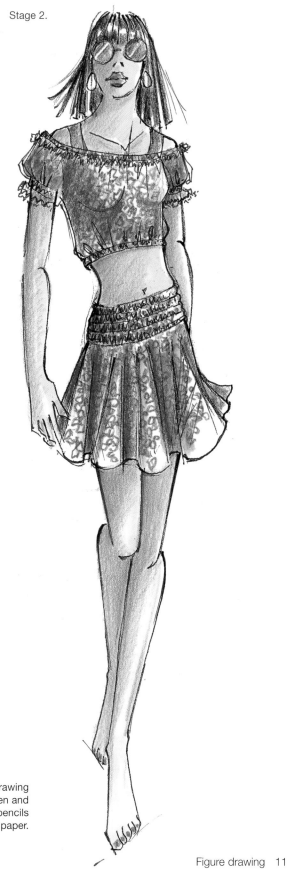

Presentation drawing
produced with a fine pen and
Derwent watercolour pencils
on white cartridge paper.

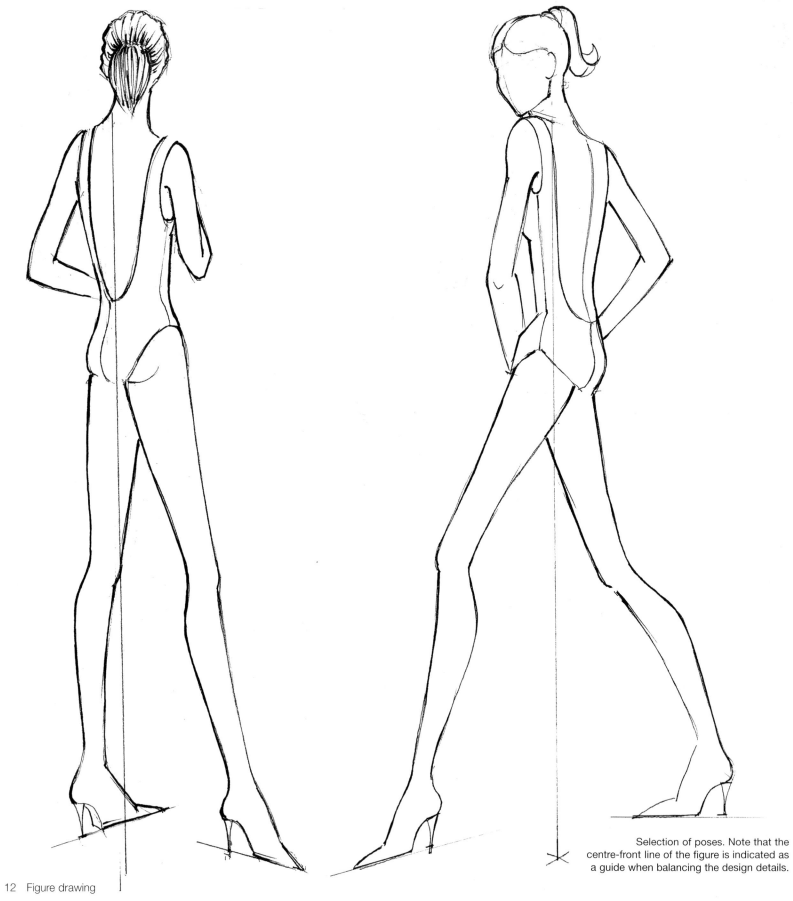

Selection of poses. Note that the
centre-front line of the figure is indicated as
a guide when balancing the design details.

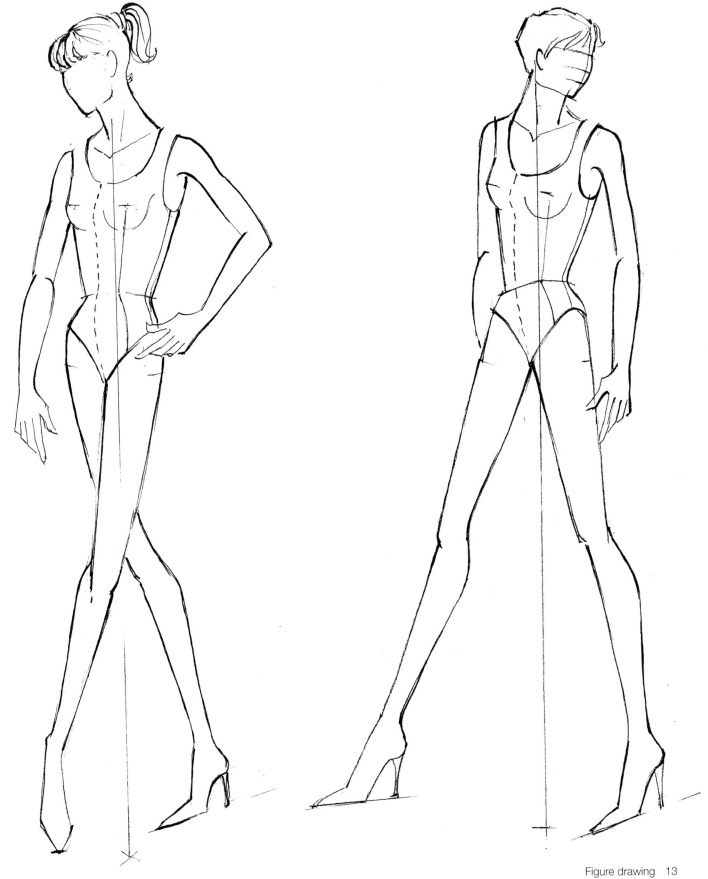

Stage 1.

Stage 2.

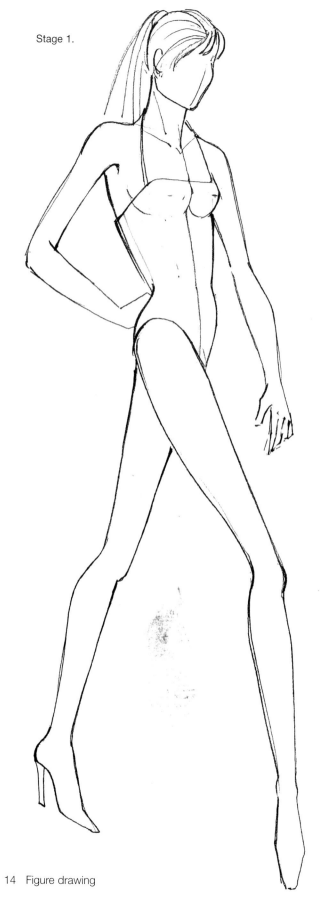

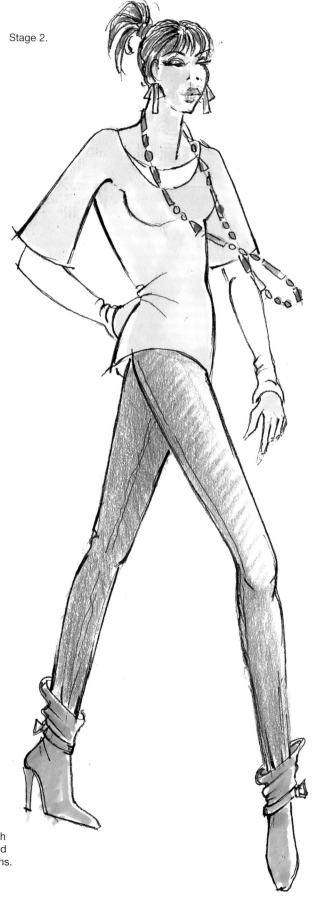

Presentation drawing
produced on white card with
a black pencil. Colour added
with Letraset Promarker pens.

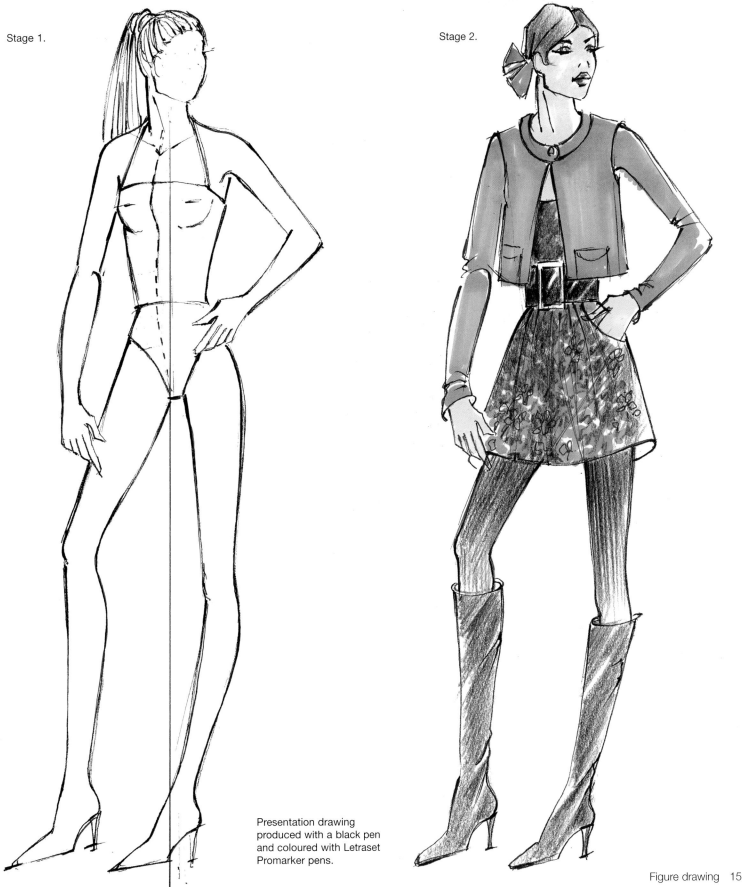

Stage 1.

Stage 2.

Presentation drawing
produced with a black pen
and coloured with Letraset
Promarker pens.

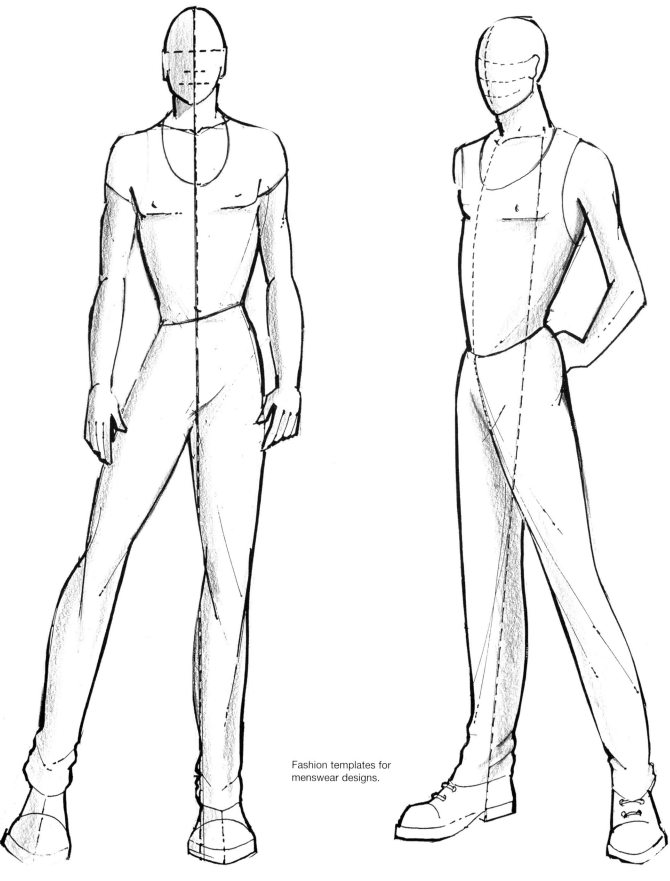

Fashion templates for menswear designs.

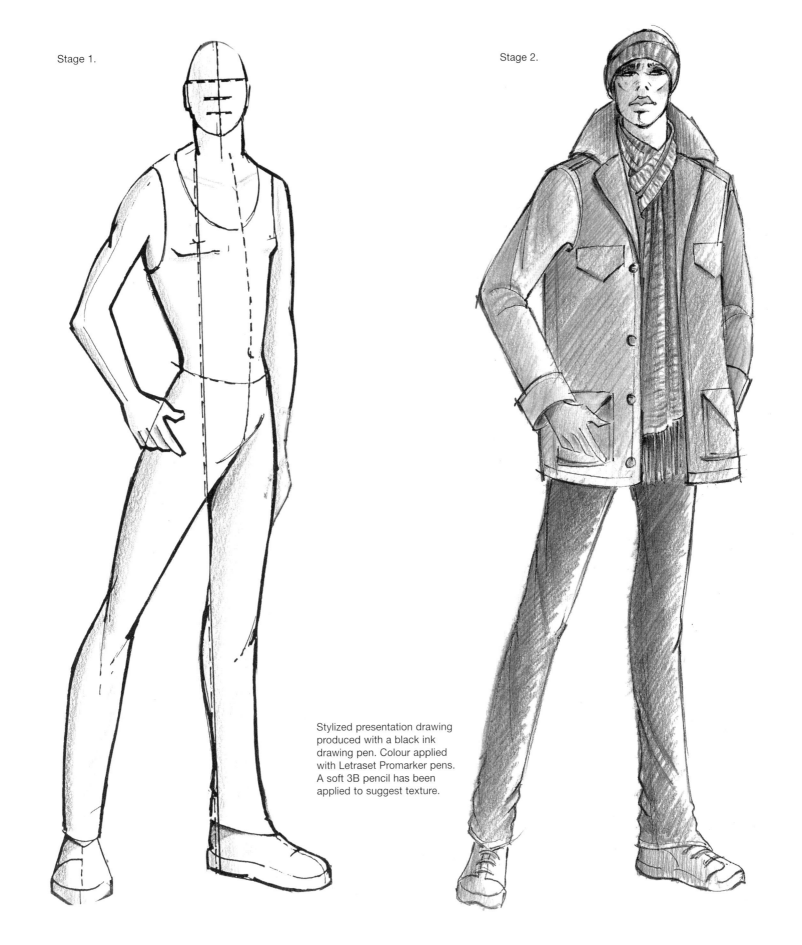

Stage 1.

Stage 2.

Stylized presentation drawing
produced with a black ink
drawing pen. Colour applied
with Letraset Promarker pens.
A soft 3B pencil has been
applied to suggest texture.

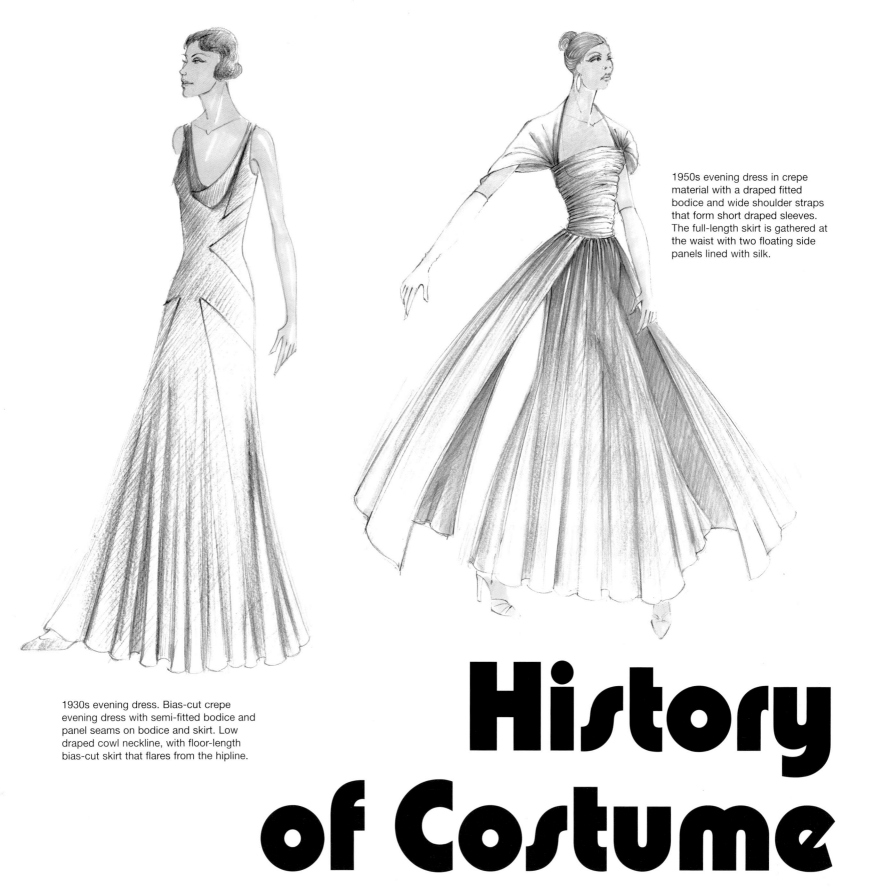

1950s evening dress in crepe material with a draped fitted bodice and wide shoulder straps that form short draped sleeves. The full-length skirt is gathered at the waist with two floating side panels lined with silk.

1930s evening dress. Bias-cut crepe evening dress with semi-fitted bodice and panel seams on bodice and skirt. Low draped cowl neckline, with floor-length bias-cut skirt that flares from the hipline.

History of Costume

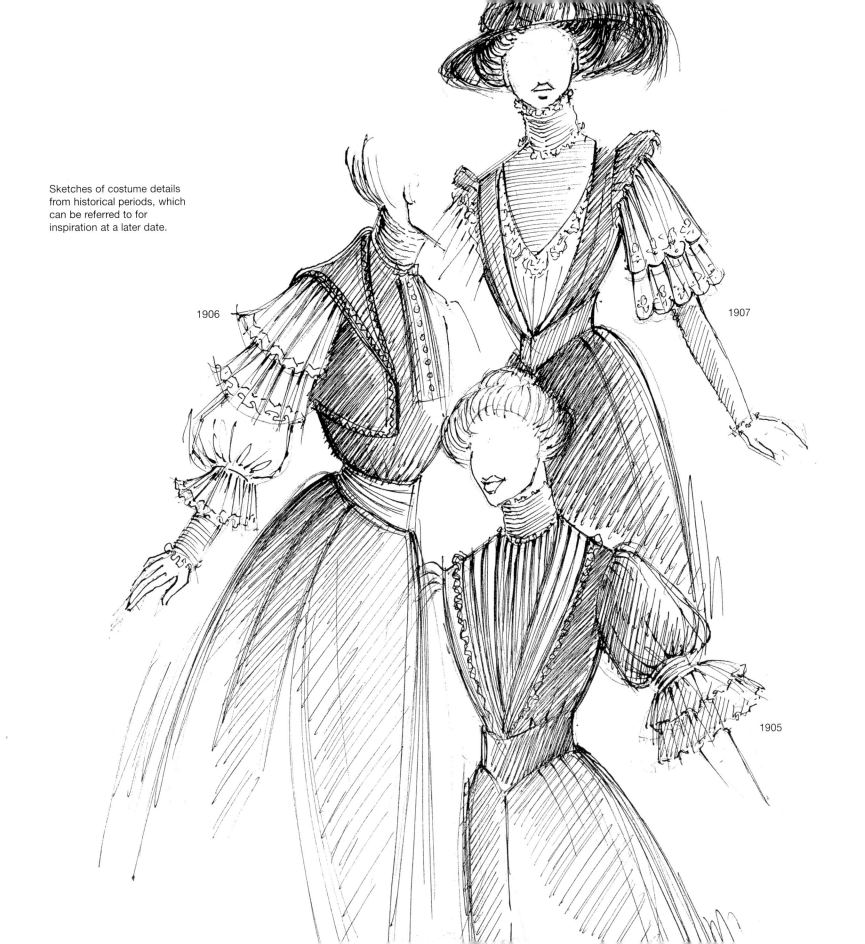

Sketches of costume details
from historical periods, which
can be referred to for
inspiration at a later date.

1906

1907

1905

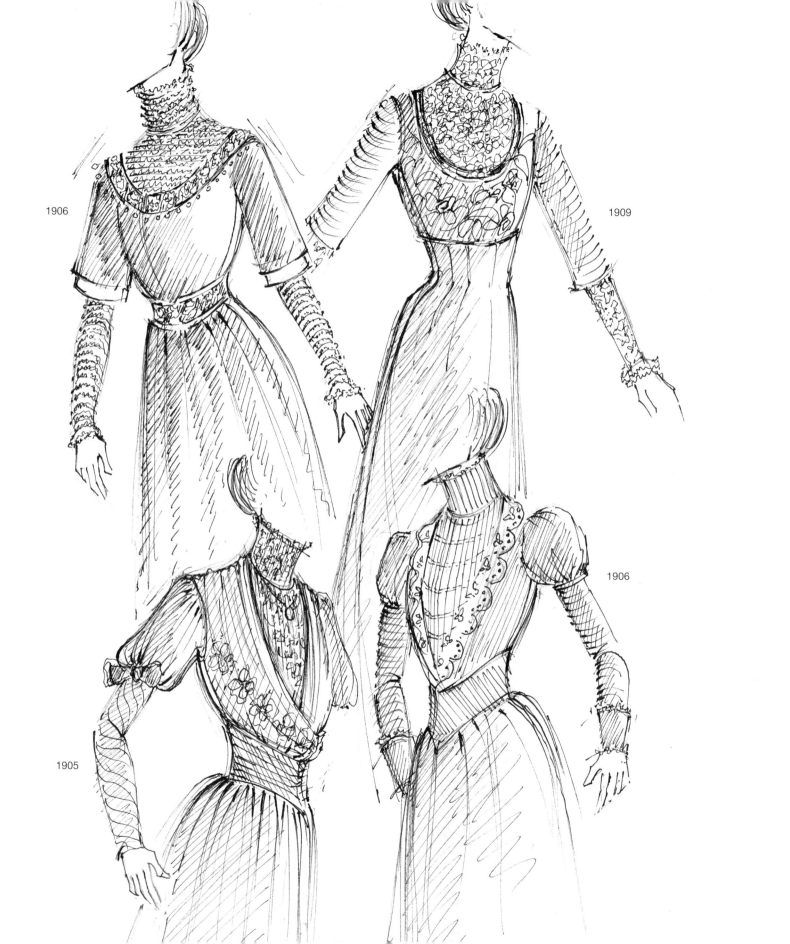

1906

1909

1905

1906

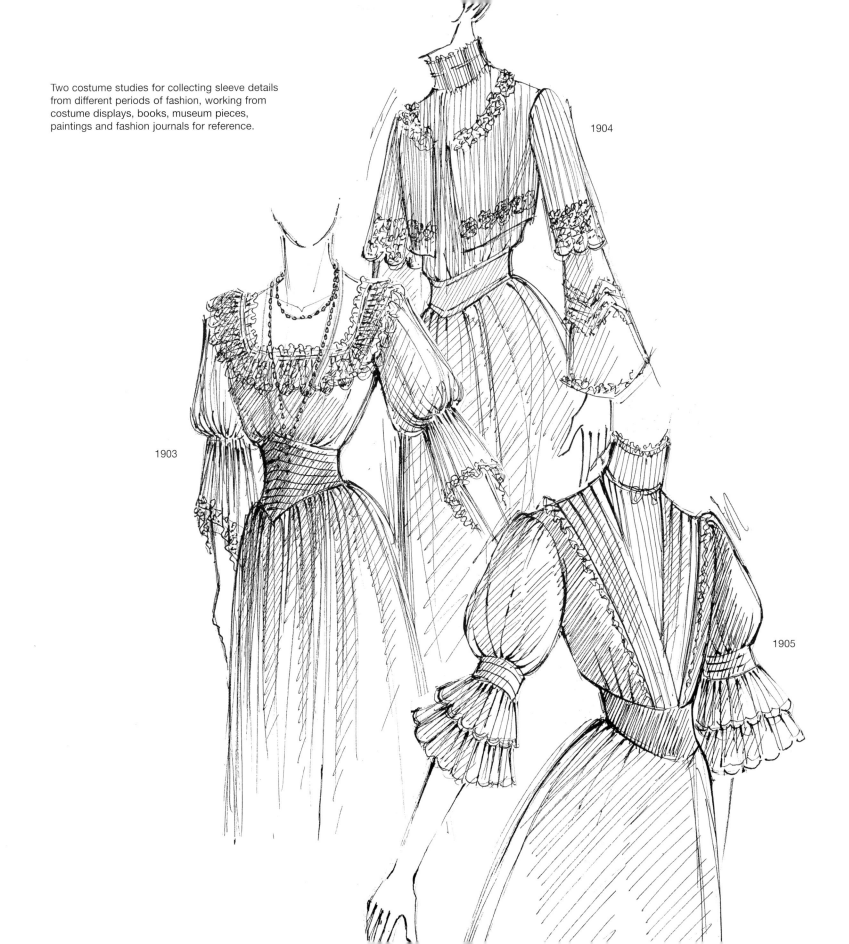

Two costume studies for collecting sleeve details from different periods of fashion, working from costume displays, books, museum pieces, paintings and fashion journals for reference.

1904

1903

1905

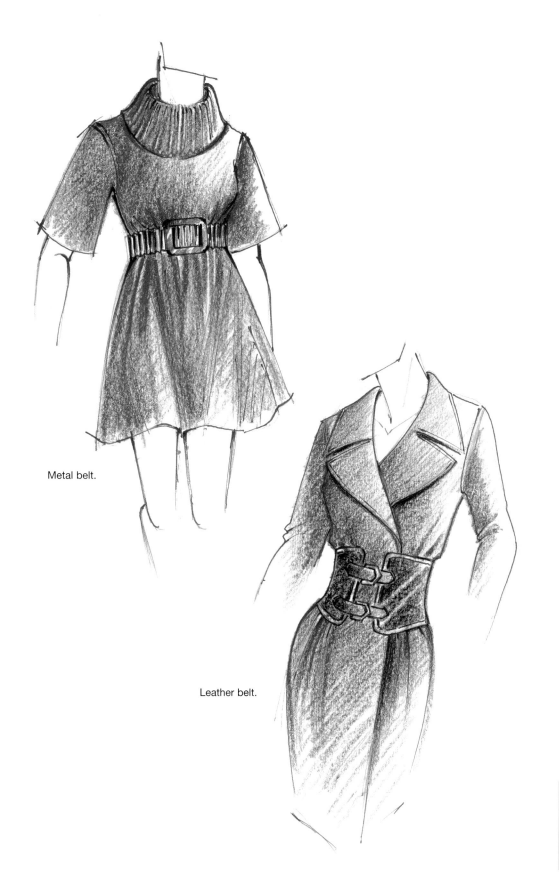

Metal belt.

Leather belt.

The belt as a fashion accessory has become a very important feature. It may be used as a detail, as part of a fashion image or as the main focal point of a design. The designs vary, depending on the image, from a casual sporty look to the sophisticated and classic designs. The shapes change from large, bold designs with a variety of fastenings to the more delicate and understated effects.

The fastenings may be buckles, clasps, ties, lacing, hooks, studs or slotted straps and many ingenious ideas have been designed to achieve a desired effect. The materials may be selected from a large range of leathers of different colours and textures or from fabrics, rubber, metal or a combination of different materials.

Belts

Leather belt.

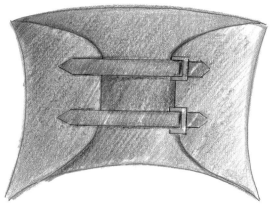

Leather belt.

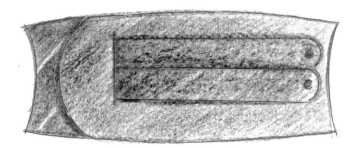

Leather belt.

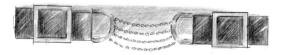

Leather, brass and chains.

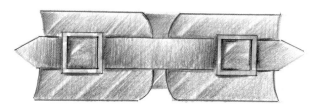

Leather belt.

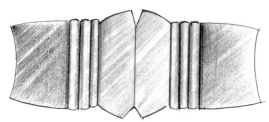

Metal belt.

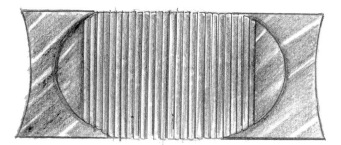

Metal belt.

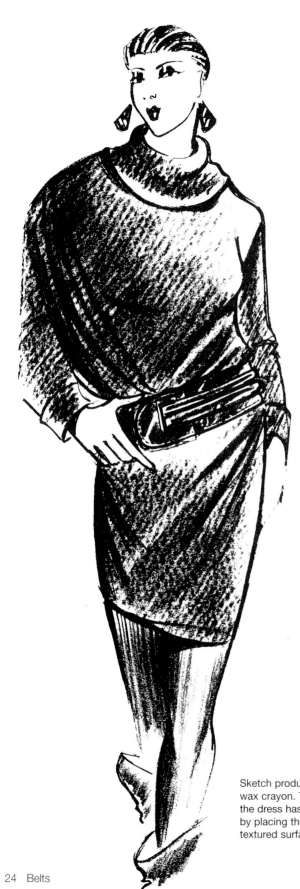

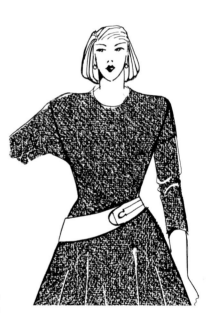

Selection of different belt designs, worn both on and below the waist.

Sketch produced with a black wax crayon. The texture of the dress has been achieved by placing the paper on a textured surface.

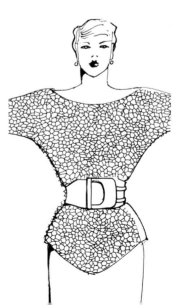

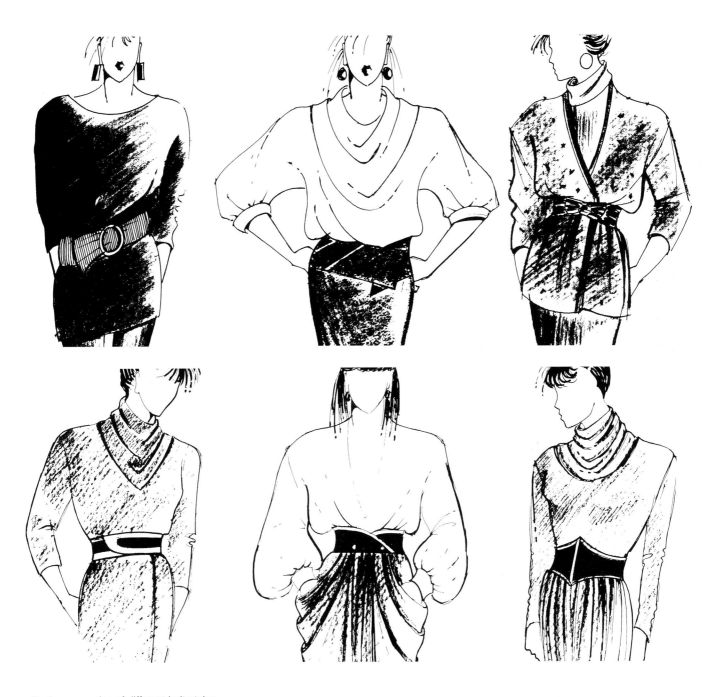

Further examples of different belt styles.

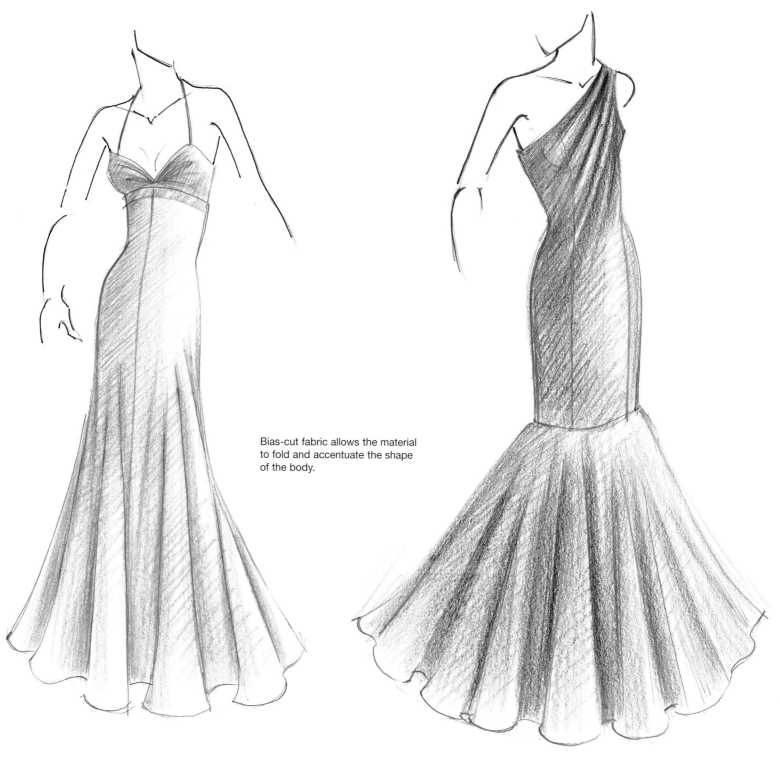

Bias-cut fabric allows the material to fold and accentuate the shape of the body.

Bias Cut

Fabric can be cut across the grain of a fabric, which causes the material to fall into a smooth vertical drape. The bias cut allows the material to be easily manipulated into folds.

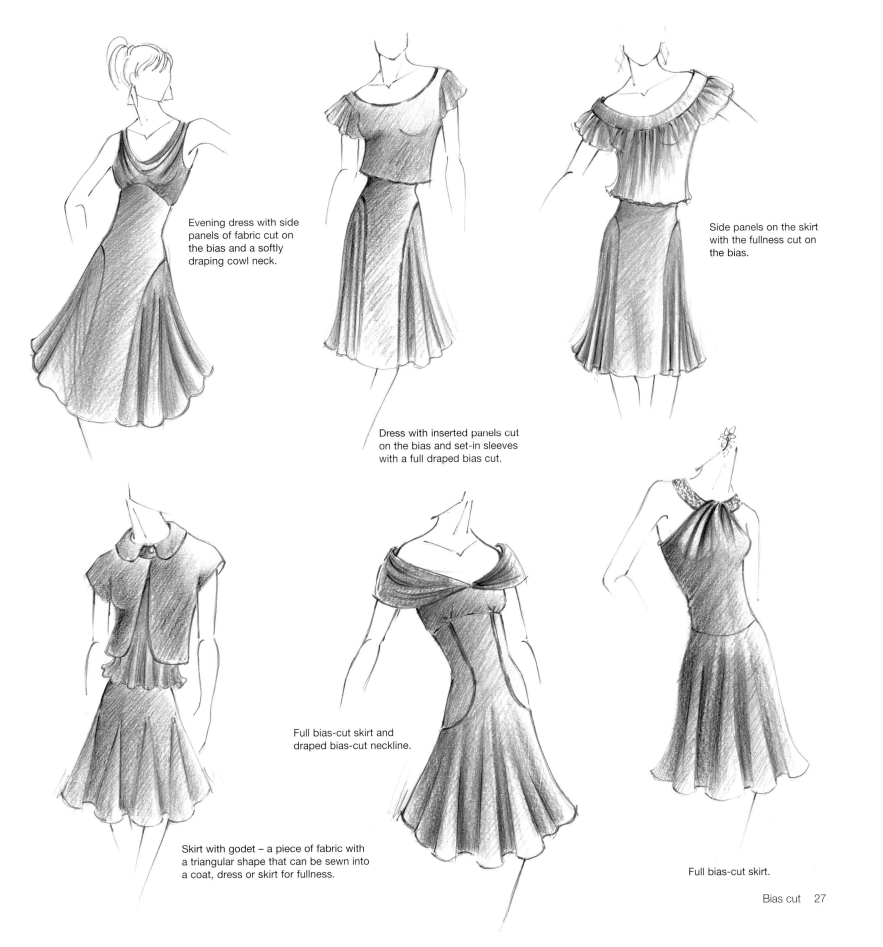

Evening dress with side panels of fabric cut on the bias and a softly draping cowl neck.

Dress with inserted panels cut on the bias and set-in sleeves with a full draped bias cut.

Side panels on the skirt with the fullness cut on the bias.

Skirt with godet – a piece of fabric with a triangular shape that can be sewn into a coat, dress or skirt for fullness.

Full bias-cut skirt and draped bias-cut neckline.

Full bias-cut skirt.

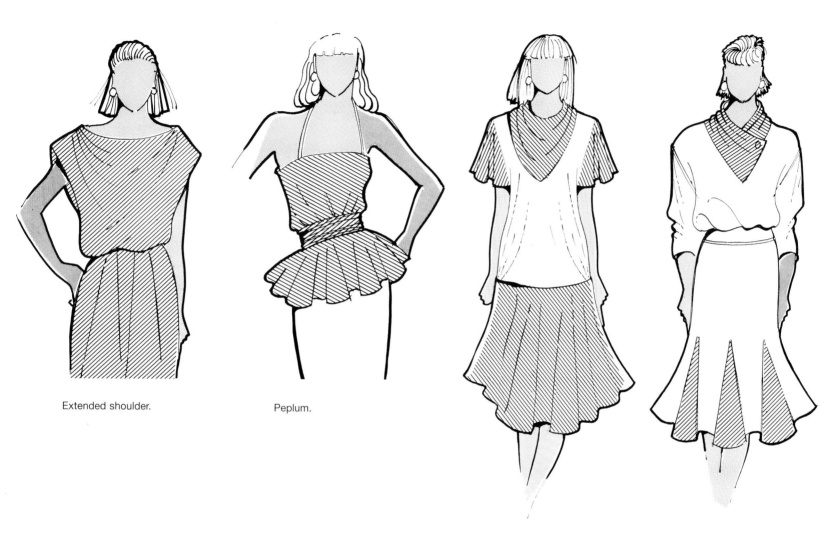

Extended shoulder.

Peplum.

Full skirt, sleeves and neckline cut on the bias.

Godets in contrast fabric with bias-cut detail on neckline.

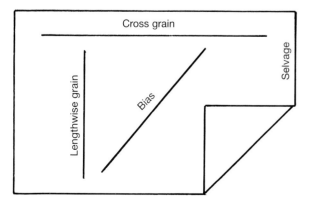

Cross grain

Lengthwise grain

Bias

Selvage

The grains of the weave indicate the direction of the thread. Lengthwise is the *warp* and crosswise the *weft*. The diagonal which intersects these two grain lines is the *bias*. The crosswise grain has more 'give' and drapes well, achieving a fuller effect.

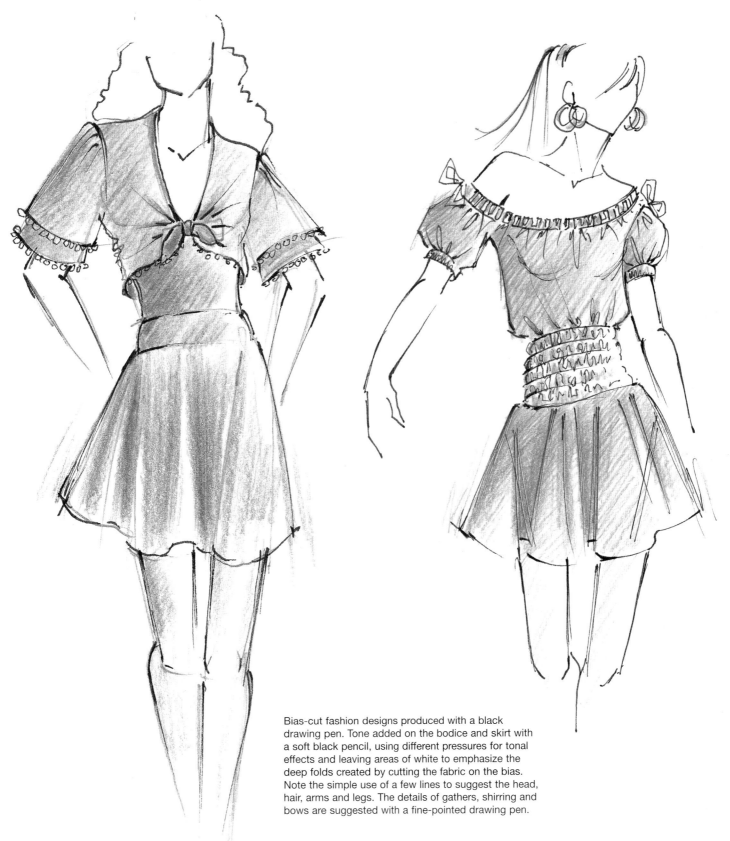

Bias-cut fashion designs produced with a black drawing pen. Tone added on the bodice and skirt with a soft black pencil, using different pressures for tonal effects and leaving areas of white to emphasize the deep folds created by cutting the fabric on the bias. Note the simple use of a few lines to suggest the head, hair, arms and legs. The details of gathers, shirring and bows are suggested with a fine-pointed drawing pen.

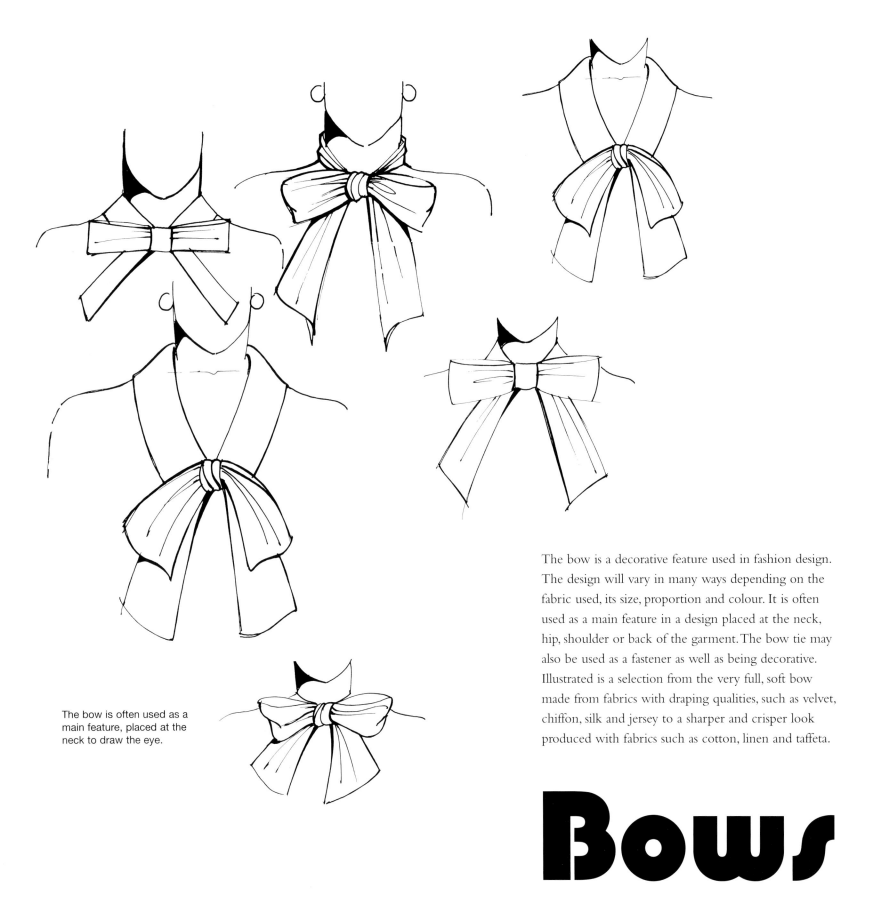

The bow is often used as a main feature, placed at the neck to draw the eye.

The bow is a decorative feature used in fashion design. The design will vary in many ways depending on the fabric used, its size, proportion and colour. It is often used as a main feature in a design placed at the neck, hip, shoulder or back of the garment. The bow tie may also be used as a fastener as well as being decorative. Illustrated is a selection from the very full, soft bow made from fabrics with draping qualities, such as velvet, chiffon, silk and jersey to a sharper and crisper look produced with fabrics such as cotton, linen and taffeta.

Bows

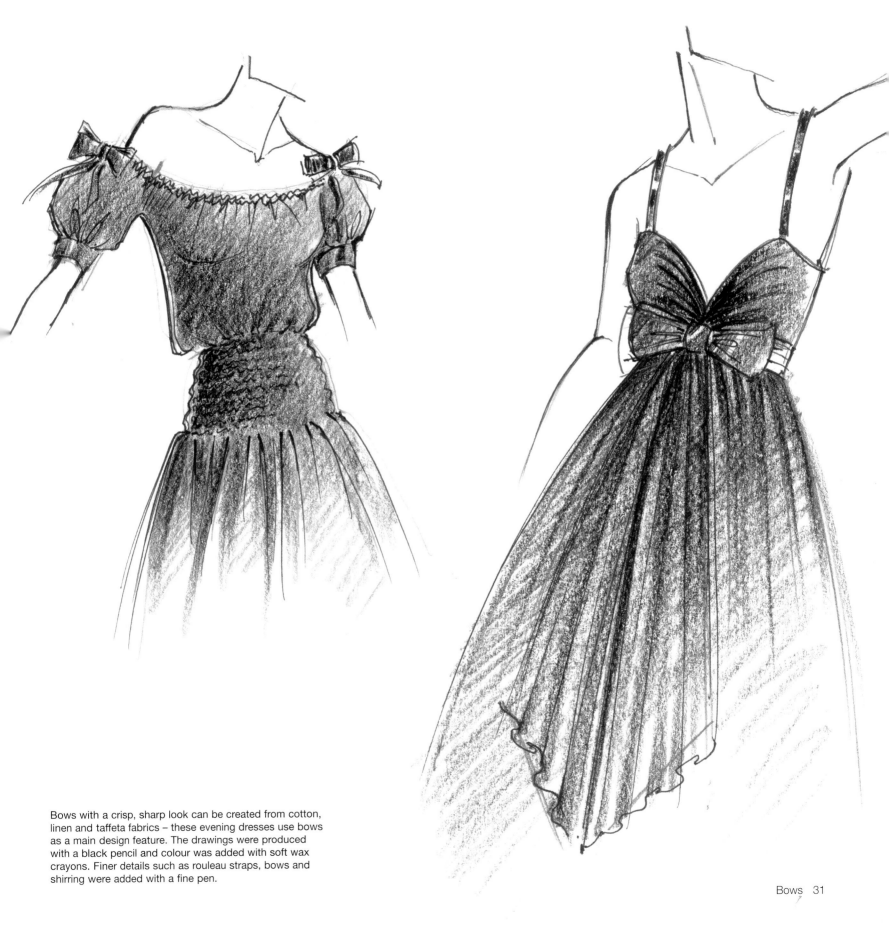

Bows with a crisp, sharp look can be created from cotton, linen and taffeta fabrics – these evening dresses use bows as a main design feature. The drawings were produced with a black pencil and colour was added with soft wax crayons. Finer details such as rouleau straps, bows and shirring were added with a fine pen.

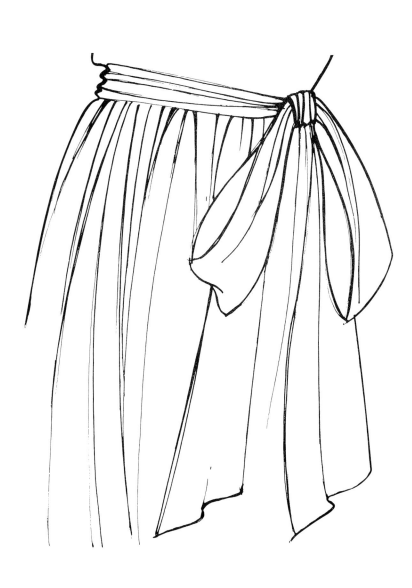

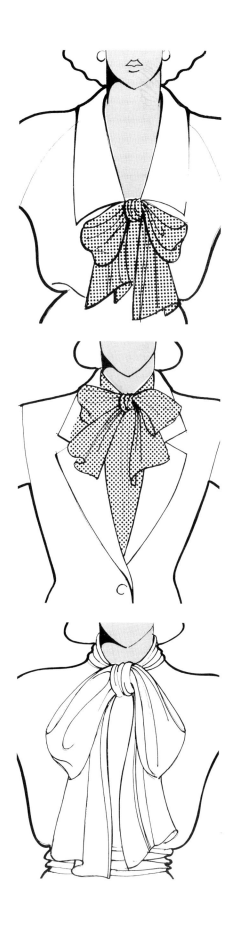

A selection of bows made
from fabrics with good drape.

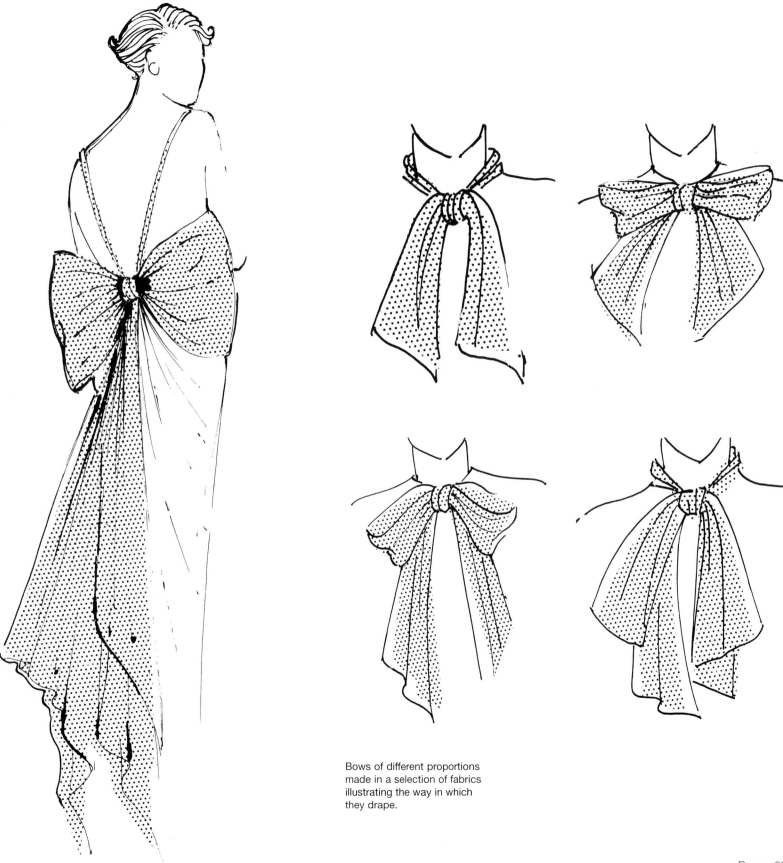

Bows of different proportions
made in a selection of fabrics
illustrating the way in which
they drape.

Eveningwear with bow details.

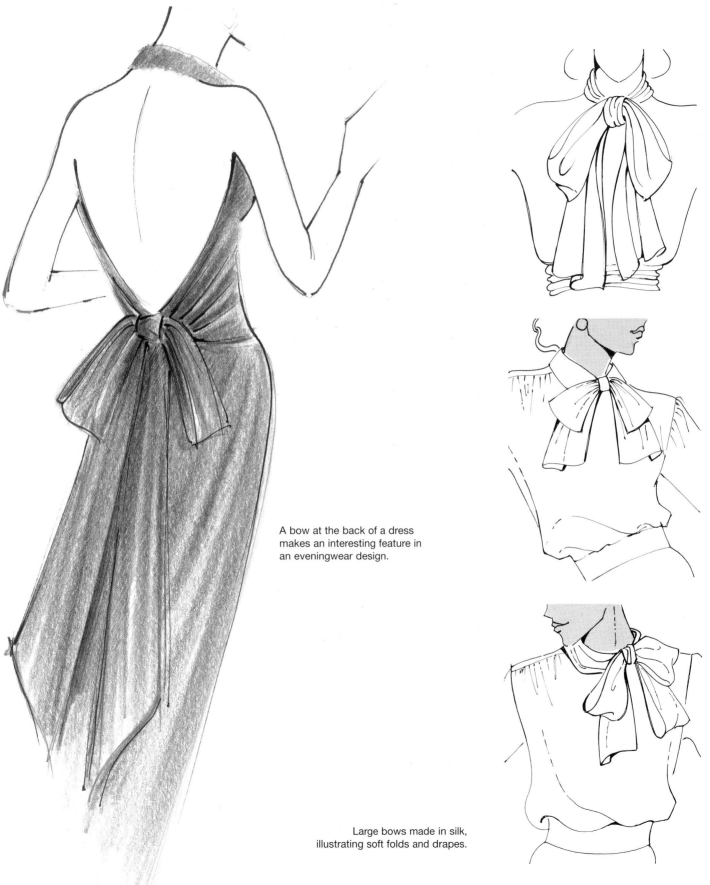

A bow at the back of a dress makes an interesting feature in an eveningwear design.

Large bows made in silk, illustrating soft folds and drapes.

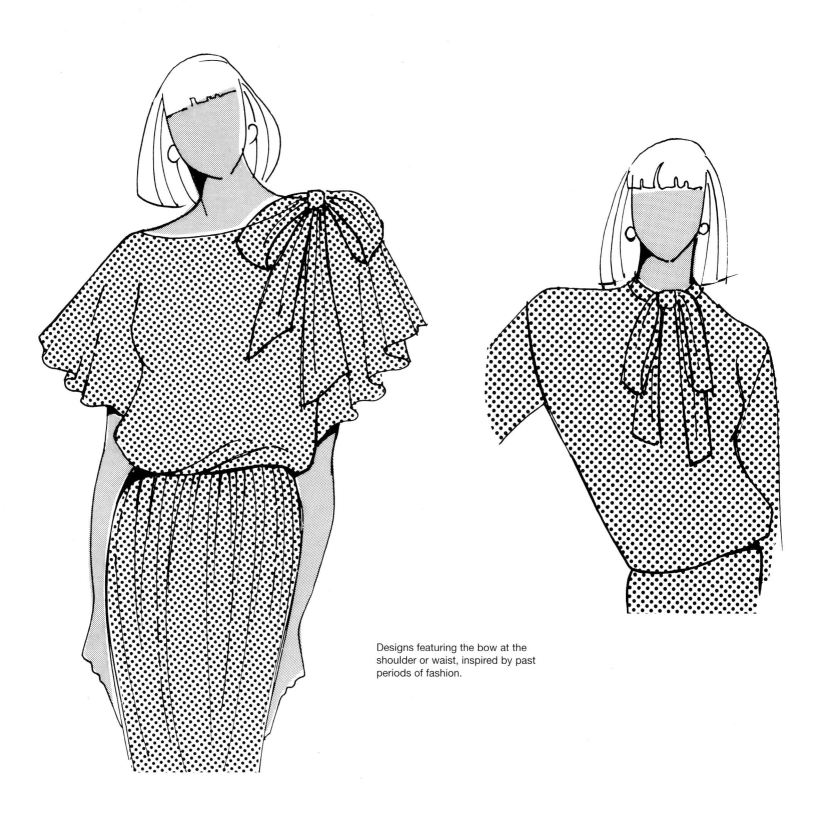

Designs featuring the bow at the
shoulder or waist, inspired by past
periods of fashion.

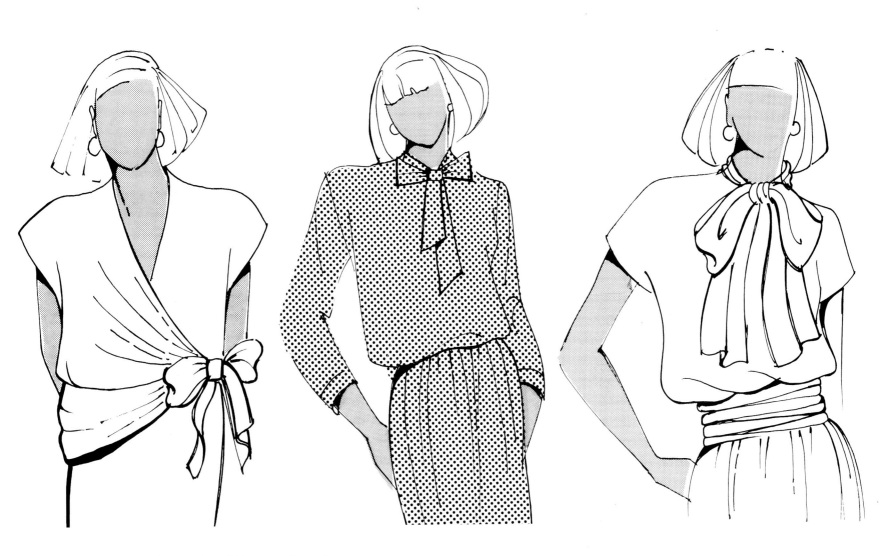

Bows placed at the neck, shoulder and hip, as used in past periods of fashion. The bow can be used as a decorative feature or as a fastener. Note how using different fabrics creates different proportions and styles of drape.

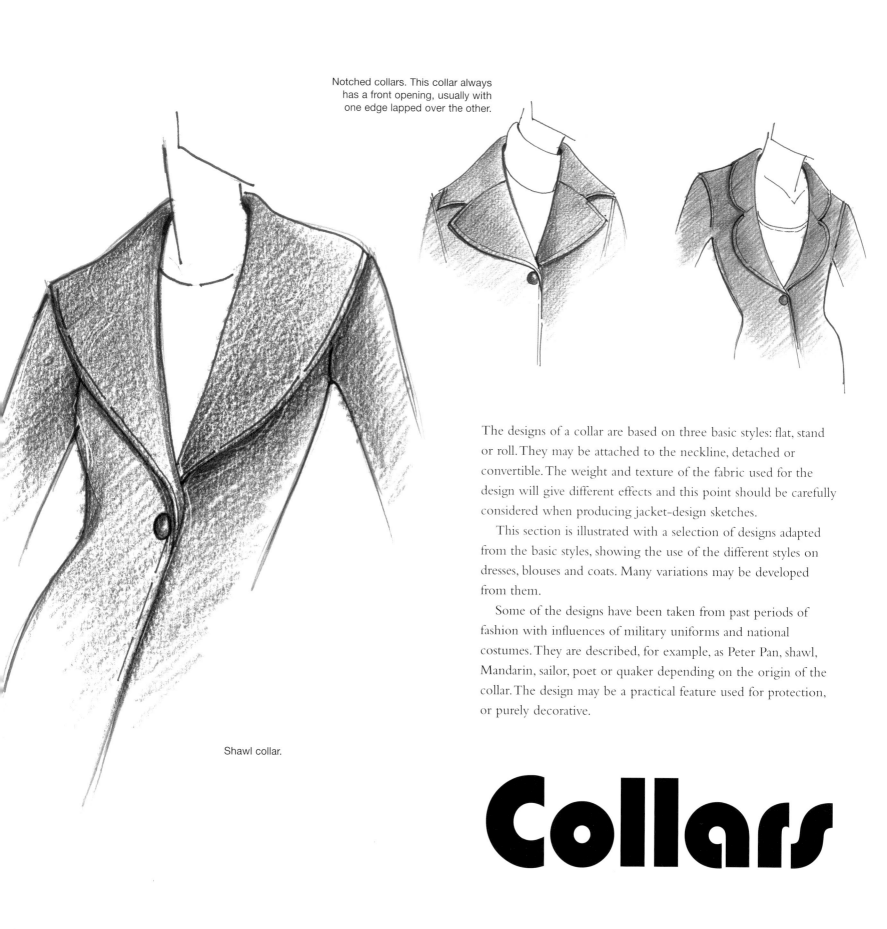

Notched collars. This collar always has a front opening, usually with one edge lapped over the other.

Shawl collar.

The designs of a collar are based on three basic styles: flat, stand or roll. They may be attached to the neckline, detached or convertible. The weight and texture of the fabric used for the design will give different effects and this point should be carefully considered when producing jacket-design sketches.

This section is illustrated with a selection of designs adapted from the basic styles, showing the use of the different styles on dresses, blouses and coats. Many variations may be developed from them.

Some of the designs have been taken from past periods of fashion with influences of military uniforms and national costumes. They are described, for example, as Peter Pan, shawl, Mandarin, sailor, poet or quaker depending on the origin of the collar. The design may be a practical feature used for protection, or purely decorative.

Collars

Roll collar.

Stand collar.

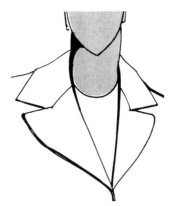

Tailored collar.

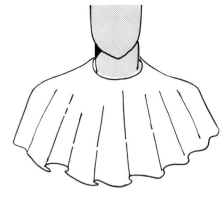

Bertha collar: a 1920s copy of a short shoulder cape.

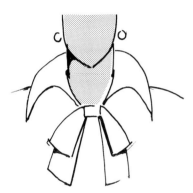

Gladstone collar. A standing collar with long points worn with a scarf tie made of silk.

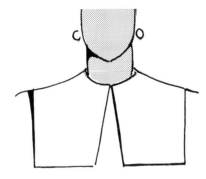

Quaker collar. A flat, broad turned-down collar.

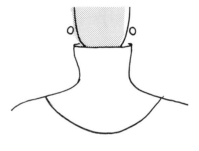

Funnel collar. This collar flares outward at the top of the neckline.

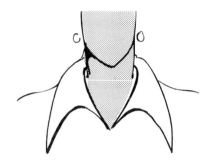

Poet collar. Made from softly draping fabric attached to a shirt blouse.

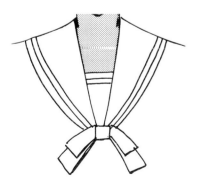

Sailor collar, which is square at the back and narrow in the front.

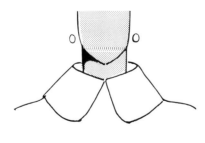

Eton collar. A large collar made of stiffened fabric.

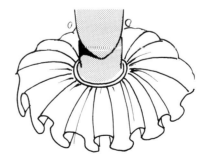

Pierrot collar. A very wide ruff of fabric.

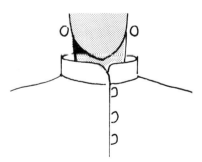

Mandarin collar. A small stand collar cut close to the neck.

Parts of the collar

The *stand* is the part that fits close to the neck. This part is covered by the turnover or *fall*. The height of the stand will vary depending on the design. The *break line* is the line on which the lapels turn back and the fall turns over the stand. The *style line* is the shape of the outer edge of the collar. The shape between the lapel and the collar is the *notch*.

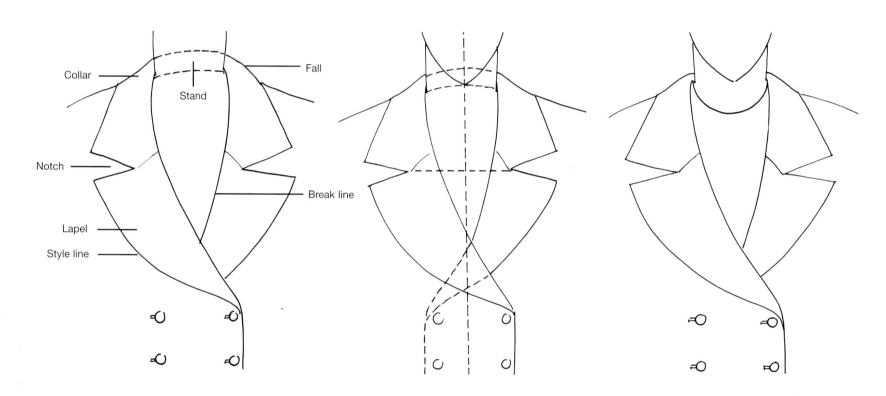

Two stages of drawing a double-breasted collar and lapel on a coat. Note the dotted line showing the balance of the collar working from the centre-front line.

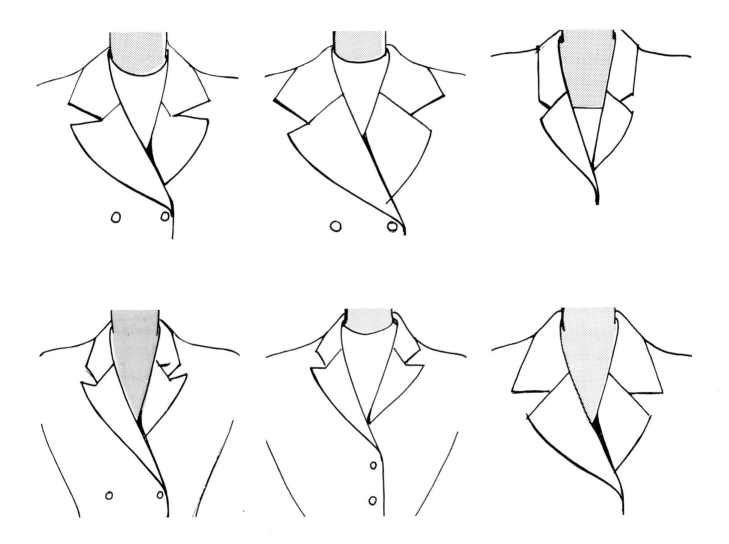

A selection of tailored collars
and lapels.

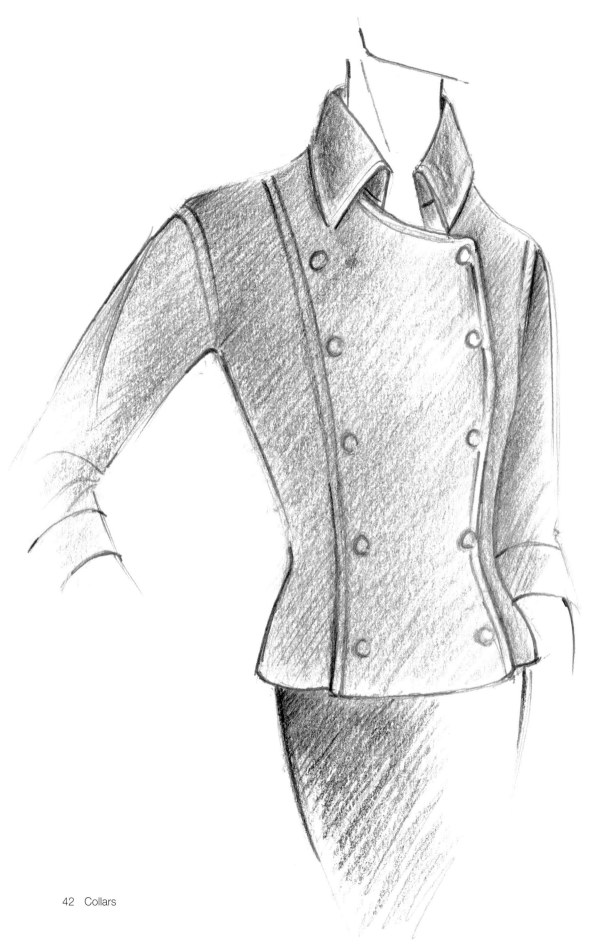

Stand collars with a military-influenced design.
The drawings feature stand collars, pockets,
cuffs and single and double-breasted button
fastenings. Cord-piped, flat-felled welt seaming
has also been used in the designs (see page
244). The drawings were produced using a white
cartridge drawing paper with a fine-grain surface
for texture. Colour was applied with Derwent
artist coloured pencils and details added with
a sharp-pointed HB pencil.

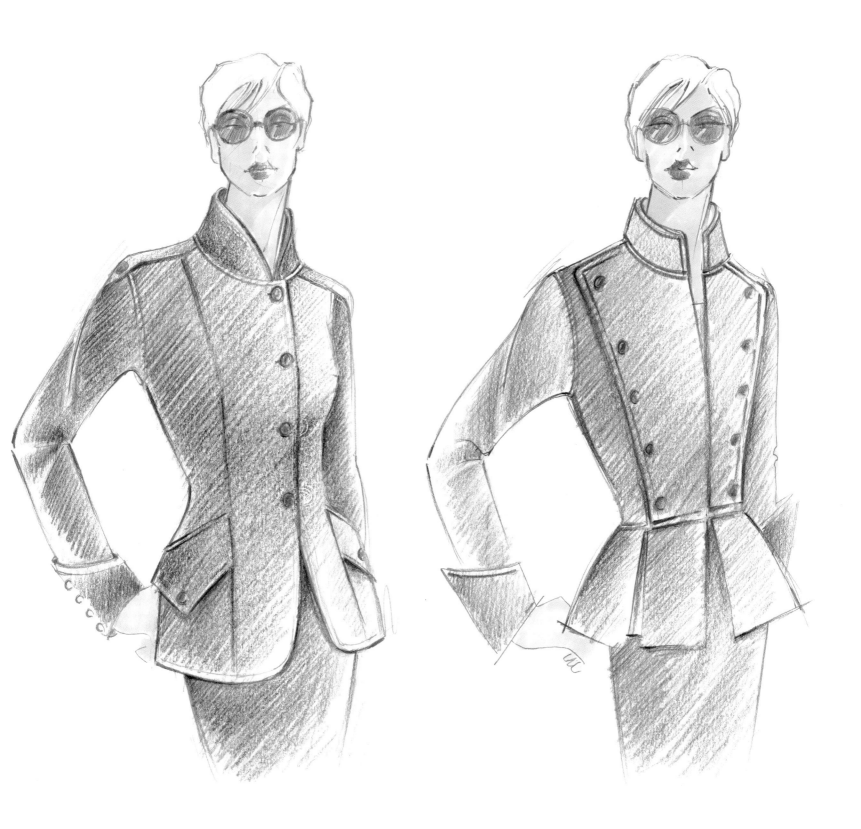

The stand

This collar extends above the neck seamline of the garment. The height will vary depending on the design effects required. It may be made from a single-width band or a double band that turns down on itself. This collar may be used on coats, suits, dresses or blouses – anywhere there's a neckline.

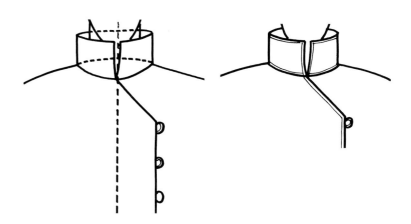

Note the two stages of drawing the standing collar.

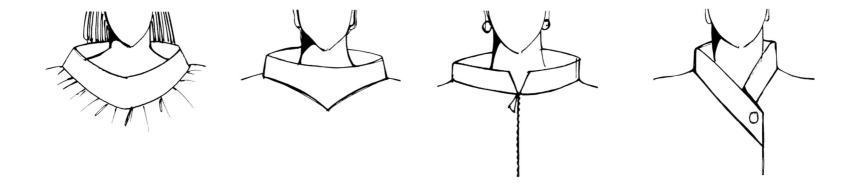

Variations of the stand collar.

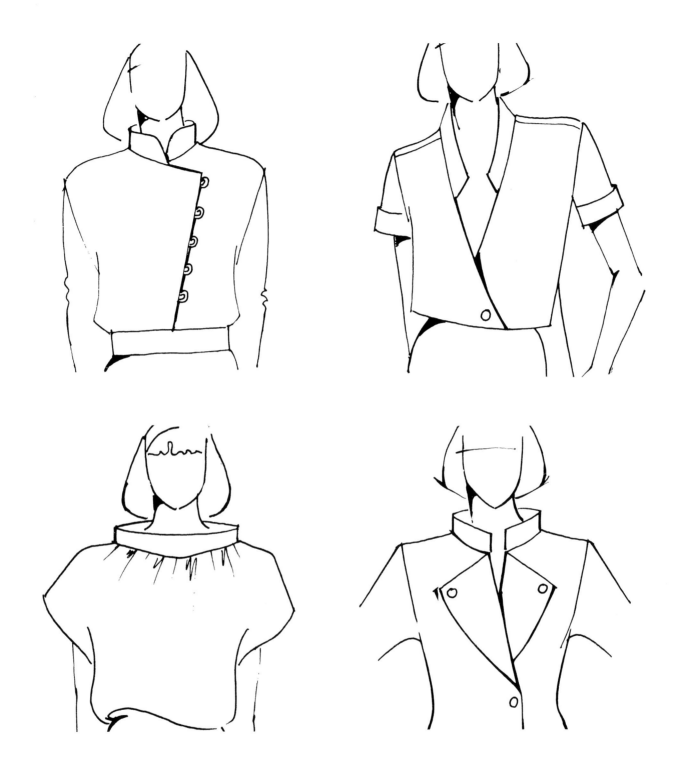

Further variations of the
stand collar.

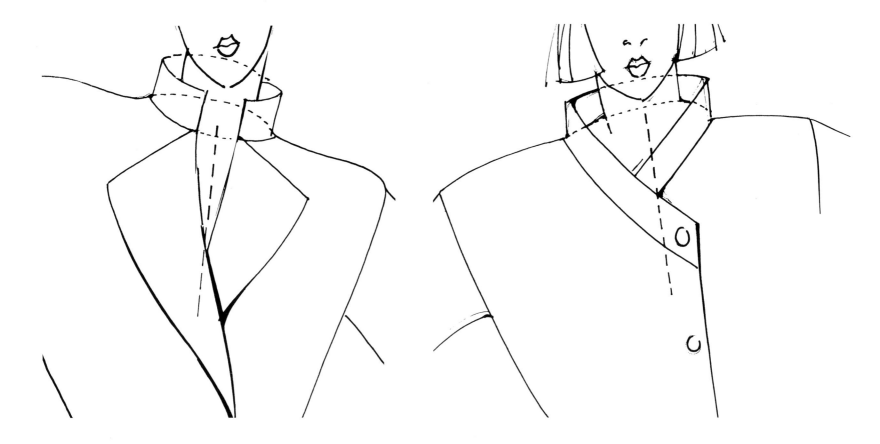

Four designs showing the variations of a stand collar on a selection of garments. Note the dotted construction lines for assistance when sketching.

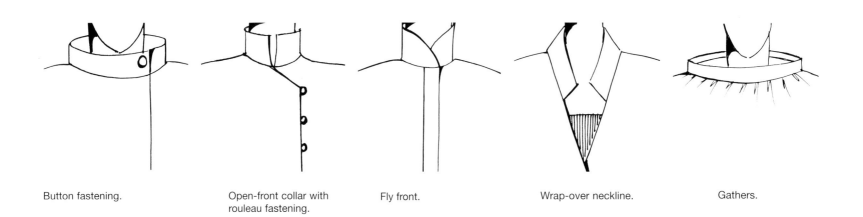

Button fastening.

Open-front collar with rouleau fastening.

Fly front.

Wrap-over neckline.

Gathers.

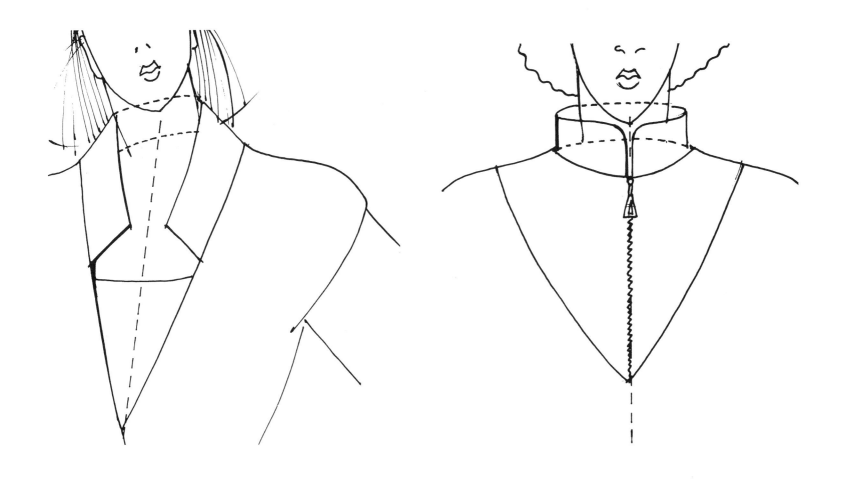

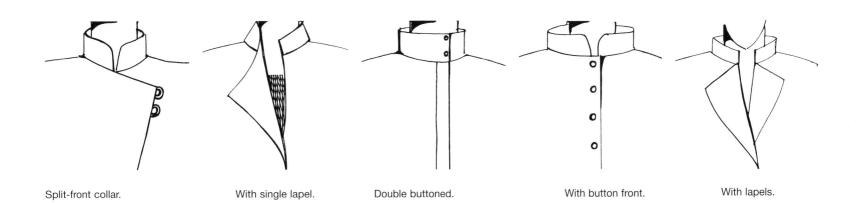

Split-front collar. With single lapel. Double buttoned. With button front. With lapels.

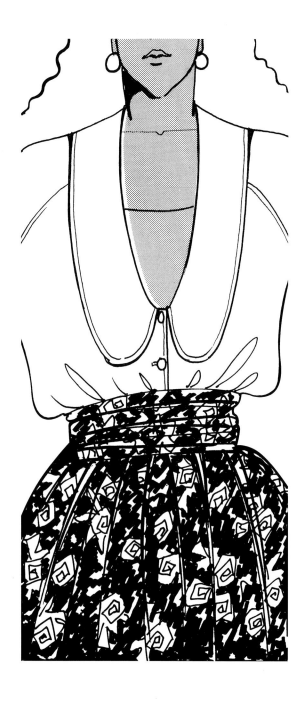

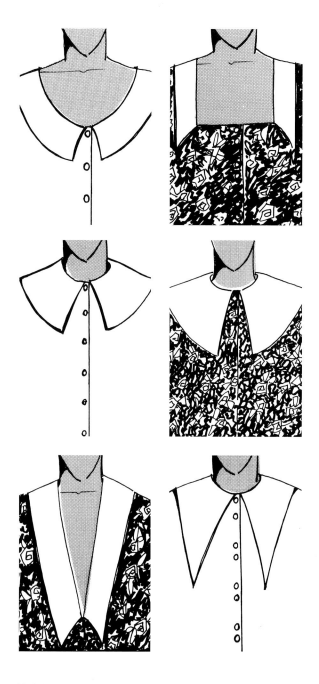

Variations of a flat collar.

Flat collar

A flat collar is attached to the neckline to lay flat against the garment, rising slightly about the neck edge. The Peter Pan collar is a good example of the flat collar. Variations from the basic flat collar are illustrated here.

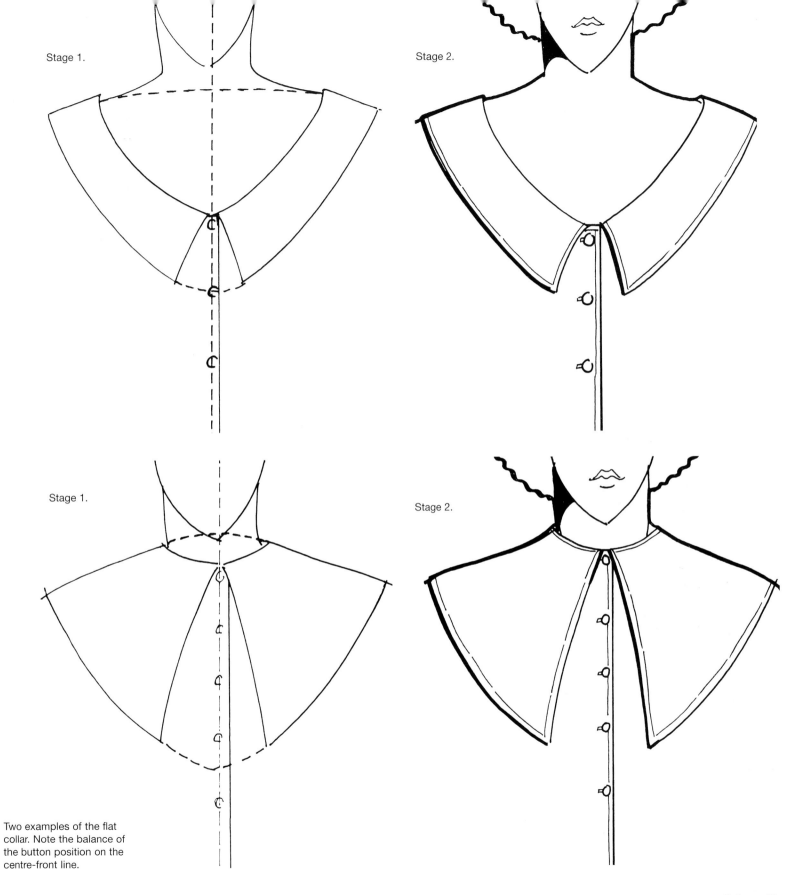

Stage 1.

Stage 2.

Stage 1.

Stage 2.

Two examples of the flat collar. Note the balance of the button position on the centre-front line.

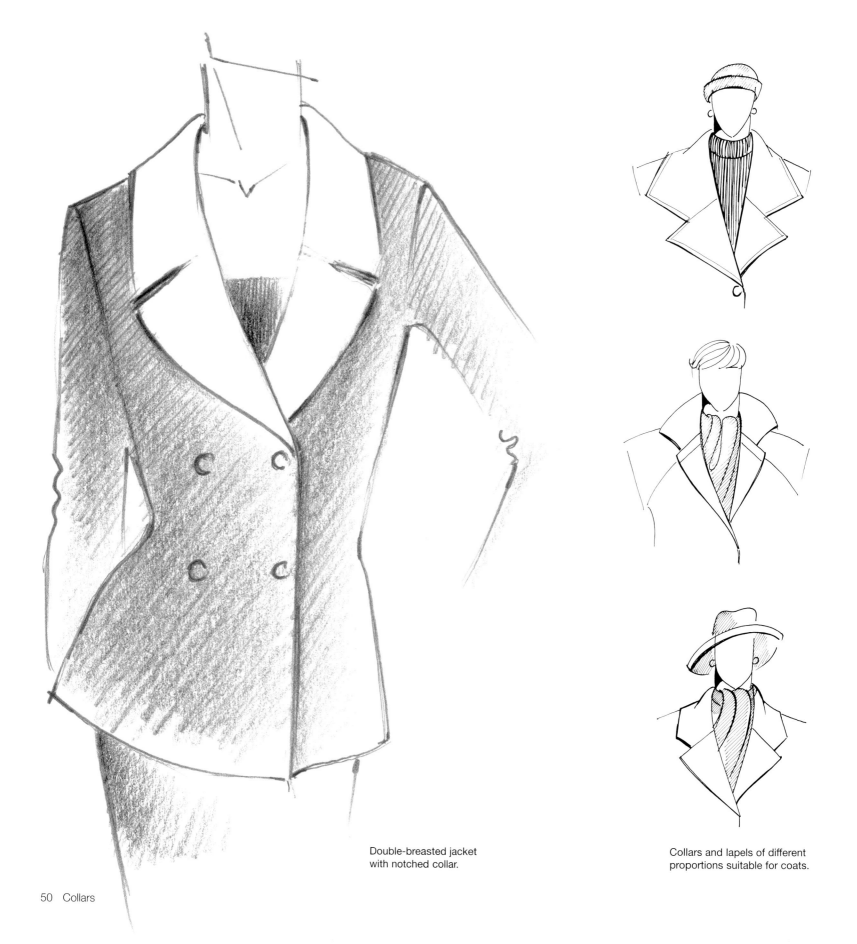

Double-breasted jacket
with notched collar.

Collars and lapels of different
proportions suitable for coats.

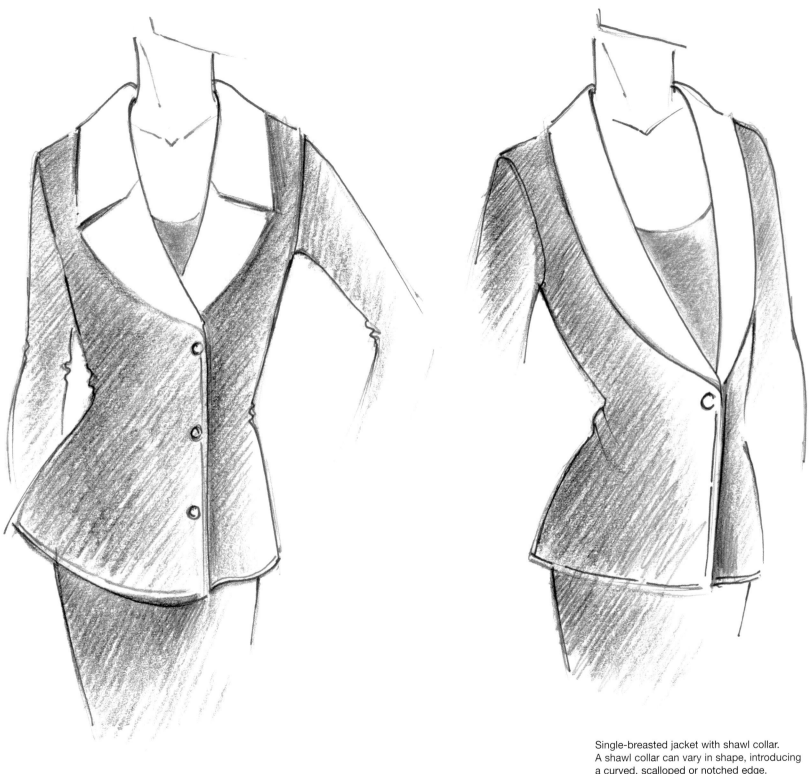

Single-breasted jacket with
notched collar.

Single-breasted jacket with shawl collar.
A shawl collar can vary in shape, introducing
a curved, scalloped or notched edge.
Traditionally the shawl collar is wrapped in
the front and held with a sash (see overleaf).

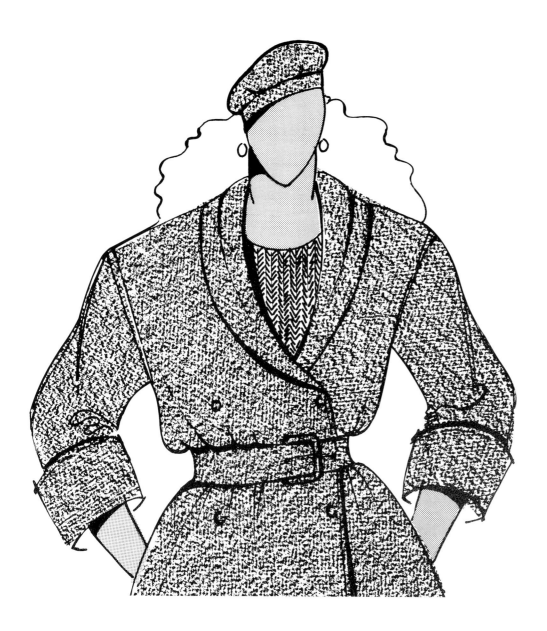
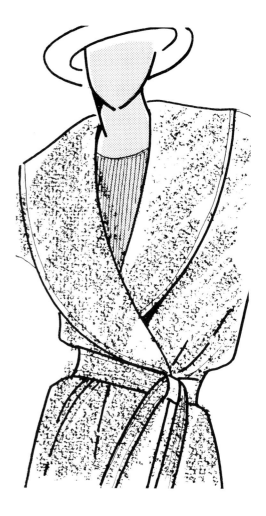

Shawl collar

The shawl collar is cut in one single piece. This eliminates the need for the seam between the collar and the lapel. It is usually an unbroken line but in some designs it may be notched or scalloped. The design is usually a front wrapped garment held together by a belt in place of buttons, but it may also be designed with other fastenings as illustrated on page 54.

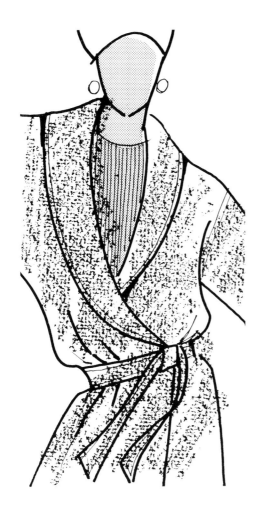
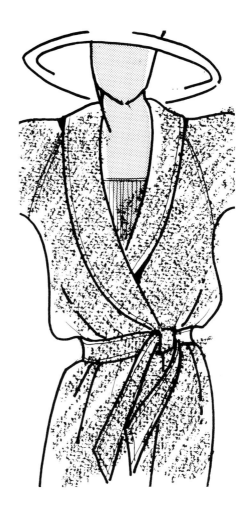

Stage 1.

Stage 2.

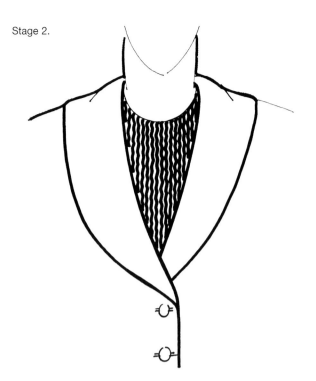

Drawing the shawl collar in two stages,
balancing the front centre line.

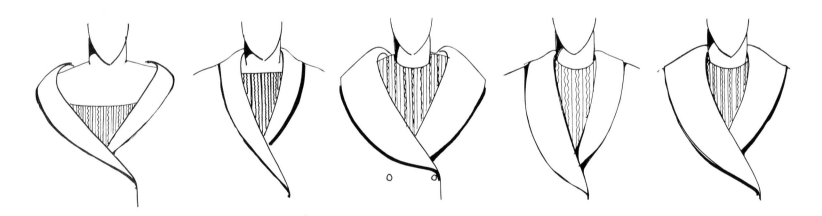

A selection of designs based
on a shawl collar.

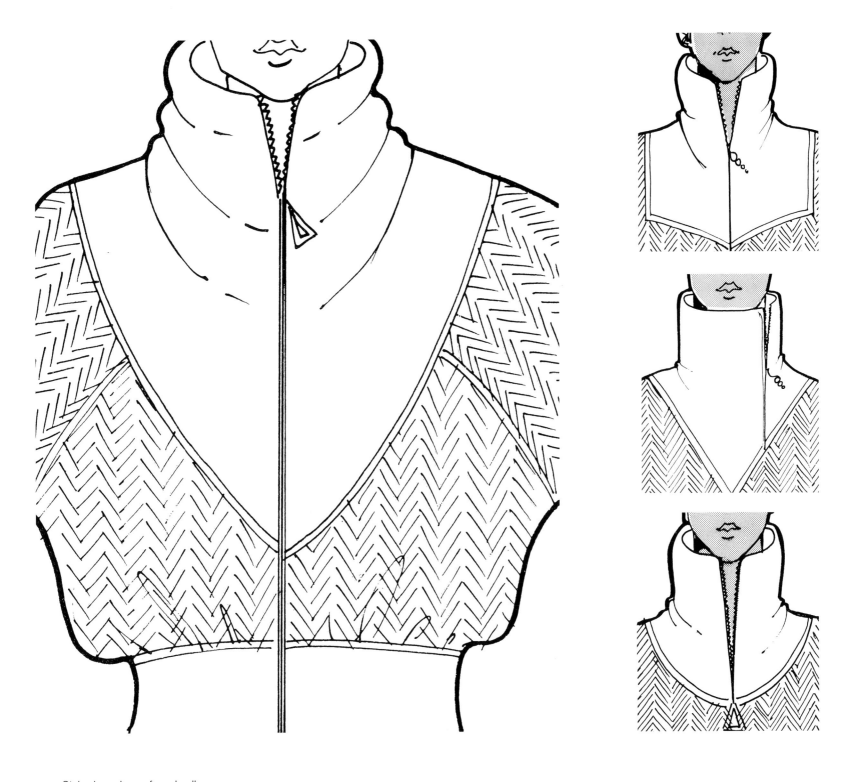

Styles based on a funnel collar
with zip-fastener openings.

Stage 1.

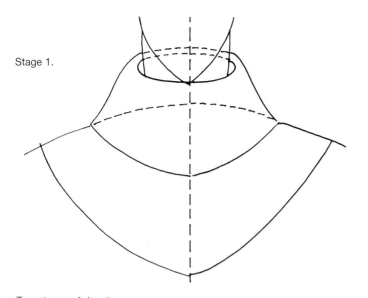

Stage 2.

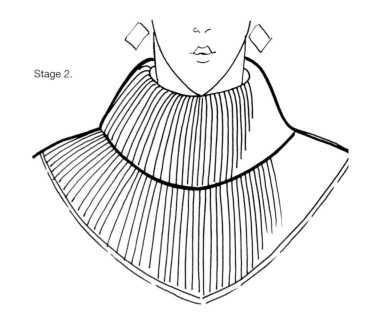

Two stages of drawing a
polo neck.

Stage 1.

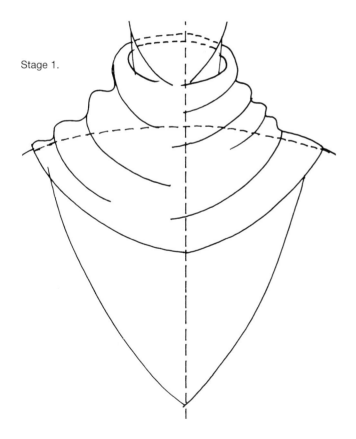

Stage 2.

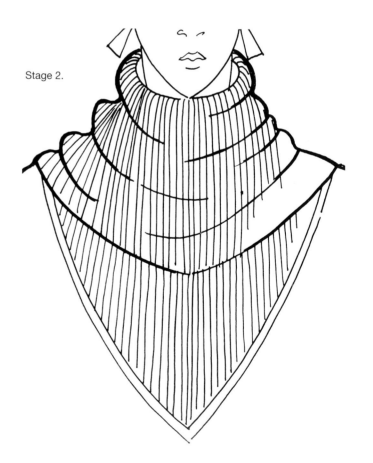

Two stages of drawing a turtle-neck collar set
into a yoke with a centre-front fastening.

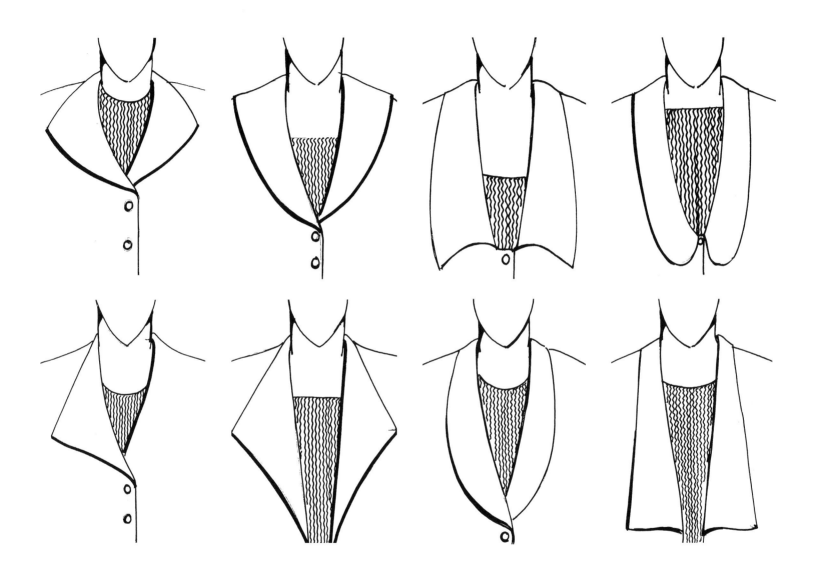

A selection of collars.

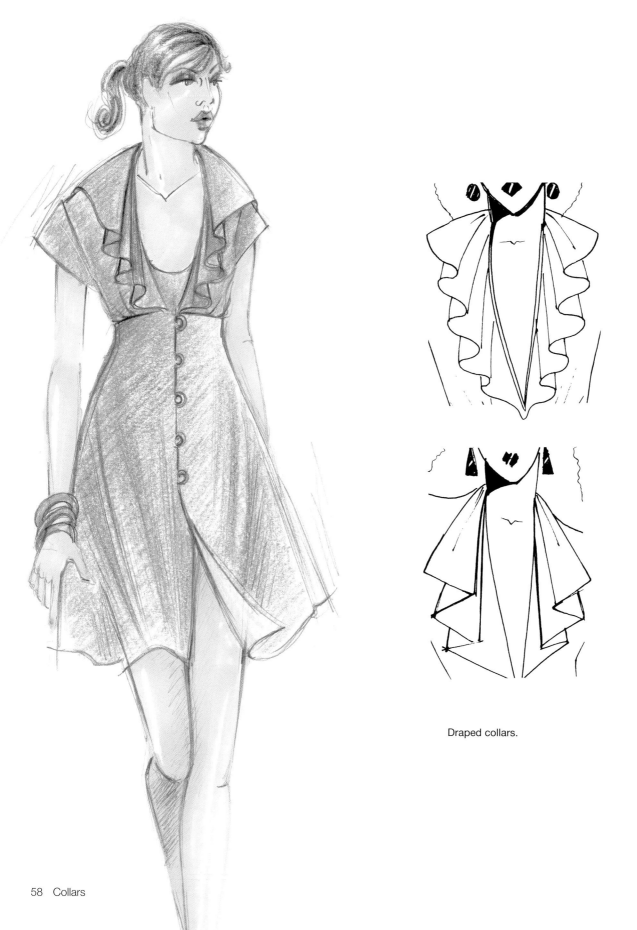

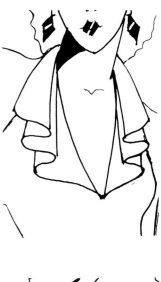

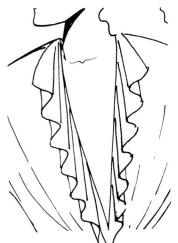

Draped collars.

Stage 1.

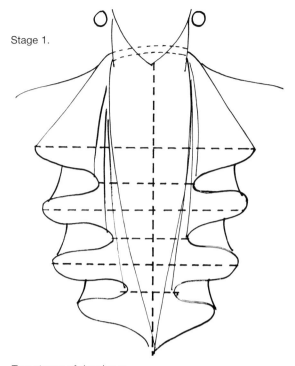

Stage 2.

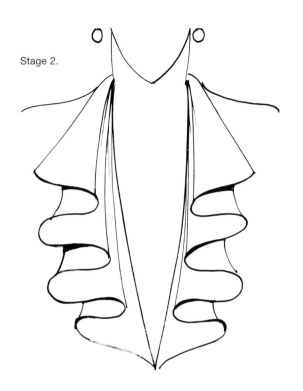

Two stages of drawing a
draped collar.

Stage 1.

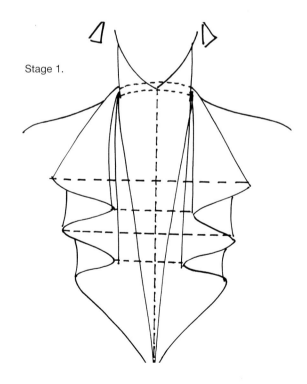

Stage 2.

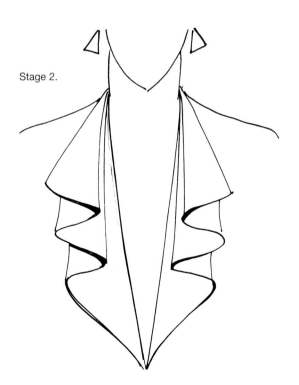

Note the horizontal dotted lines used as balance
lines when sketching the folds of the flounce.

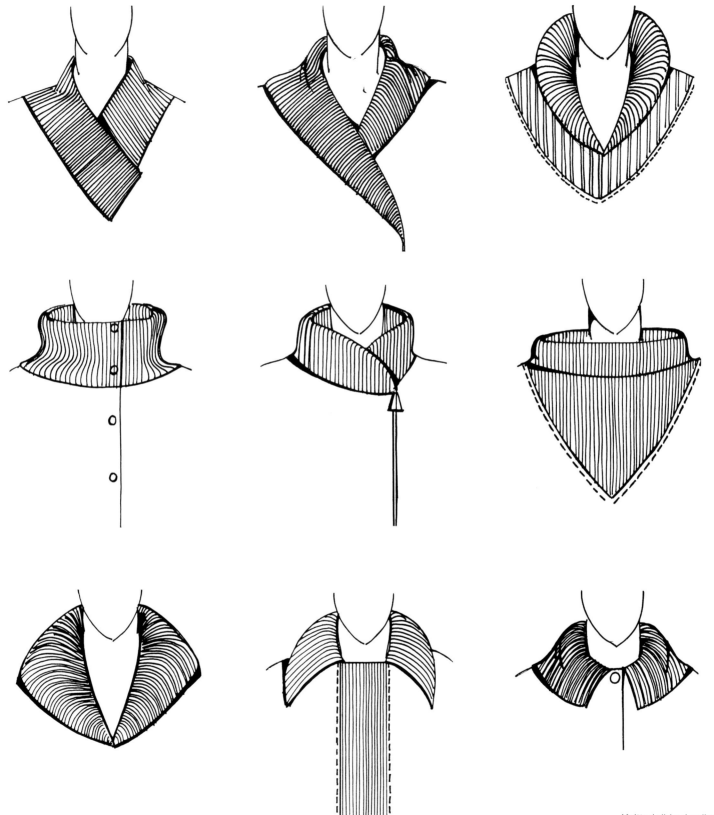

Knitted ribbed collars.

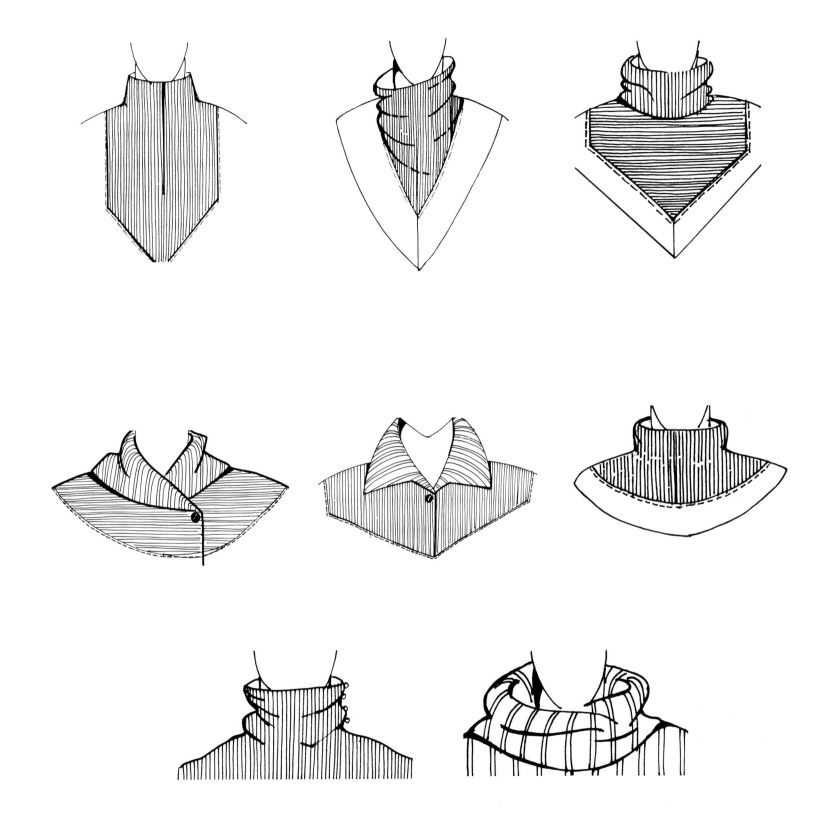

A selection of knitted collars
combined with fabric in a design.
The effects vary depending on
the yarns used.

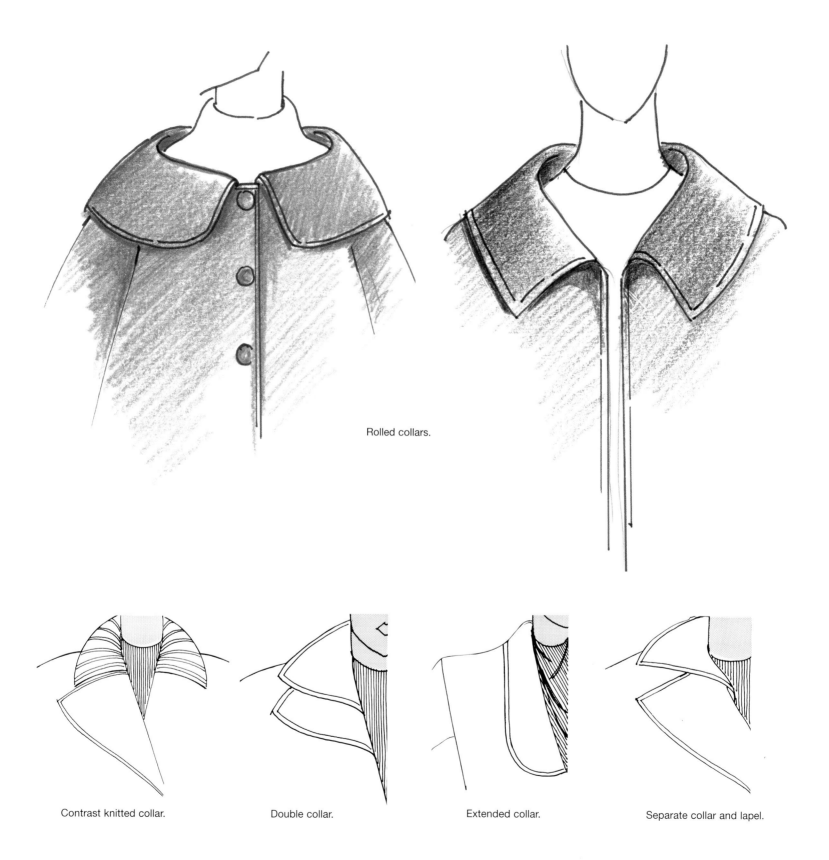

Rolled collars.

Contrast knitted collar.

Double collar.

Extended collar.

Separate collar and lapel.

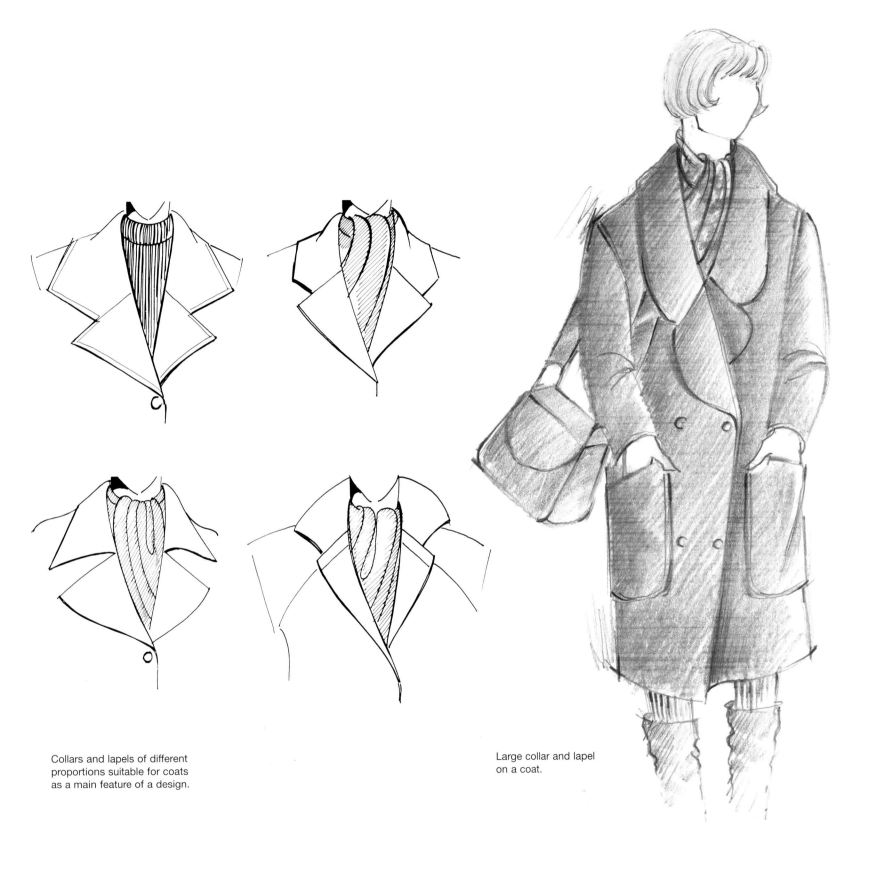

Collars and lapels of different
proportions suitable for coats
as a main feature of a design.

Large collar and lapel
on a coat.

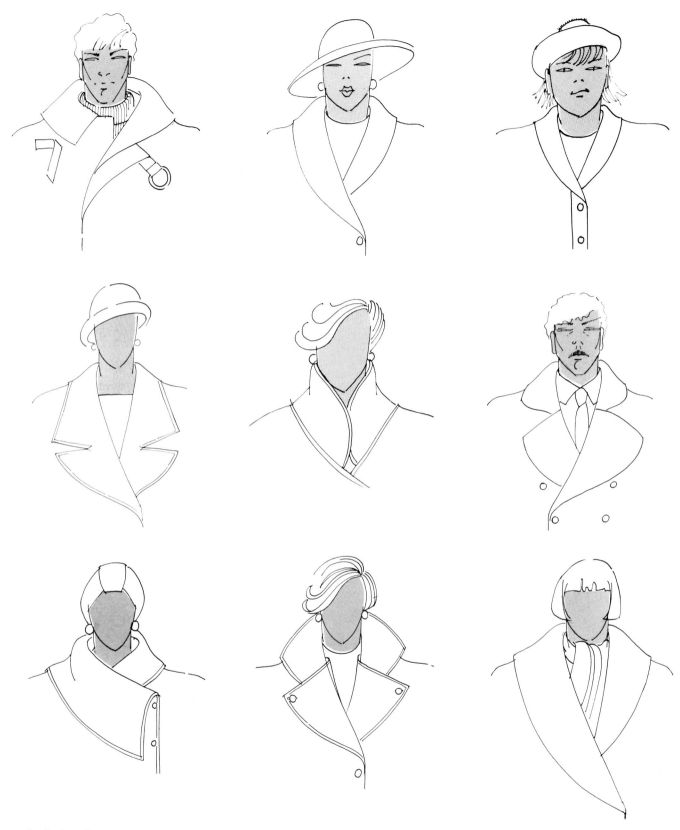

A selection of collars and lapels.

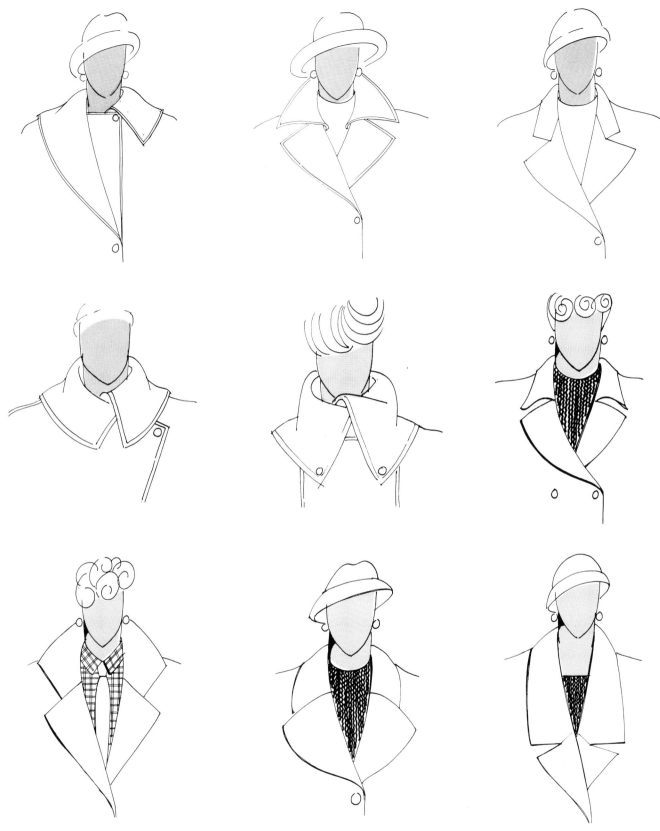

Collars and lapels.

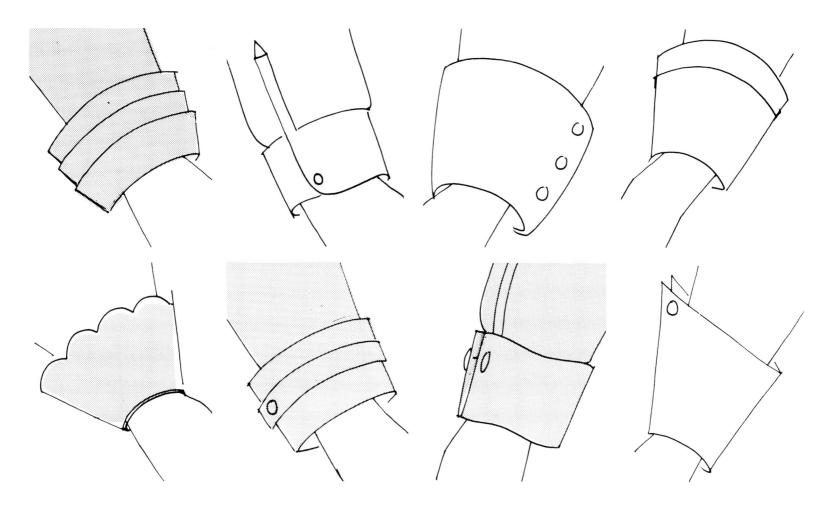

A selection of cuffs.

Cuffs

Sleeves are finished either with a simple hem or with a cuff. Cuffs can be short or long, slimline or chunky, shaped, square-cut or angled. They can be plain, contrasting or decorated and they can be single or multi-layered. Many design effects may be achieved with trimmings, pleating, tucks, gathers and shirring.

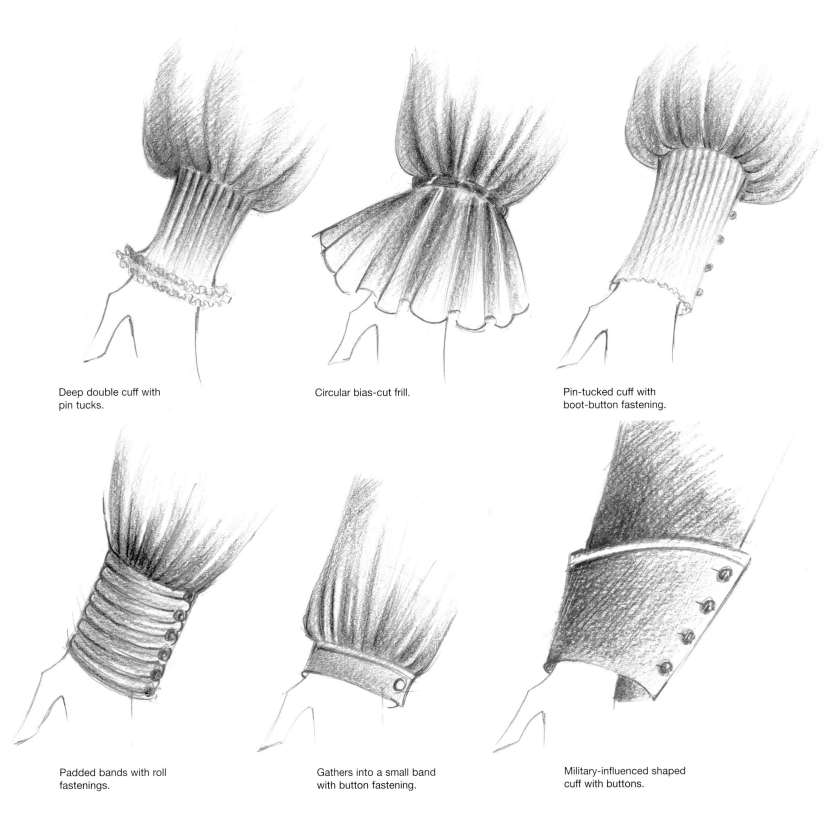

Deep double cuff with
pin tucks.

Circular bias-cut frill.

Pin-tucked cuff with
boot-button fastening.

Padded bands with roll
fastenings.

Gathers into a small band
with button fastening.

Military-influenced shaped
cuff with buttons.

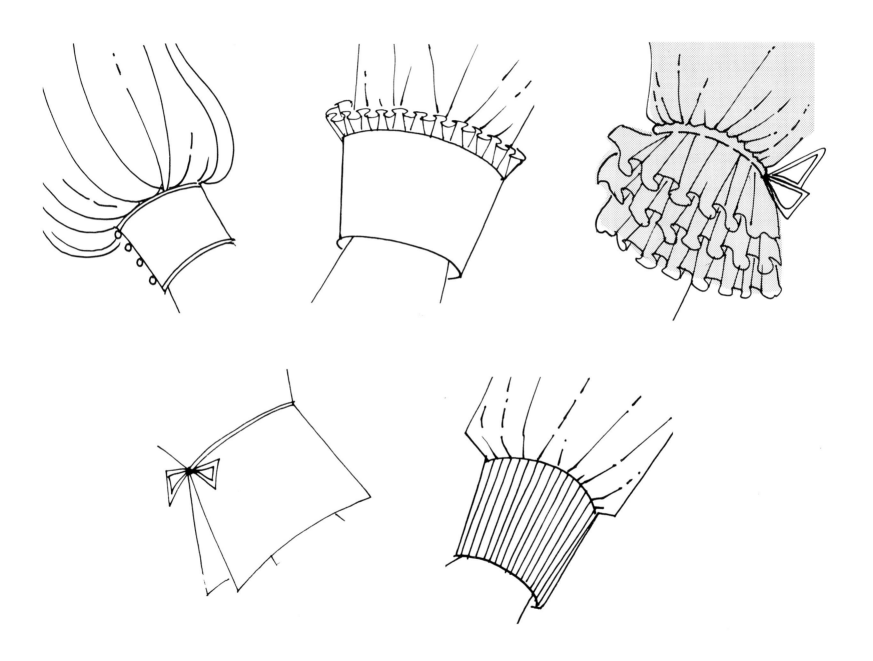

A selection of cuffs. A variety of trimmings are
used to add interest and complement the design.

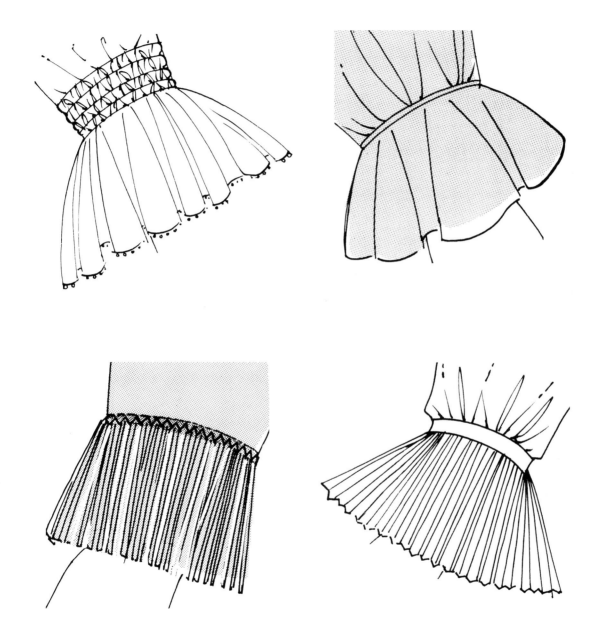

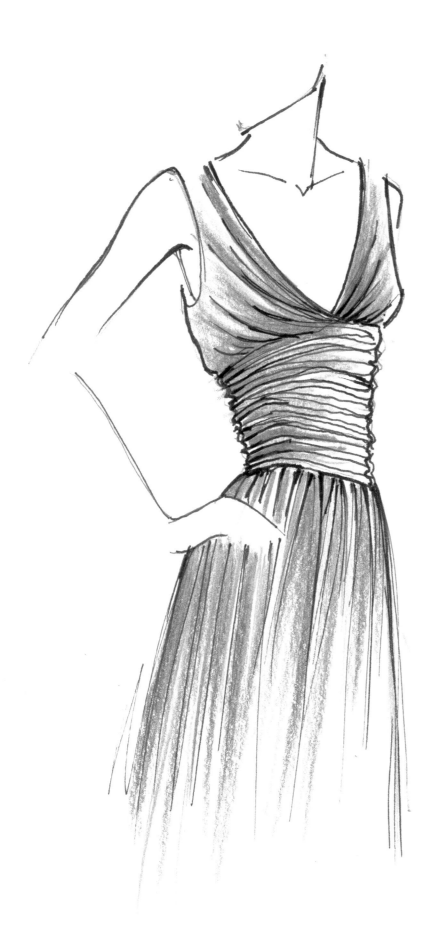

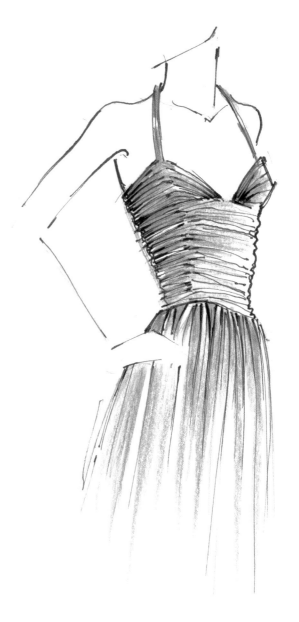

Many effects may be achieved with the use of drapes within a design. They may be introduced as a complete theme or as a detail on the collar, bodice, sleeve or skirt. The fabric used must have good draping qualities, such as silk, jersey, fine wool, velvet or chiffon. The drapes will vary from fine, soft folds to very deep folds depending on the fabric.

Drapes

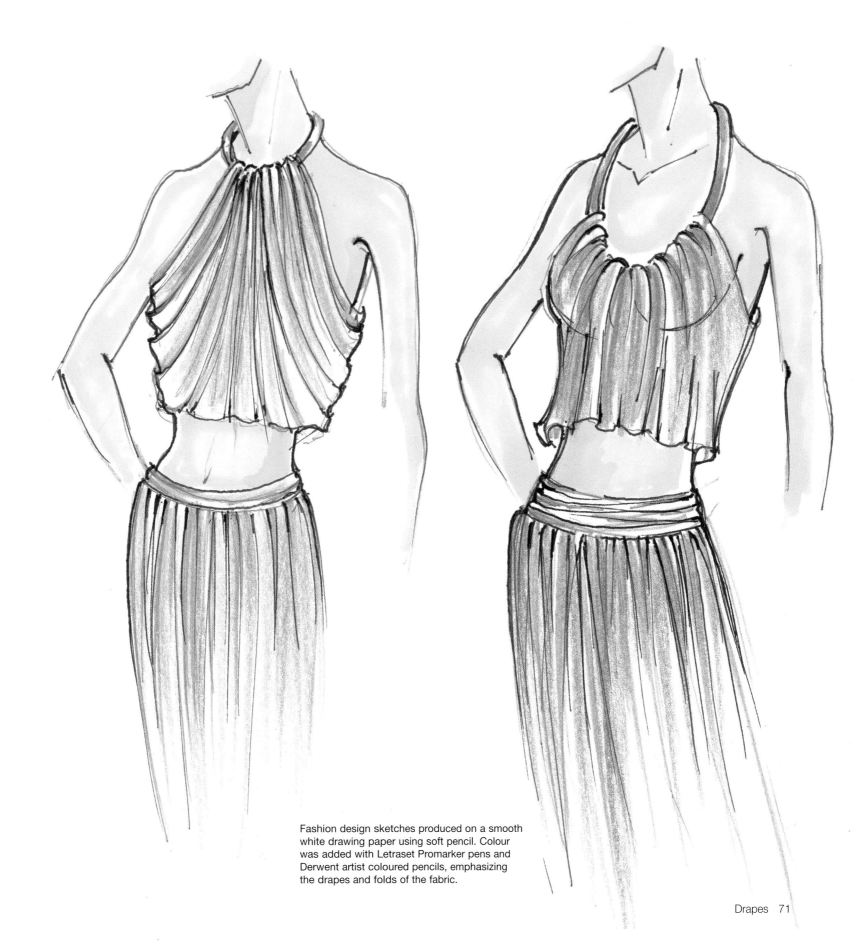

Fashion design sketches produced on a smooth white drawing paper using soft pencil. Colour was added with Letraset Promarker pens and Derwent artist coloured pencils, emphasizing the drapes and folds of the fabric.

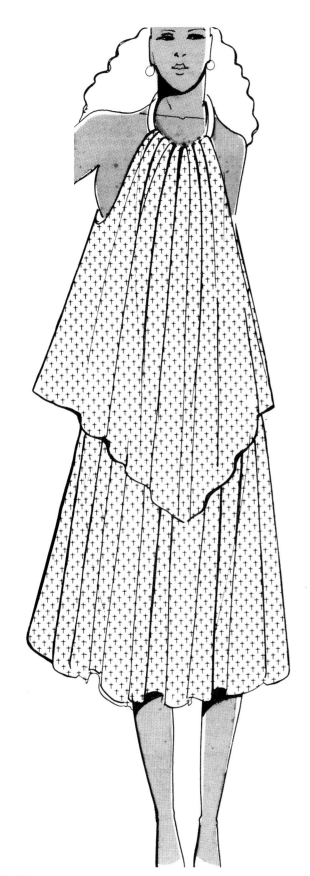

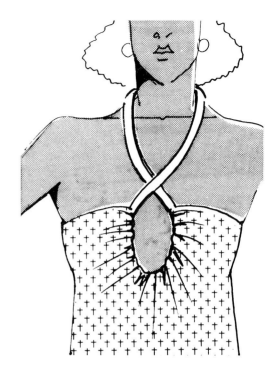

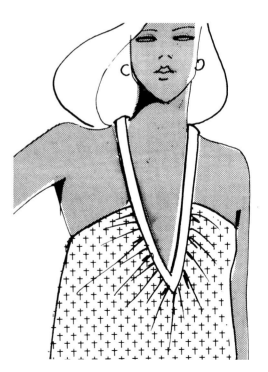

Drapes from the neckline
combined with rouleau straps.

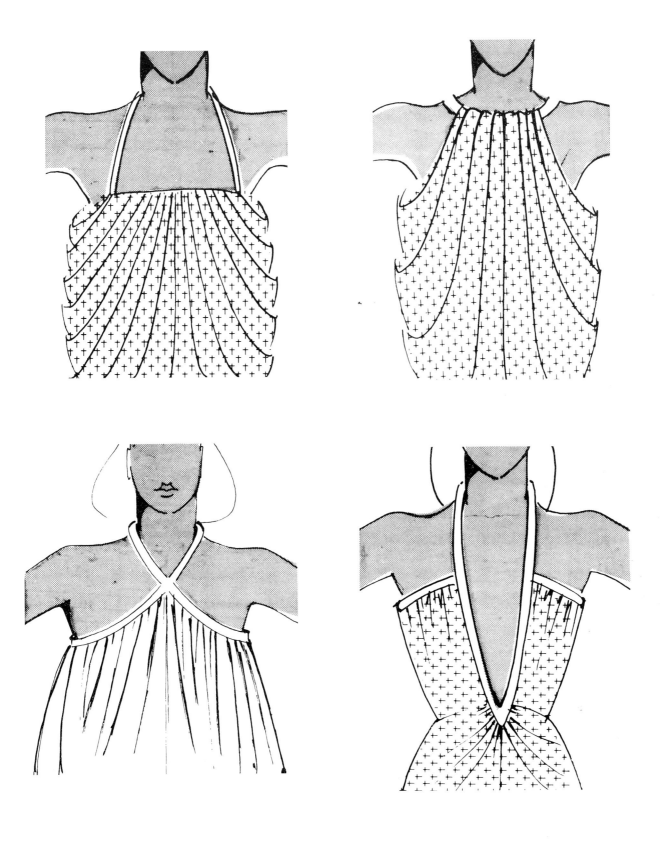

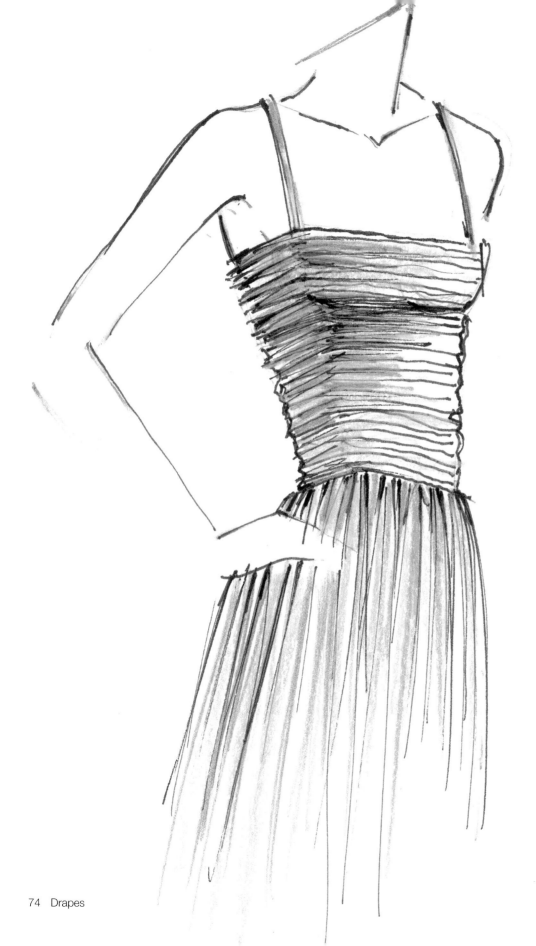

Draped bodices. These drawings illustrate how drapes and shoulder straps can be combined to create interesting neckline shapes on eveningwear. Many design effects are created by using drapes on the bodice of a dress, often allowing the fabric to fall in soft folds extending to the skirt or used in a more controlled and restricted way to accentuate the body shape, as illustrated.

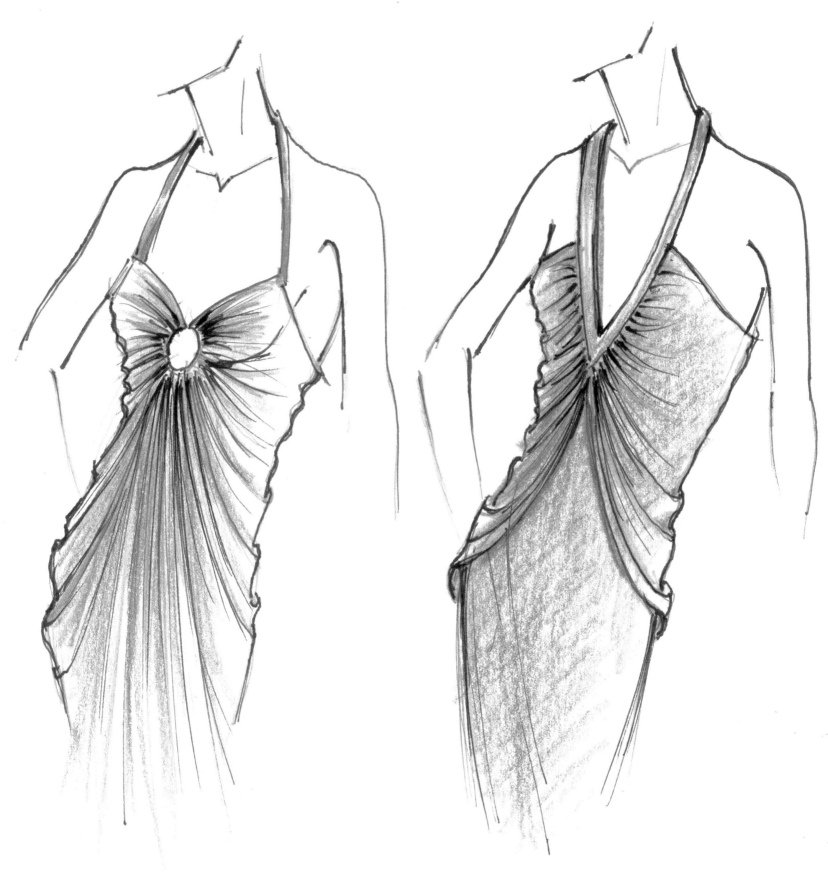

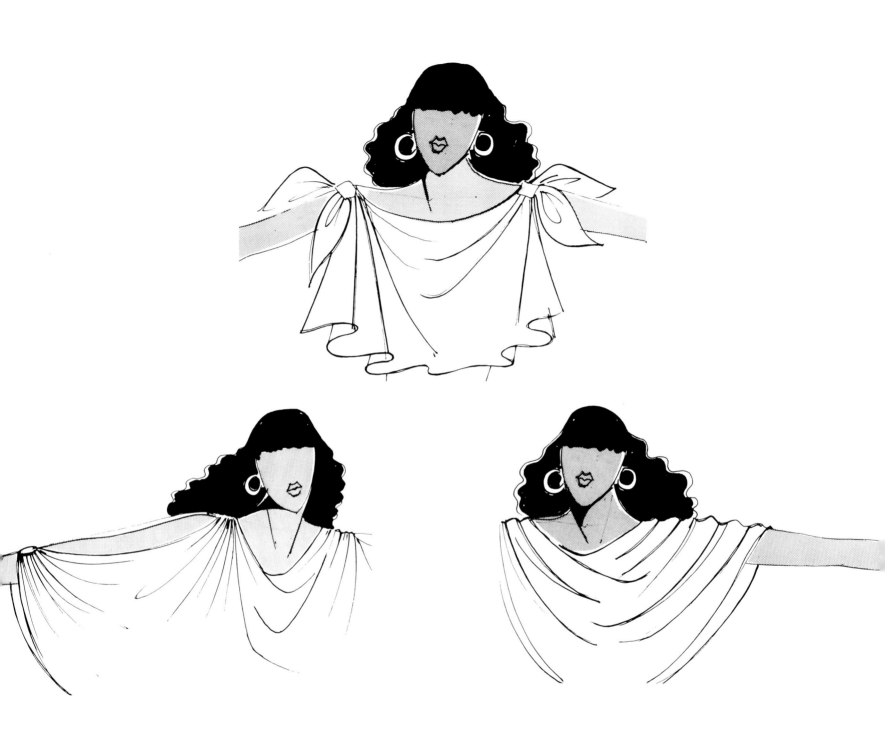

Drapes from the shoulder
designed for eveningwear.

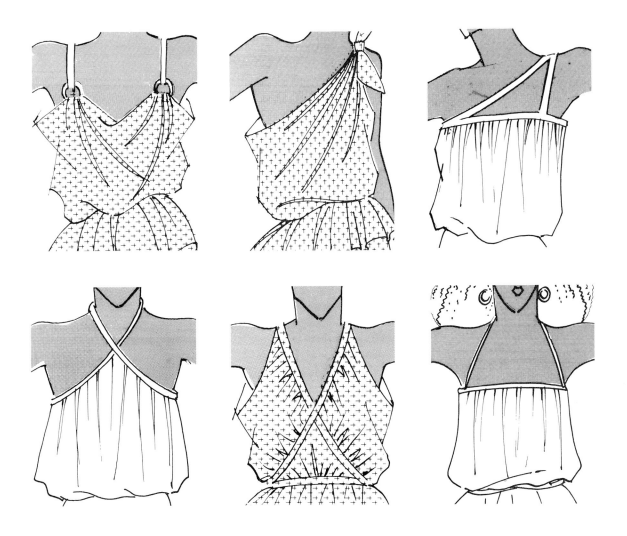

More drapes from the neckline
combined with rouleau straps.

1920s

Draped eveningwear from the
1920s era.

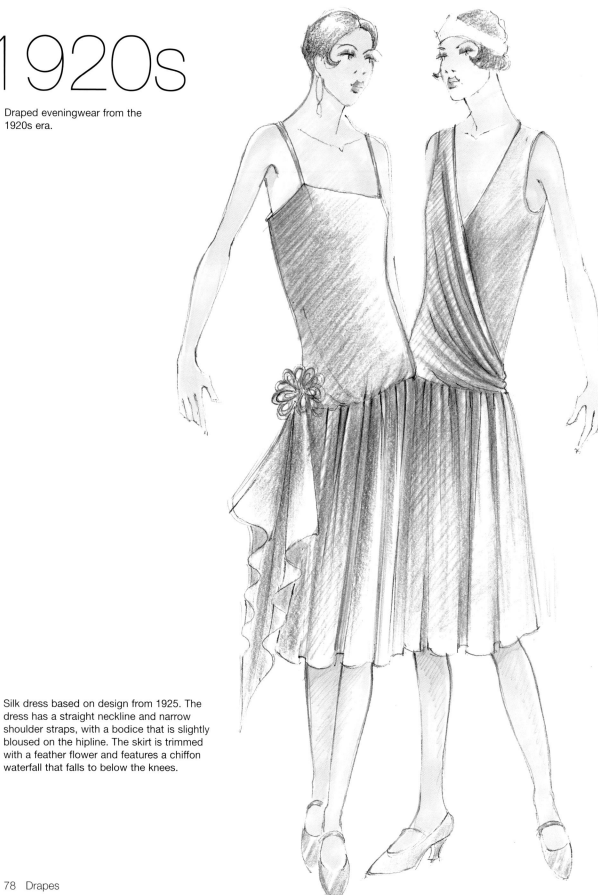

Silk dress based on design from 1925. The
dress has a straight neckline and narrow
shoulder straps, with a bodice that is slightly
bloused on the hipline. The skirt is trimmed
with a feather flower and features a chiffon
waterfall that falls to below the knees.

Another 1920s design with a draped,
wrap-over bodice and gathered skirt.
A pretty headband adds period detail
to the design.

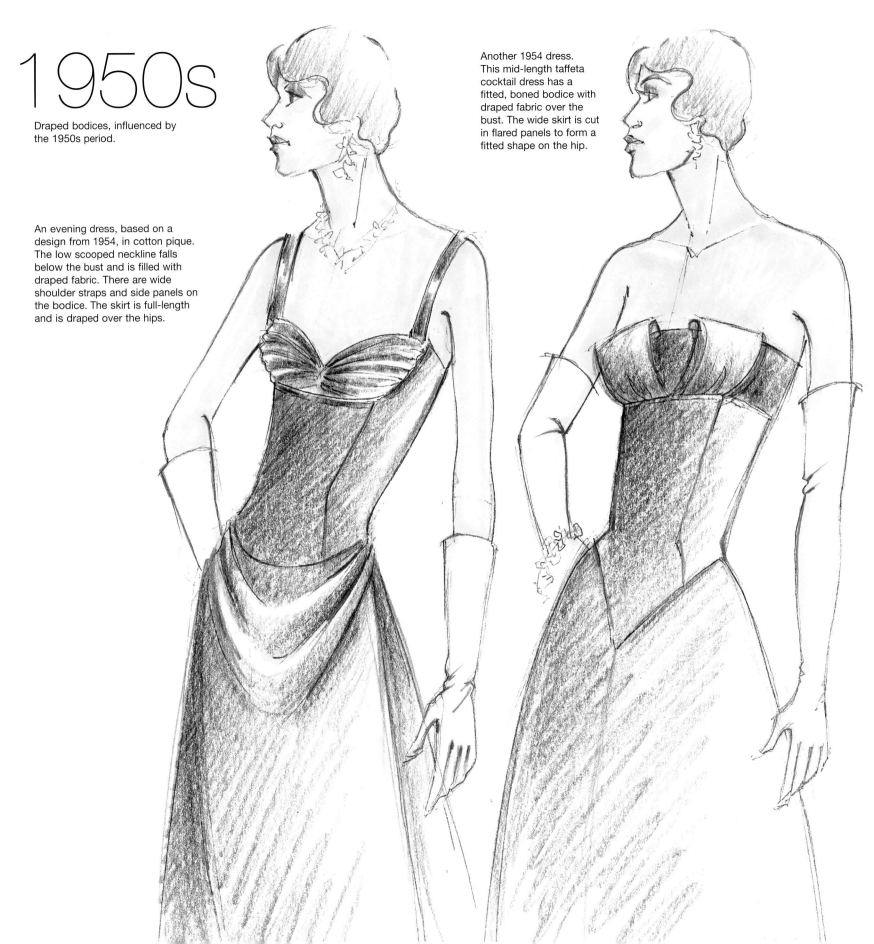

1950s

Draped bodices, influenced by the 1950s period.

An evening dress, based on a design from 1954, in cotton pique. The low scooped neckline falls below the bust and is filled with draped fabric. There are wide shoulder straps and side panels on the bodice. The skirt is full-length and is draped over the hips.

Another 1954 dress. This mid-length taffeta cocktail dress has a fitted, boned bodice with draped fabric over the bust. The wide skirt is cut in flared panels to form a fitted shape on the hip.

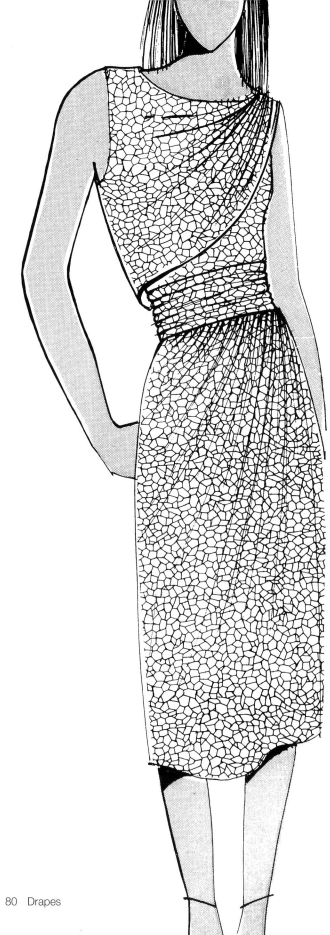

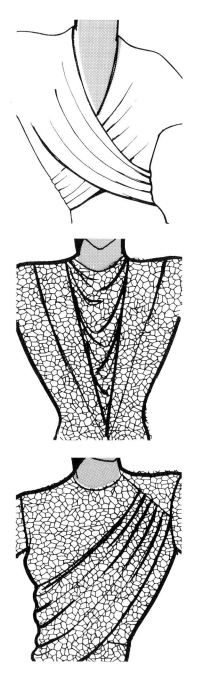

Drapes on the bodice taken
from the 1930s and '40s.

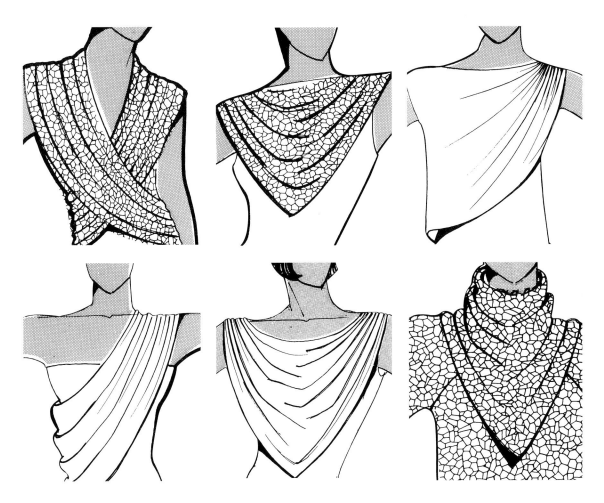

More draped styles inspired by the
fashions of the 1930s and '40s.

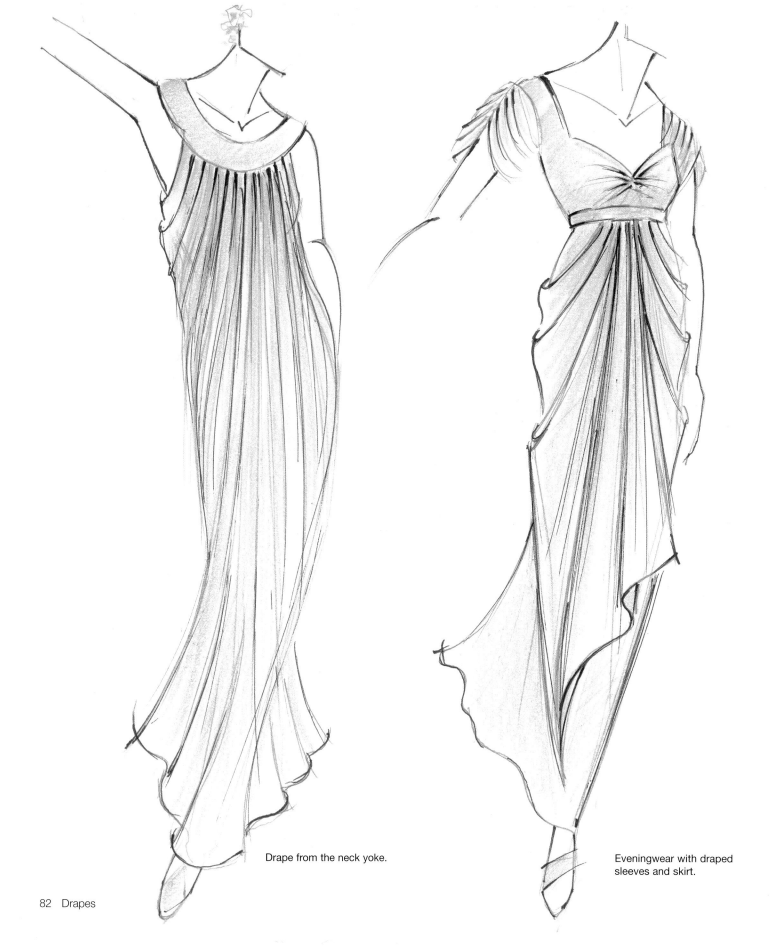

Drape from the neck yoke.

Eveningwear with draped sleeves and skirt.

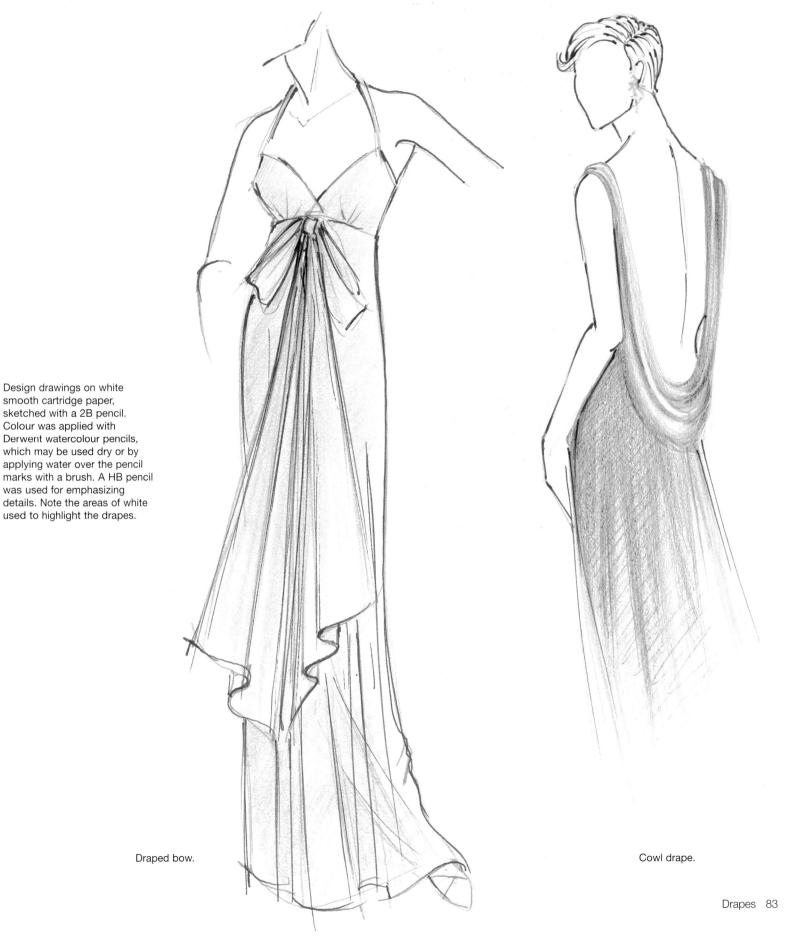

Design drawings on white smooth cartridge paper, sketched with a 2B pencil. Colour was applied with Derwent watercolour pencils, which may be used dry or by applying water over the pencil marks with a brush. A HB pencil was used for emphasizing details. Note the areas of white used to highlight the drapes.

Draped bow.

Cowl drape.

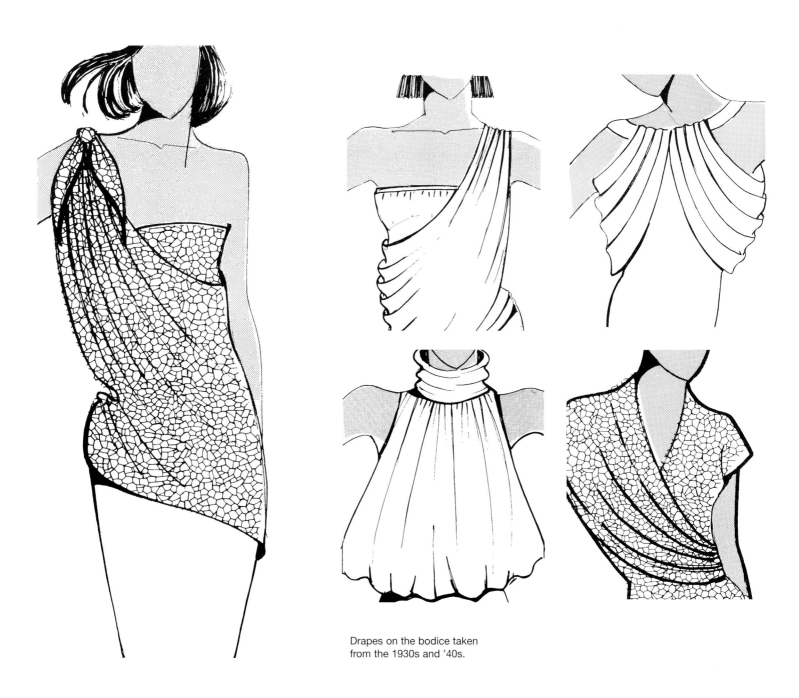

Drapes on the bodice taken
from the 1930s and '40s.

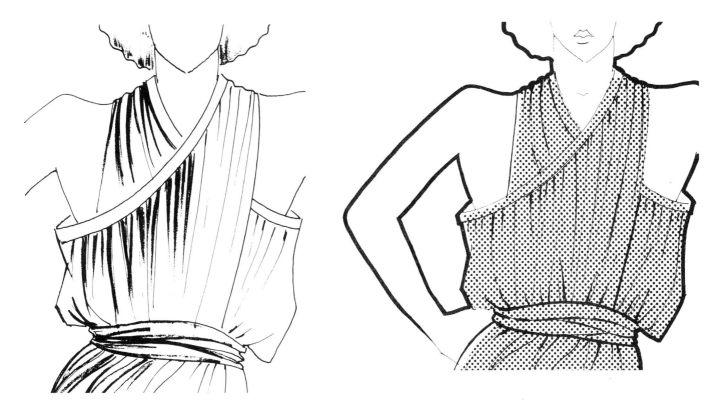

Stage 1. A simple line sketch. Shade the folds using a soft pencil.

Stage 2. Emphasize the drapes using a heavier pressure with a pencil.

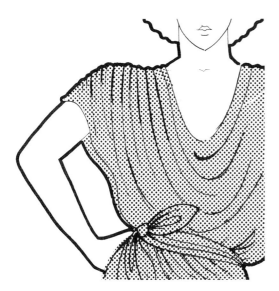
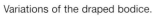
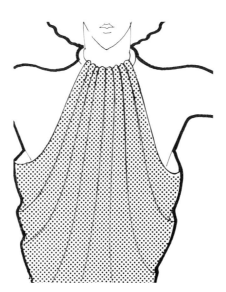
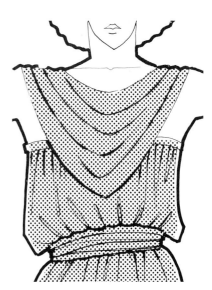

Variations of the draped bodice.

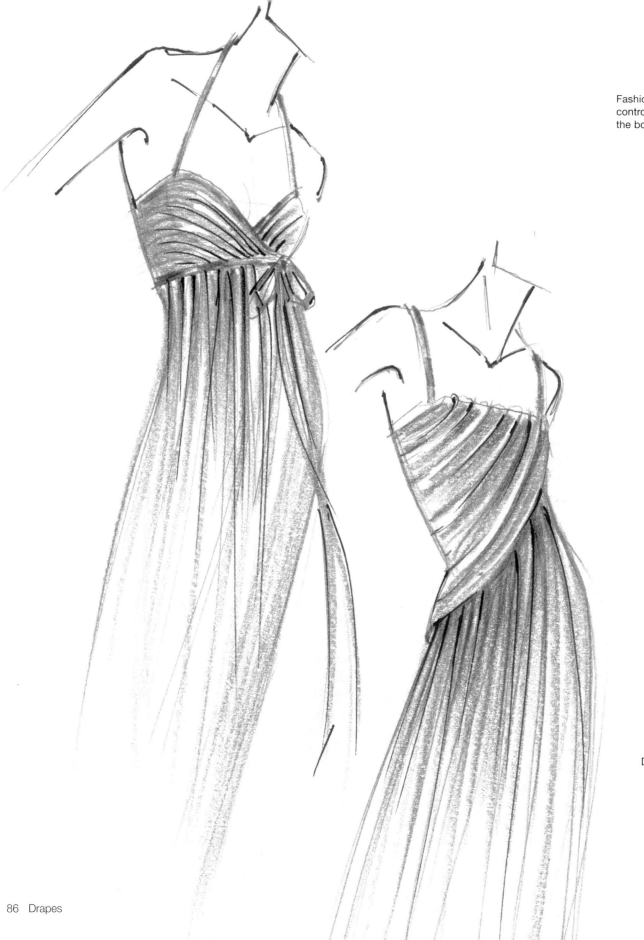

Fashion designs illustrating a more
controlled way of using drapes on
the bodice of an evening dress.

Draped bodices and skirts.

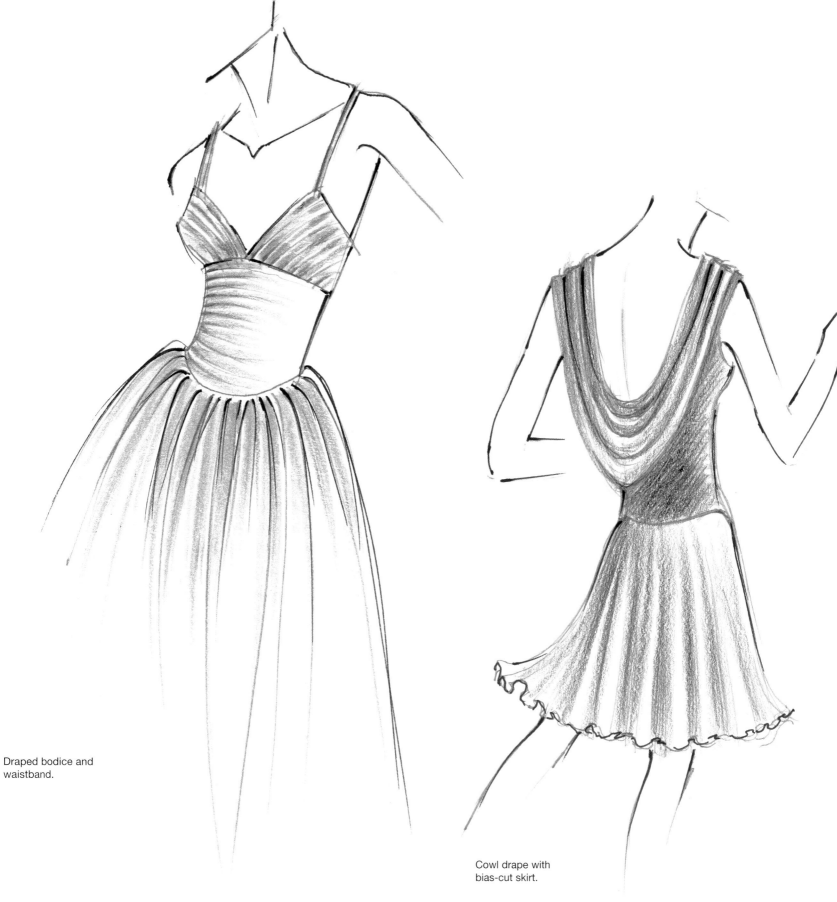

Draped bodice and
waistband.

Cowl drape with
bias-cut skirt.

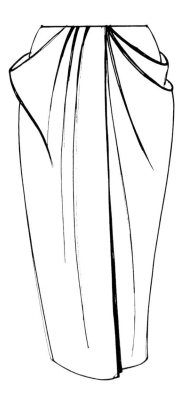

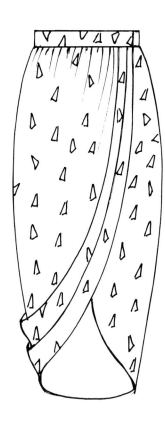

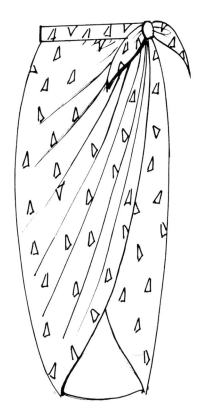

Wrap-over skirts incorporating
different drapes.

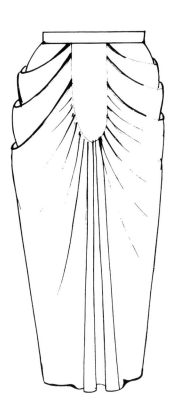

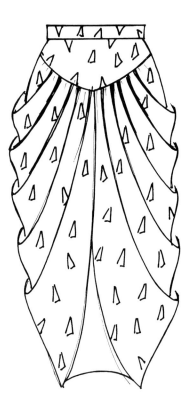

Variations of a draped skirt
combined with a yoke panel.

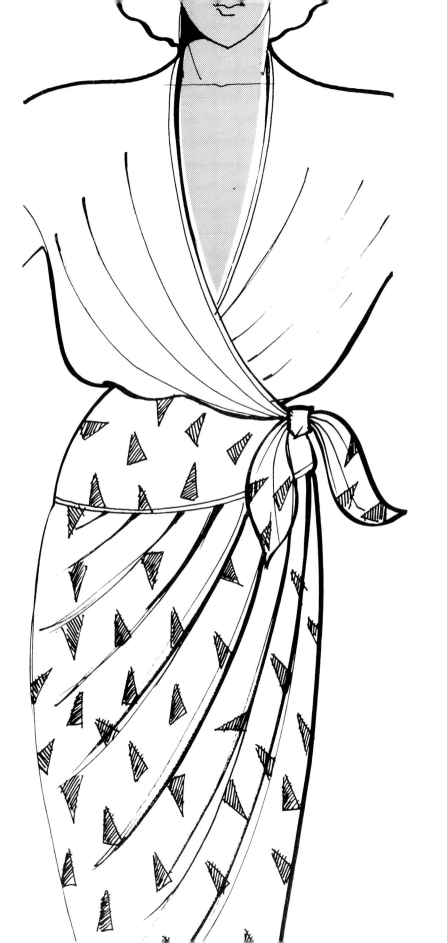

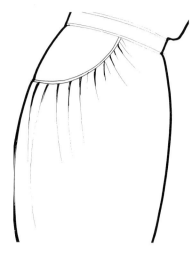

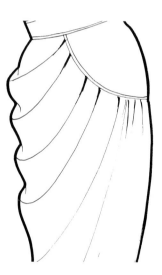

Drapes on a skirt from a side
yoke panel.

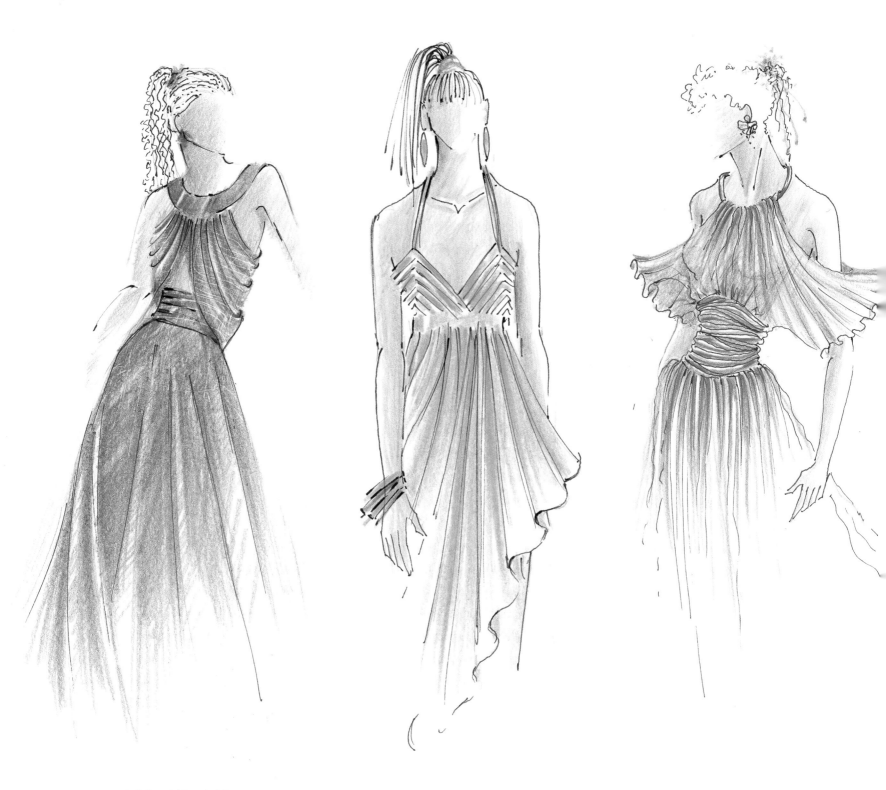

Soft drapes in lightweight material.

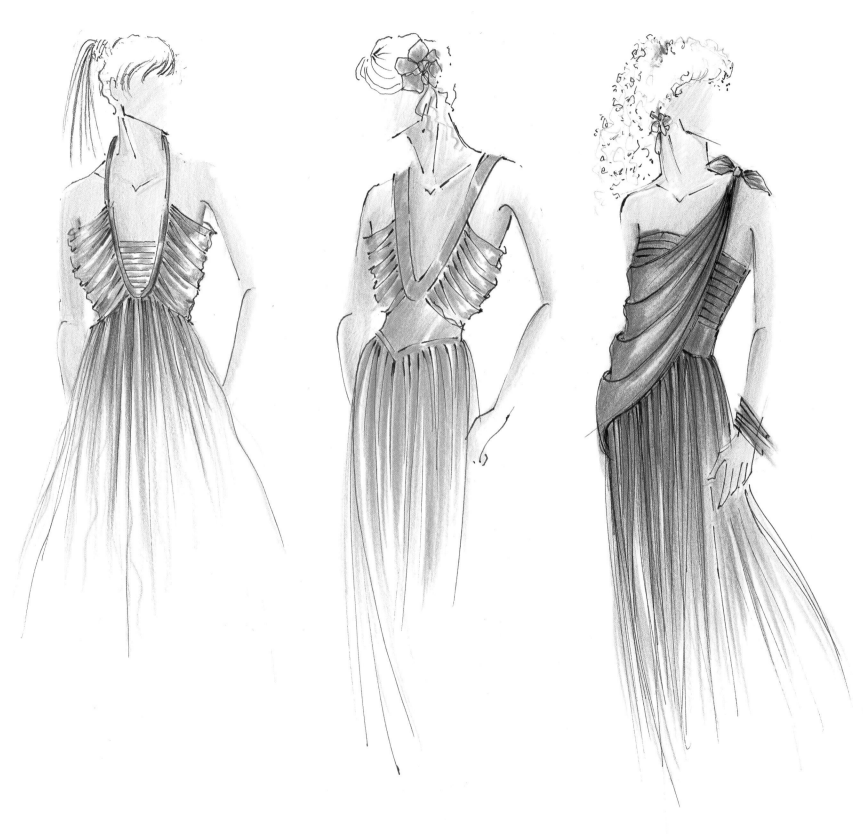

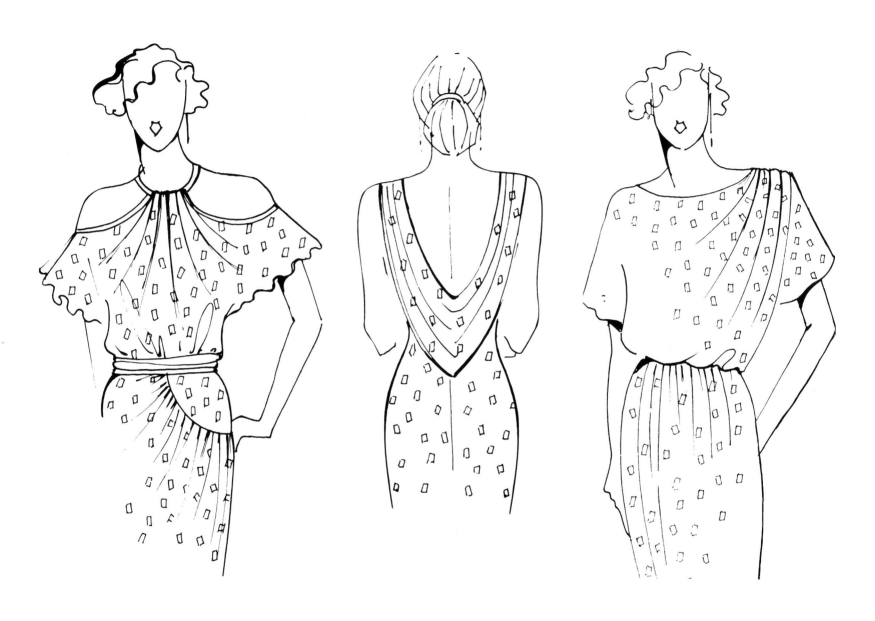

Sketches of a dress collection, observing the use of
drape in past periods of fashion. Note the effects used
on the neckline, shoulder, sleeve, waist and skirt.

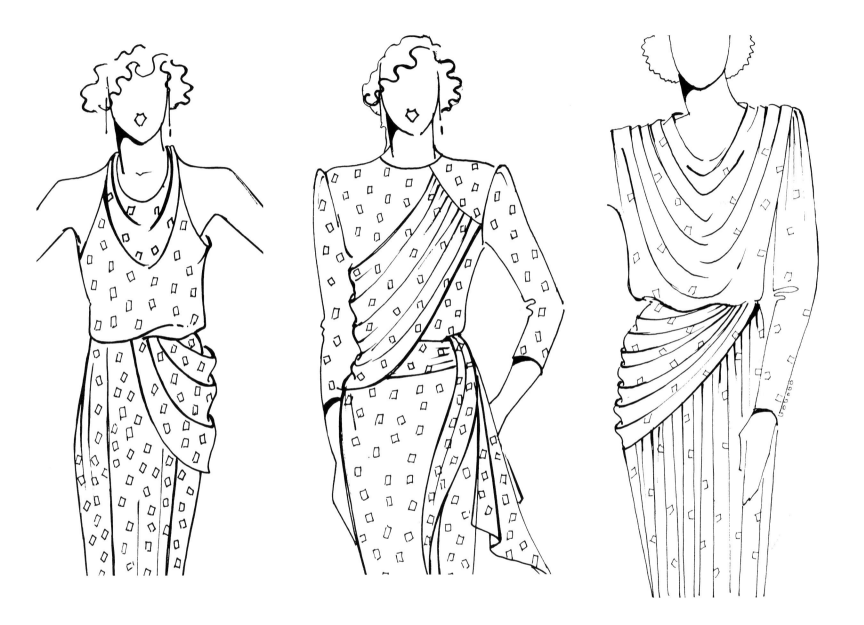

The drawstring is effectively used on many areas of a garment, such as hems of a jacket or blouse, necklines, sleeves and trousers. A cord is inserted in the casing or hem to pull an area of fullness together. The cord may vary – piping, braid or rouleau, for example.

Drawstrings

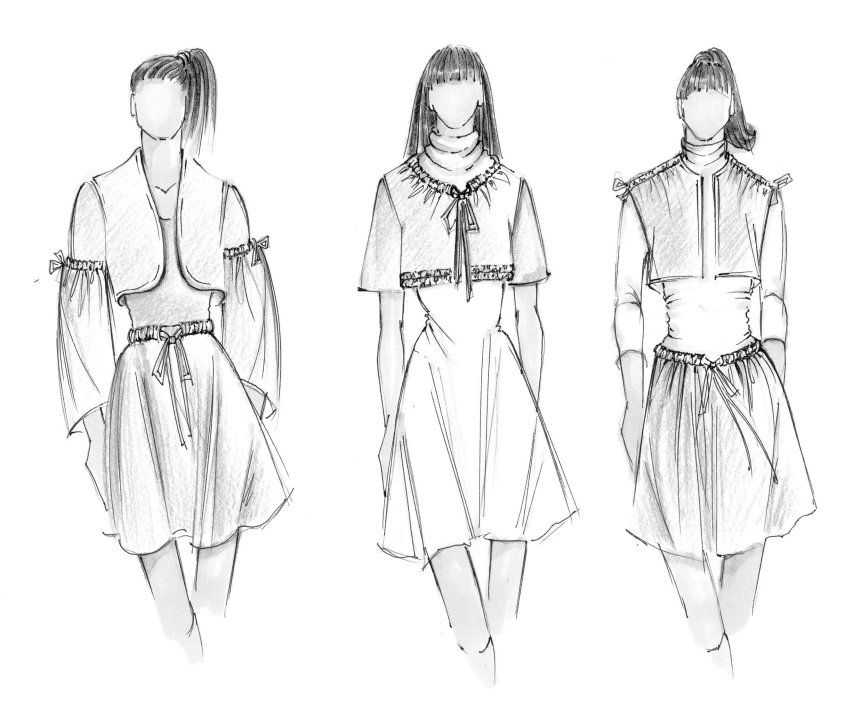

Selection of designs working on introducing drawstrings to the waist, sleeves, shoulders, neckline and hems. Note how the same pose is used for a number of designs to save time. It is helpful to line the figures up on the paper when working on new ideas. This allows you to refer back to previous sketches and develop ideas as the designs evolve.

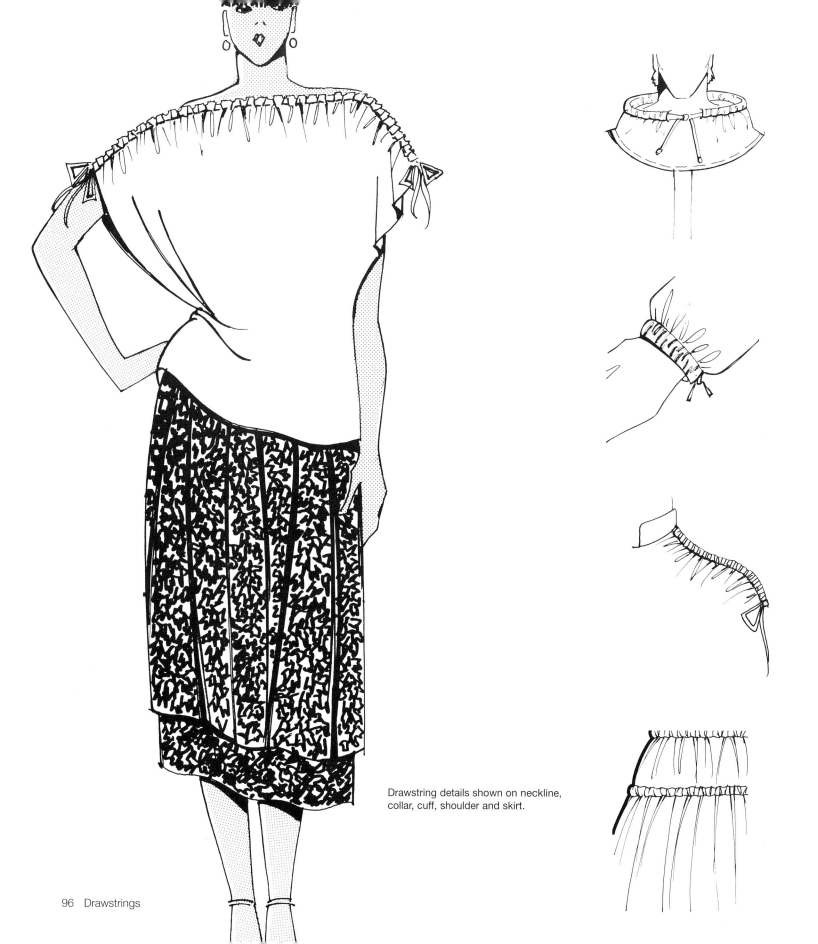

Drawstring details shown on neckline, collar, cuff, shoulder and skirt.

Illustrated is a simple way of suggesting a ruched casing on a design sketch. The width and general effects would vary depending on the fabric used. The cord may also be braid, piping or rouleau.

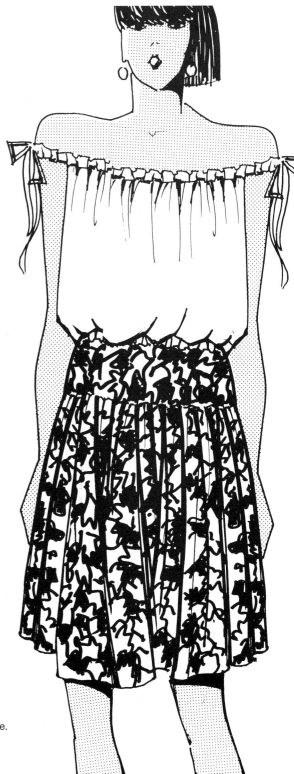

Drawstring details shown on the neckline.

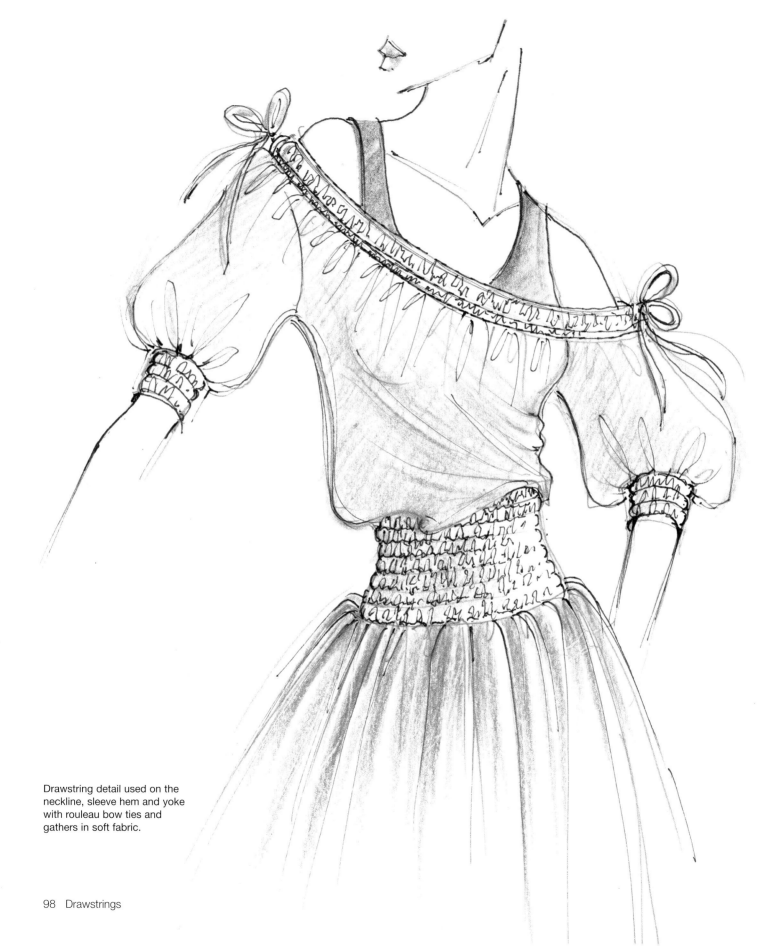

Drawstring detail used on the
neckline, sleeve hem and yoke
with rouleau bow ties and
gathers in soft fabric.

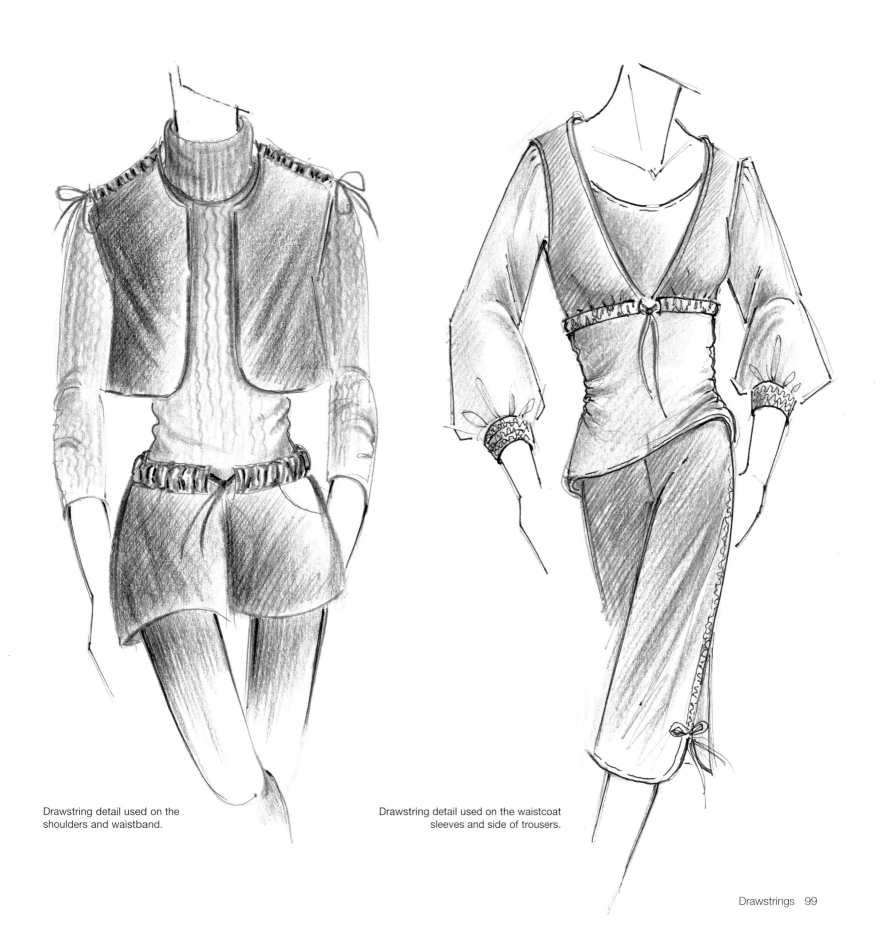

Drawstring detail used on the shoulders and waistband.

Drawstring detail used on the waistcoat sleeves and side of trousers.

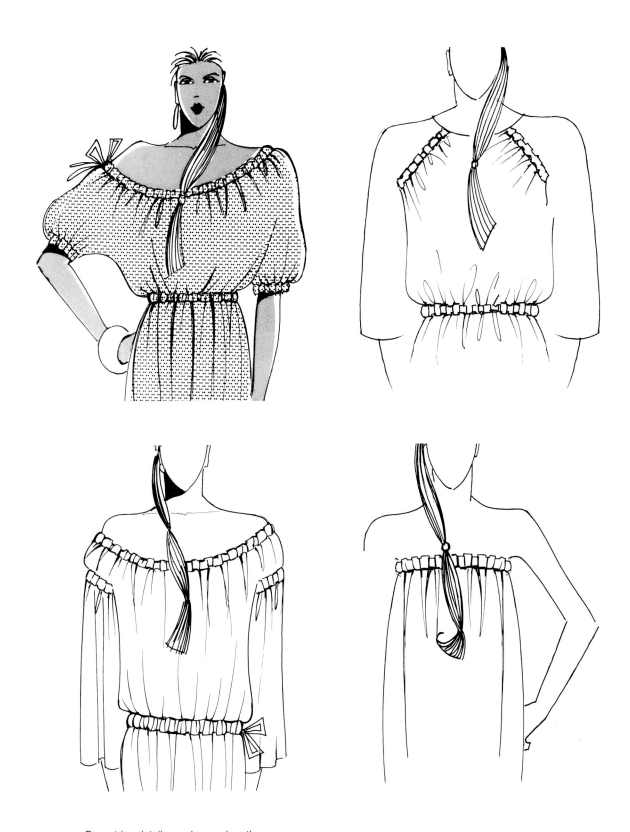

Drawstring details can be used on the
neckline, sleeve and waistline.

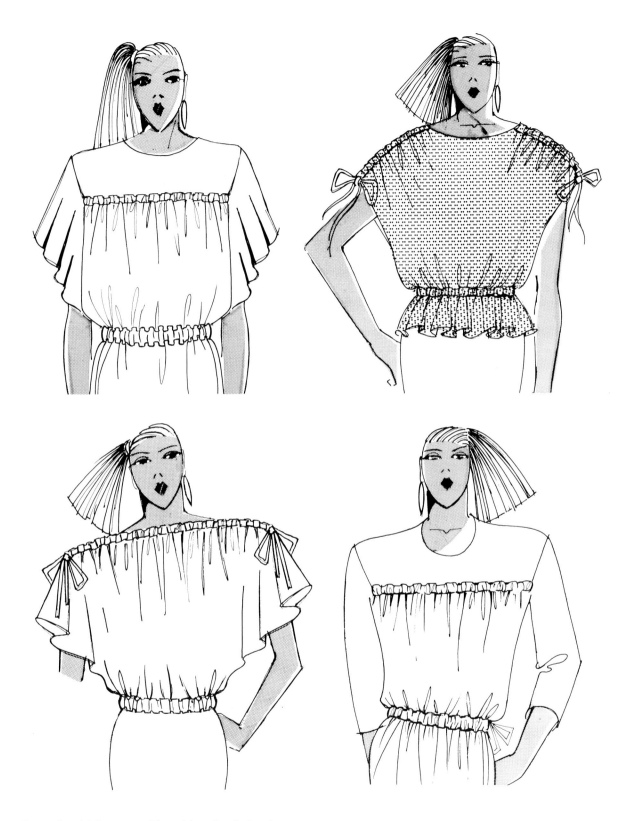

Drawstring details can provide an interesting feature for
a neckline, waistline, shoulder or bodice.

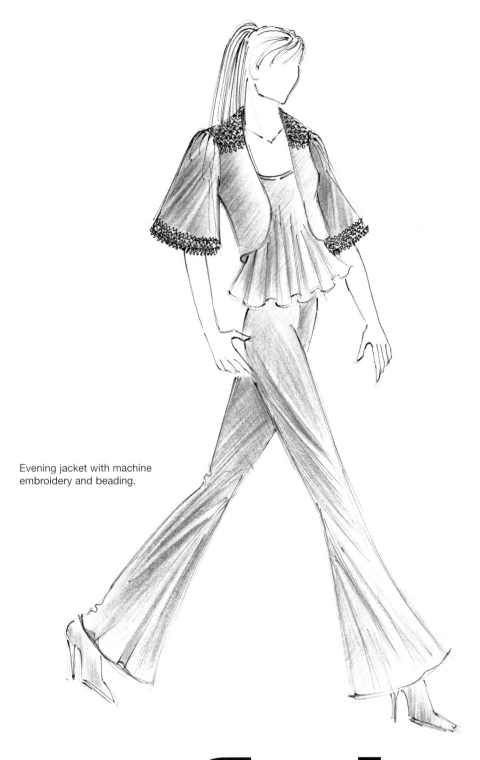

Evening jacket with machine embroidery and beading.

The effects of embroidery are many, producing a variety of decorative effects on a design. Different techniques are often used together to produce imaginative designs. Illustrated in this chapter is a selection of samples showing the use of tambour beading, sequins, machine and hand embroidery. The illustrations shown are combined with fabric dye, printing, smocking, quilting and appliqué work.

Embroidery

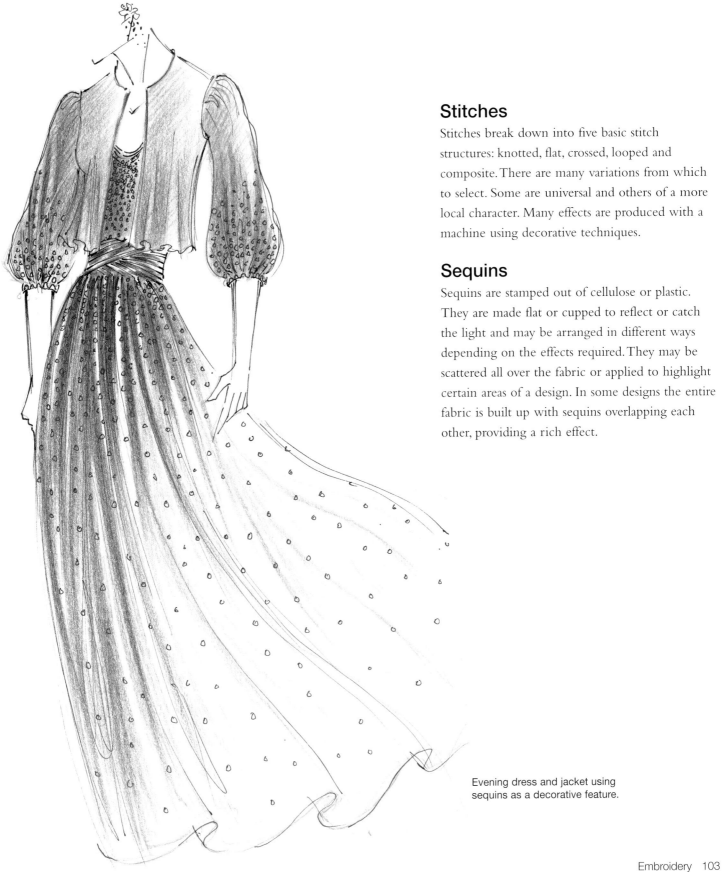

Stitches

Stitches break down into five basic stitch structures: knotted, flat, crossed, looped and composite. There are many variations from which to select. Some are universal and others of a more local character. Many effects are produced with a machine using decorative techniques.

Sequins

Sequins are stamped out of cellulose or plastic. They are made flat or cupped to reflect or catch the light and may be arranged in different ways depending on the effects required. They may be scattered all over the fabric or applied to highlight certain areas of a design. In some designs the entire fabric is built up with sequins overlapping each other, providing a rich effect.

Evening dress and jacket using sequins as a decorative feature.

Beading

Beads can be used to great decorative effect in many ways. They are often used to enrich a fabric design or arranged on a plain fabric to add interest.

Tambour beading

In this beading technique the beads are applied with a tambour hook onto a tightly stretched fabric on a frame.

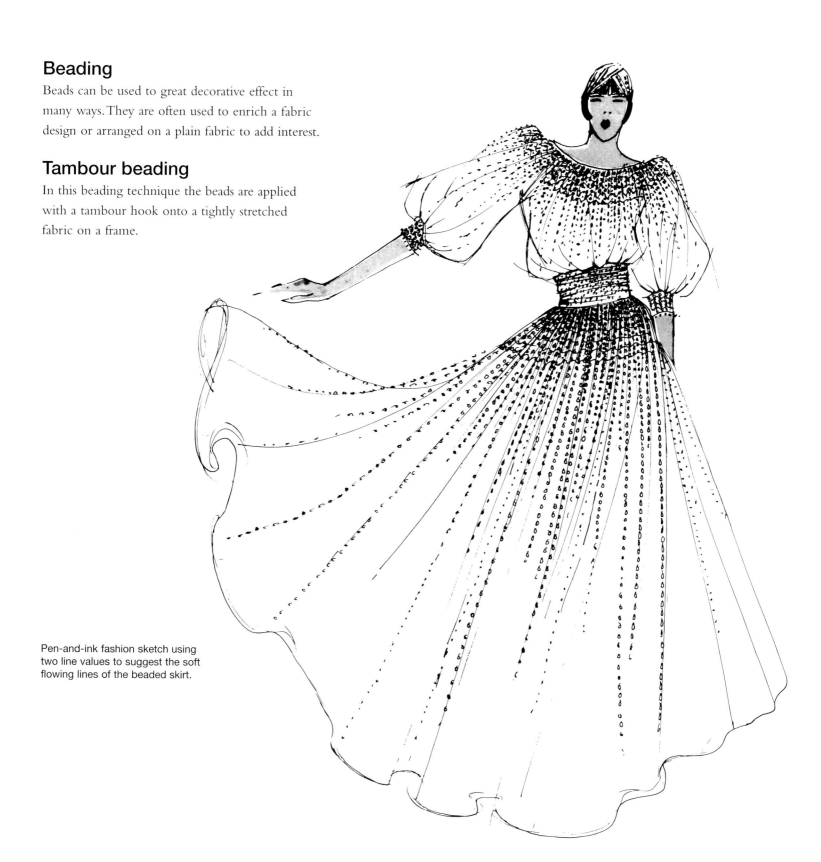

Pen-and-ink fashion sketch using two line values to suggest the soft flowing lines of the beaded skirt.

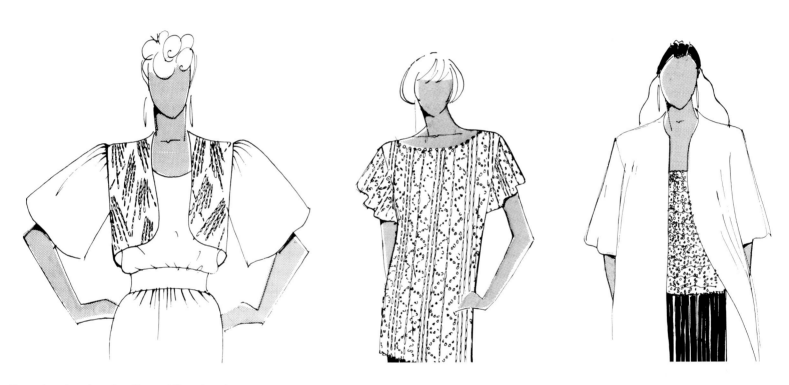

Examples of tambour beading and thread work.

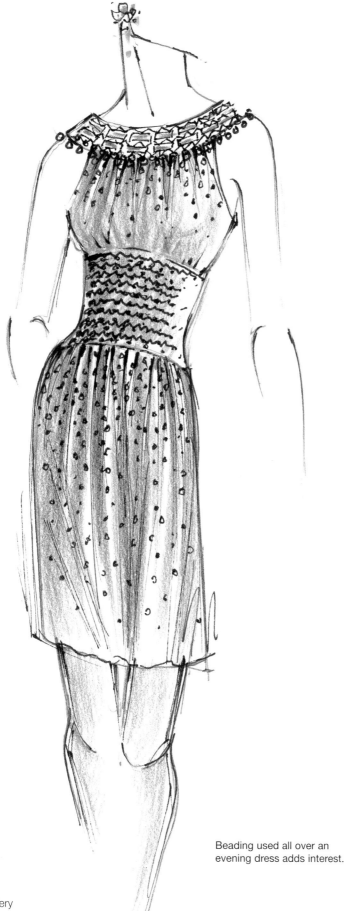

Beading used all over an evening dress adds interest.

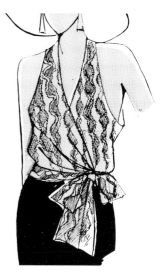

Cornely chain and hemstitching.

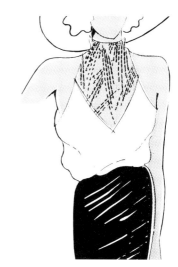

Tambour beading.

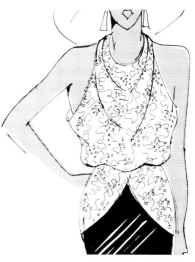

Machine embroidery on dyed fabric.

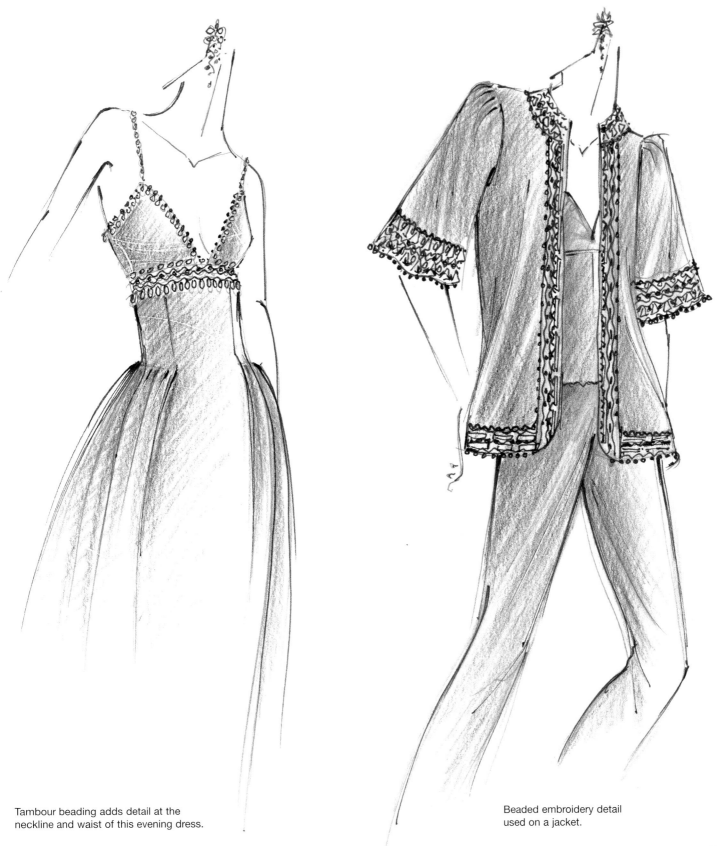

Tambour beading adds detail at the
neckline and waist of this evening dress.

Beaded embroidery detail
used on a jacket.

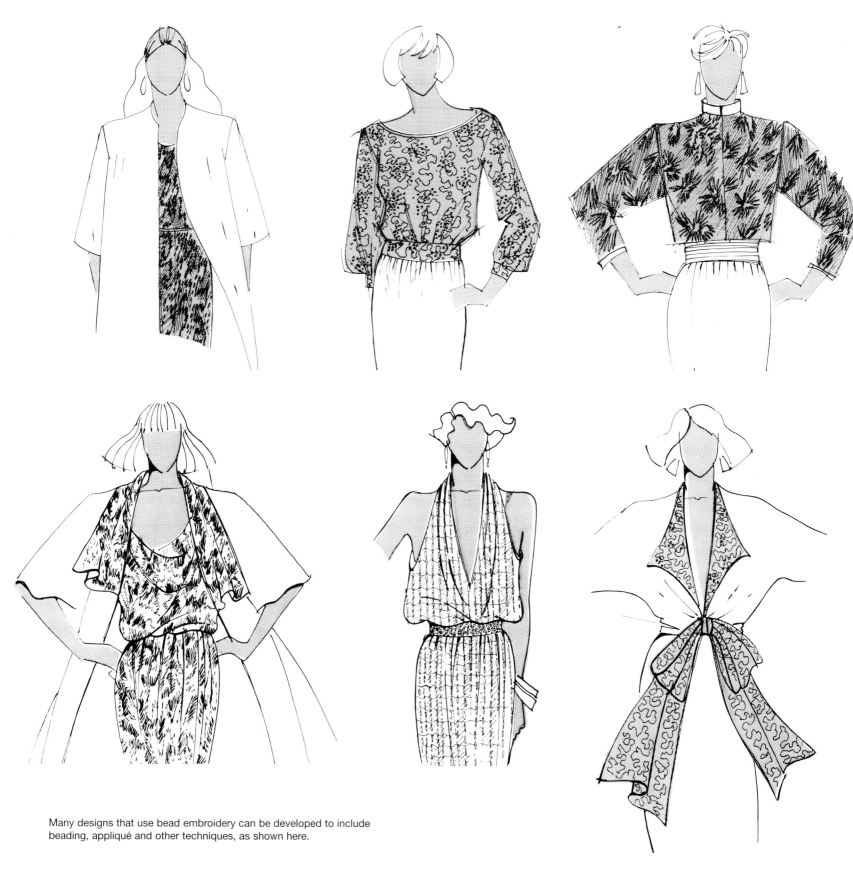

Many designs that use bead embroidery can be developed to include beading, appliqué and other techniques, as shown here.

Appliqué

This effect is produced by applying pieces of fabric of different shapes and sizes to the surface of another fabric. The fabric pieces may vary in colour, pattern and texture. The technique varies from machine to handwork.

The design and use of appliqué should be carefully planned, bearing in mind the surface fabric on which the decoration is to be applied. Consideration should also be given to the colour, size, balance and proportion of the appliqué design relating to the entire garment. The designs may be bold and simple as often used on leisure and beachwear, and on children's garments. More delicate designs are needed for use on lingerie, day and eveningwear.

Many embroidery techniques may be combined with appliqué work such as quilting, beading and machine embroidery. The materials used may be fabric, felts, leathers, net or lace.

Bands of braid.

Lace band on the cuff.

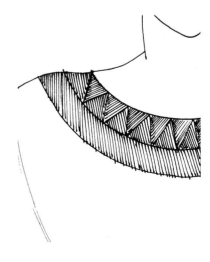

Contrast neckline of braids.

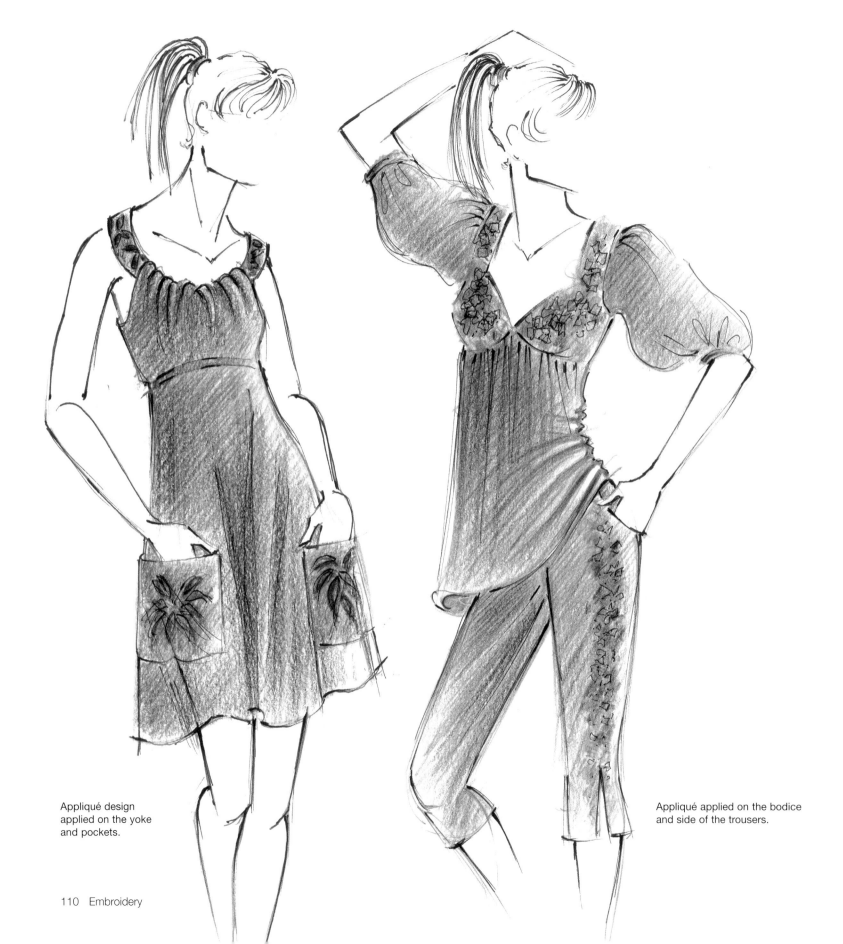

Appliqué design
applied on the yoke
and pockets.

Appliqué applied on the bodice
and side of the trousers.

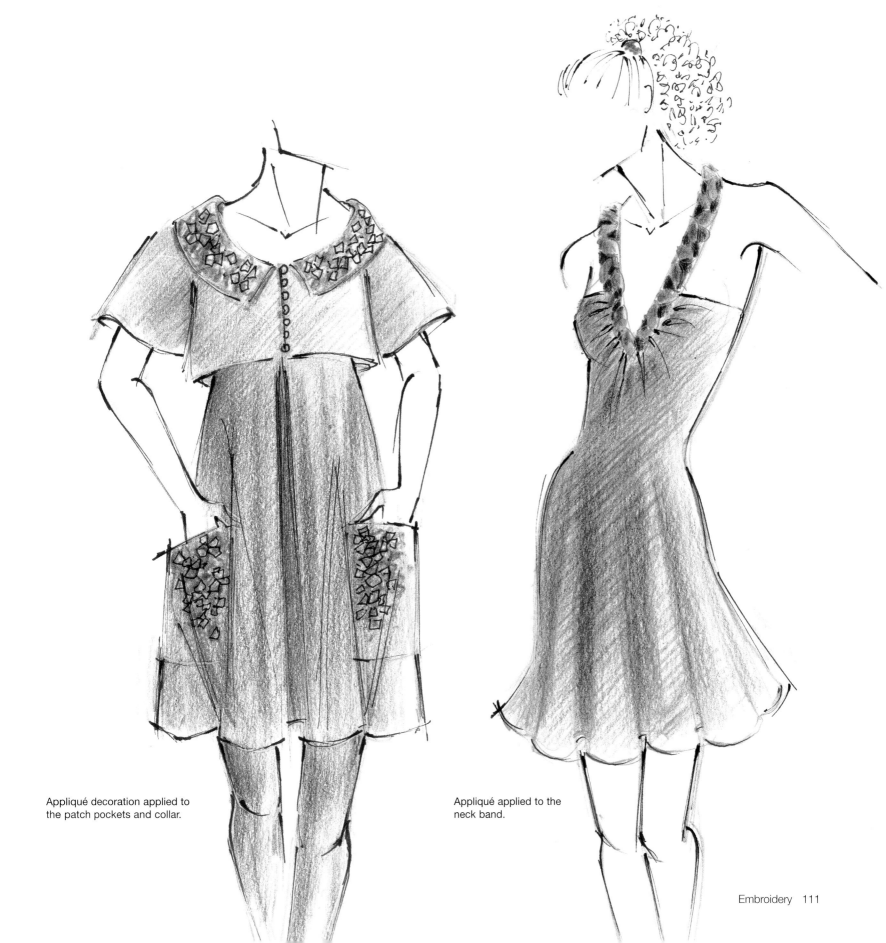

Appliqué decoration applied to
the patch pockets and collar.

Appliqué applied to the
neck band.

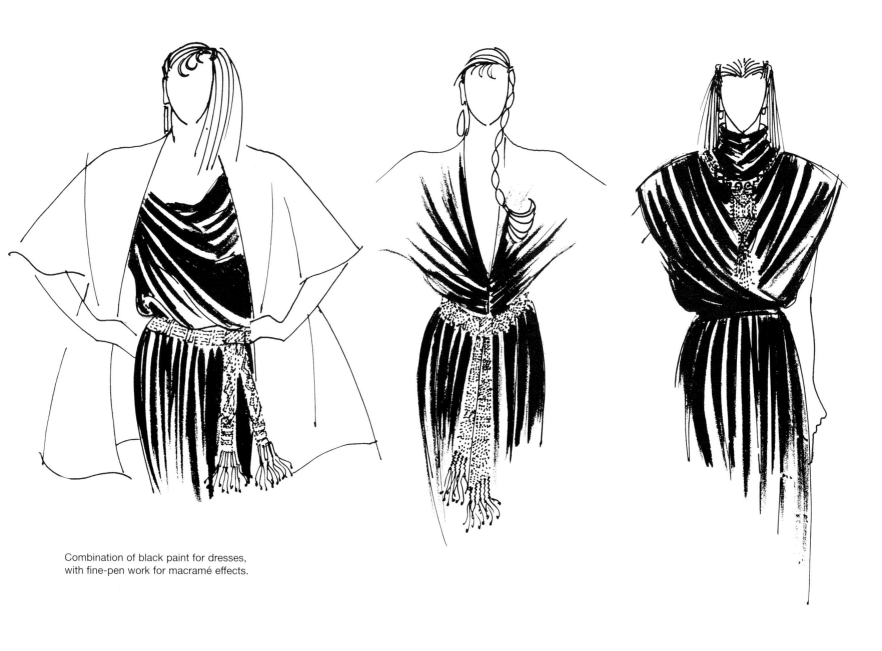

Combination of black paint for dresses,
with fine-pen work for macramé effects.

Macramé

Macramé is decorative knotting using two basic knots, the flat
(or reef) and the half hitch, with variations. It produces a close,
firm texture that is hardwearing. The decorations will vary
depending on the colours used and may be extended by
making tassels or fringes, or by including beads in the design.

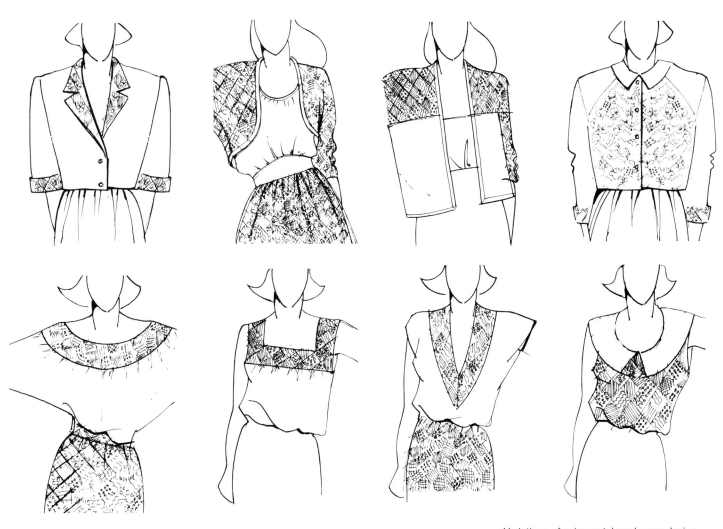

Variations of using patchwork on a design
at the neck, on a collar, cuff or skirt.

Patchwork

Whether you are designing a skirt, jacket or a dress the basic method is the same:
simply joining one geometric shape of fabric to another edge to edge, stitched
either by hand or by machine to create attractive effects on a border, collar and
cuffs or for a complete garment. Fabrics used for the patchwork should be of the
same or similar weight. If the fabrics vary too much the garment could lose its
shape. Individual and creative effects may be achieved when introducing patchwork
in a design, depending on the variations of techniques used – padding individual
patches, for example, or joining sections of patchwork together with embroidery
stitches such as feather stitches, herringbone, coral and topstitching.

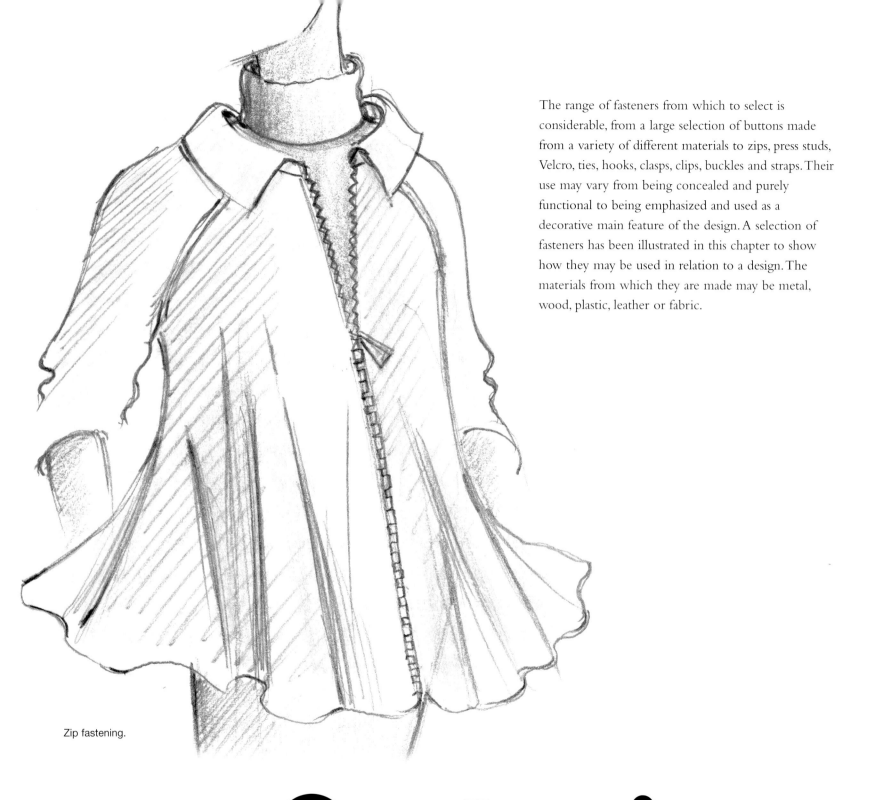

The range of fasteners from which to select is considerable, from a large selection of buttons made from a variety of different materials to zips, press studs, Velcro, ties, hooks, clasps, clips, buckles and straps. Their use may vary from being concealed and purely functional to being emphasized and used as a decorative main feature of the design. A selection of fasteners has been illustrated in this chapter to show how they may be used in relation to a design. The materials from which they are made may be metal, wood, plastic, leather or fabric.

Zip fastening.

Fastenings

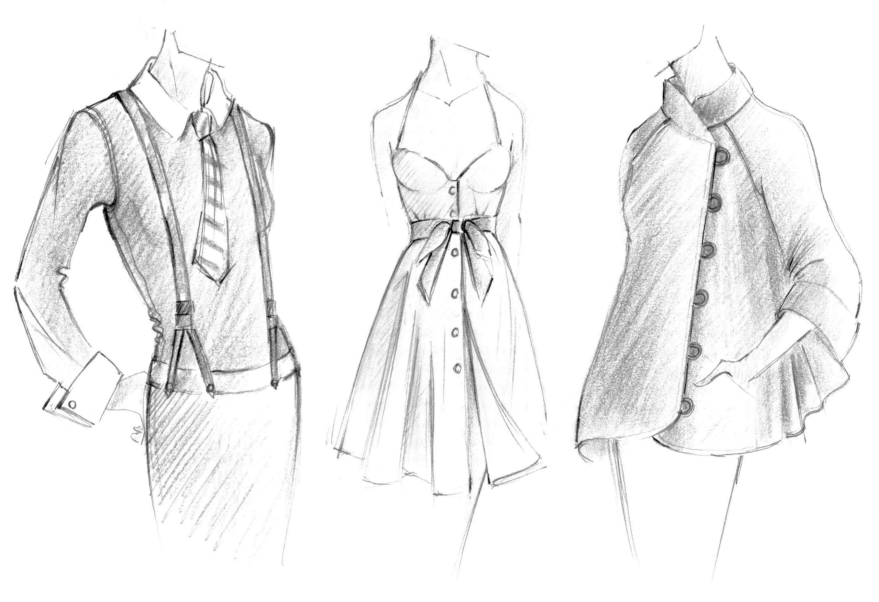

Braces and cufflinks.

Bow tie and buttons.

Rouleau loops.

Snap fasteners

These may be obtained in many sizes. They may be used as a decorative feature as well as being functional. They look very effective when introduced on sportswear and industrial garments. These are press studs usually made of metal and which may subsequently be covered with fabric. Straps and buckles can be made in self material or contrasting with buckles of wood, metal, plastic, and so on.

Lacing

Lacing is drawn through eyelets. The thickness of the lacing and eyelets vary. The way in which the lacing is tied will vary depending on the design effect required.

Zip fasteners (see also Zips, page 300)

Zip fasteners vary in width and length. They are made of metal or nylon. Many variations are produced in different weights of slides and colour.

Rouleau fastenings

These are rolls or folds of fabric, used for making loops and piping for fastening (see also button loops).

Frog fastenings

These may be made from cording or braid.

Velcro

Velcro is made of two strips of fabric. One strip is covered with hooks and the other with very fine loops. When the two strips are pressed together the hooks engage the loops and give a very secure fastening that can be easily opened by a pulling action. This fastening is often used on sports and industrial garments and is both functional and adaptable when used at the neck, cuffs or pockets. Velcro comes in several widths.

Zip opening on collar.

Button-down lapel.

Button-down tab fastening.

Zip opening on the hem of the sleeve.

Buckle and strap on braces.

Patch pocket and flap with button-down fastening.

Button loops

Button loops may be substituted for buttonholes. They may be set into the seam at the edge of the garment where the opening is placed or a frog fastener may be used, which is more decorative. Button loops are made of fabric tubing, self filled or corded. The thickness of the loops varies according to the button used, the fabric and the placing.

Any buttons may be used with button loops. The most popular are ball buttons, usually covered in the same fabric as the garment. Chinese ball buttons are made with a length of round cord.

Drawstring and casing

The casing is used to accommodate a drawstring or elastic. It can be used in many ways and looks effective on a design as illustrated on pages 94–101. This fastener is decorative as well as being functional.

Bows (see also Bows, page 30)

A bow drapes better when cut on the bias with the ends cut at an angle. It is often used at the neck of a dress or blouse or at the waist as a belt, and may be purely decorative or serve as a fastener.

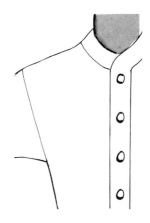

Covered buttons.

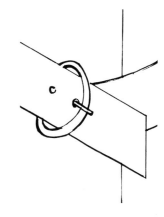

Buckle and belt.

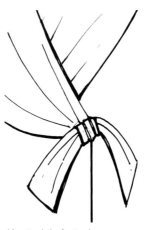

Knotted tie fastening.

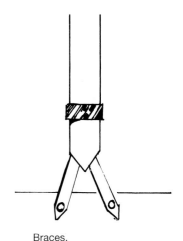

Braces.

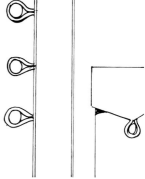

Zip openings on centre front.

Rouleau and button fastenings.

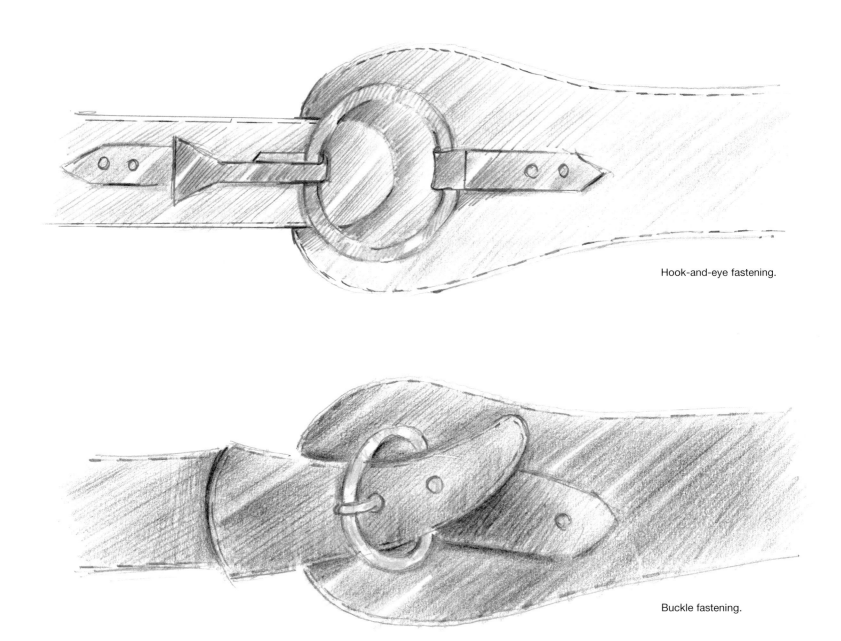

Hook-and-eye fastening.

Buckle fastening.

Belt fastenings

Belts are made from a variety of different materials, often
worn as a main feature on, above or below the waistline.
The fastenings may vary from buckles, hook–and–eye
fastenings, straps and lacing to studs, ties, velcro and clips.
The texture and colour of the materials used are carefully
considered in relation to the overall effect.

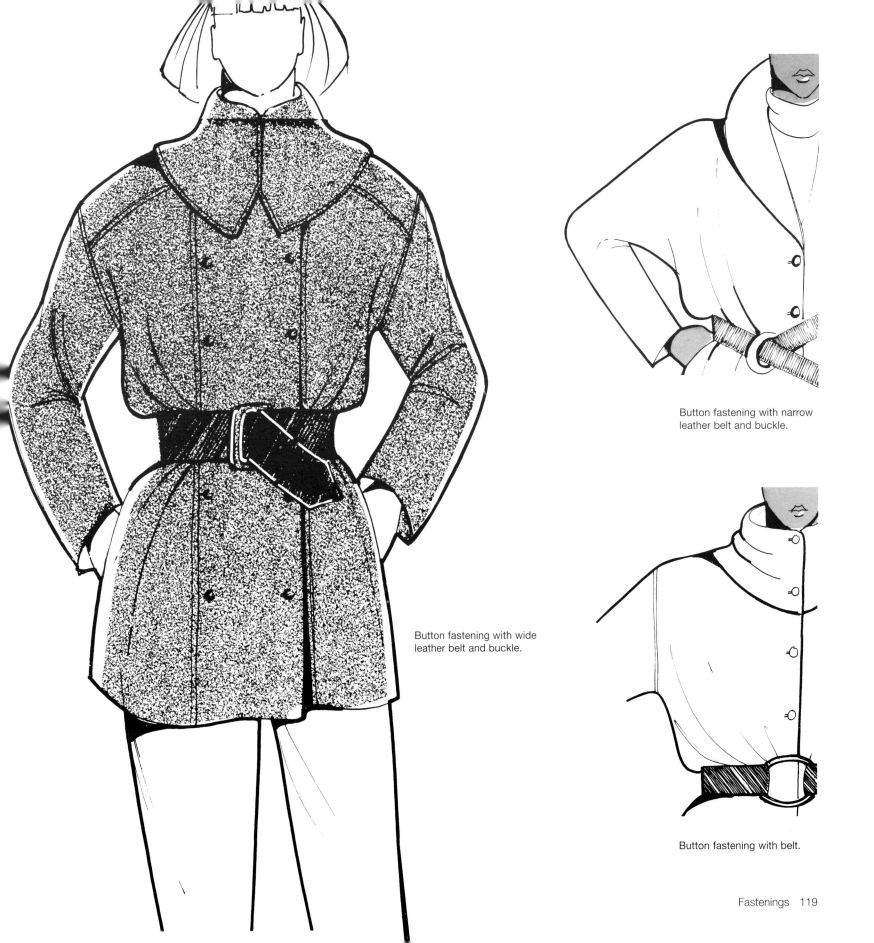

Button fastening with wide
leather belt and buckle.

Button fastening with narrow
leather belt and buckle.

Button fastening with belt.

Belt in leather and soft suede.

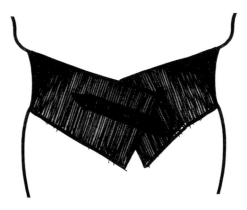

Belt in rubber with ribbing.

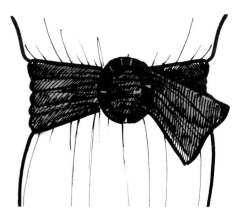

Soft draped belt in fine wool fabric.

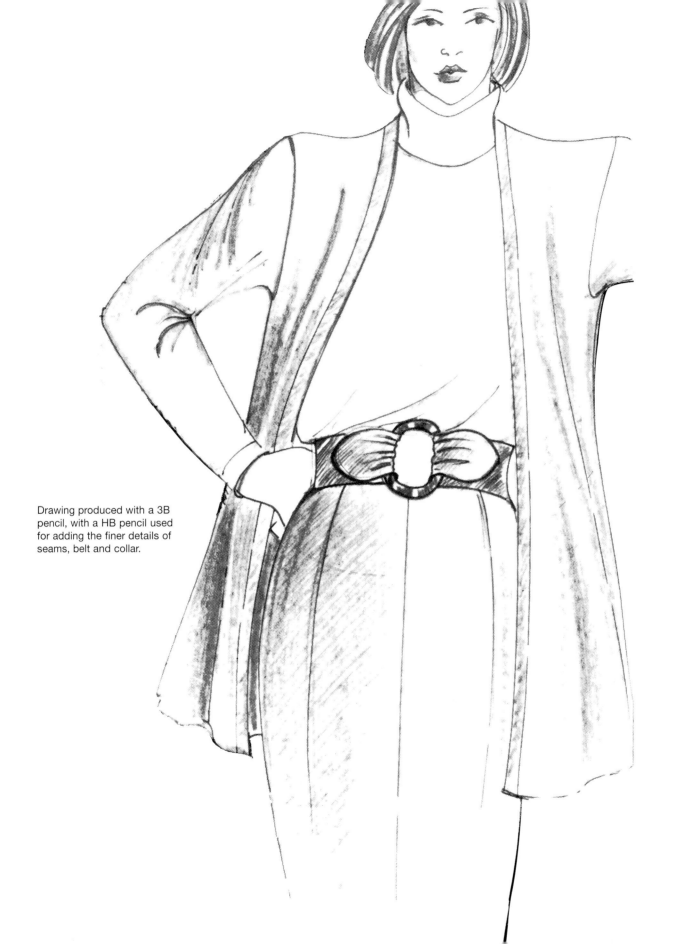

Drawing produced with a 3B
pencil, with a HB pencil used
for adding the finer details of
seams, belt and collar.

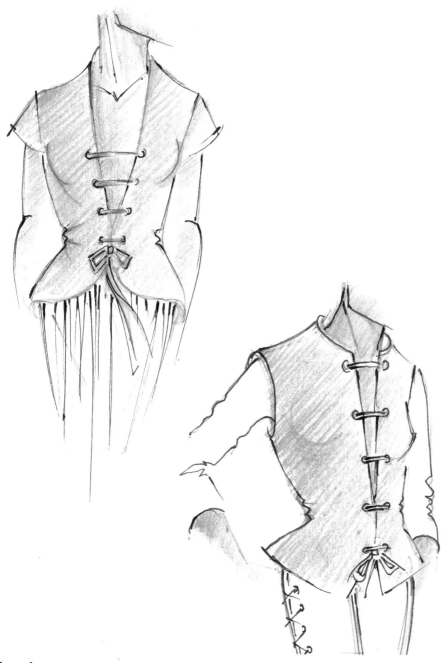
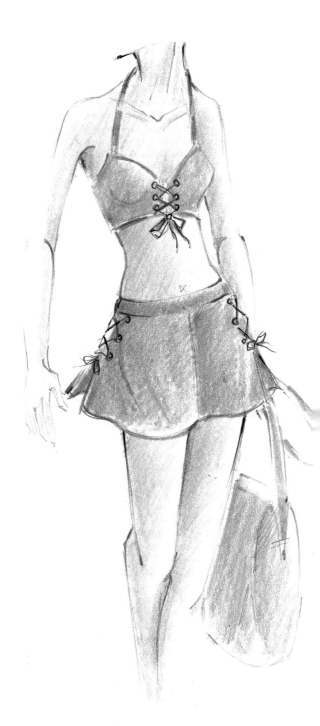

Lacing

Lacing is a decorative fastening that can be introduced into a design in many ways. Often used for casualwear, it can be equally effective when used for eveningwear designs. The lacing can be applied on the shoulder, front openings, sleeves, cuffs, belts, trousers and skirts. Different effects can be achieved by placing the eyelets in groups and experimenting with the way in which the lacing is arranged and tied.

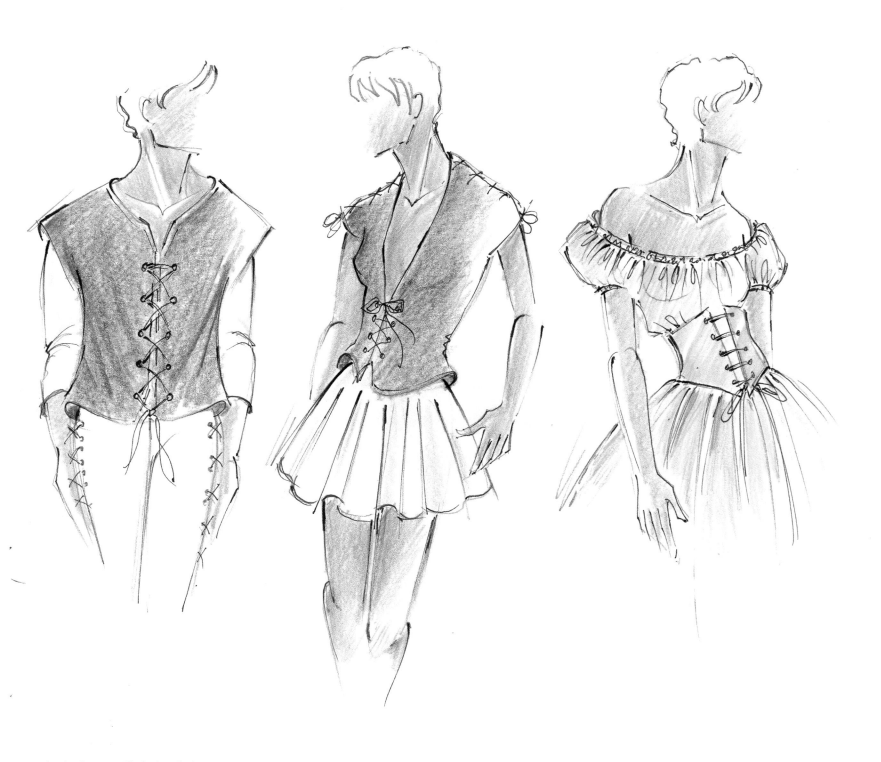

Lacing is a versatile feature that can
be used on a variety of designs.

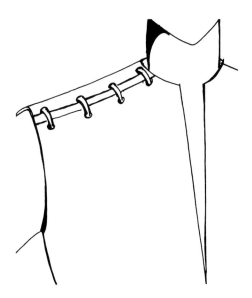

Lacing can be purely decorative,
as on this shoulder seam.

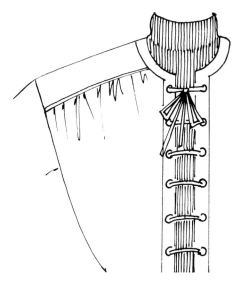

Front lacing can be functional and
decorative or, if a secondary fastening
is provided, it can be purely decorative.

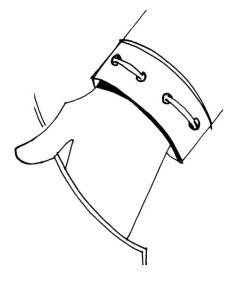

This sleeve lacing would combine well
with the shoulder lacing, shown left.

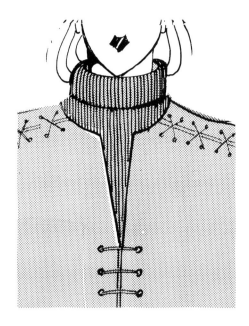

A combination of lacing on
the shoulder and bodice.

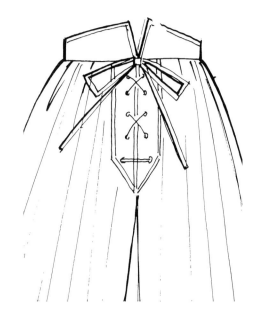

Trousers with functional fly lacing.

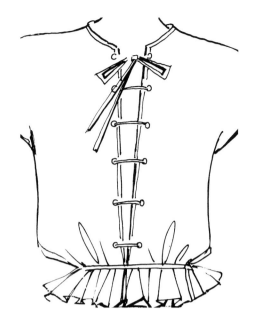

Simple front lacing.

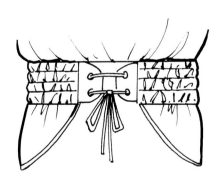

Lacing works well on belts as
shown here.

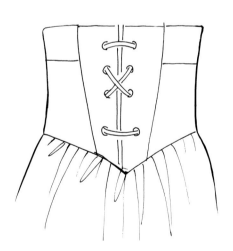

A corset effect can be
achieved with front lacing.

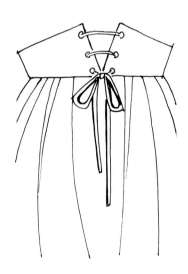

Two laced edges to not have
to butt together exactly.

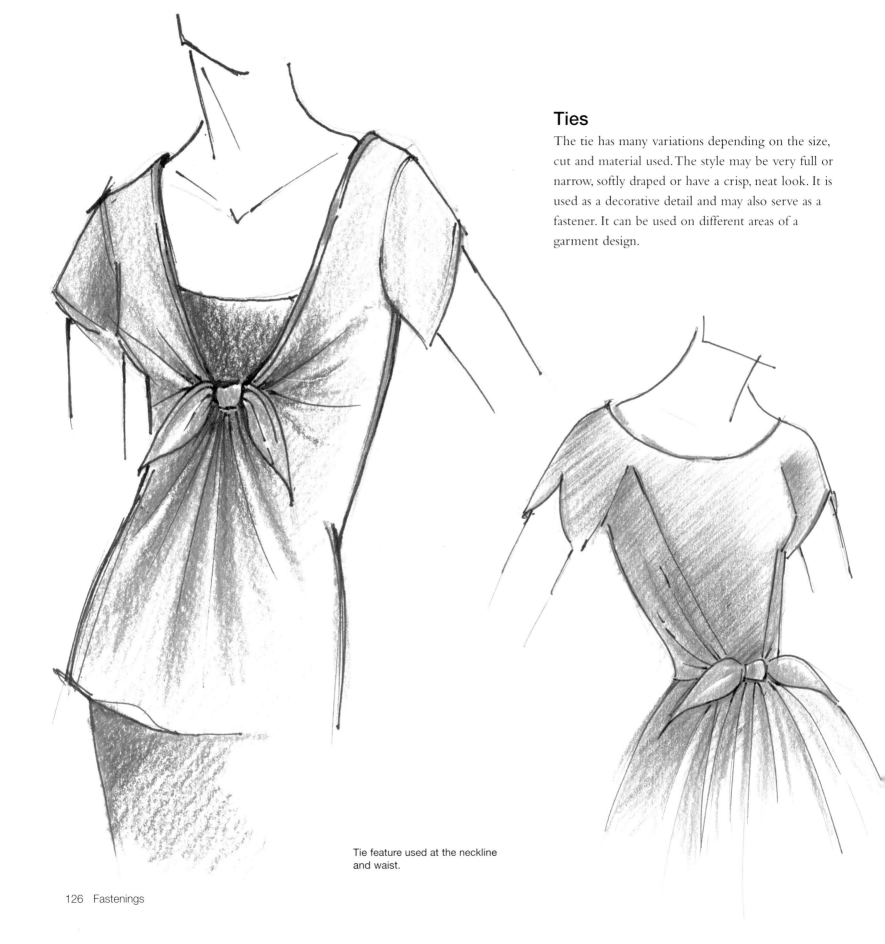

Ties

The tie has many variations depending on the size, cut and material used. The style may be very full or narrow, softly draped or have a crisp, neat look. It is used as a decorative detail and may also serve as a fastener. It can be used on different areas of a garment design.

Tie feature used at the neckline and waist.

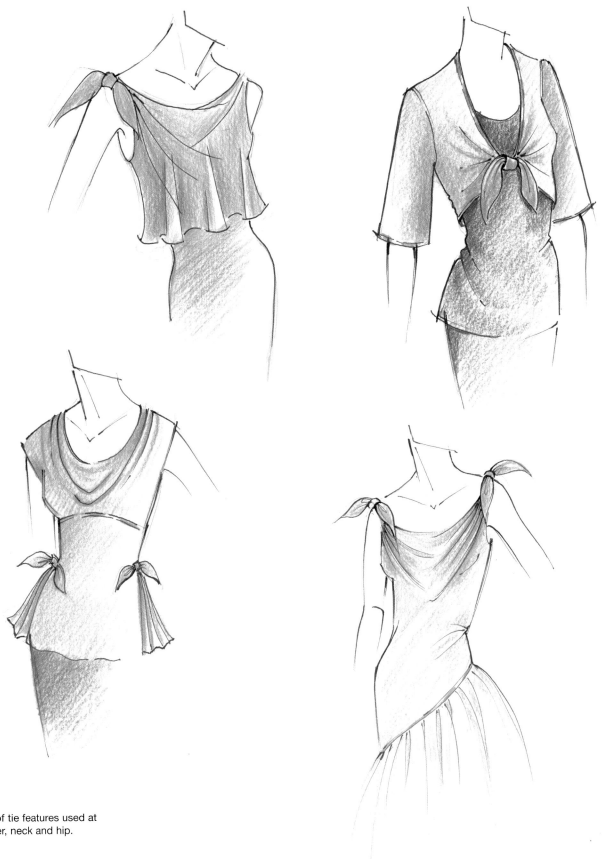

Variations of tie features used at
the shoulder, neck and hip.

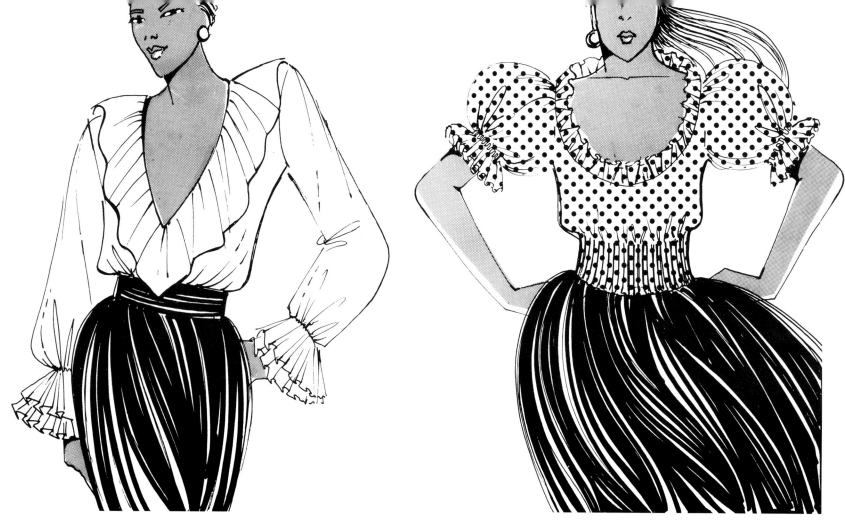

Flounce at the neckline cut on the bias.
Double layered frills on the sleeves.

Large puff sleeves gathered into a
band and frill.

A frill or flounce can be attached to garment edges and
seams or applied to a pattern piece with topstitching, and
adds an attractive feature to a design. Certain fabrics lend
themselves to this decorative treatment – the fineness of the
fabric determines the amount of fullness the flounce or frill
will take but it must be made in a reasonably soft fabric that
naturally falls into folds. A flounce is cut from two circles. It
is fully flared at the hem but keeps a smooth fitting line at
the point at which it is attached to the garment.

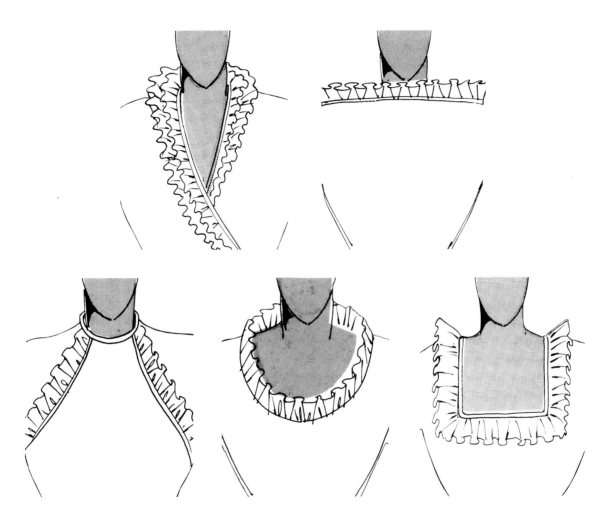

A selection of frills used to
highlight the neck area.

Stage 1.

Stage 2.

Stage 1.

Stage 2.

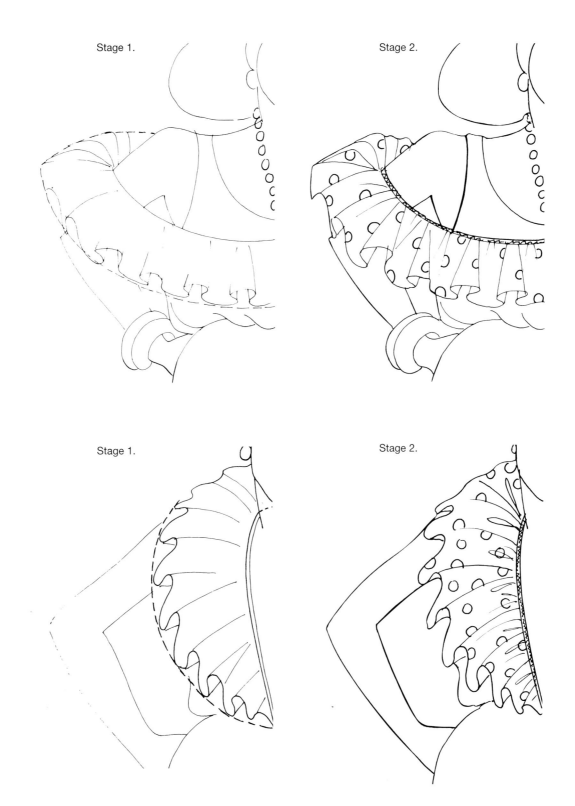

Illustrating in two stages the sketching of a large frill on the
bodice. Note the dotted line indicating the balance of the hem.
It is helpful to give yourself this guideline when sketching.

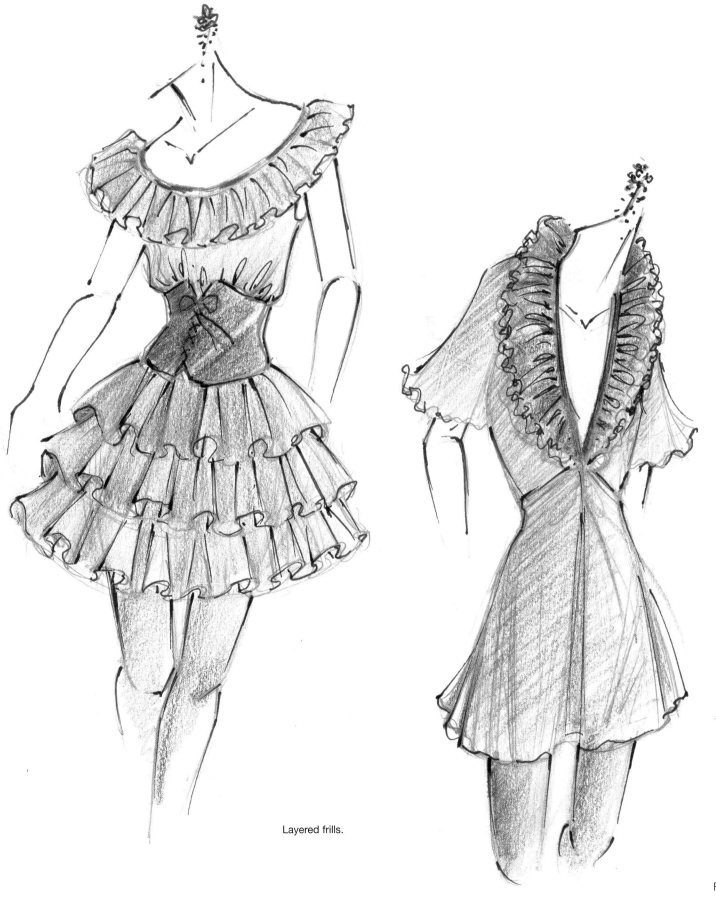

Layered frills.

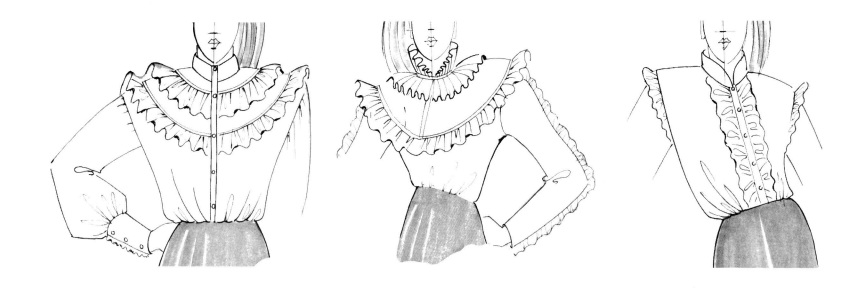

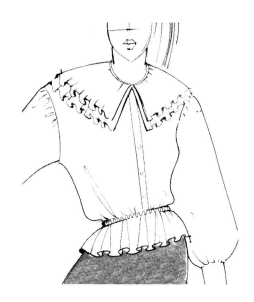

A selection of frills in a
soft fabric.

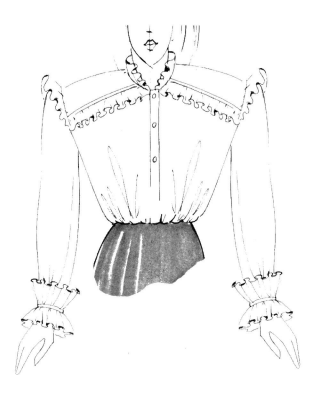

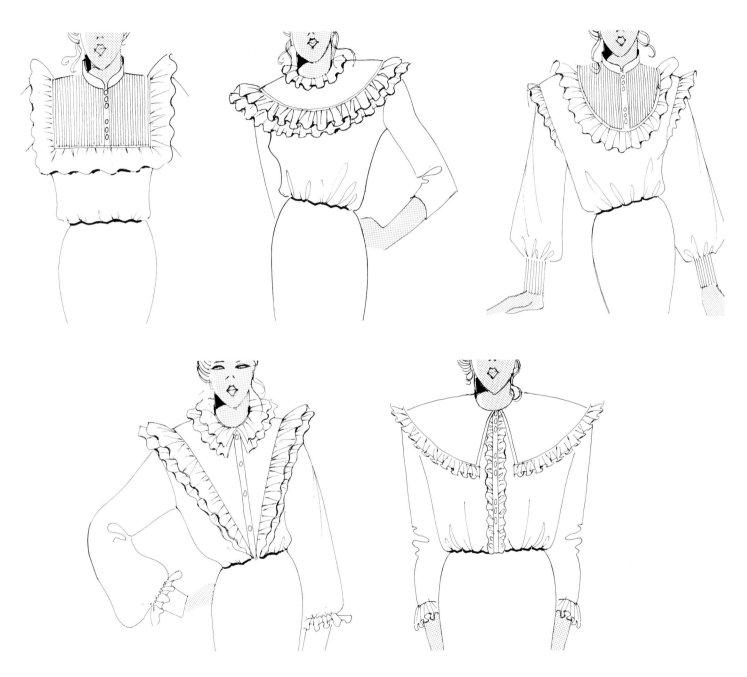

A selection of single and double frills
on yokes, collars and cuffs, taken
from past periods of fashion to be
used as a reference when designing.

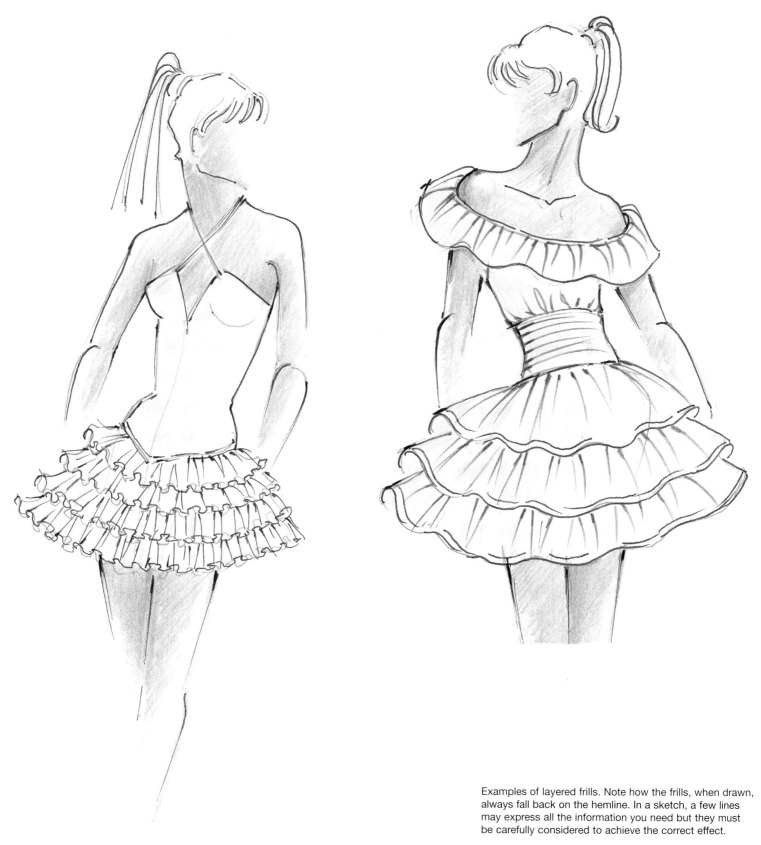

Examples of layered frills. Note how the frills, when drawn, always fall back on the hemline. In a sketch, a few lines may express all the information you need but they must be carefully considered to achieve the correct effect.

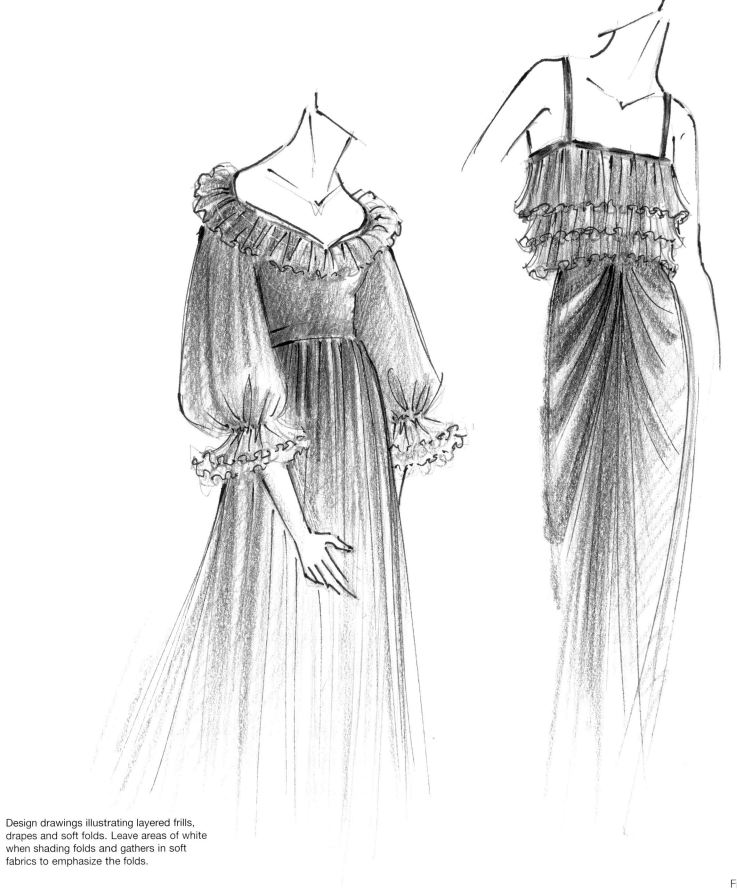

Design drawings illustrating layered frills,
drapes and soft folds. Leave areas of white
when shading folds and gathers in soft
fabrics to emphasize the folds.

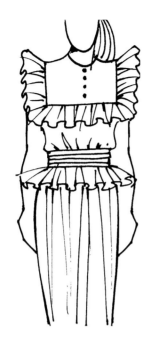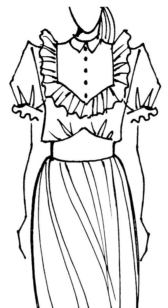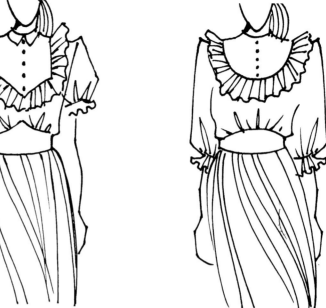

Full frills around yokes.

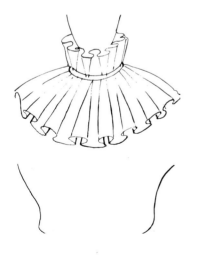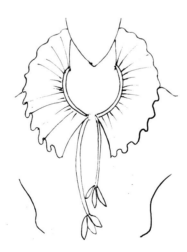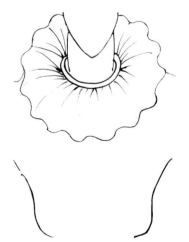

A selection of collars made
from frills and flounces.

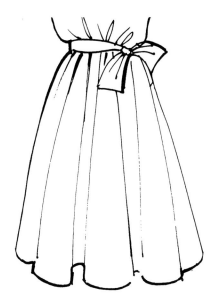

Deep gathers.

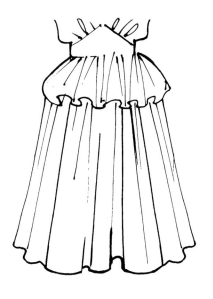

Full gathered shirt with gathered
peplum creates a frill effect.

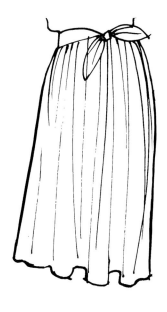

Gathers from waist.

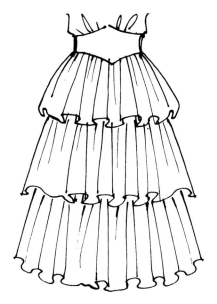

Long layered frills.

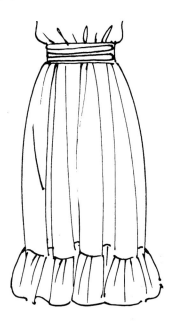

Deep frill on hem of
gathered skirt.

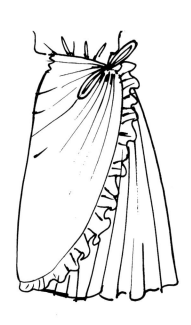

Wrap-over skirt with
frilled edge.

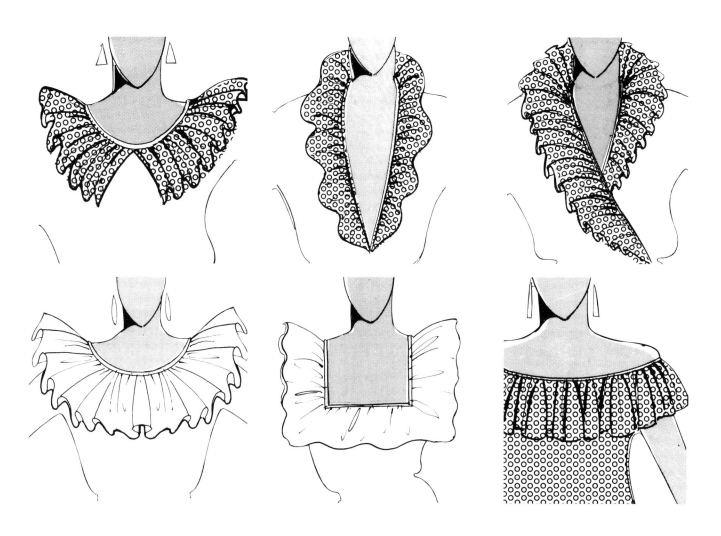

Examples of frills used on the
neckline (see also page 136).

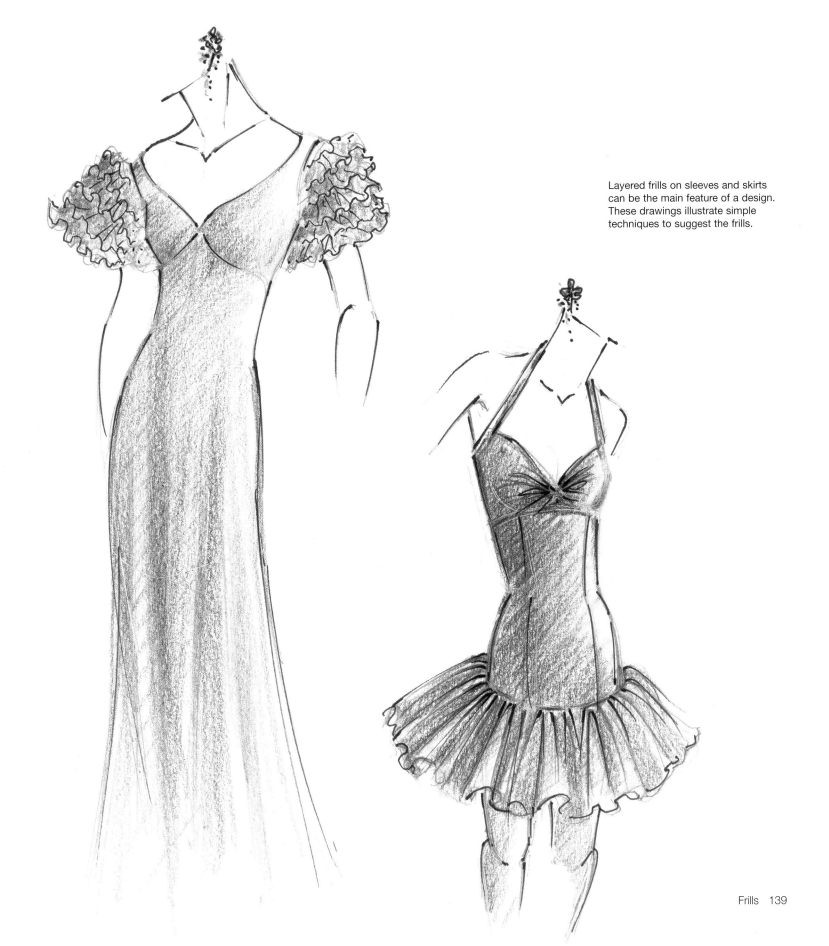

Layered frills on sleeves and skirts
can be the main feature of a design.
These drawings illustrate simple
techniques to suggest the frills.

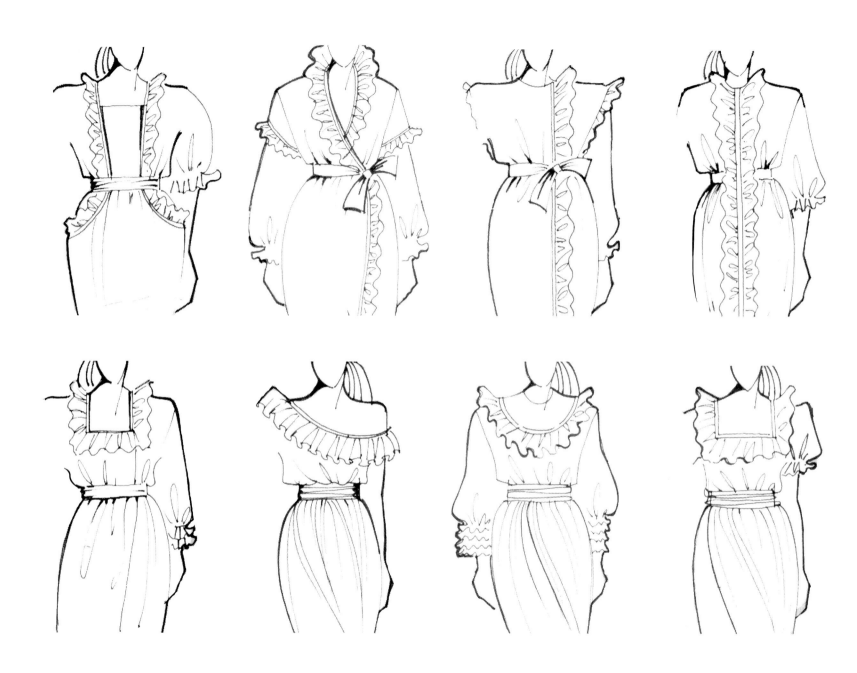

Frills are usually inserted in seams or added to hems. Developing design ideas over the same basic shape (flats) allows a progression of ideas while keeping the garment outline the same. Lining up the designs allows you to relate one idea to the next, which is a quick and effective way of working when developing designs in the early stages.

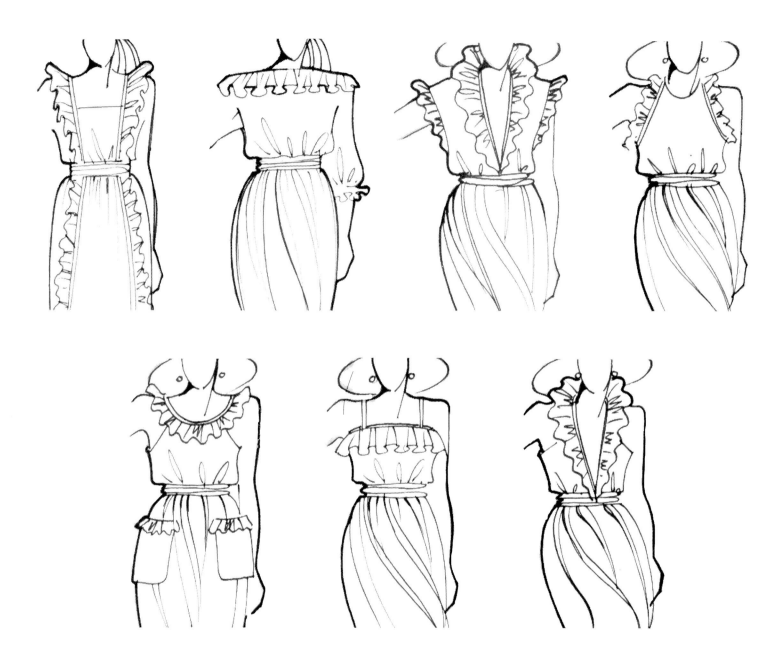

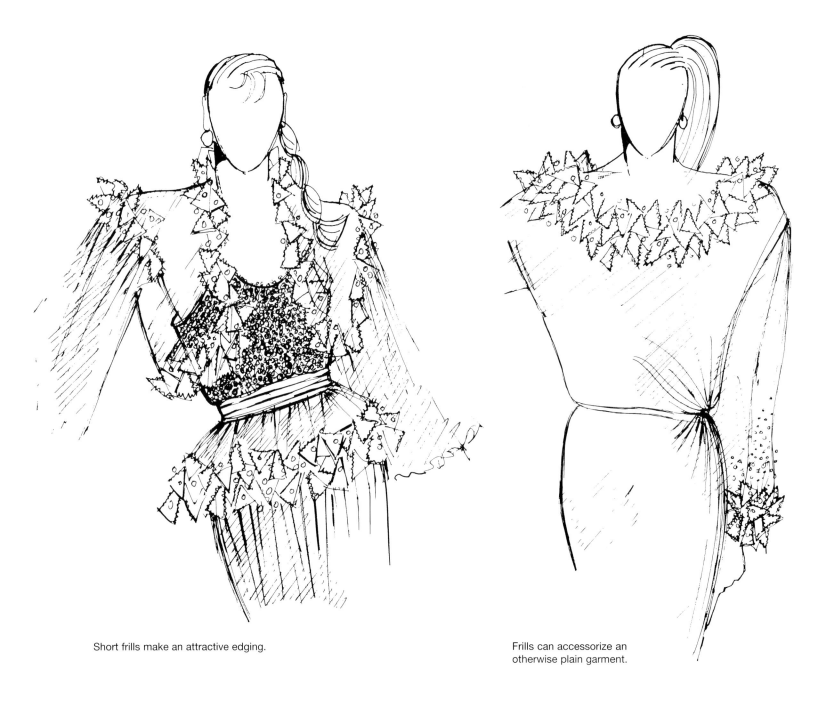

Short frills make an attractive edging.

Frills can accessorize an
otherwise plain garment.

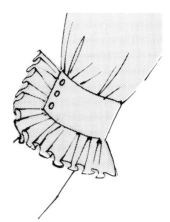

Frilled cuff.

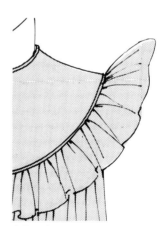

Full gathers on the yoke.

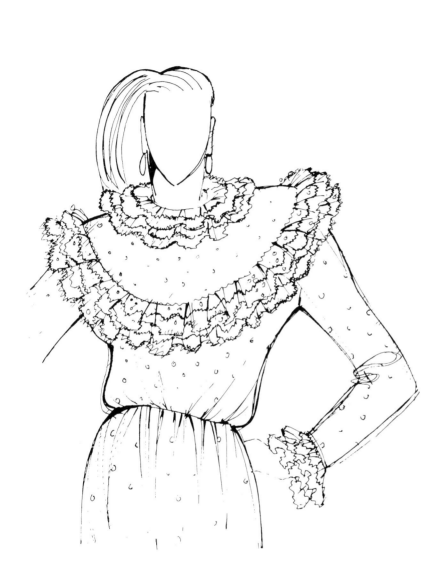

You can use frills to emphasize a section of garment, such as the yoke.

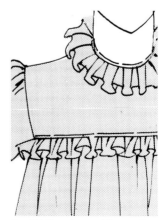

Small frill at the neckline and the yoke.

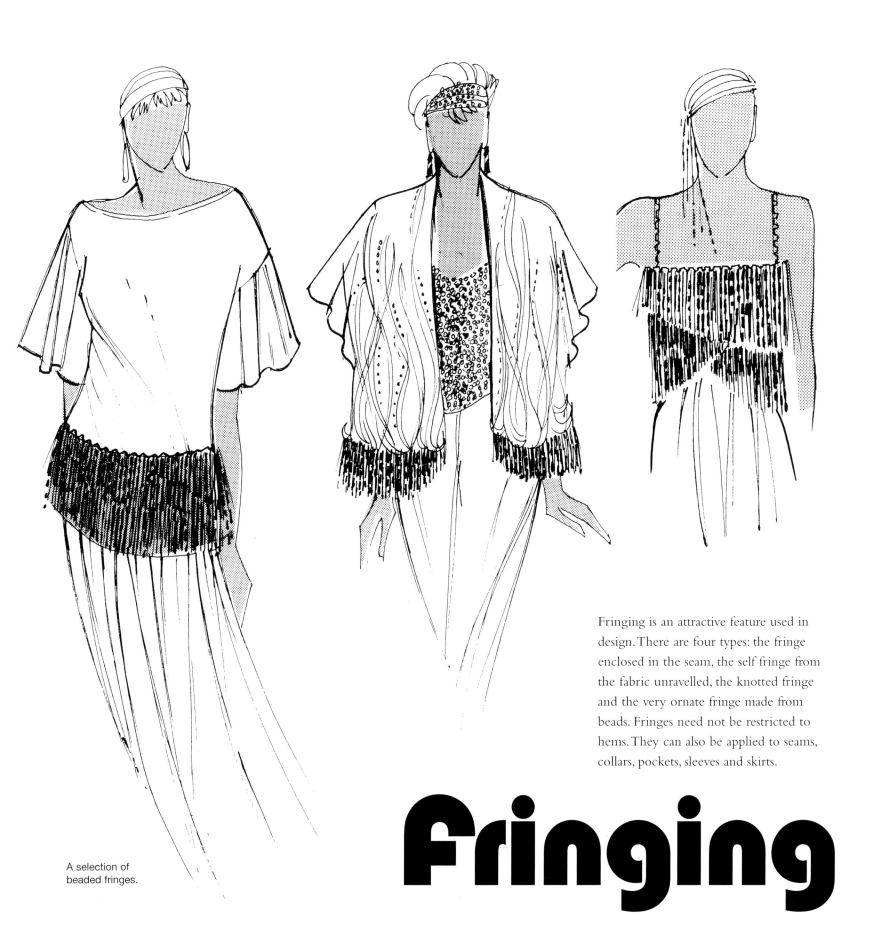

Fringing is an attractive feature used in design. There are four types: the fringe enclosed in the seam, the self fringe from the fabric unravelled, the knotted fringe and the very ornate fringe made from beads. Fringes need not be restricted to hems. They can also be applied to seams, collars, pockets, sleeves and skirts.

A selection of beaded fringes.

Fringing

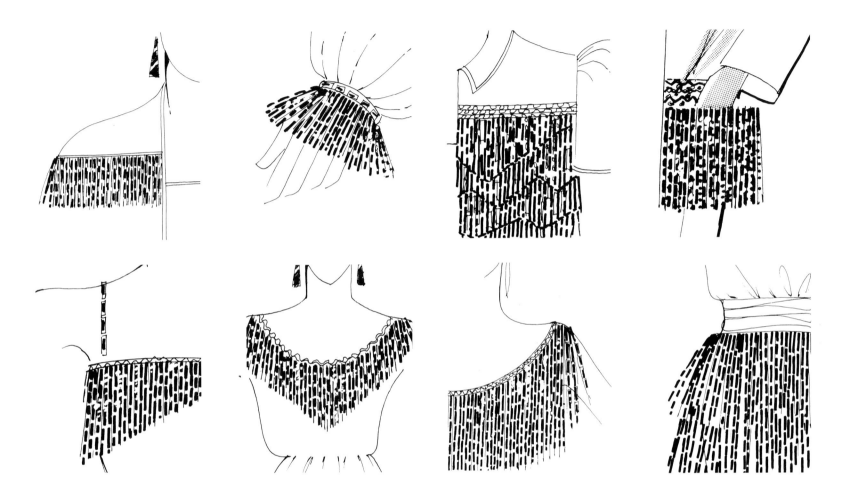

More examples of beaded fringes.

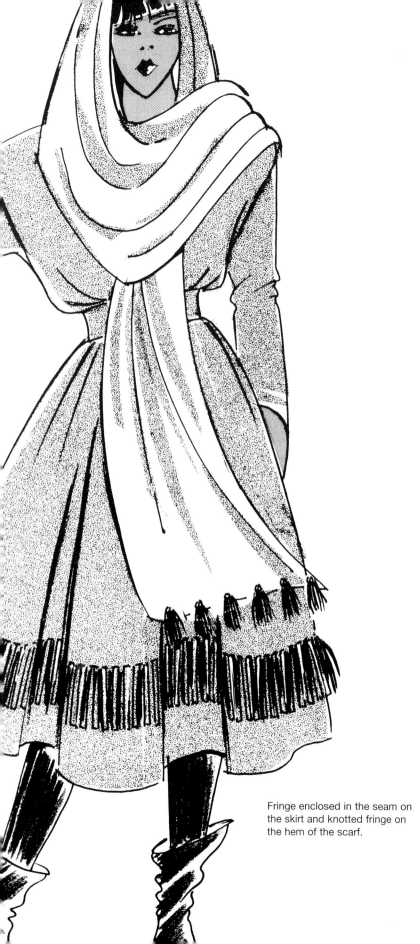

Fringe enclosed in the seam on
the skirt and knotted fringe on
the hem of the scarf.

Fringe enclosed in the seam.

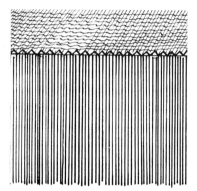

Fringe unravelled from woven fabric. To
prevent any further unravelling a small
zigzag stitch is used over the edge.

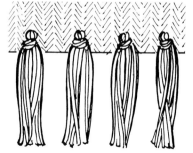

Knotted fringe used on a finished
edge of woven fabric. A hole is made
for the knot between the threads.

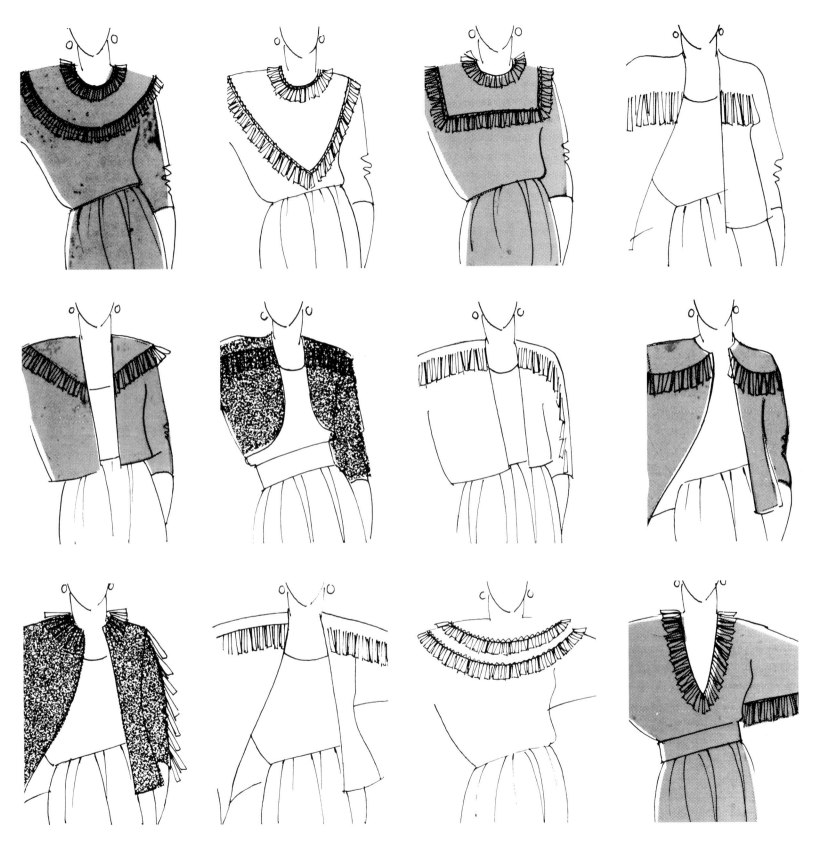

Ideas for fringe placement.

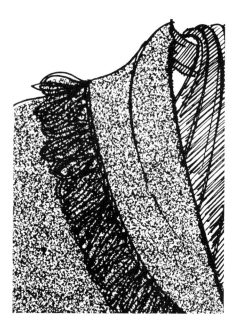 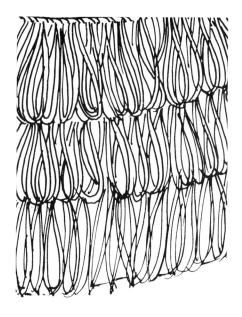 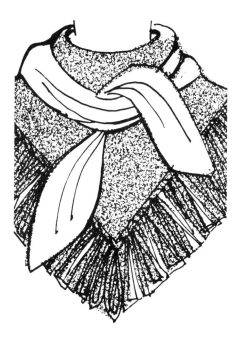

The fringe can be produced in various ways, either produced or made up. Add a silk fringe to a shiny fabric, or rows of wool fringing in different shades to accent the subtle colours of a tweed garment. Fringing can be make from a selection of materials in rows of four or more. As illustrated, effects can be created using rouleau loops, beading, self fringing and knotted fringes used to great effect on necklines, sleeves, panel lines and hems of skirts.

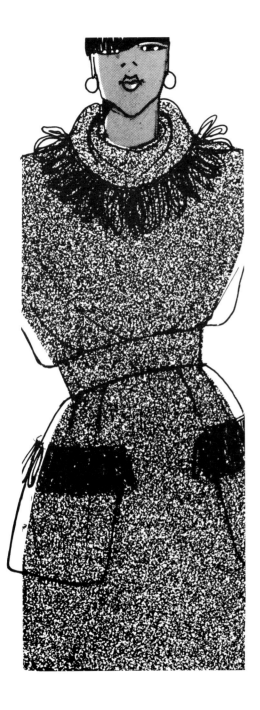

More fringing made from rouleau
loops enclosed in a seam.

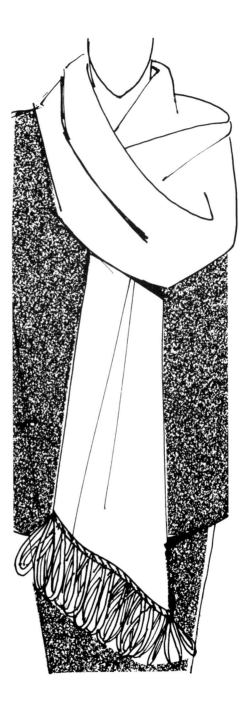

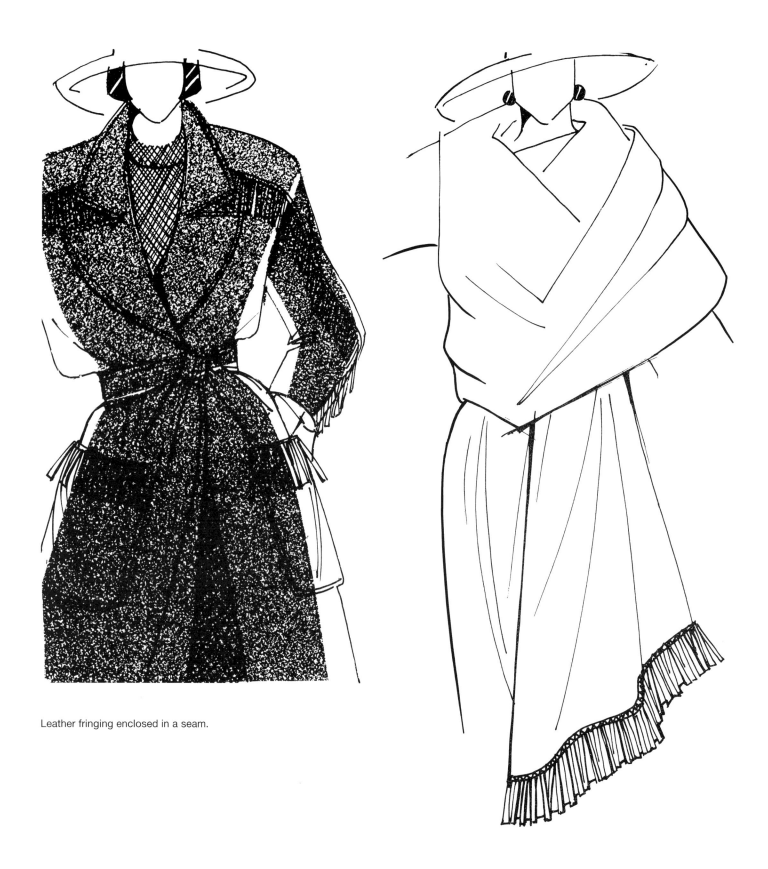

Leather fringing enclosed in a seam.

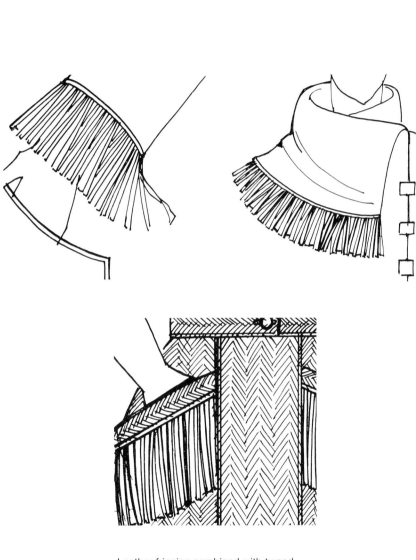

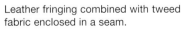
Leather fringing combined with tweed fabric enclosed in a seam.

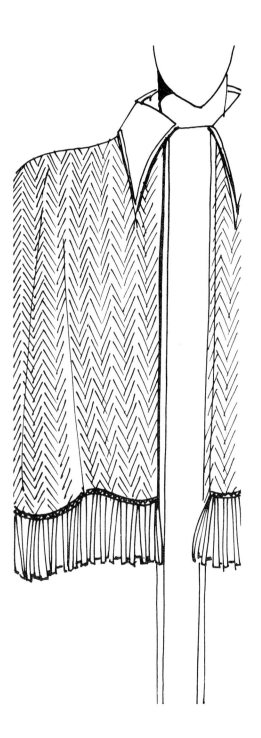

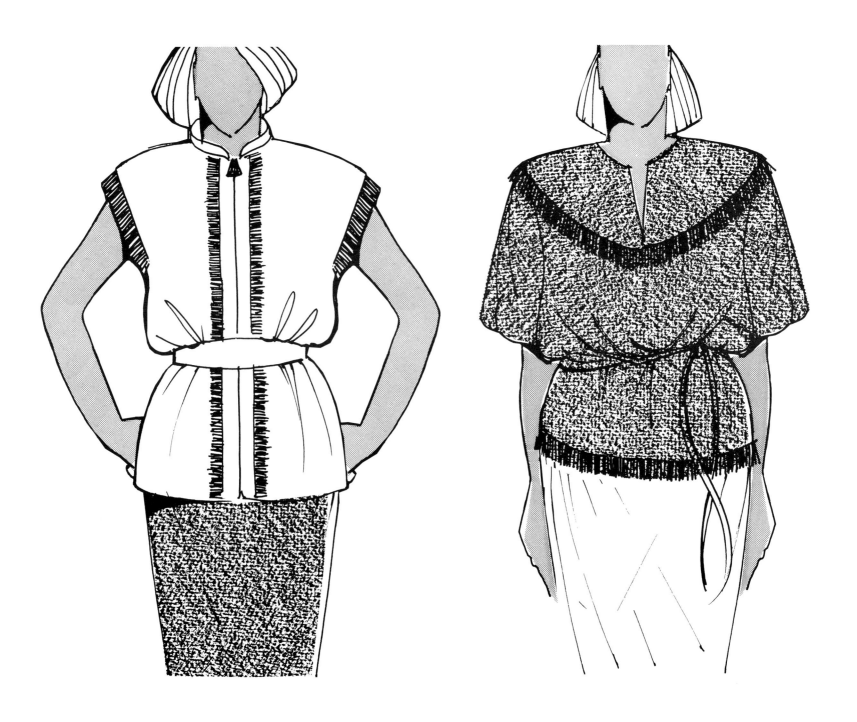

Fringe unravelled from the
fabric hem.

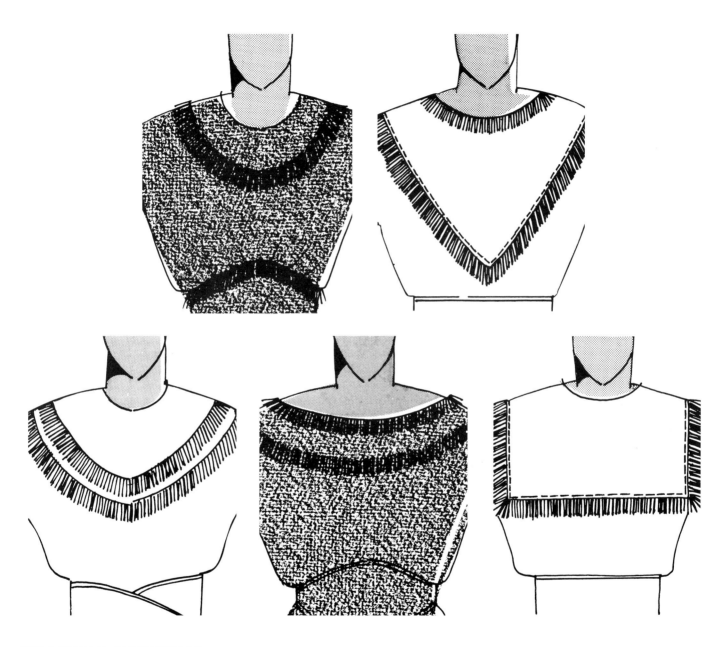

More examples of where the fringe has
been unravelled from the fabric hem.

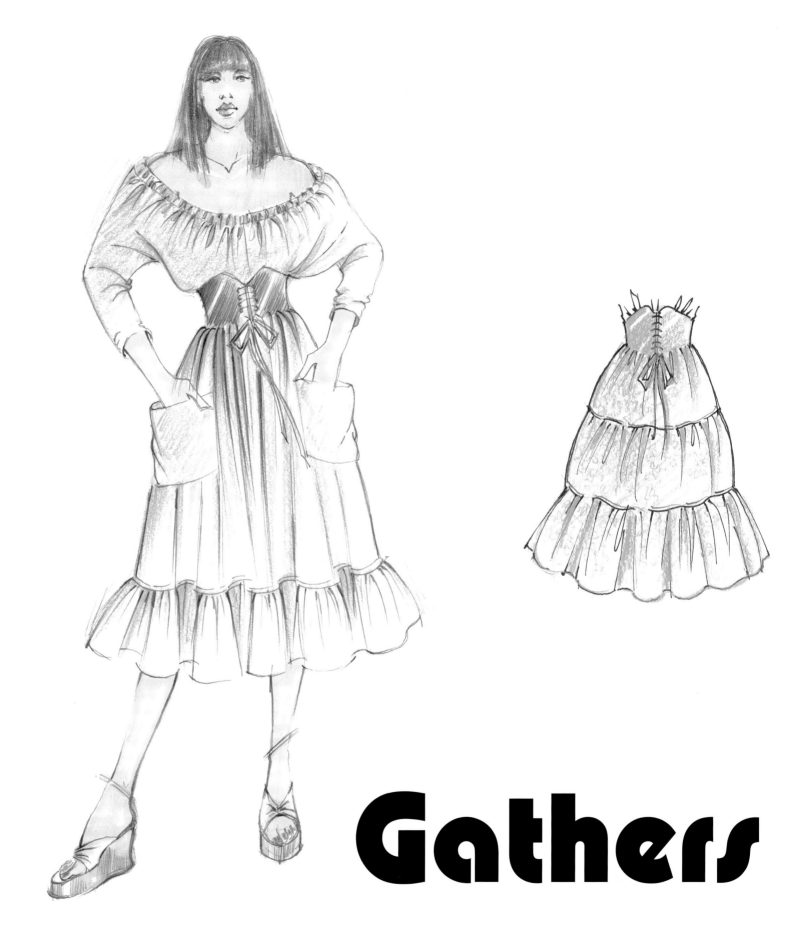

Gathers

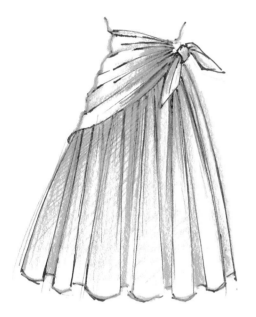
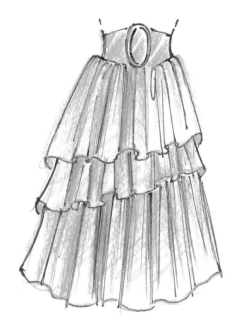
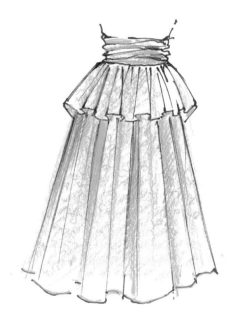

Illustration produced on a smooth white cartridge paper. Figure and skirts sketched in pencil with Derwent artist coloured pencils added for colour.

When designing, gathers are used in a variety of ways on different areas of a garment, such as the yoke, sleeves, skirt or panel lines. They are often used as a detail on a pocket, cuff or peplum. Gathering usually reduces to about one half or one third of the original width. Depending on the fabric being used for the design, the effects will vary from very soft draped folds of jersey, silk or fine wool to the rich gathers produced with brocade, taffeta or cotton. The gathers fall best on the lengthwise grain of the fabric.

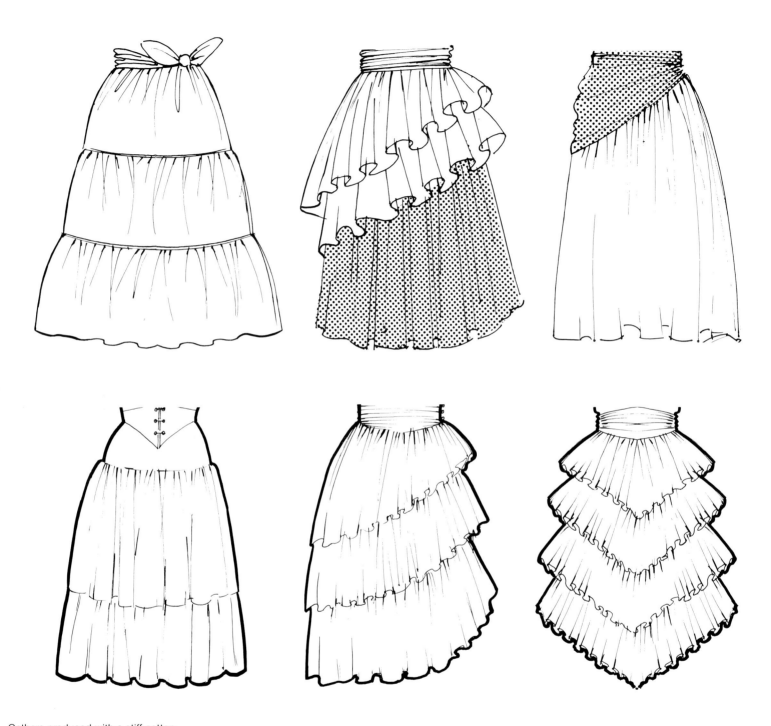

Gathers produced with a stiff cotton,
achieving a crisp and billowing effect on
the hems of skirts, peplums and waistlines.

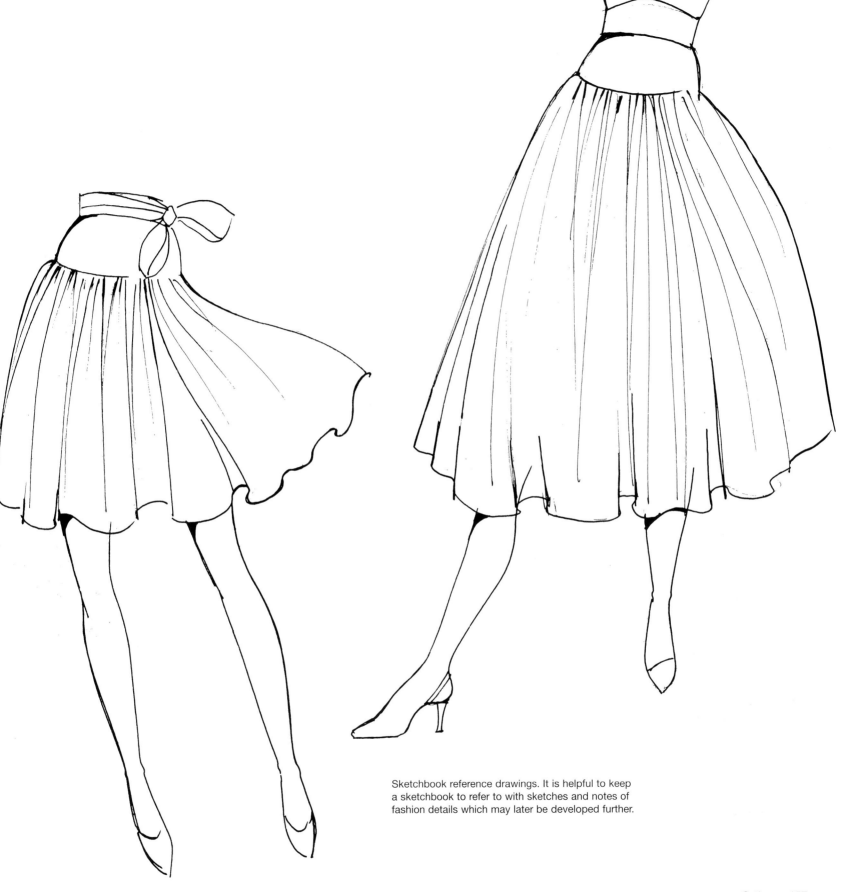

Sketchbook reference drawings. It is helpful to keep a sketchbook to refer to with sketches and notes of fashion details which may later be developed further.

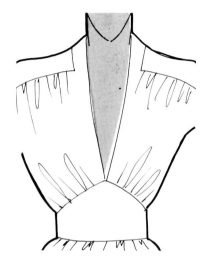

Gathers from waist and
shoulder yokes.

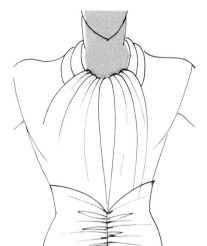

Gathers at waist from
centre-front seam.

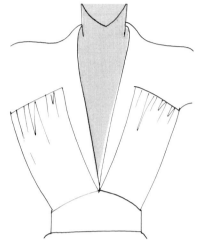

Gathers from the
shoulder yokes.

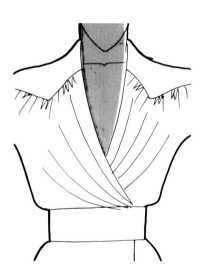

Gathers from the shoulder yokes
with a soft draped bodice.

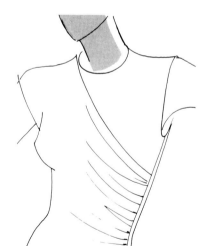

Gathers from a side seam.

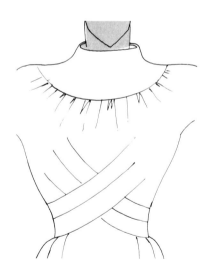

Gathers from the neck yoke.

1920s

Adaption of a 1920s dress using modern design features. This 1929 silk velvet eveningwear features asymmetric V-shaped necklines, hip-length bodices ruched into left side seam and pointed inset panels on the hip.

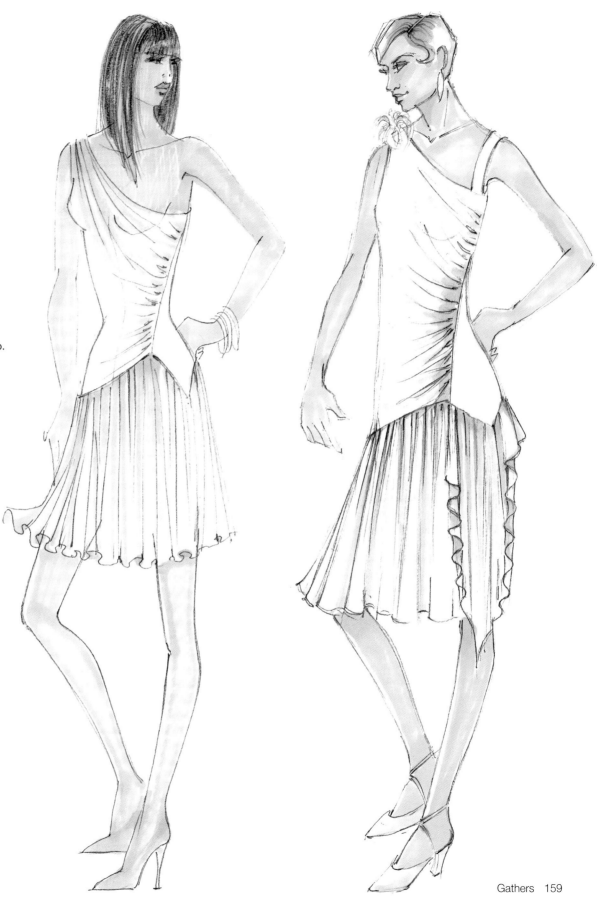

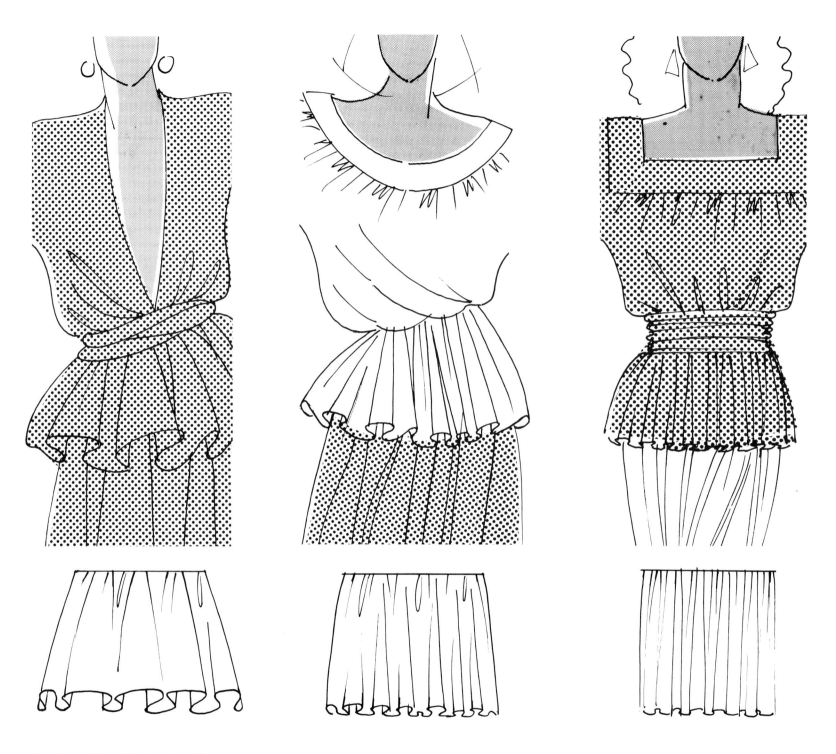

Note the variation of the hemline of the fabrics illustrated from a crisp cotton with deep folds to silk and the soft folds of jersey.

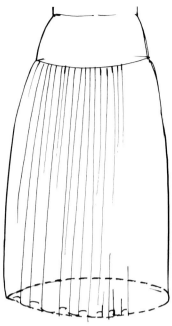

Three stages of sketching folds in a soft fabric with small, delicate gathers.

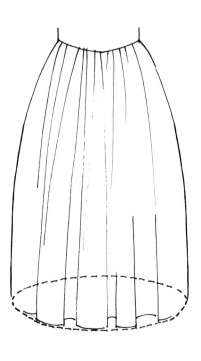
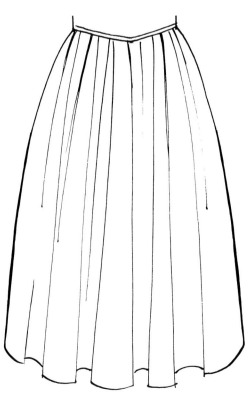

Three stages of sketching deeper folds of a stiffer and crisper cotton fabric.

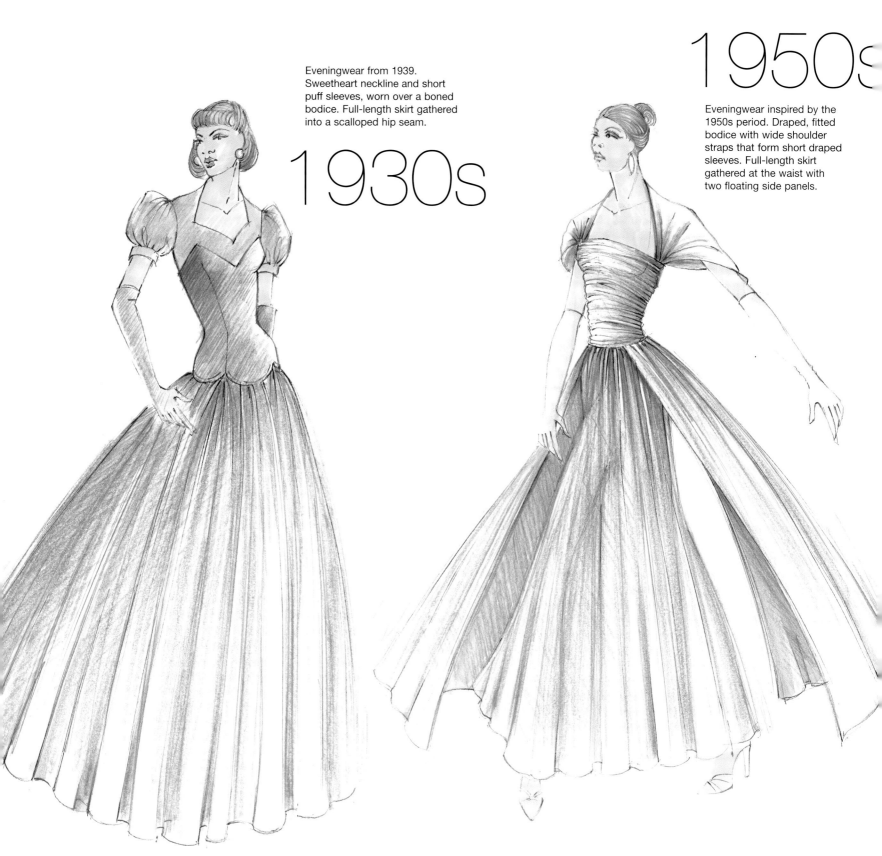

Eveningwear from 1939.
Sweetheart neckline and short
puff sleeves, worn over a boned
bodice. Full-length skirt gathered
into a scalloped hip seam.

1930s

1950s

Eveningwear inspired by the
1950s period. Draped,
fitted bodice with wide shoulder
straps that form short draped
sleeves. Full-length skirt
gathered at the waist with
two floating side panels.

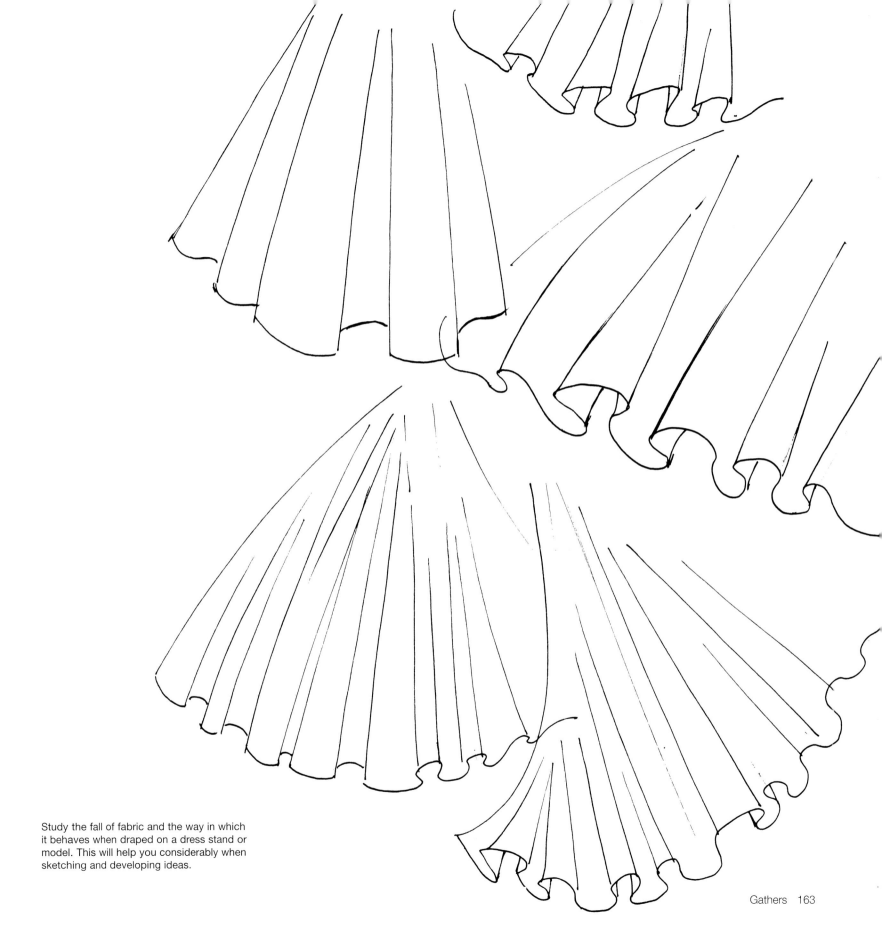

Study the fall of fabric and the way in which it behaves when draped on a dress stand or model. This will help you considerably when sketching and developing ideas.

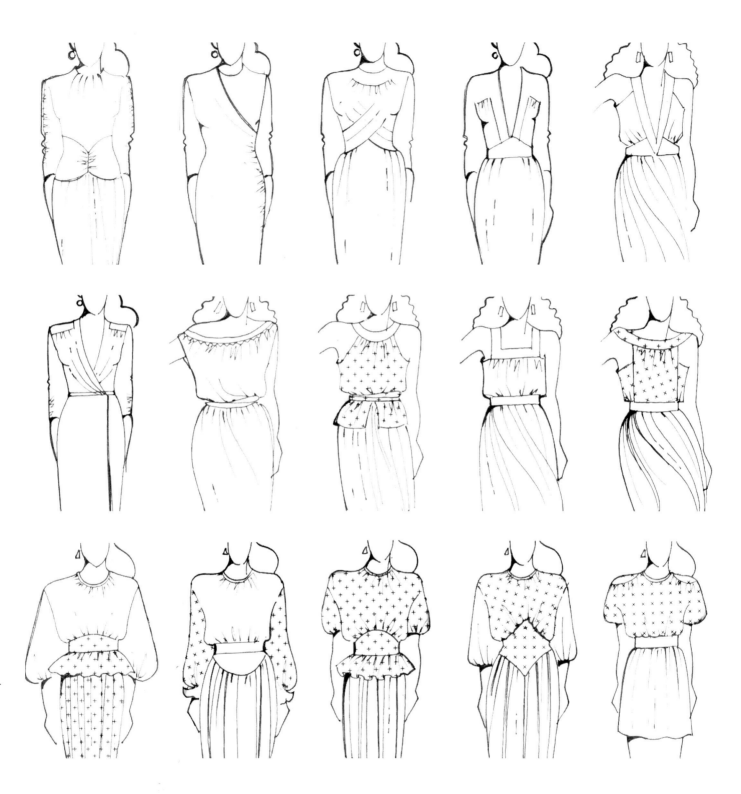

Designs that reflect the influence of the 1940s and '50s. Note the gathers
and soft folds in jersey silk with gathers from shoulder and waist yokes.

Presentation drawings produced on a white Bristol board. Sketched with a soft pencil and a fine drawing pen for seams and gathers.

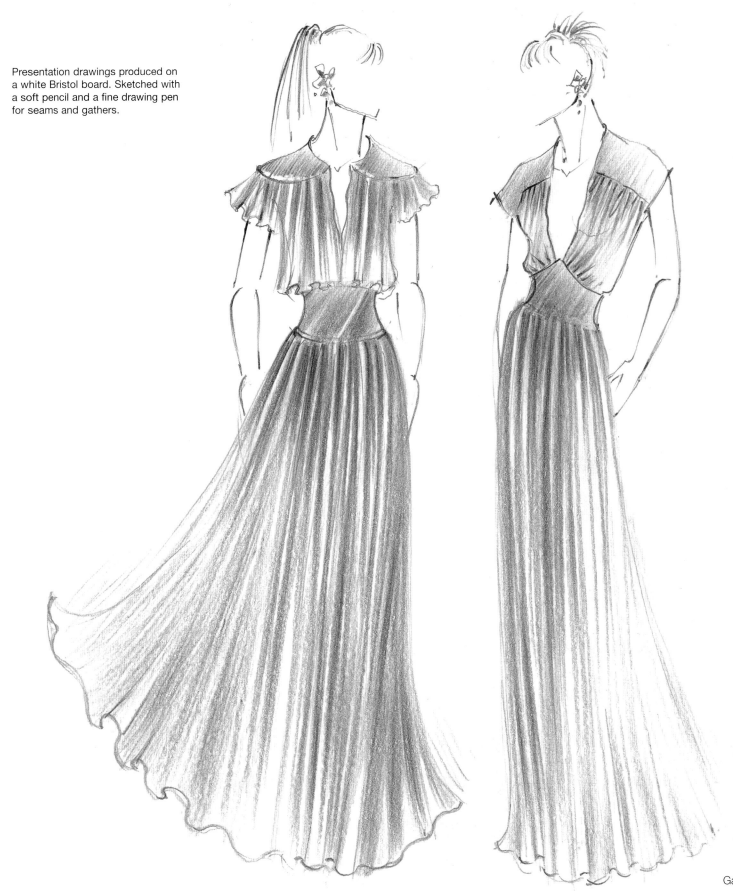

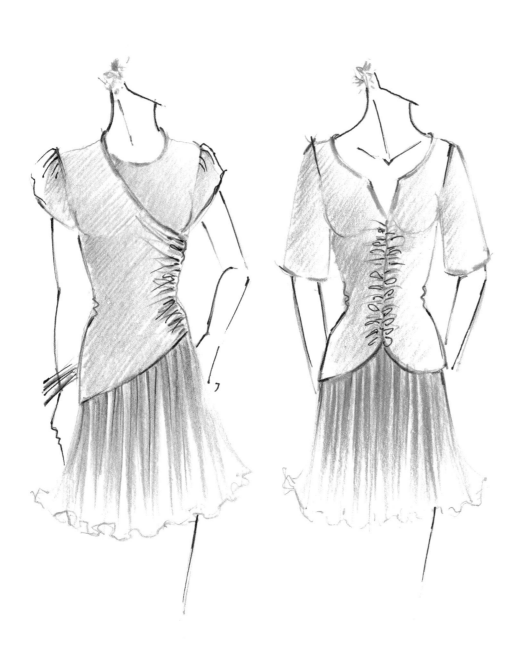

Development drawing exploring the use of a gathered seam on a blouse. This style of drawing – without showing the head and finishing at the hem – is used when developing design ideas as a quick and effective method of working.

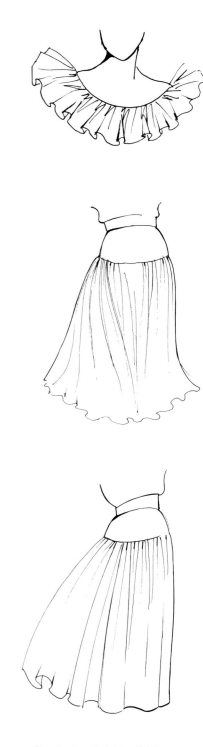

Developing sketchbook ideas.

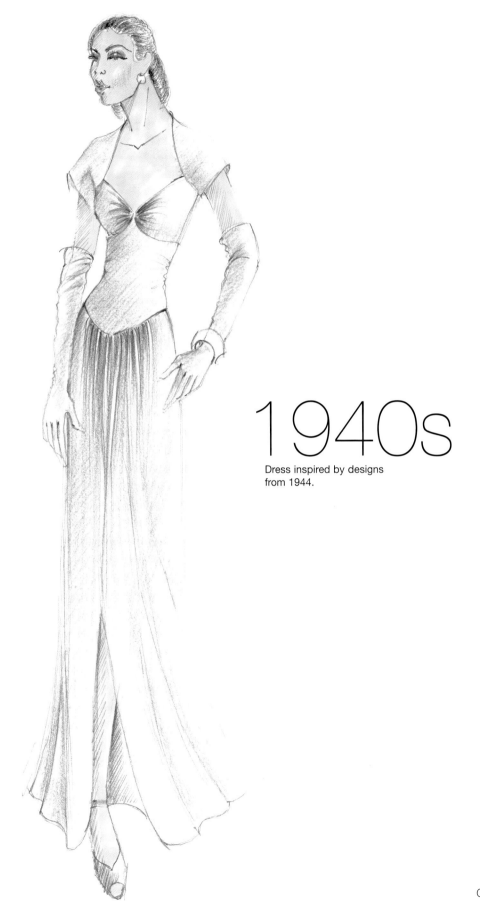

1940s

Dress inspired by designs
from 1944.

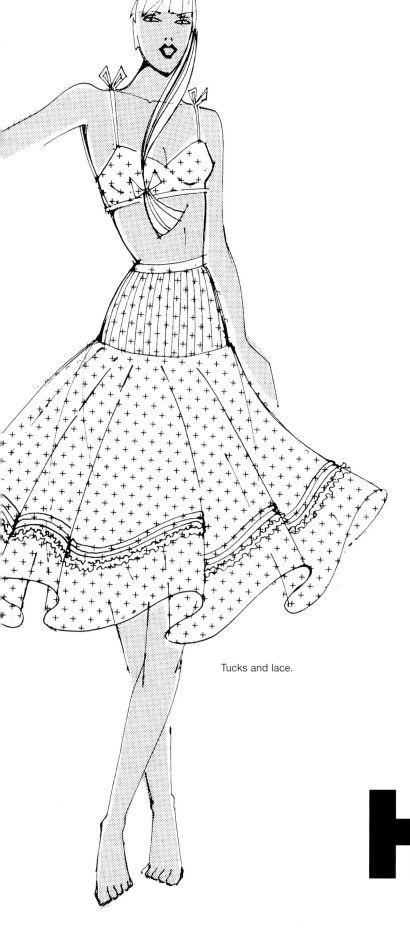

Tucks and lace.

The hemlines of a design vary considerably from very simple hems to folds, pleats, gathers, fringing and beading, and so on. The interest of the hemline may be featured on the hem of a skirt, sleeve or neckline. The shape will vary from very full to narrow, regular, straight hems. Draped and shaped hems are often used on eveningwear. The hem is often trimmed with braids, tucks, frills and flounces.

Underskirts are an important feature to give emphasis to the skirt's shape and fullness, or when featured as a layered look, draped to be revealed below the skirt. The hemline is often the feature of an underskirt with different effects of gathering, pleating, edging, frills and flounces.

Hemlines

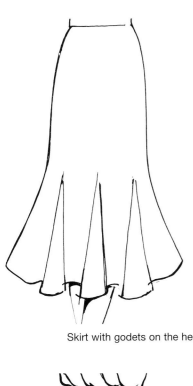

Skirt with godets on the hem.

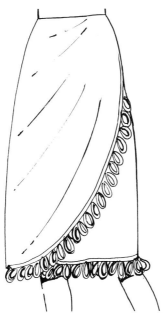

Fringe of rouleau loops.

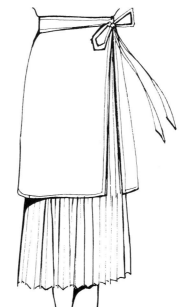

Accordion pleating and piping.

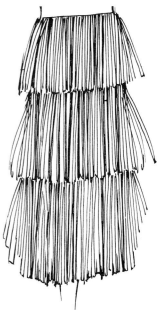

Hems of tied fringing.

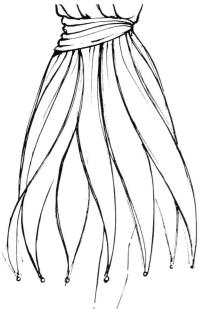

Layered, shaped panels with beads on each point.

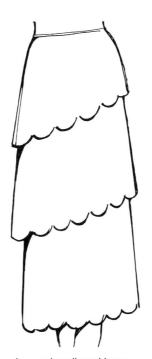

Layered scalloped hems.

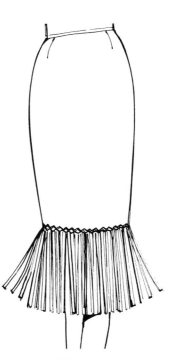

Fringing.

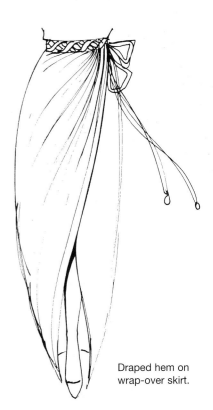

Draped hem on wrap-over skirt.

Presentation drawing of a puff skirt, produced on white cartridge paper using a 2B pencil. Colour was added with Derwent artist pencils and Letraset Promarker blush felt-tip pen for the flesh tint.

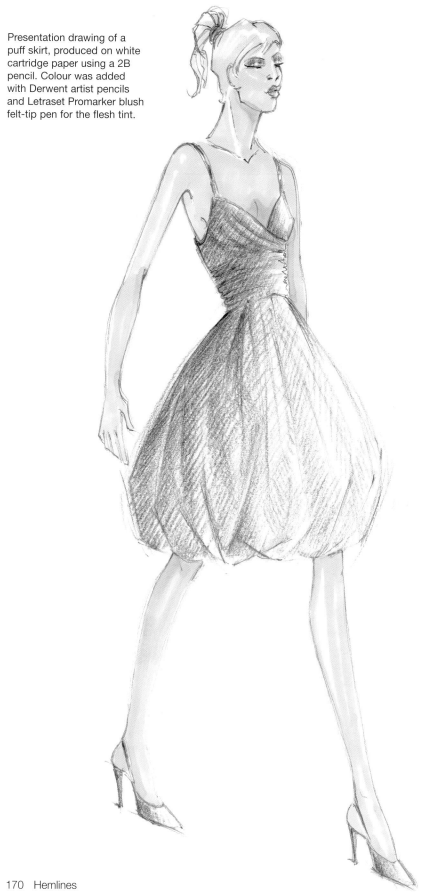

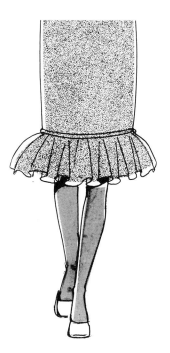

Flared hem.

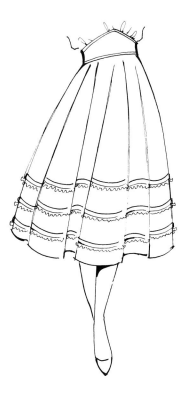

Tucks and lace trimming.

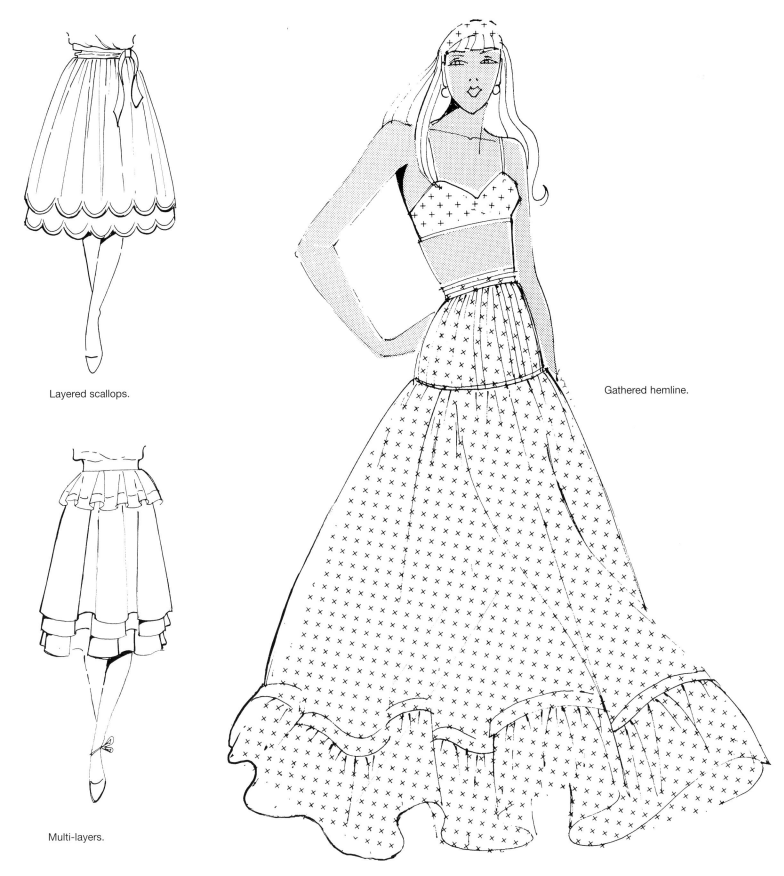

Layered scallops.

Multi-layers.

Gathered hemline.

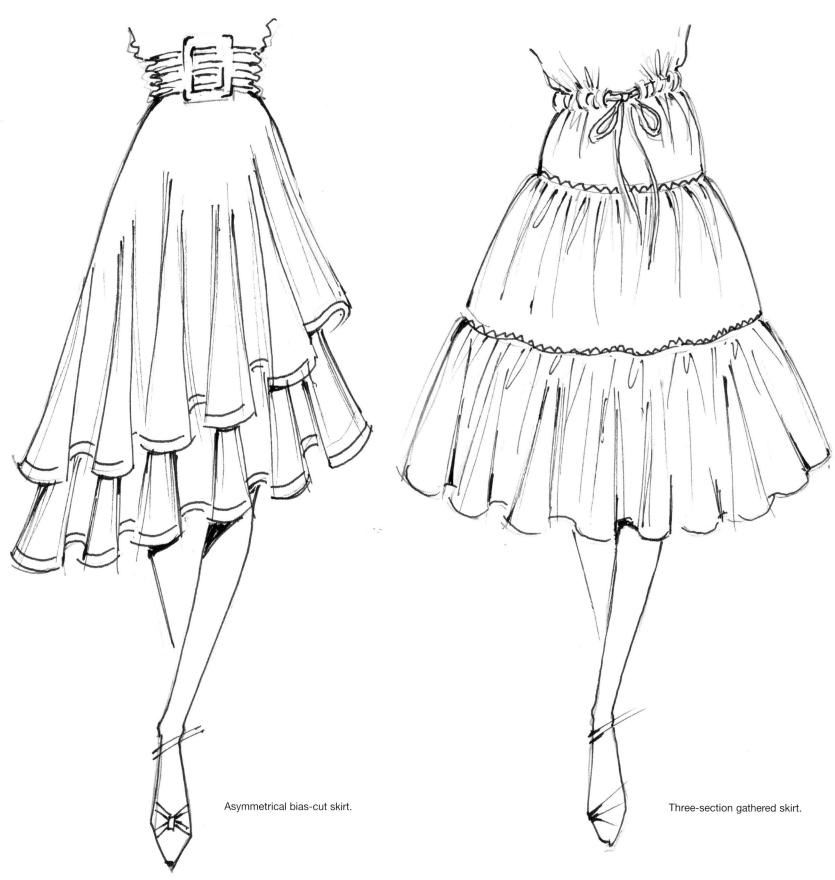

Asymmetrical bias-cut skirt.

Three-section gathered skirt.

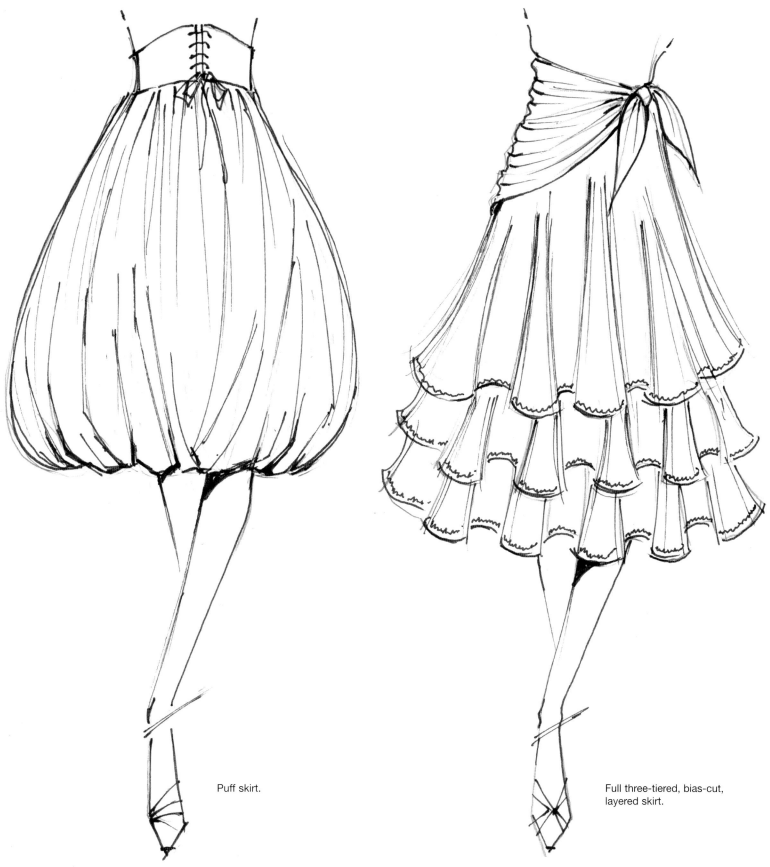

Puff skirt.

Full three-tiered, bias-cut,
layered skirt.

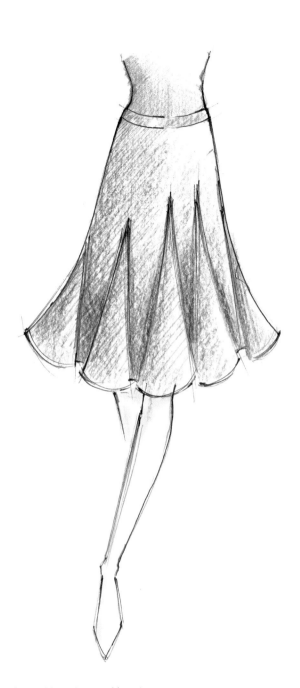

Skirt with godet panel inserts,
used to add swing to a skirt.

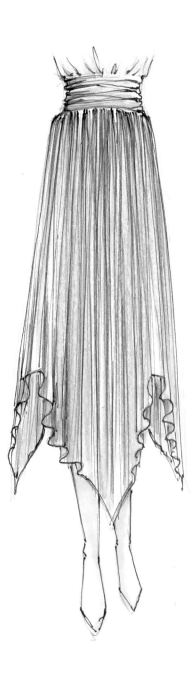

Skirt gathered from the waist in soft
folds with pointed, uneven hemline.

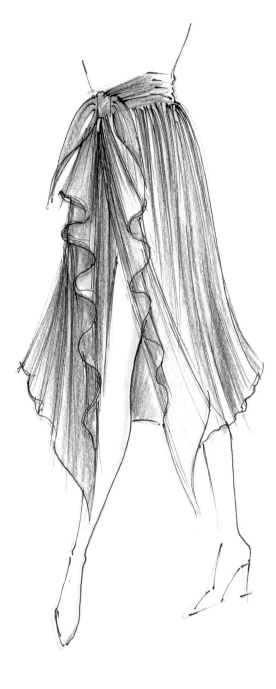

Draped skirt gathered from the waist
with a front opening and uneven hem.

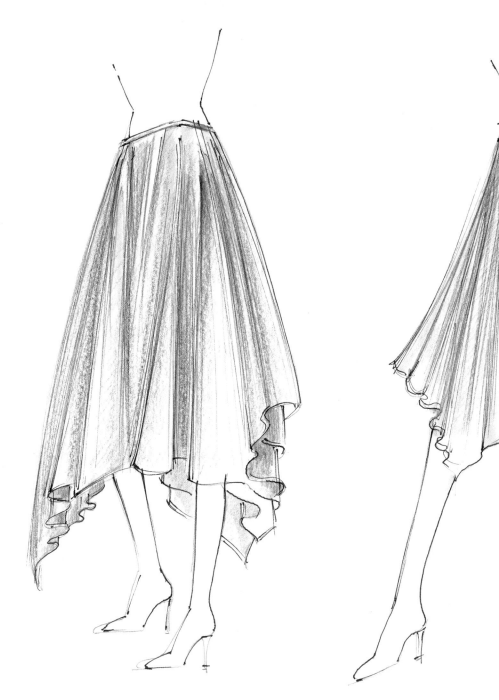

Very full skirt, cut on the bias, falling
into soft folds with an uneven hemline.

Skirt with gathers from the waist, falling
into soft folds with a pointed hemline.

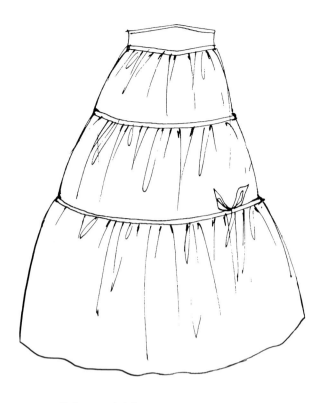

Gathers and piping.

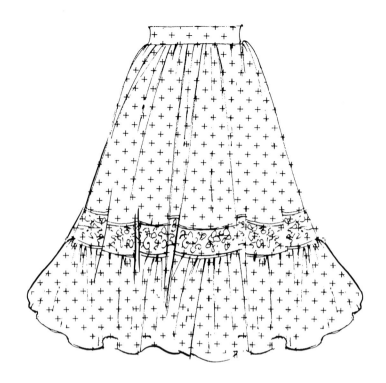

Inset lace section.

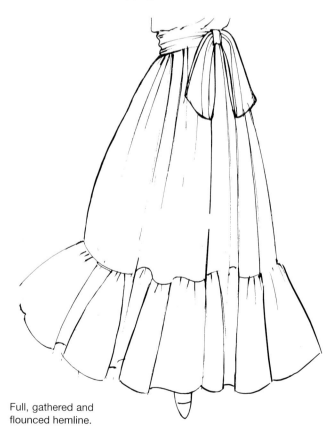

Full, gathered and
flounced hemline.

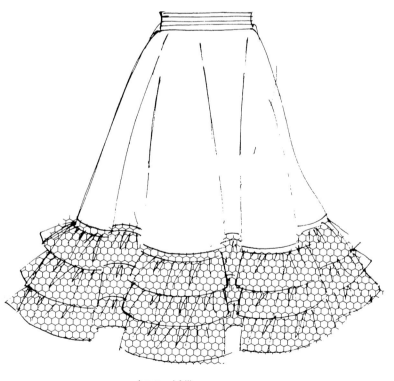

Layered frills.

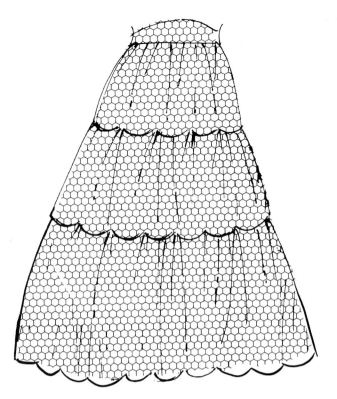

Scallops and gathers.

Blind tucks.

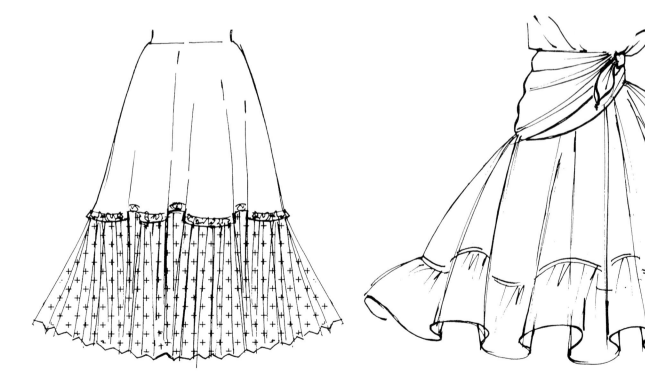

Lace inset and accordion pleats.

Full frill at the hem.

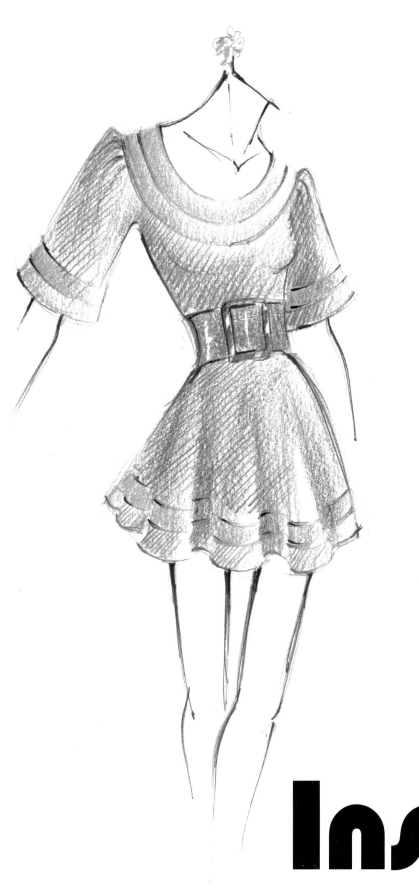

This effect is achieved by stitching sections of a contrasting material into a garment. The contrast may be of a different colour, pattern or texture. The insertions will vary from knitted sections, leather, suede or lace to contrasting patterned fabric. This effect is used in many areas of design from day and casualwear to very delicate designs made in lighter fabrics for daywear and eveningwear as well as for lingerie.

Insertions

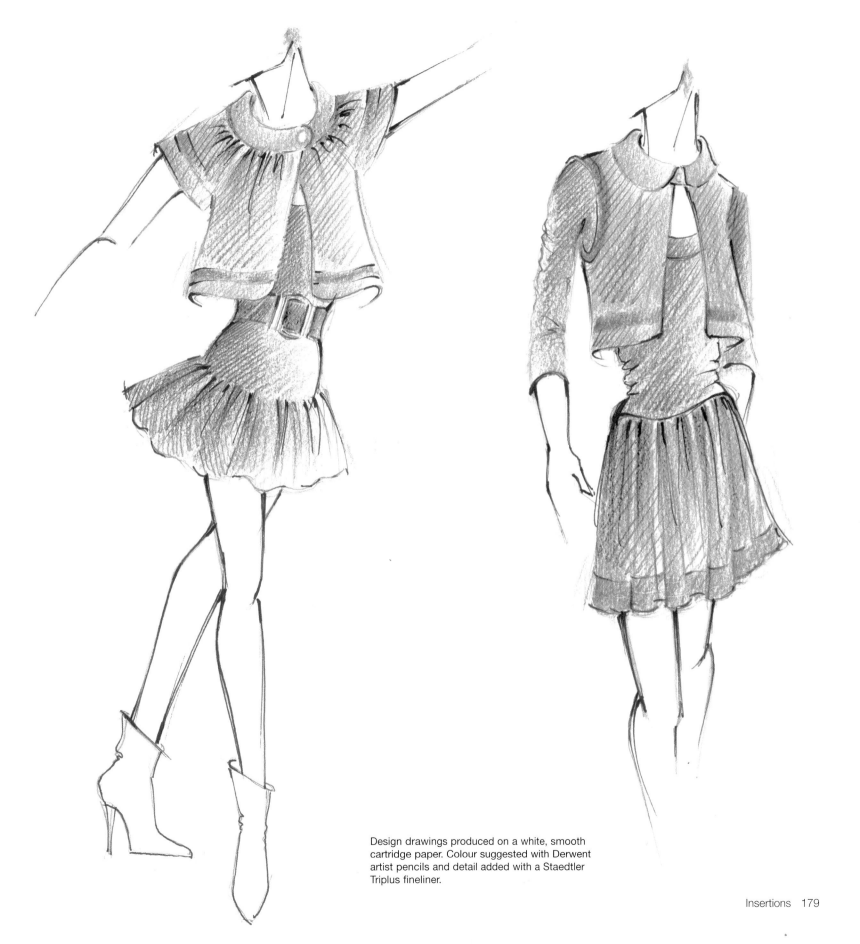

Design drawings produced on a white, smooth cartridge paper. Colour suggested with Derwent artist pencils and detail added with a Staedtler Triplus fineliner.

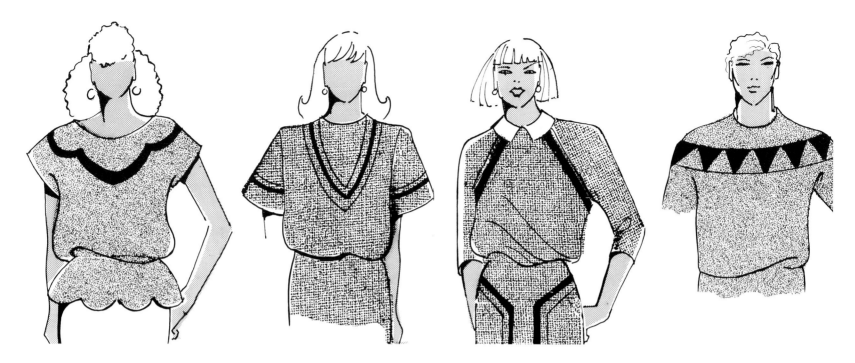

Contrast inserts of leather combined
with tweed fabrics.

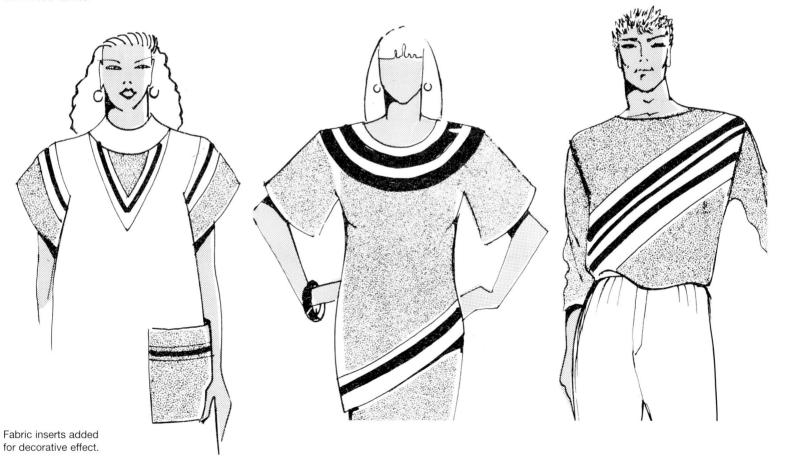

Fabric inserts added
for decorative effect.

Inserts to emphasize design lines.

Insert contrast on peplum.

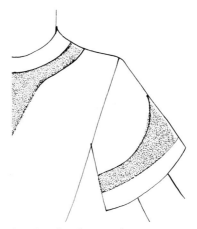

Insert on the sleeve and the neckline.

Insert bands of contrast on a pocket.

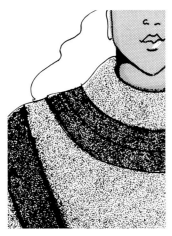

Contrast fabric.

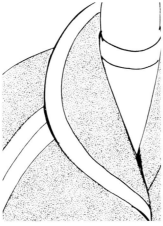

Suede insertions.

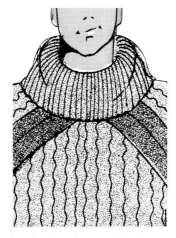

Leather insertions combined with a knitted texture.

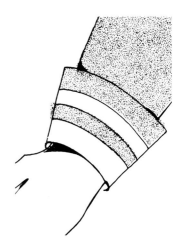

Contrast fabrics on the cuff.

Contrast on the sleeve in suede combined with tweed fabric.

Contrast insert on the back of a jacket.

Inset contrast on the neckline and sleeve.

Inset shapes on the pocket in contrasting textures.

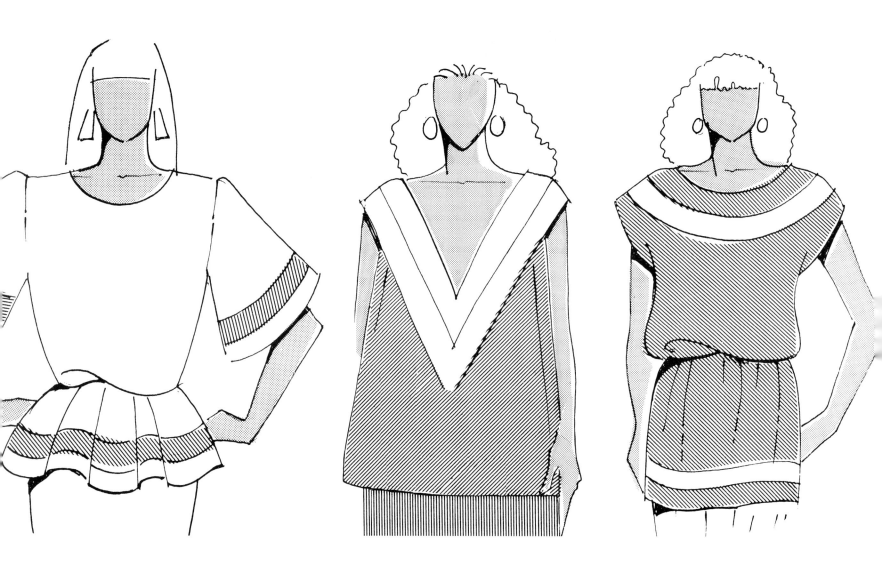

A selection of contrast bands with fabric inserts on
blouses, dresses, skirts and peplum. These sketches
may be developed at a later stage for presentation.

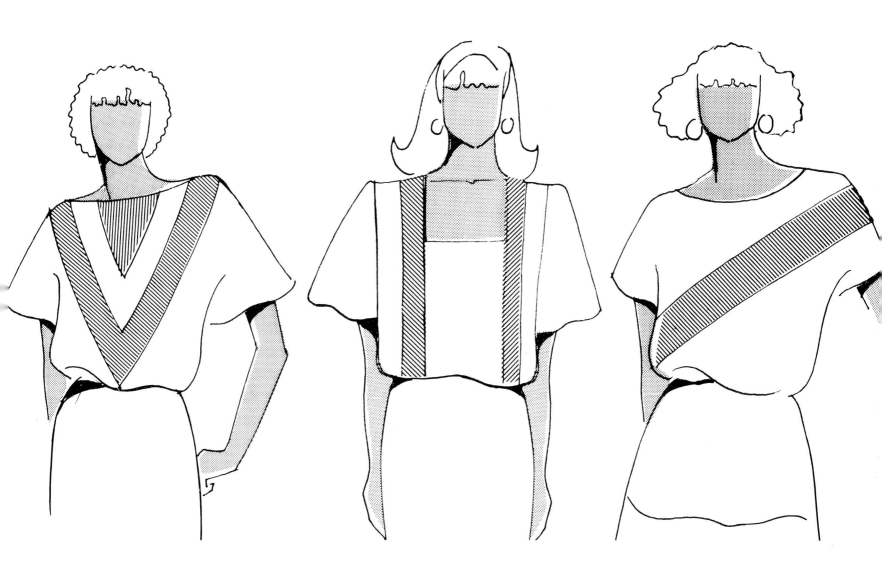

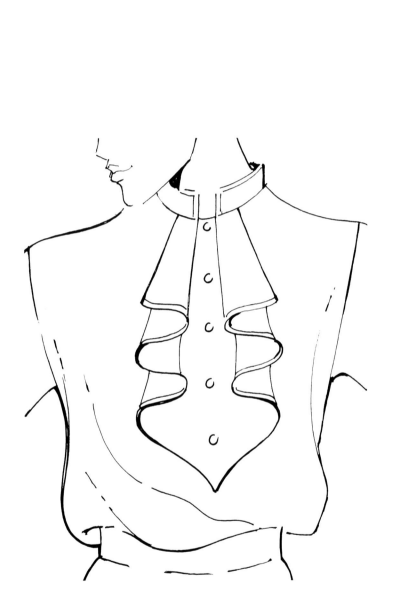

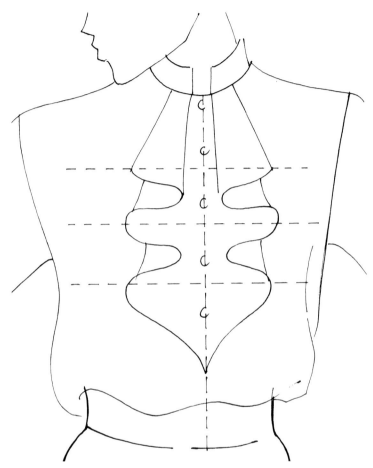

This is a frill or ruffle, worn on the front of the bodice and fastened at the neck, which may be laced, trimmed or made of lace. Many variations are used.

Jabot

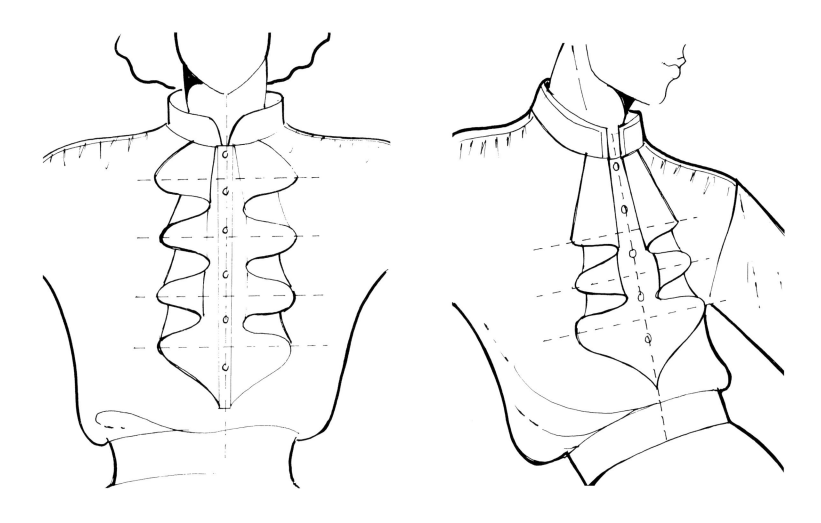

Note the dotted lines as
guides when sketching.

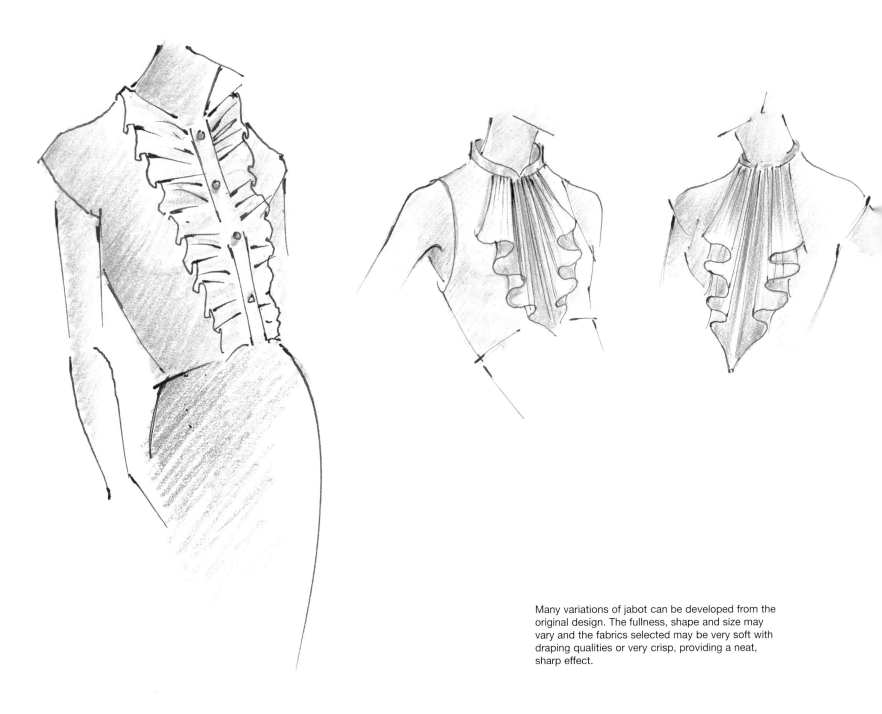

Many variations of jabot can be developed from the original design. The fullness, shape and size may vary and the fabrics selected may be very soft with draping qualities or very crisp, providing a neat, sharp effect.

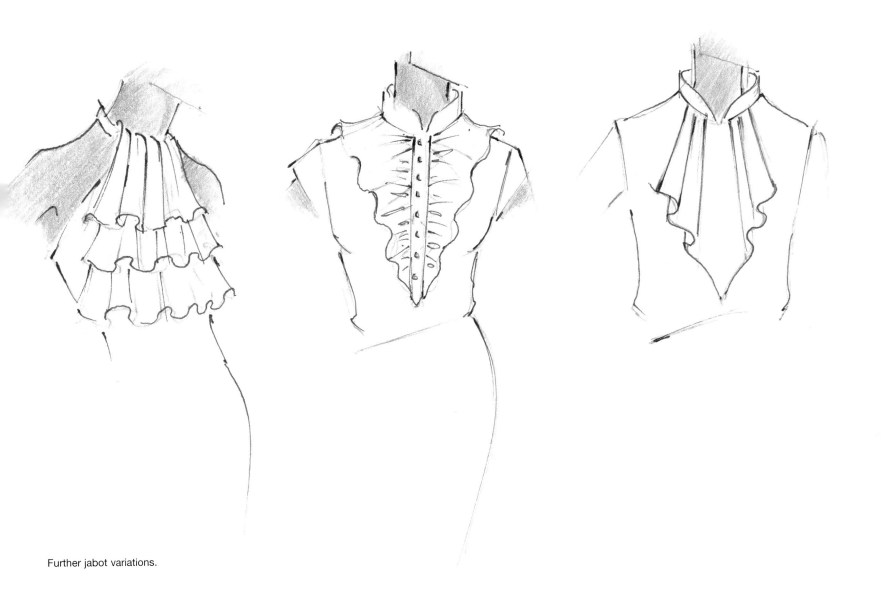

Further jabot variations.

A large selection of yarns is available in various colours and colour combinations, giving textured effects that can be incorporated as part of a design. A knitted yoke, collar or inset section can add interest. The contrast of the texture of knitting combined with fabrics such as corduroy, tweeds and wool or even delicate yarns combined with lightweight fabrics for eveningwear, look most attractive. Knitted accessories, such as hats, scarves and gloves, can give a design a complete fashion image.

Knit

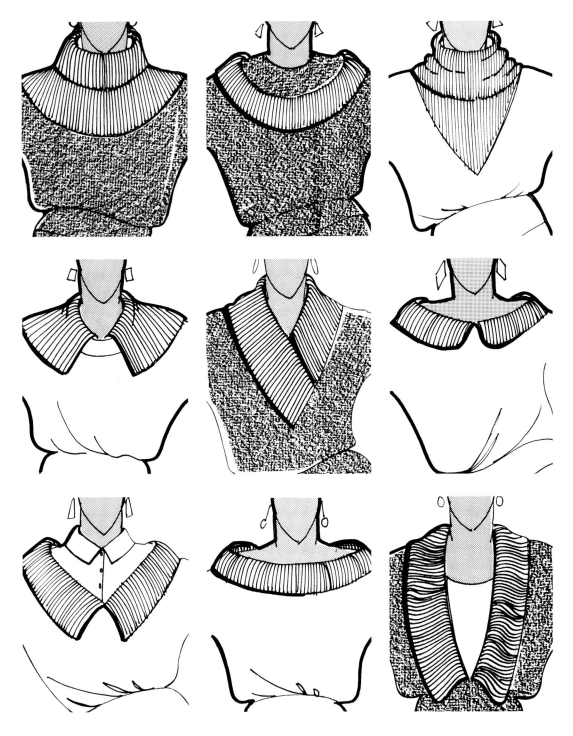

A selection of knitted, ribbed collars
combined with contrasting fabrics.

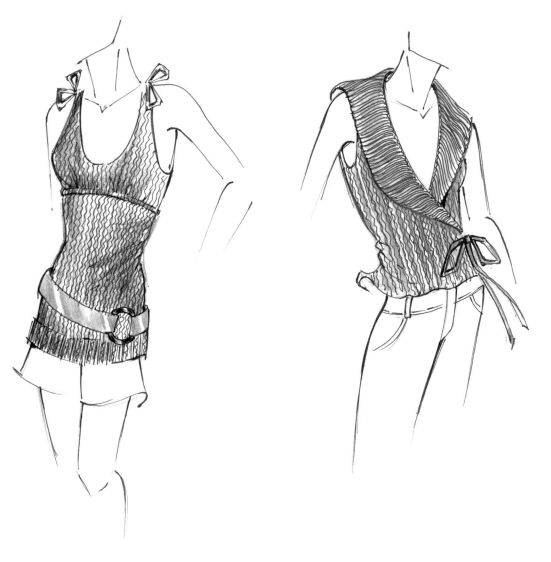
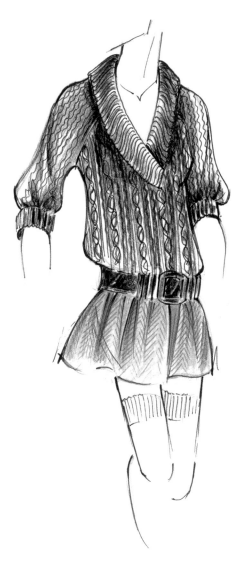

Fashion design drawings sketched freely with a fine drawing pen. The figure pose has only been suggested, leaving details of arms, hands and faces out of the drawing. The design details of collars, belts and sleeves have been sketched with a fine pen, suggesting the ribbing and variation of the knitted pattern. Colour was applied with Derwent pencils to suggest tone and texture.

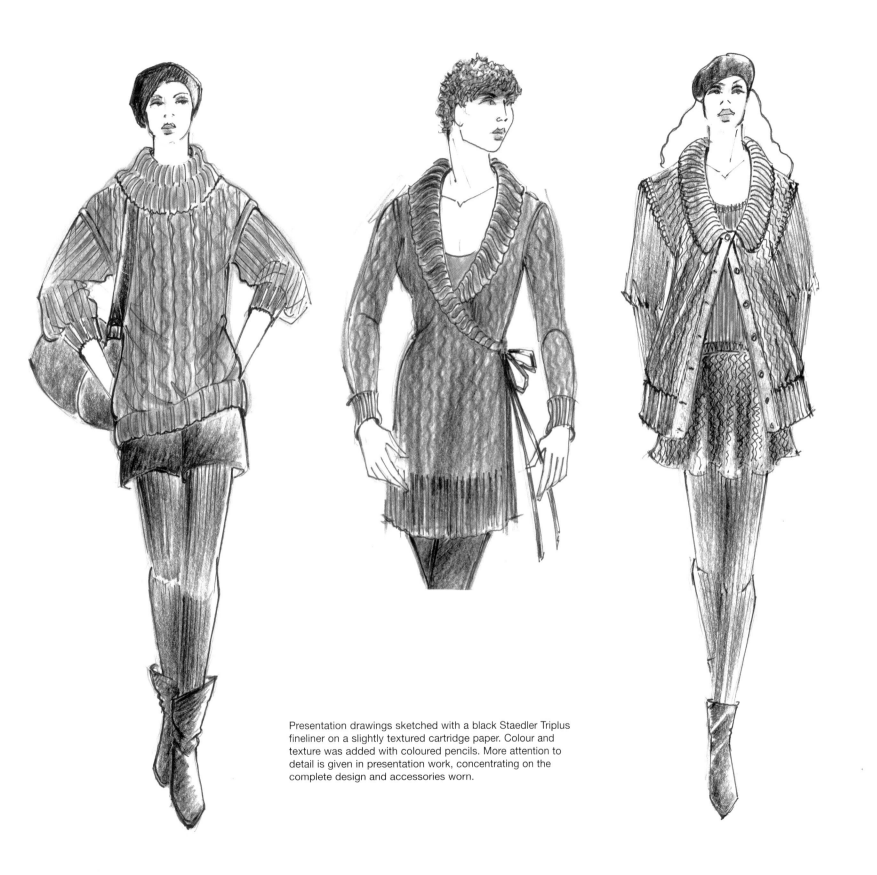

Presentation drawings sketched with a black Staedler Triplus fineliner on a slightly textured cartridge paper. Colour and texture was added with coloured pencils. More attention to detail is given in presentation work, concentrating on the complete design and accessories worn.

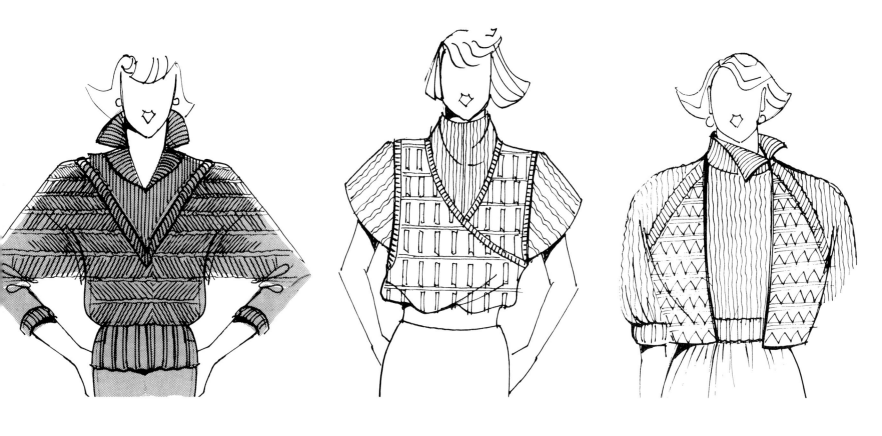

Sketchbook research, showing a selection of designs in knitted yarns. These designs have been collected in a sketchbook to observe the many pattern and texture design variations of knitted fabric. Note the use of contrasting fabrics combined with the knitting patterns and different collar and sleeve details. These drawings were produced with a drawing pen combined with a watercolour wash for tonal effects.

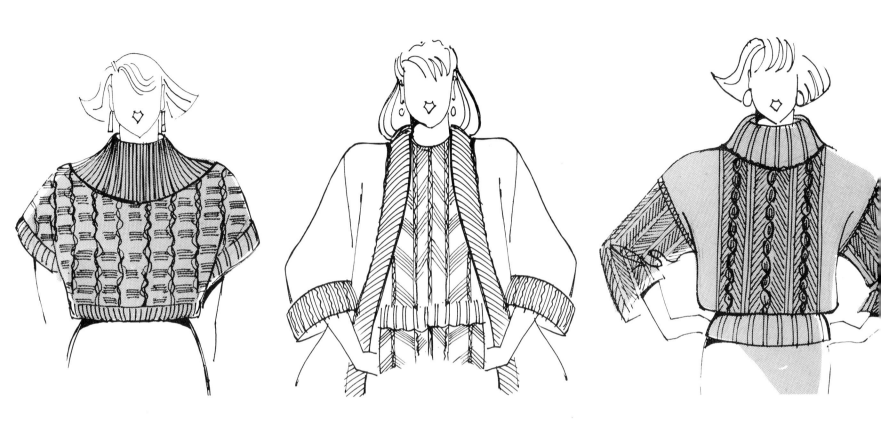

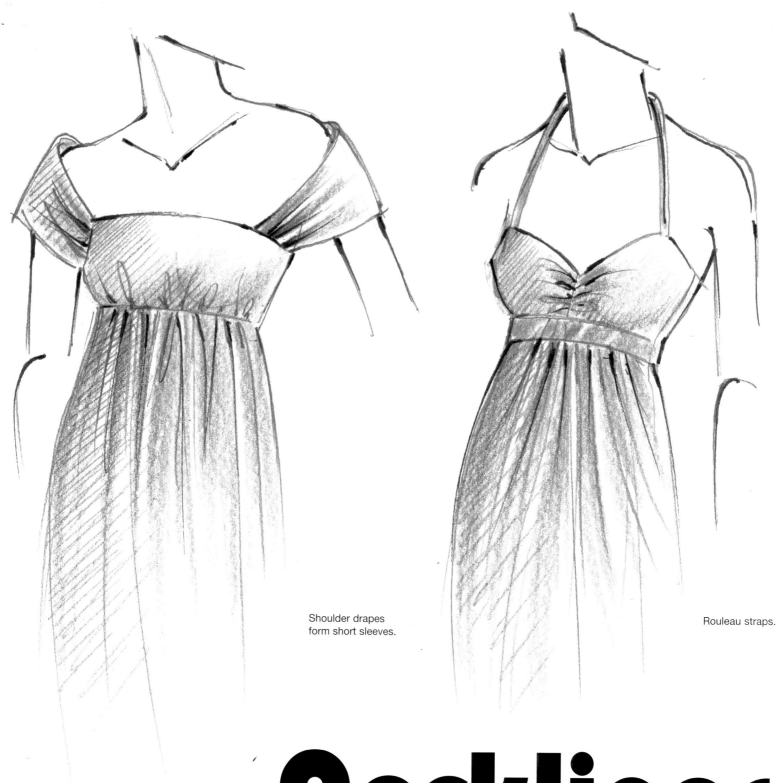

Shoulder drapes
form short sleeves.

Rouleau straps.

Necklines

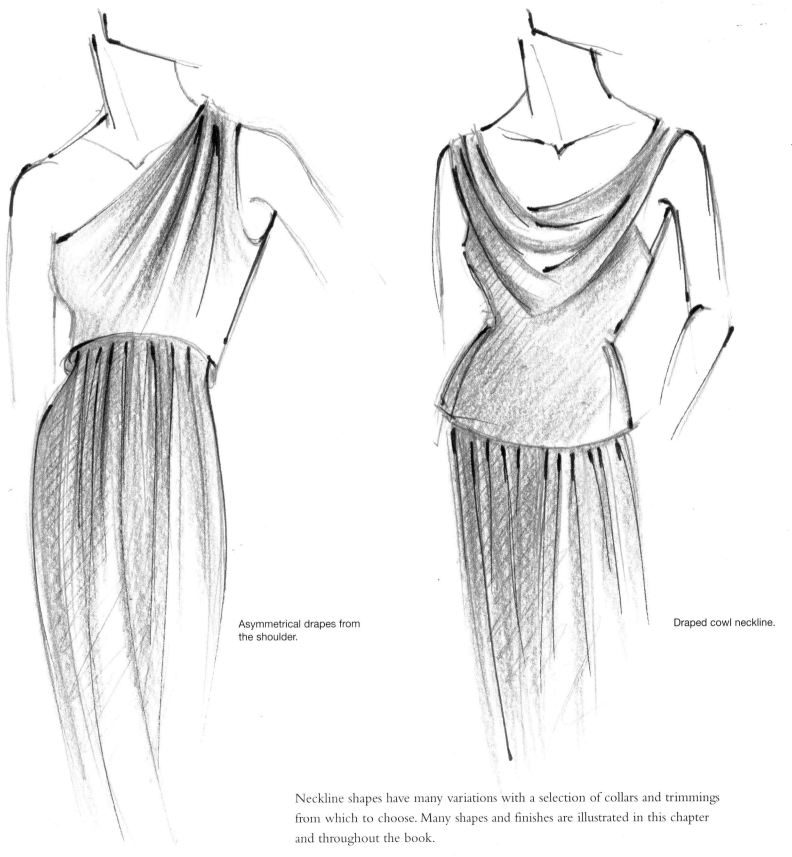

Asymmetrical drapes from
the shoulder.

Draped cowl neckline.

Neckline shapes have many variations with a selection of collars and trimmings
from which to choose. Many shapes and finishes are illustrated in this chapter
and throughout the book.

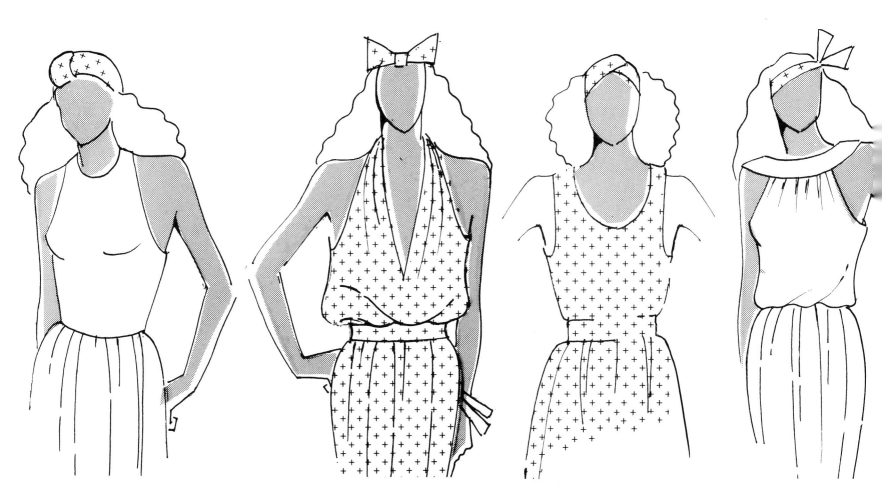

Sketchbook references showing sketches of different necklines. Study the shapes, trimmings and collars worn during different periods of fashion – this is a useful resource to refer to when designing

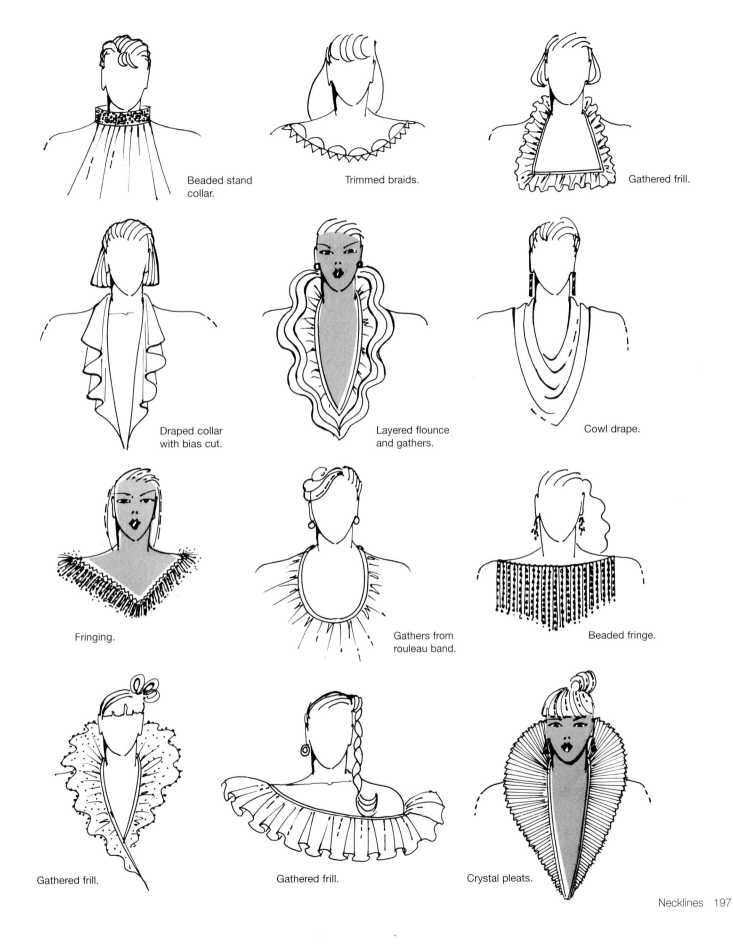

Beaded stand collar.

Trimmed braids.

Gathered frill.

Draped collar with bias cut.

Layered flounce and gathers.

Cowl drape.

Fringing.

Gathers from rouleau band.

Beaded fringe.

Gathered frill.

Gathered frill.

Crystal pleats.

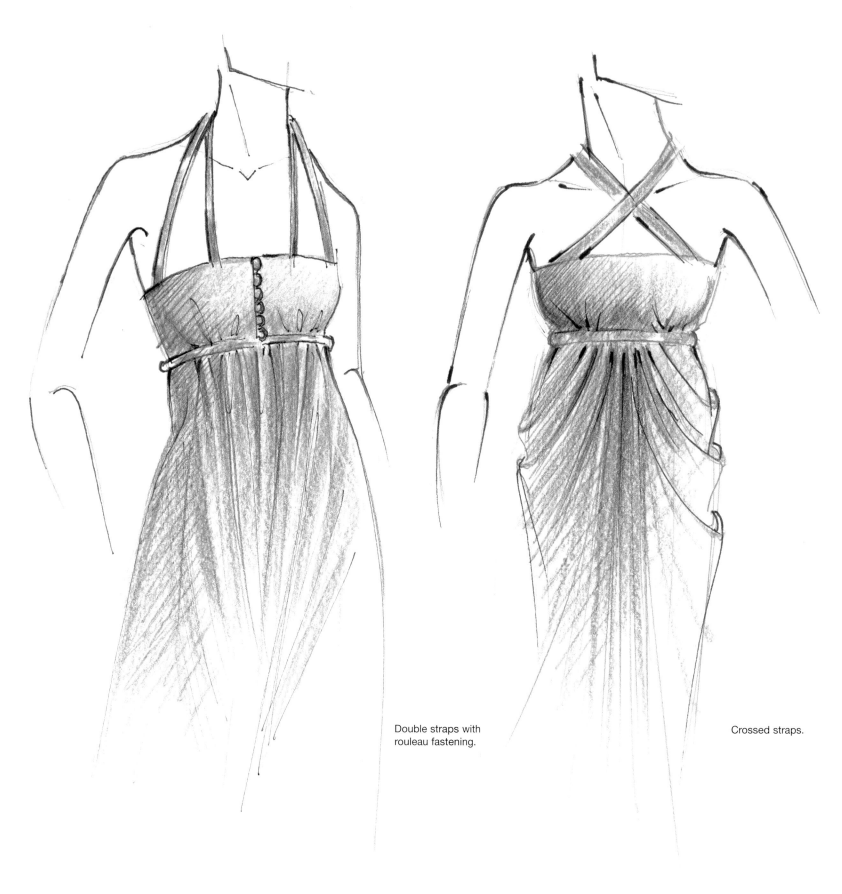

Double straps with
rouleau fastening.

Crossed straps.

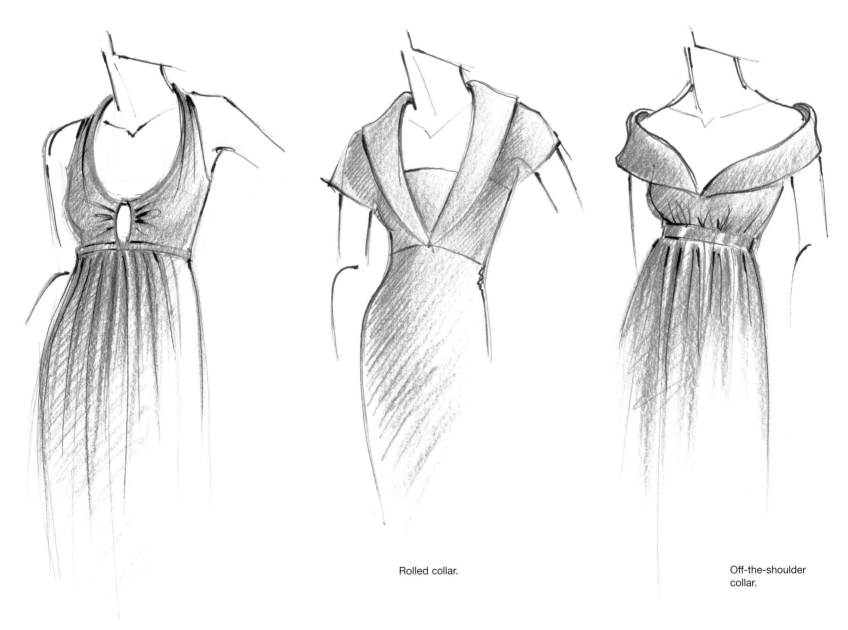

Draped, rounded neckline.

Rolled collar.

Off-the-shoulder collar.

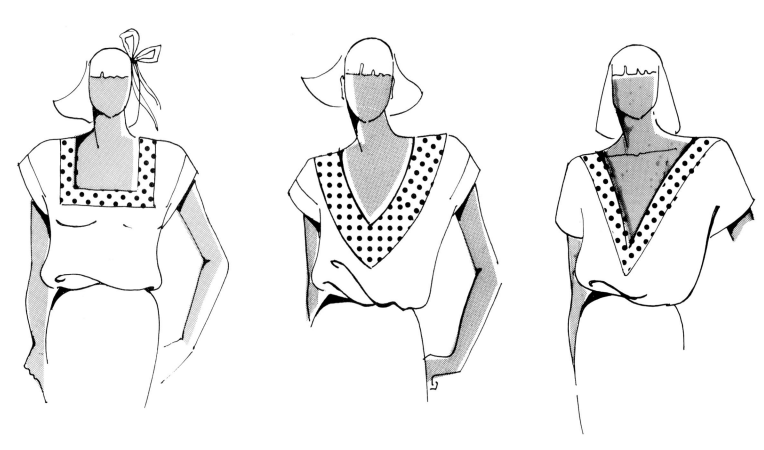

Necklines with yokes, emphasized
with contrasting fabrics.

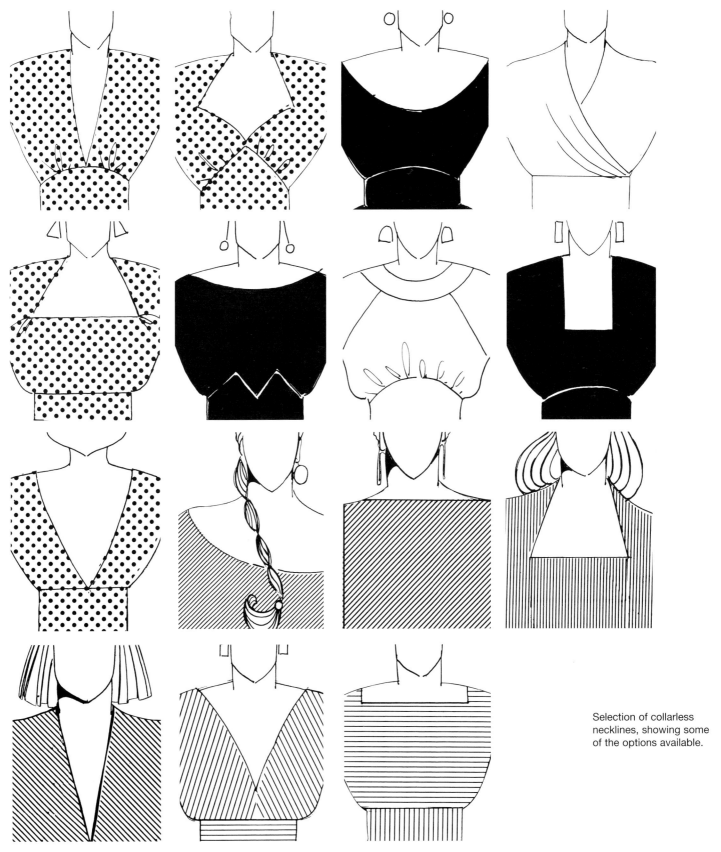

Selection of collarless
necklines, showing some
of the options available.

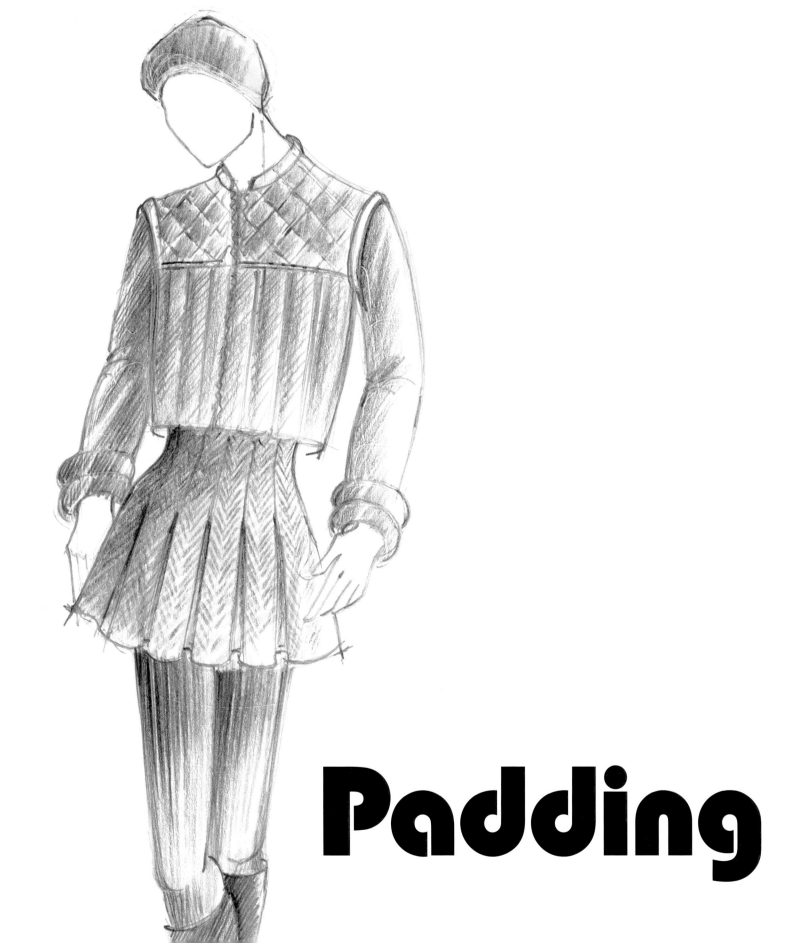

Padding

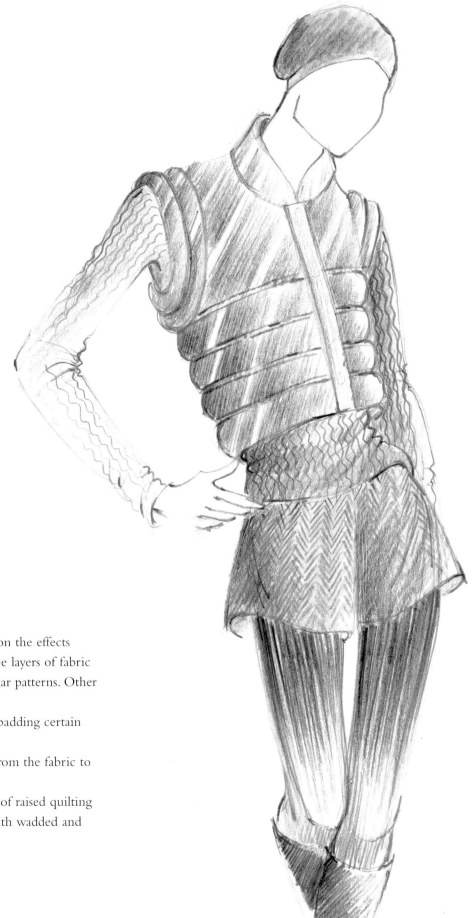

Presentation drawings sketched with a soft 2B pencil on smooth card. Colour suggested with a coloured Derwent pencil. Details added with a fine-pointed HB pencil.

The techniques of padding vary depending on the effects required. The basic method is of joining three layers of fabric together with stitching, using linear or circular patterns. Other options include the following:

Raised quilting: A decorative method for padding certain areas of a design.

Cord quilting: The cord is sharply raised from the fabric to define the pattern.

Trupunto quilting: This is a padded form of raised quilting that can be used on its own or combined with wadded and cord quilting.

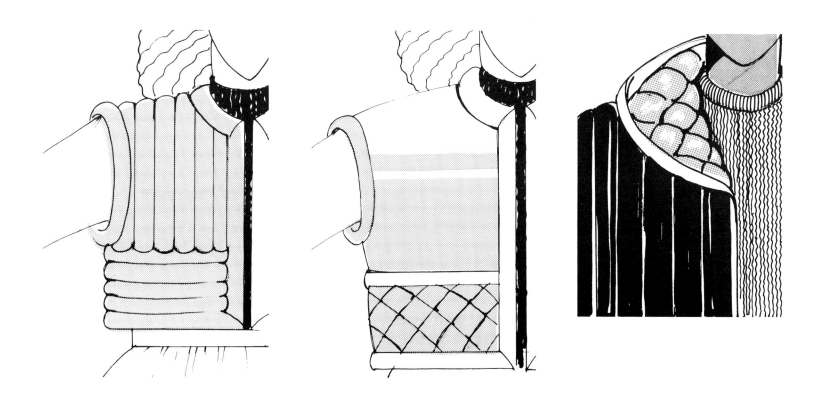

Examples of padding introduced on a garment using different shapes and
proportions of padding. Areas of a garment can be left without padding
and areas of contrasting colour and texture can be introduced.

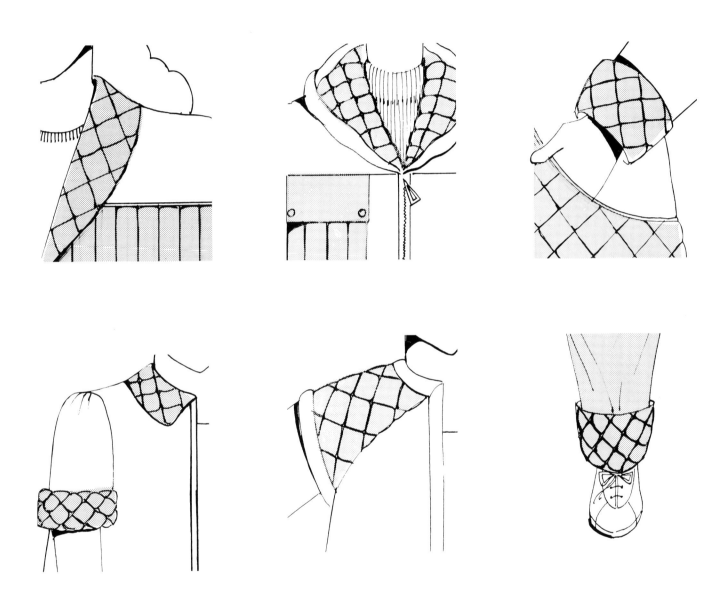

Illustrating the use of quilting in
different areas of the design.

Padded pocket details.

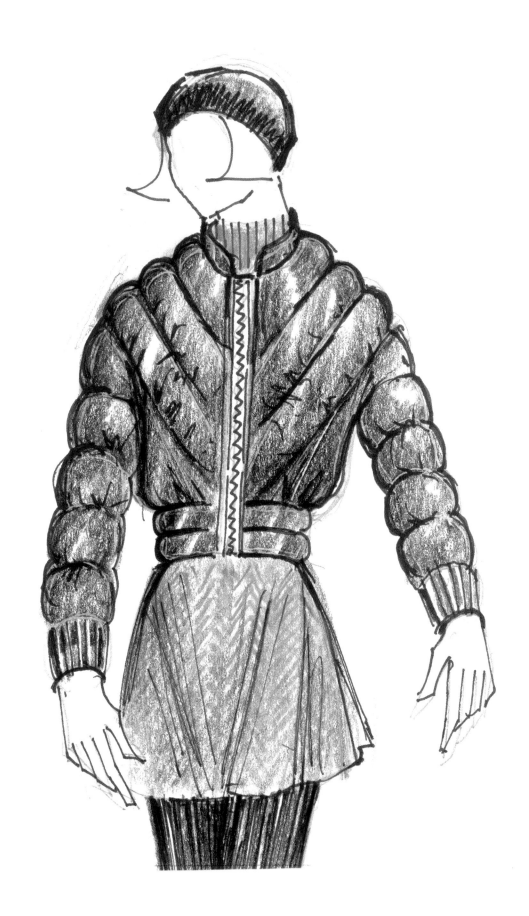

The rich, bold shapes of these design sketches are created by stitching through two or more layers of fabric. This technique of padding is often combined with areas of contrasting fabric and texture (as illustrated here). These fashion designs were produced on white textured cartridge paper in a sketchbook while developing ideas on padding with contrasting textures and coloured fabrics. Creating the effect of texture was achieved by using wax crayons on textured paper, with a black drawing pen for adding detail.

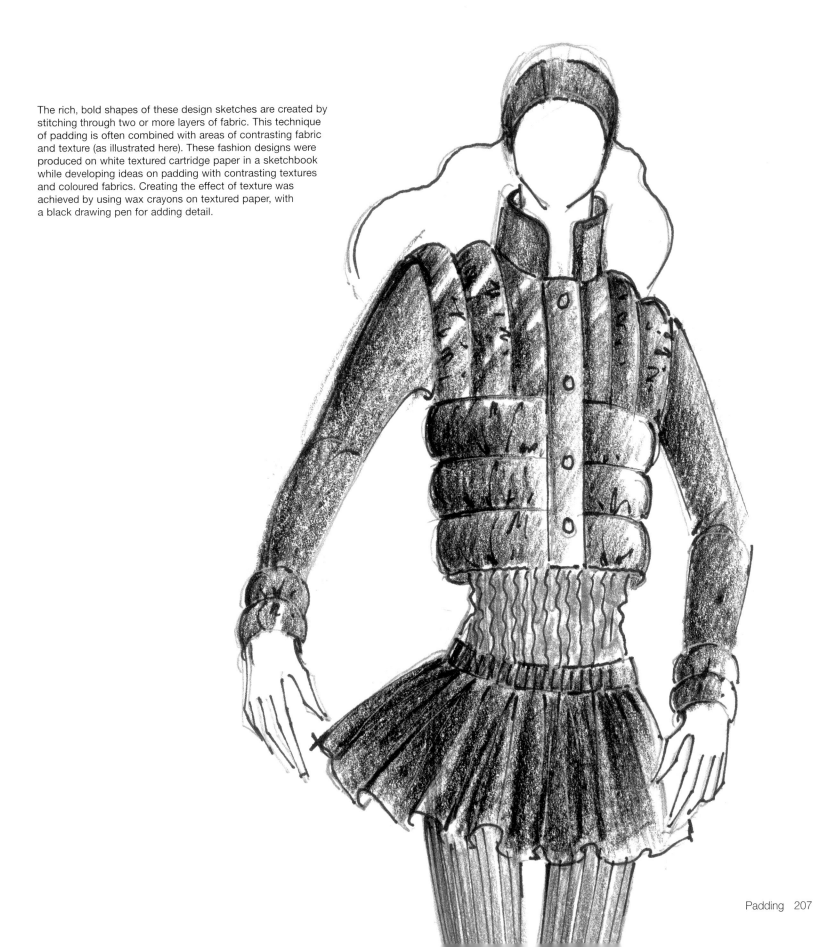

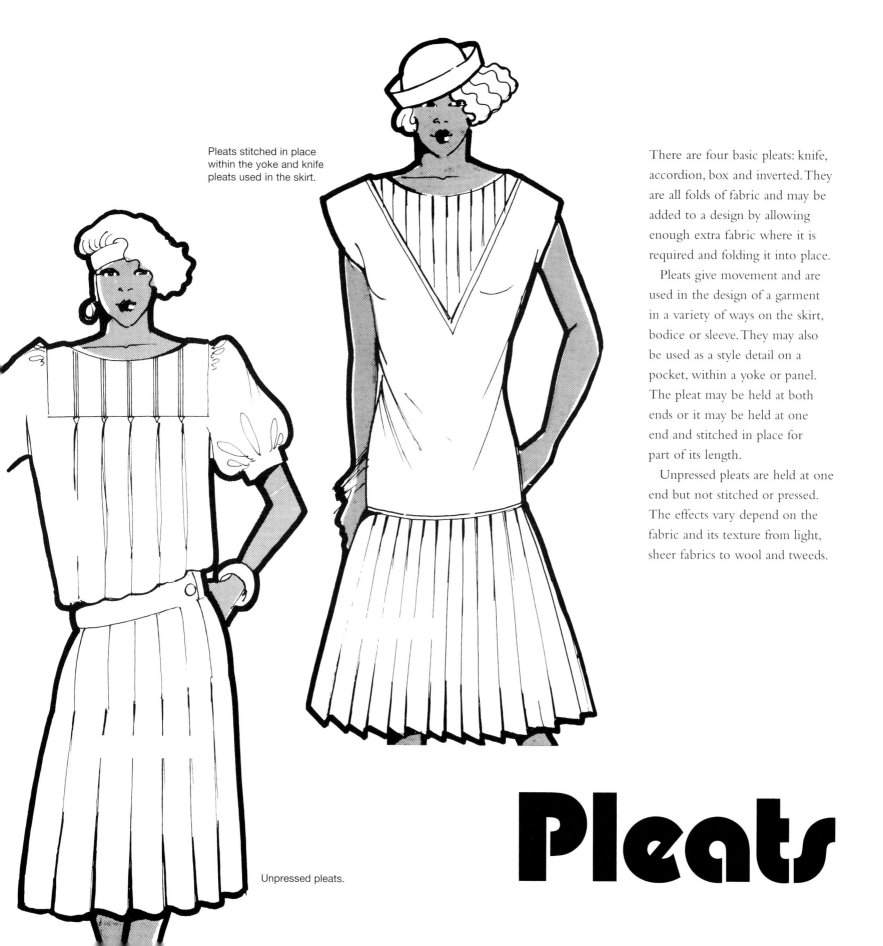

Pleats stitched in place within the yoke and knife pleats used in the skirt.

Unpressed pleats.

There are four basic pleats: knife, accordion, box and inverted. They are all folds of fabric and may be added to a design by allowing enough extra fabric where it is required and folding it into place.

Pleats give movement and are used in the design of a garment in a variety of ways on the skirt, bodice or sleeve. They may also be used as a style detail on a pocket, within a yoke or panel. The pleat may be held at both ends or it may be held at one end and stitched in place for part of its length.

Unpressed pleats are held at one end but not stitched or pressed. The effects vary depend on the fabric and its texture from light, sheer fabrics to wool and tweeds.

Pleats

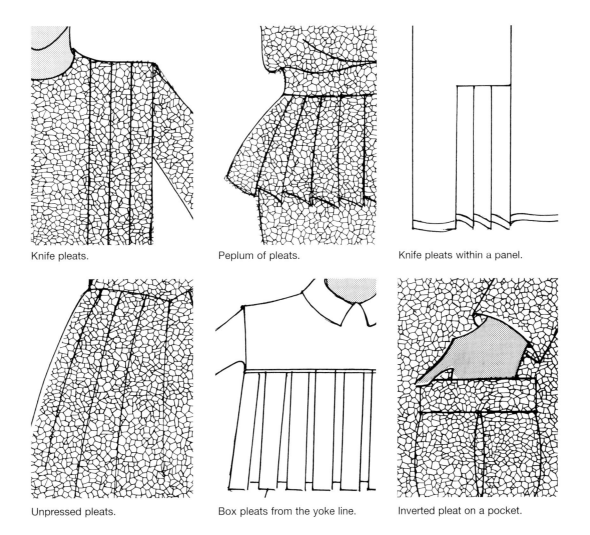

Knife pleats.

Peplum of pleats.

Knife pleats within a panel.

Unpressed pleats.

Box pleats from the yoke line.

Inverted pleat on a pocket.

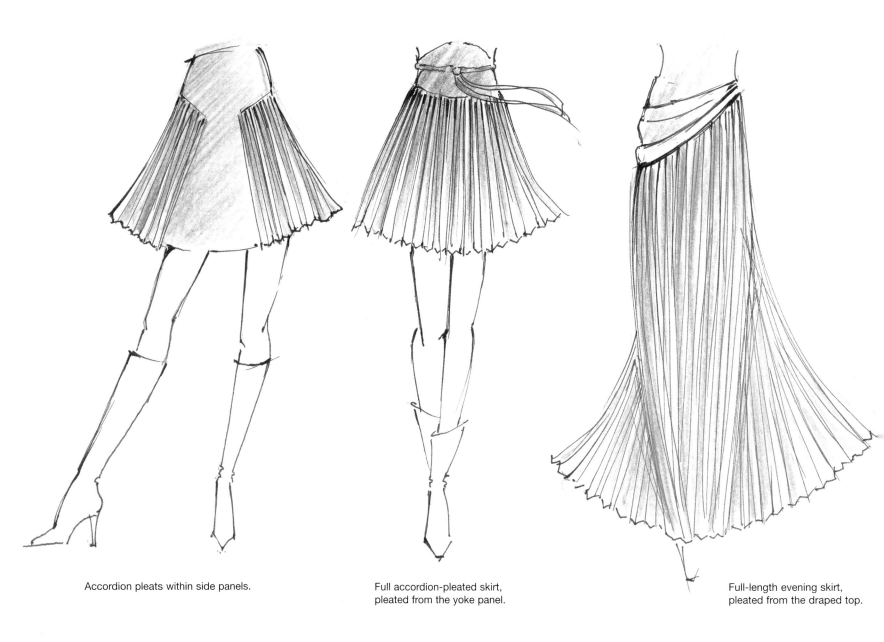

Accordion pleats within side panels.

Full accordion-pleated skirt, pleated from the yoke panel.

Full-length evening skirt, pleated from the draped top.

Accordion pleats are often used on skirts, sleeves, collars and bodices. The fabric may be taken to a pleater to be treated. The depth of the pleat may vary according to the effect required and weight of the fabric used.

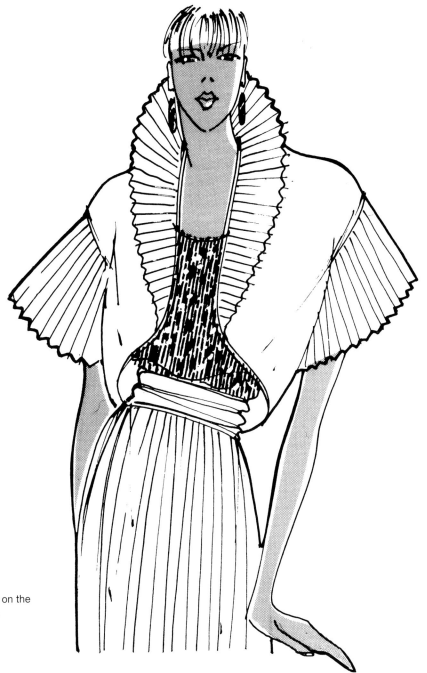

Accordion pleats used on the collar, sleeve and skirt.

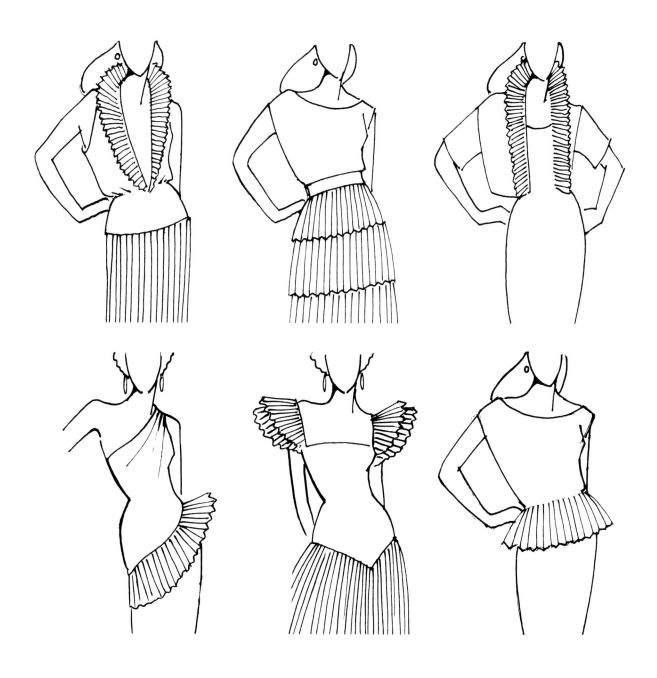

Ideas for accordian pleats developed using a simple figure pose. The head has been suggested to relate the design to the proportions of the figure. This is essential when drawing necklines and collars.

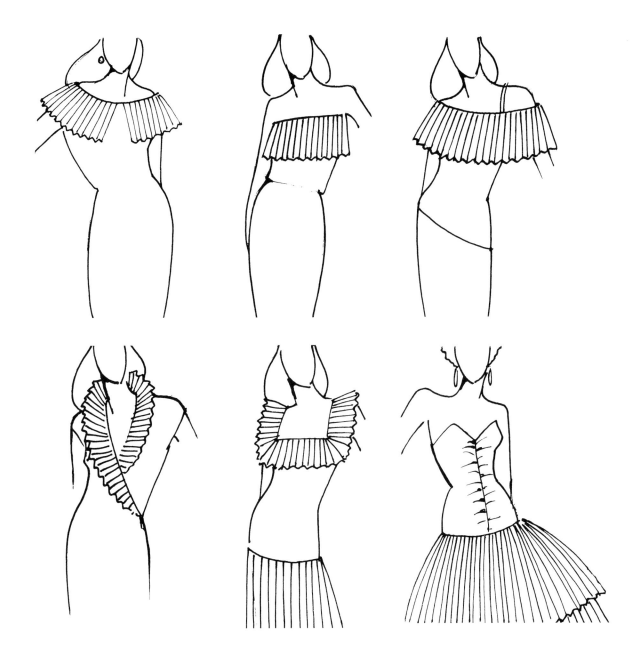

Further ideas for accordion pleats.

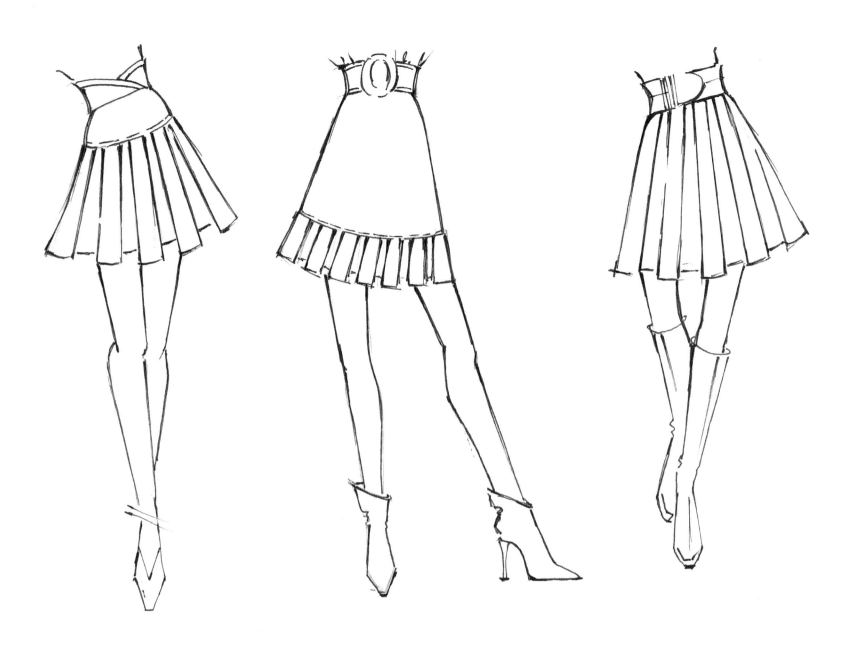

Box pleats are used on skirts and bodices, and featured as a detail on pockets and so on. The pleat is comprised of two knife pleats facing in opposite directions.

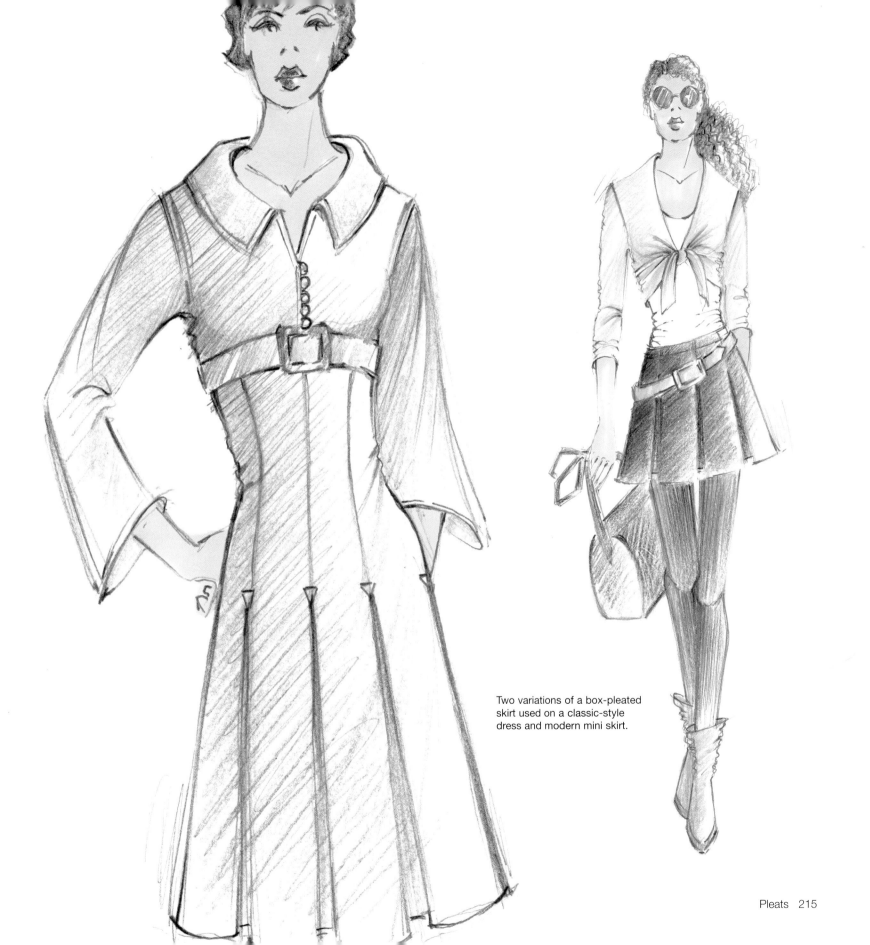

Two variations of a box-pleated skirt used on a classic-style dress and modern mini skirt.

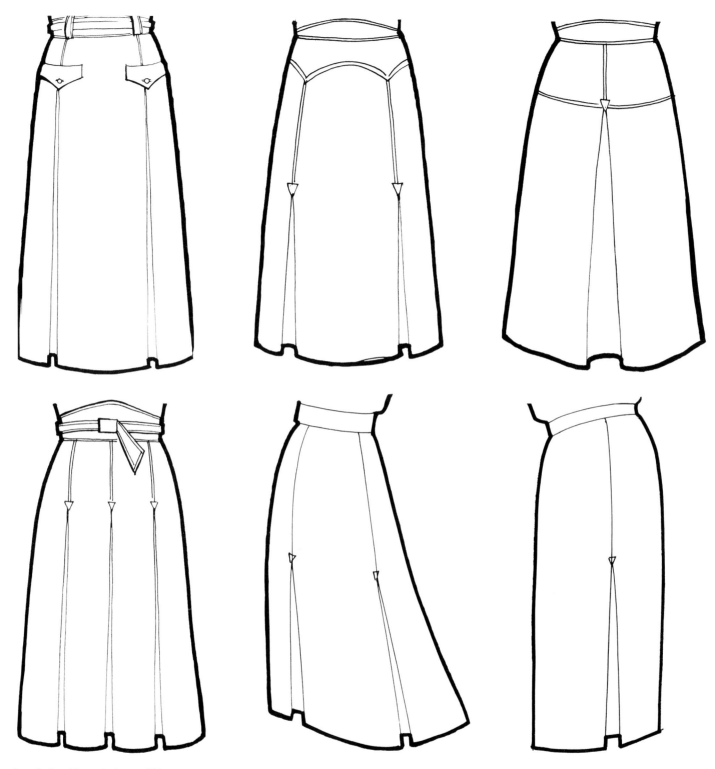

Inverted and box pleats on skirts.

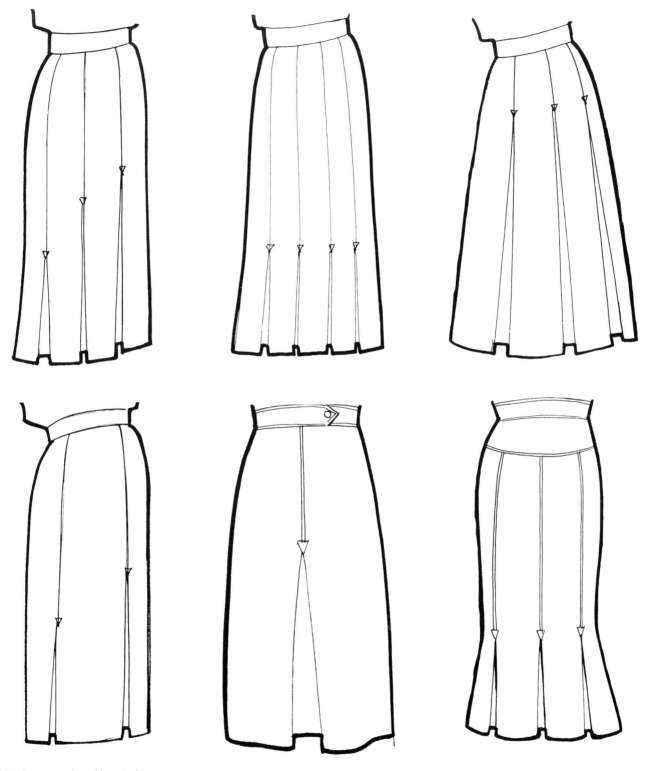

Further examples of inverted
and box pleats on skirts.

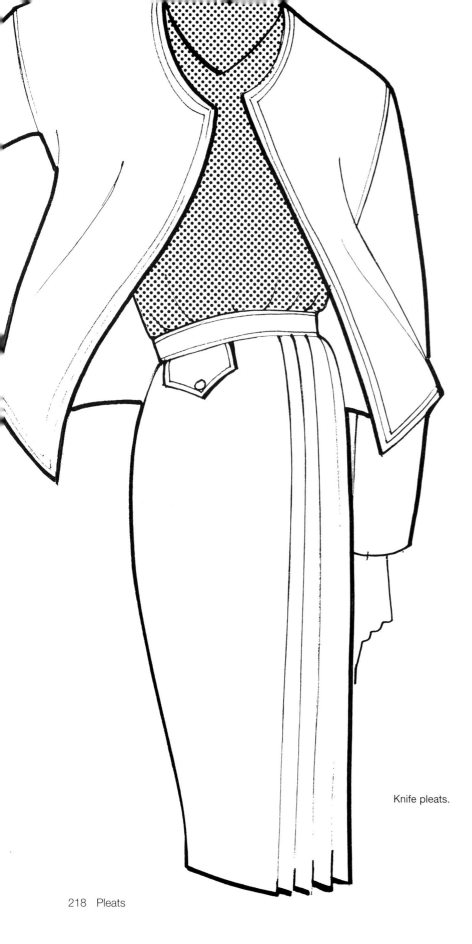

Knife pleats.

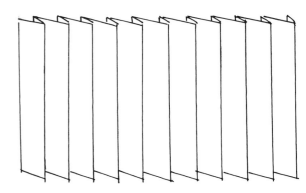

The knife pleat is a simple fold in the fabric pressed to one side. The pleats may be arranged in different ways; continuously on a skirt, in groups or as single pleats.

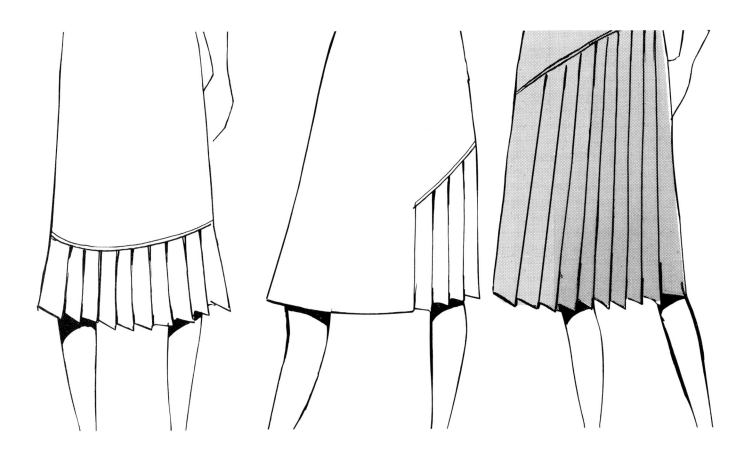

Knife pleats used in skirt panels.

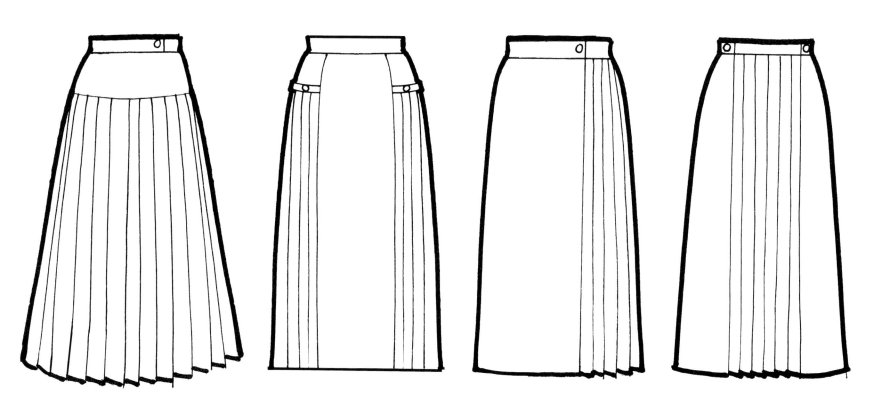

Knife pleats on skirts in a selection
of different arrangements.

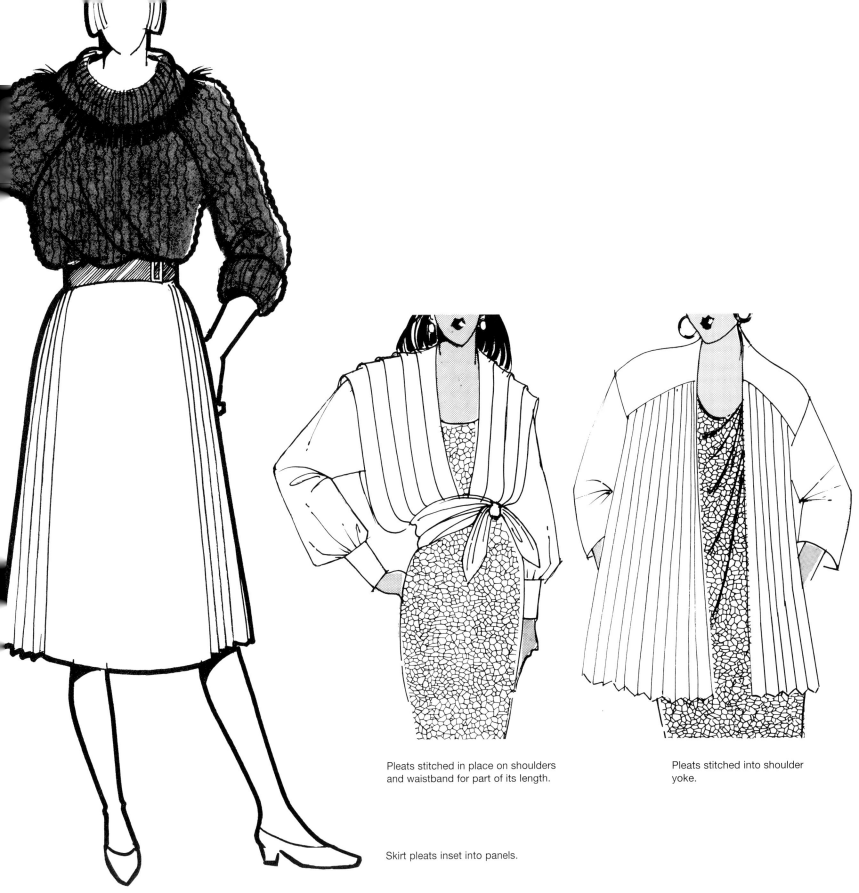

Pleats stitched in place on shoulders
and waistband for part of its length.

Pleats stitched into shoulder
yoke.

Skirt pleats inset into panels.

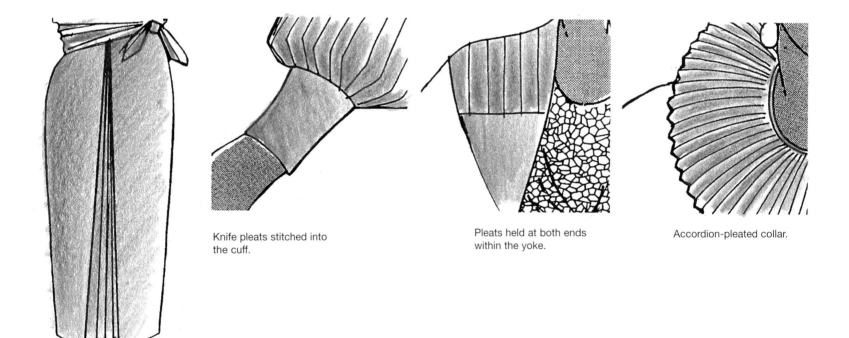

Knife pleats stitched into
the cuff.

Pleats held at both ends
within the yoke.

Accordion-pleated collar.

Pleats inset into a central panel.

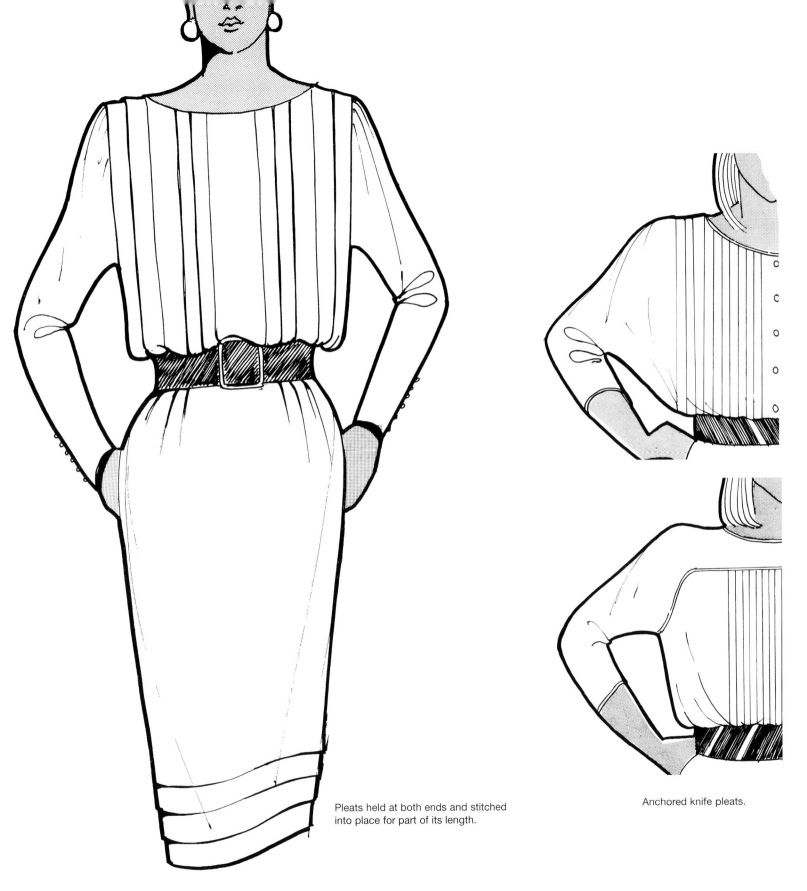

Pleats held at both ends and stitched
into place for part of its length.

Anchored knife pleats.

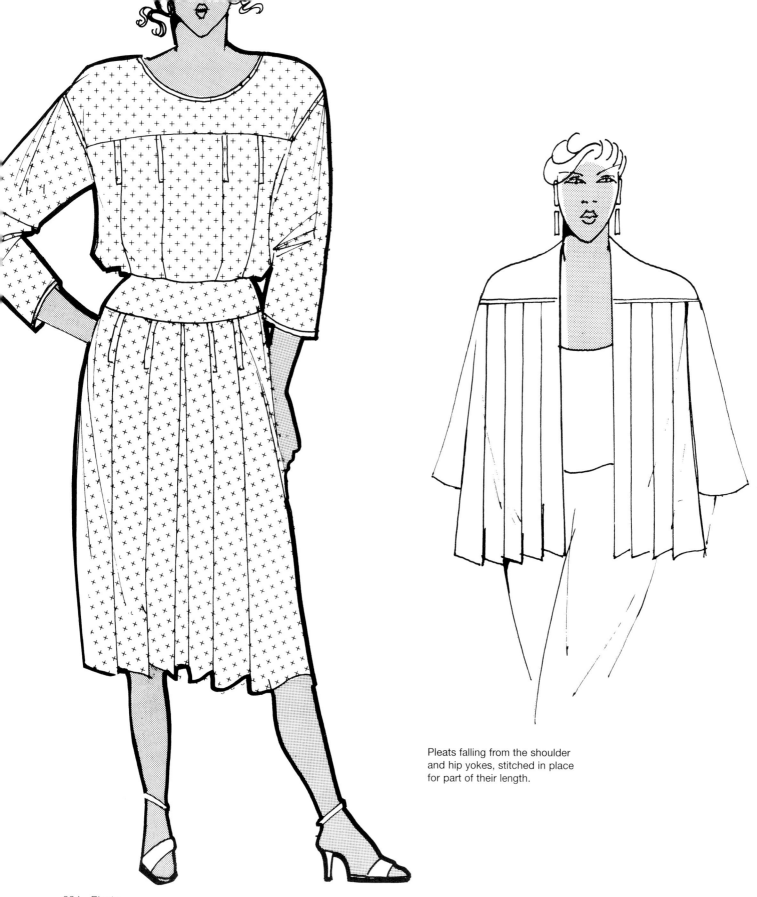

Pleats falling from the shoulder
and hip yokes, stitched in place
for part of their length.

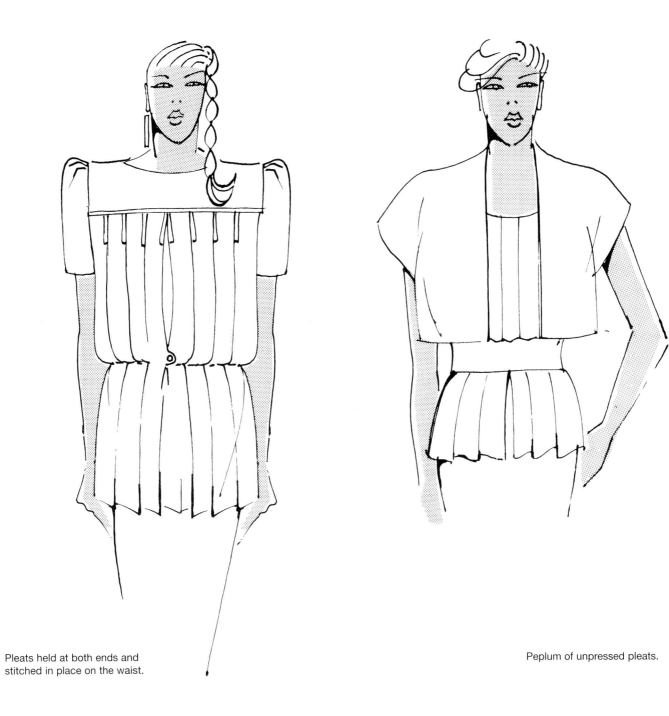

Pleats held at both ends and
stitched in place on the waist.

Peplum of unpressed pleats.

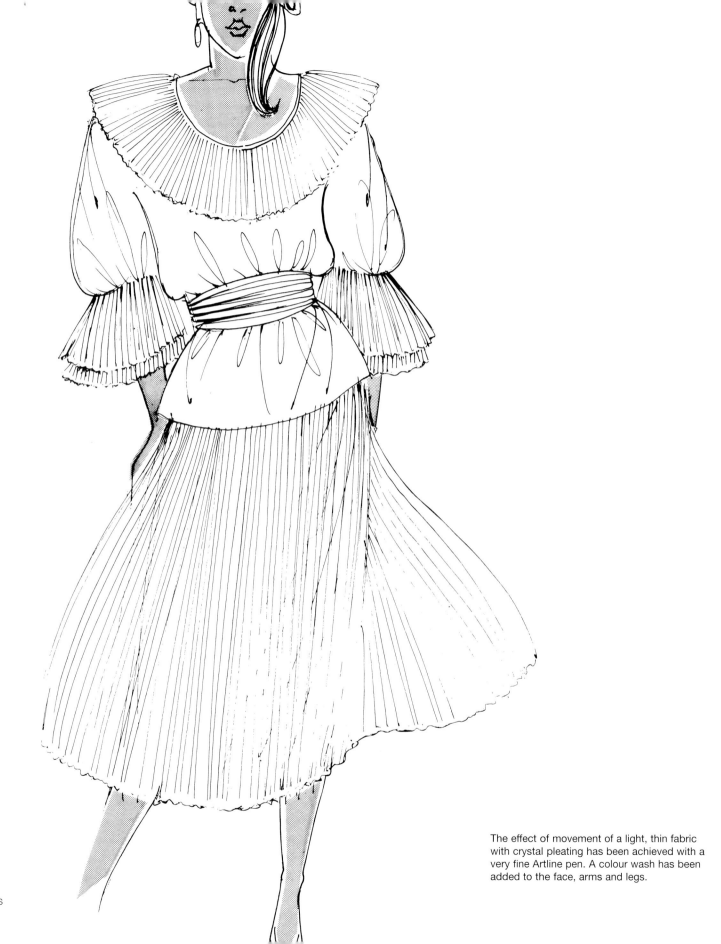

The effect of movement of a light, thin fabric
with crystal pleating has been achieved with a
very fine Artline pen. A colour wash has been
added to the face, arms and legs.

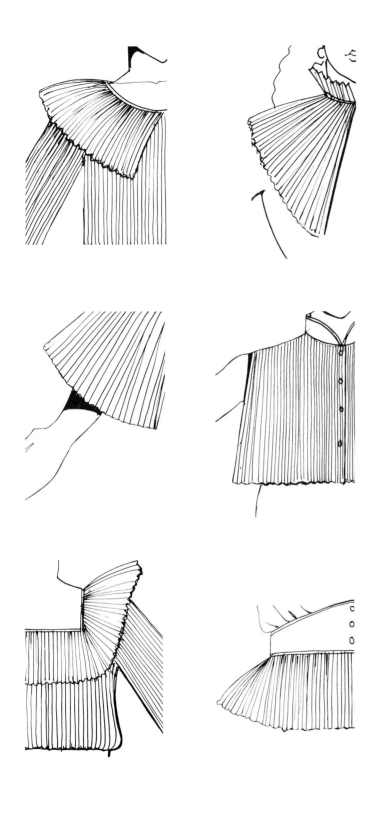

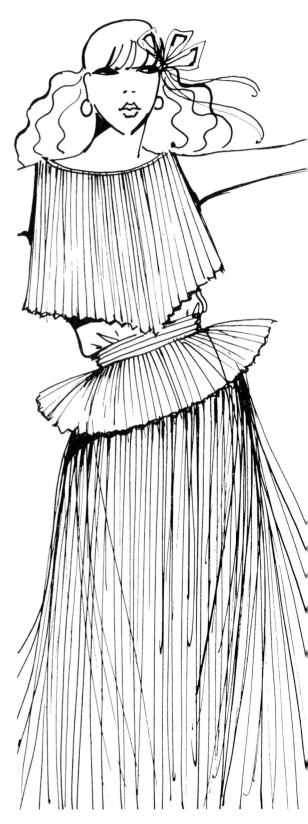

Crystal pleats are fine accordion pleats that are up to 3mm (⅛in) in width.

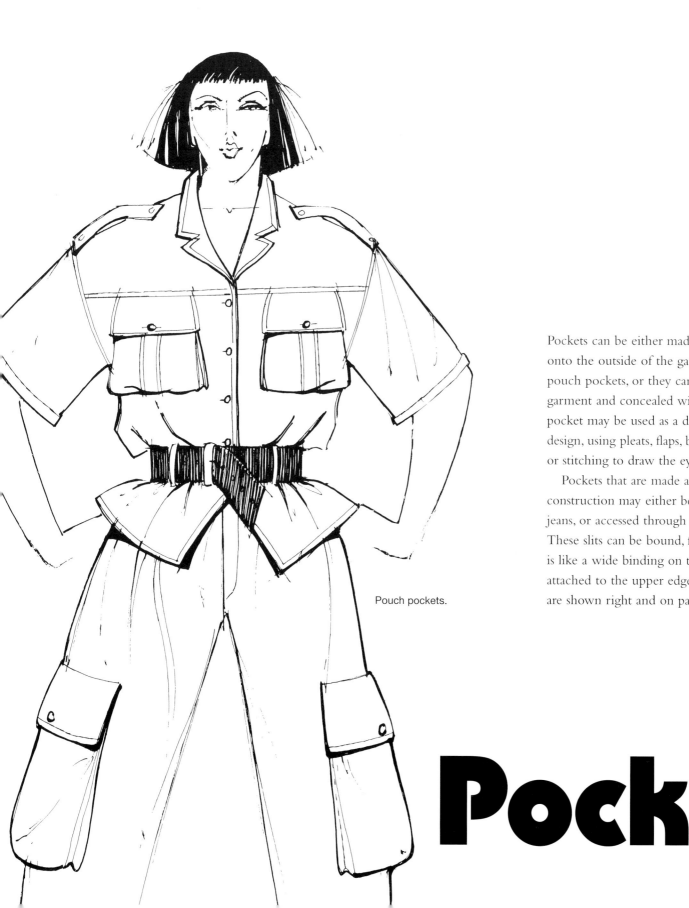

Pouch pockets.

Pockets can be either made up first and then stitched onto the outside of the garment, as with patch or pouch pockets, or they can be made as part of the garment and concealed within it. Either type of pocket may be used as a decorative feature of the design, using pleats, flaps, buttons, gathers, trimmings or stitching to draw the eye.

Pockets that are made as part of the garment construction may either be inserted into seams, as on jeans, or accessed through slits cut into the fabric. These slits can be bound, finished with a welt, which is like a wide binding on the lower slit, or have a flap attached to the upper edge of the slit. These options are shown right and on page 241.

Pockets

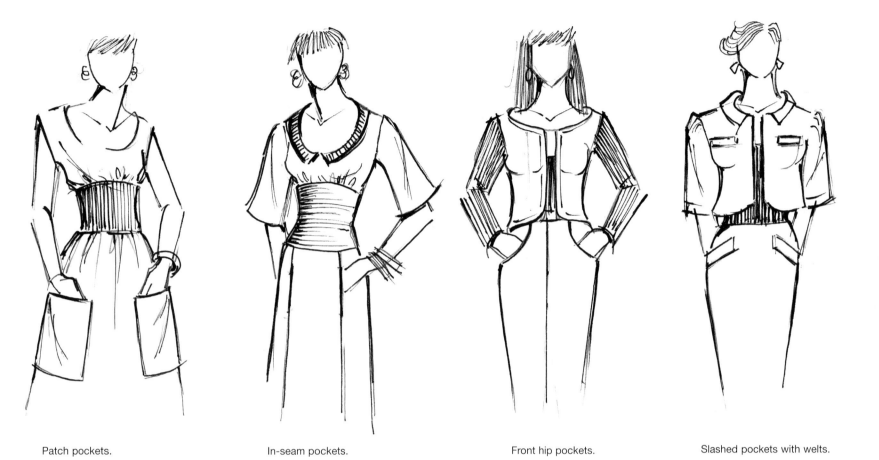

Patch pockets.　　　In-seam pockets.　　　Front hip pockets.　　　Slashed pockets with welts.

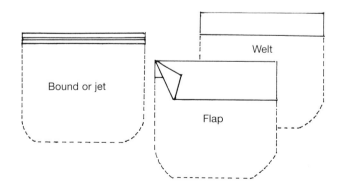

Bound or jet

Welt

Flap

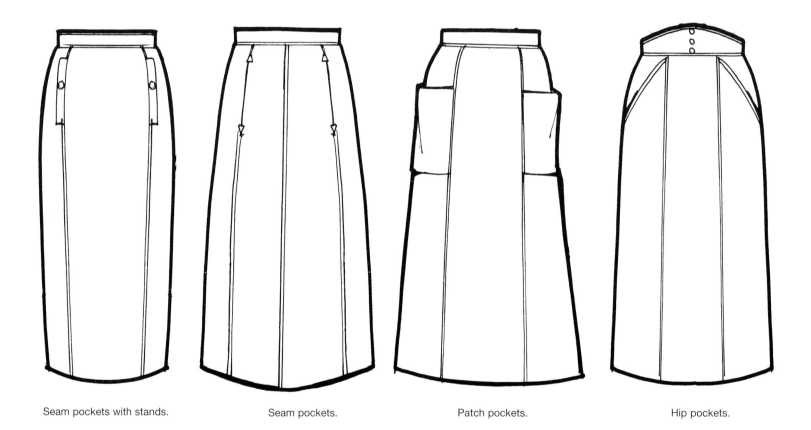

Seam pockets with stands.　　　　Seam pockets.　　　　Patch pockets.　　　　Hip pockets.

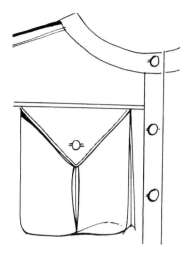

Pouch pocket with button-down
flap and pleat.

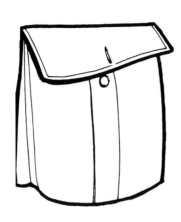

Pouch pocket with pleat
and flap.

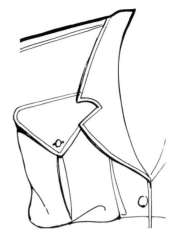

Pouch pocket with
inverted pleat.

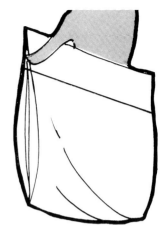

Pouch pocket.

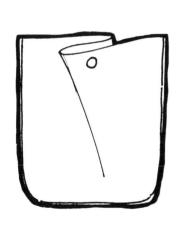

Patch pocket with fold and
button detail.

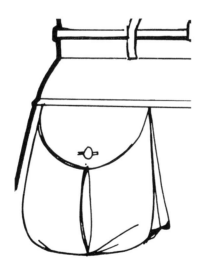

Pouch pocket with button-down
flap and inverted pleat.

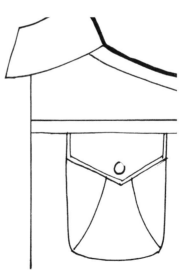

Button-down flap with seam
for added interest.

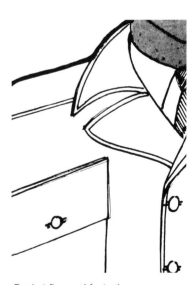

Pocket flap and fastening.

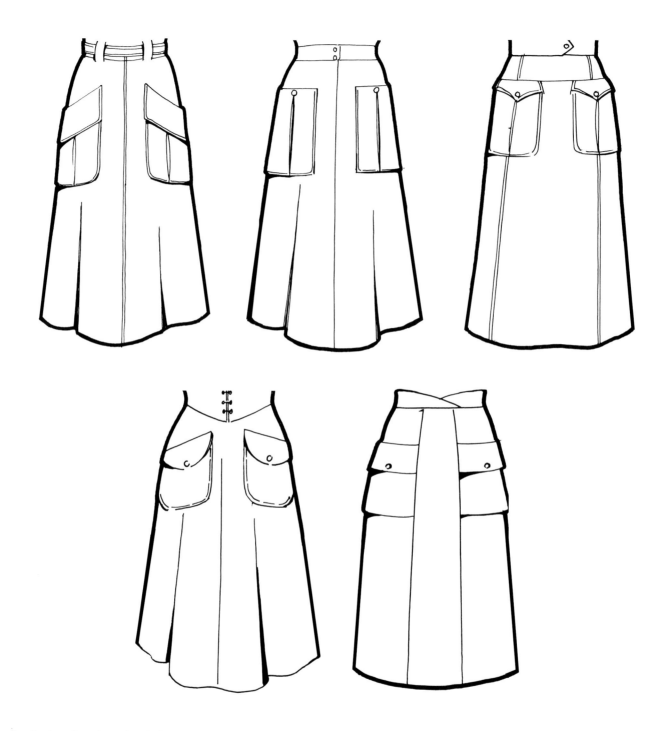

A selection of patch-pocket designs varied
with pocket flaps, pleats and placement
within panels of the skirt.

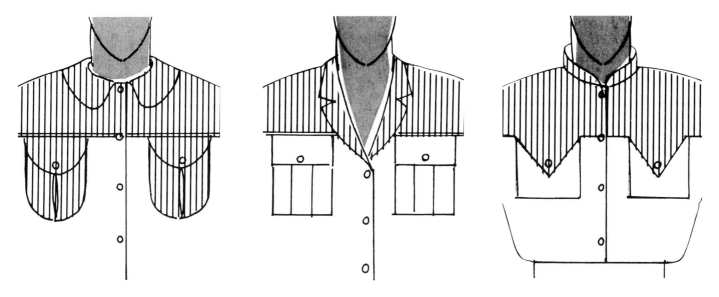

Buttoned-down flap patch pockets in
contrast fabrics combined with the yoke.

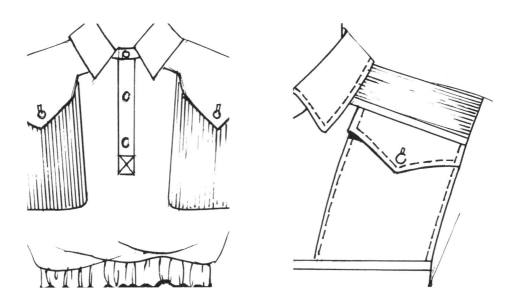

Further yoke and pocket combinations.

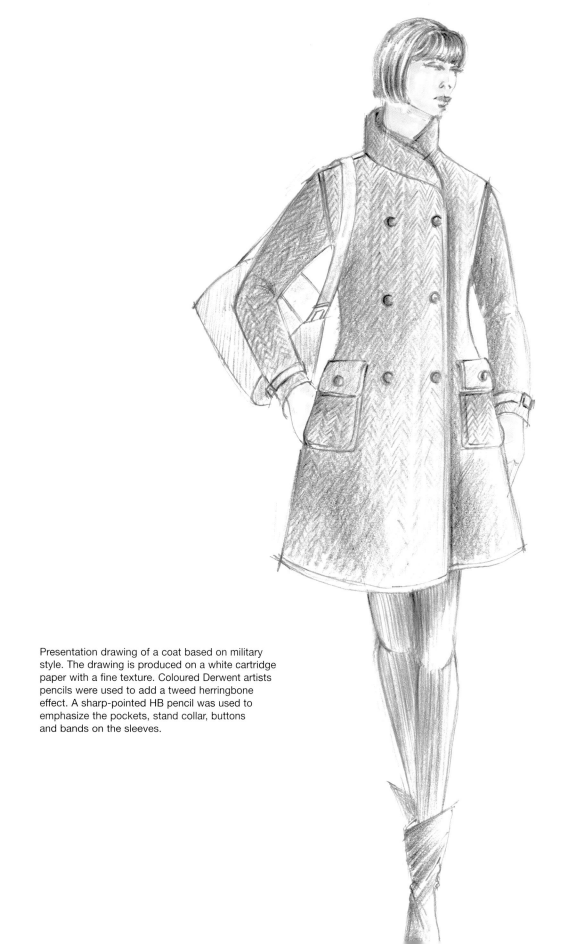

Presentation drawing of a coat based on military style. The drawing is produced on a white cartridge paper with a fine texture. Coloured Derwent artists pencils were used to add a tweed herringbone effect. A sharp-pointed HB pencil was used to emphasize the pockets, stand collar, buttons and bands on the sleeves.

Patch pocket with a zip opening.

Double patch pockets with button-down flaps.

Pocket with button-down flap and inverted pleat.

Pocket with decorative seams, top stitching and button-down flaps.

Welt opening.

Patch pocket with two button fastenings.

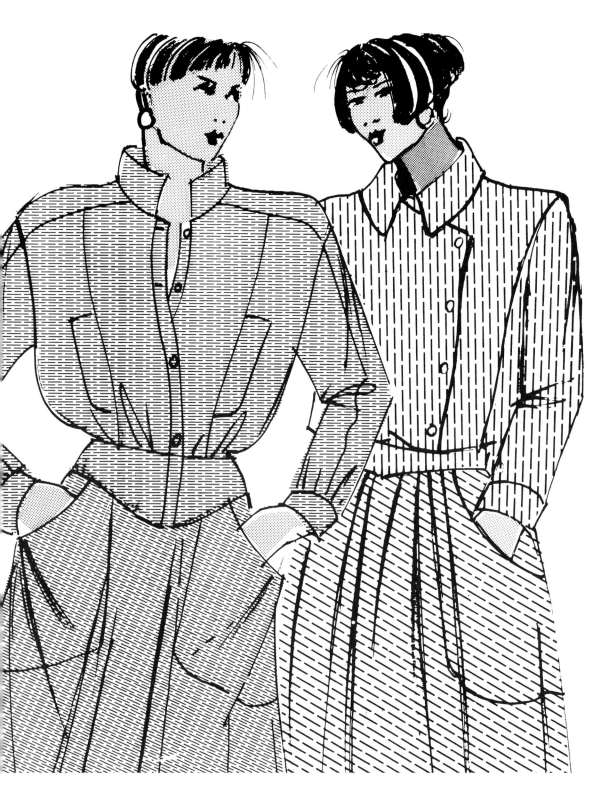

Patch pockets placed on
the hips.

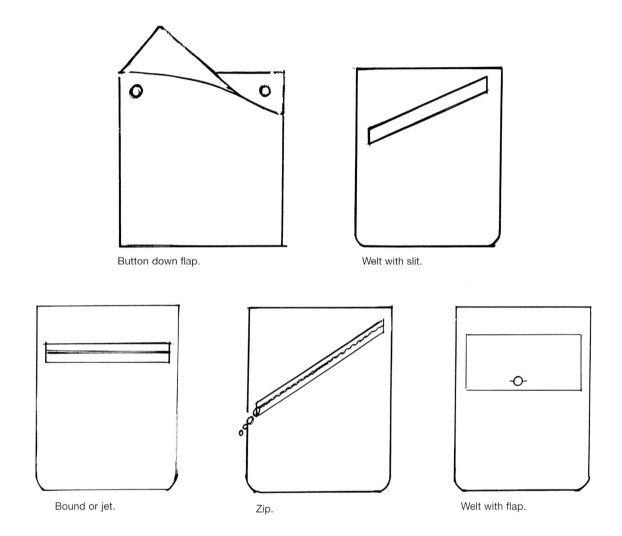

Button down flap.

Welt with slit.

Bound or jet.

Zip.

Welt with flap.

Patch pockets with a selection
of different openings.

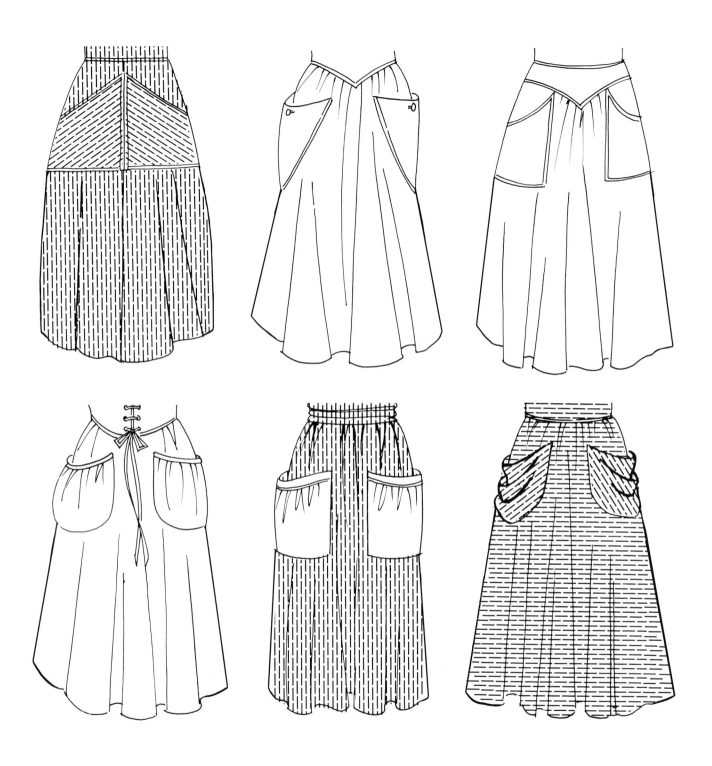

A selection of patch pockets on skirts with gathers and drapes.

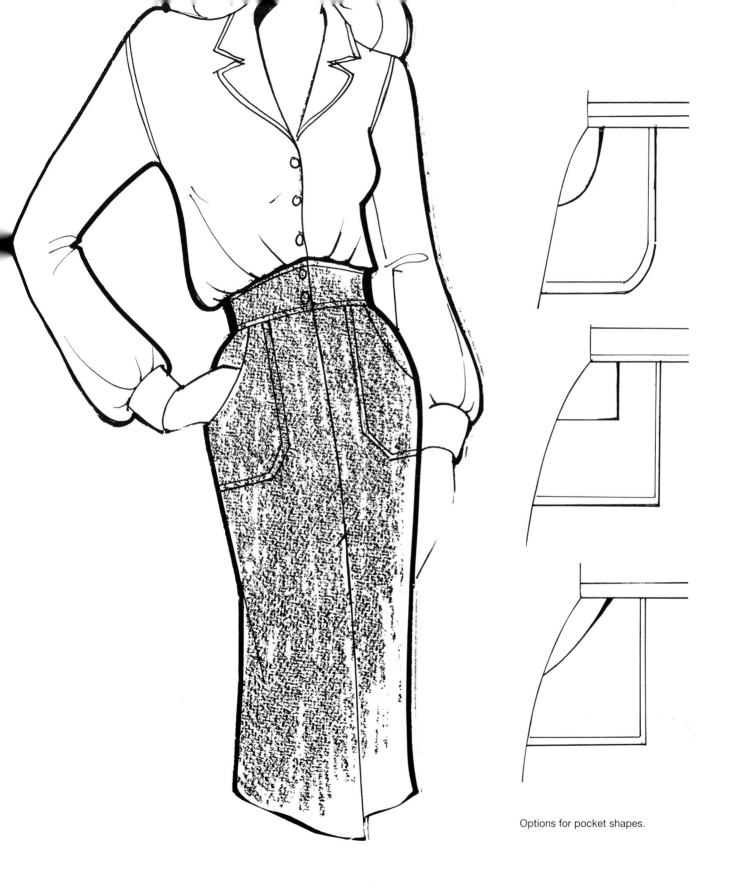

Options for pocket shapes.

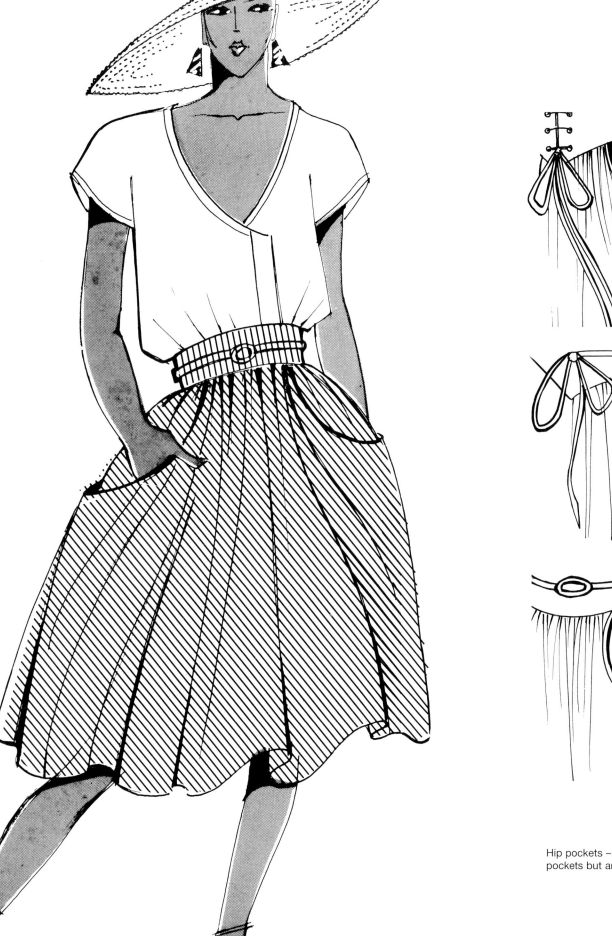
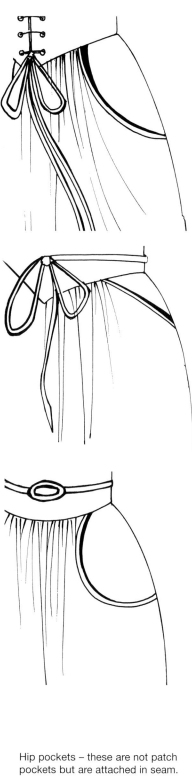

Hip pockets – these are not patch
pockets but are attached in seam.

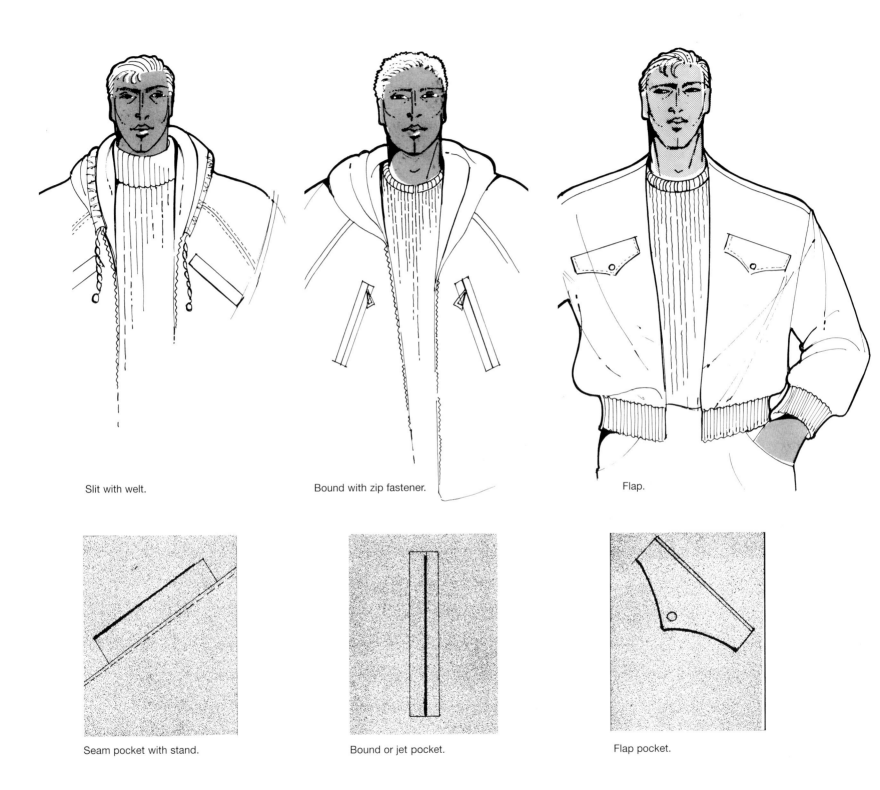

Slit with welt.

Bound with zip fastener.

Flap.

Seam pocket with stand.

Bound or jet pocket.

Flap pocket.

Examples of slit pockets.

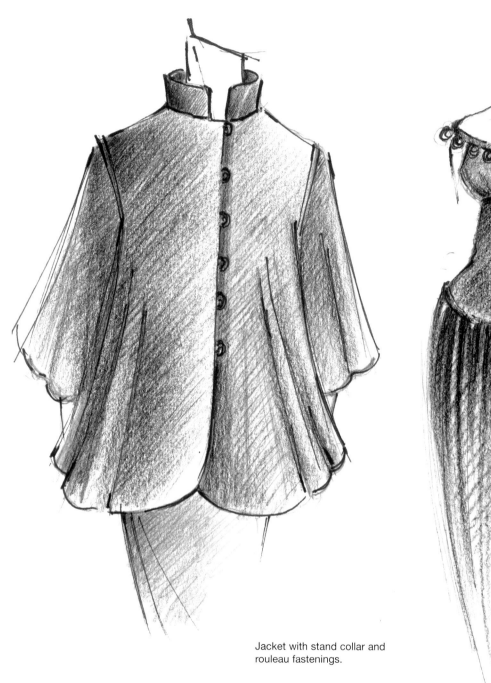

Jacket with stand collar and
rouleau fastenings.

Fashion sketches developed
with a soft black pencil, using
different pressures.

This is a roll or fold of fabric cut on the bias. It
can be used with buttoning, looped to form a
decorative edging, turned into frogging or used
for straps or ties.

Rouleau

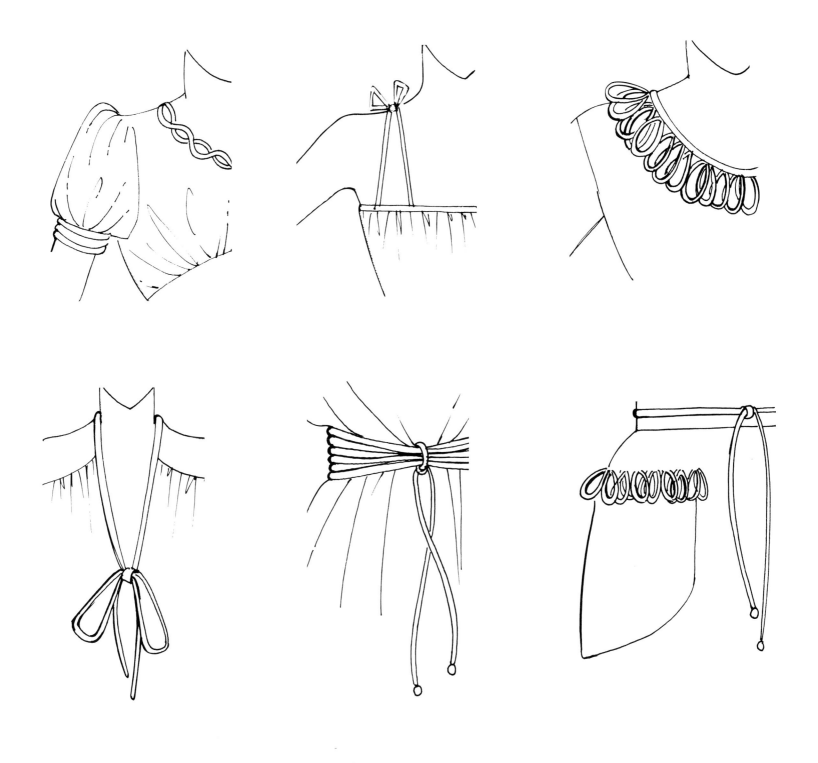

Examples of rouleau used on the neck, waist, sleeve and pocket.

Plain seam. This is a line of stitching, produced by hand or machine to hold two pieces of fabric together. Seams can be decorative as well as functional.

Corded or piped seam. The cord is covered by a bias-cut strip of fabric. The piping cord is made of cotton, which may be purchased in a variety of thickness; the fabric covering may match or be contrasting to the fabric of the garment. This effect of piped seams is often used on designs when emphasizing seam placement.

Seams produce style lines in a design, creating shape and often also providing a decorative effect. Many seam techniques are featured in a design, such as piped, contrasting slot seams, ruched and top stitching, for example. Other seams are selected for their strength, such as when designing garments for sportswear and casualwear or for their suitability for particular fabrics.

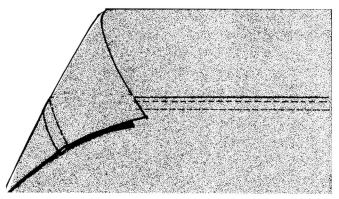

Flat-felled seam. A strong, neat seam, which may be made to appear on the inside or on the outside of a garment. It looks most effective when used on the outside as a feature on casual and sportswear.

Seams

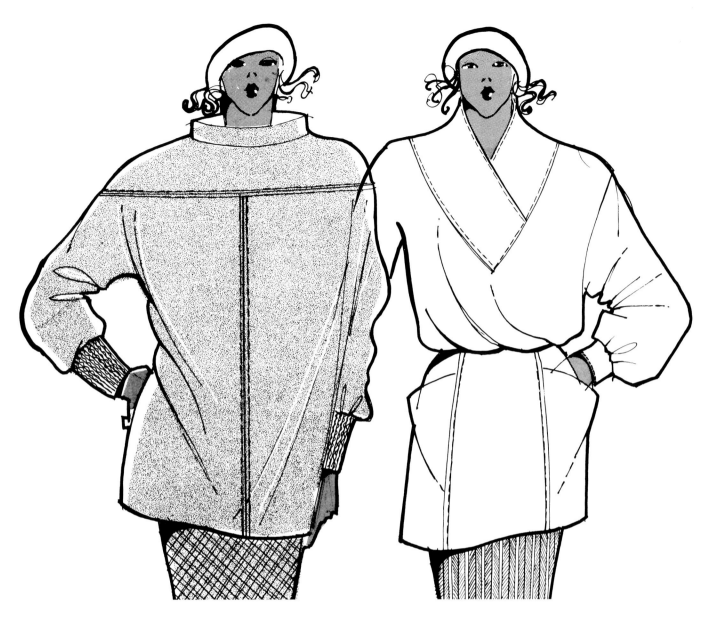

Double top-stitched seam.

Double top-stitched seam. The top stitching is an equal distance from each side of the seam line, used for decorative effects as well as providing a strong seam.

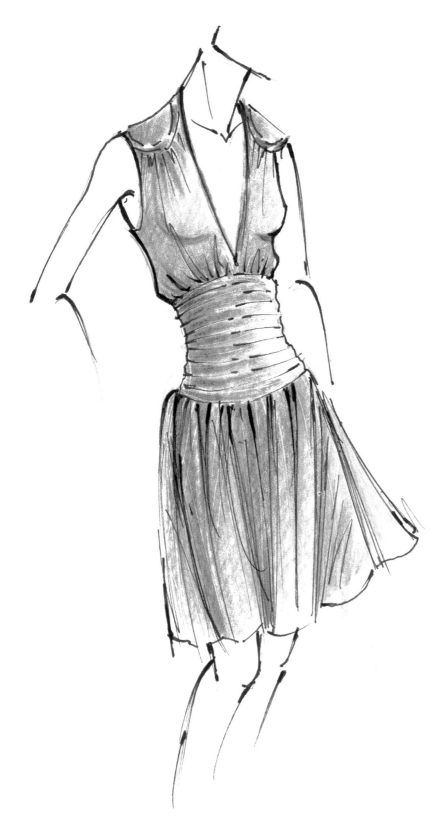

Seam details with gathers,
shoulder yokes and waistband.

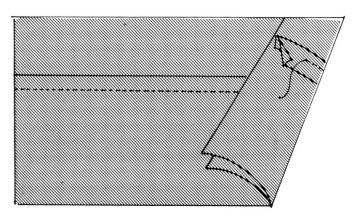

Welt seam. A variation of the felled seam, this seam is used on heavier fabrics for extra strength, often on children's casualwear, industrial garments and sportswear.

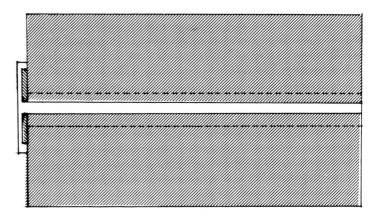

Slot seam. A decorative seam, adding interest with a contrasting fabric placed underneath the seam. The detail can be introduced on yokes, sleeves, cuffs, waistbands, pockets and panel seams. It can be made with a plain fabric, cut on the bias, or with a contrasting pattern.

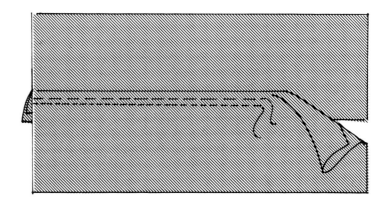

Tucked seam. This is attractive as a decorative feature, but not suitable for thick fabric.

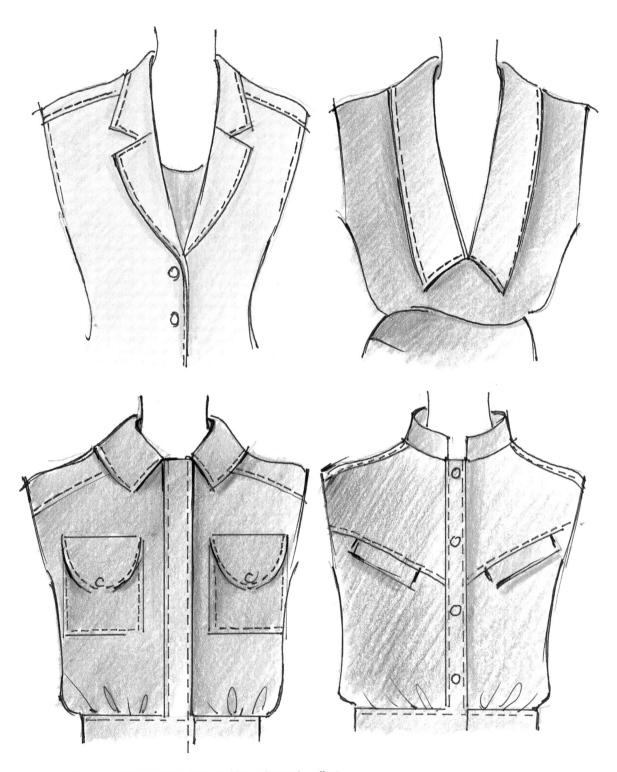

Single topstitched seam. This provides a decorative effect, emphasizing the shape of a collar, cuff, yoke, or pocket, for example. A contrast thread may also be used.

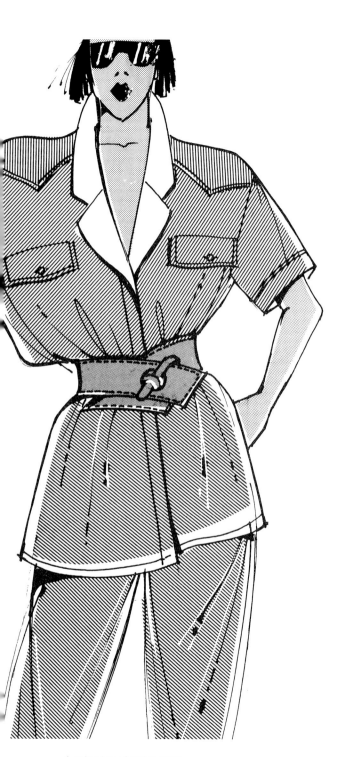

A selection of welt seams.

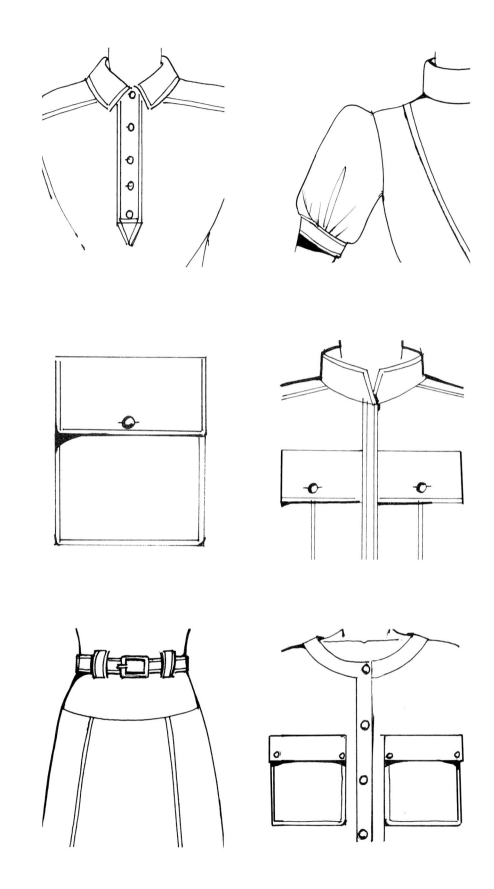

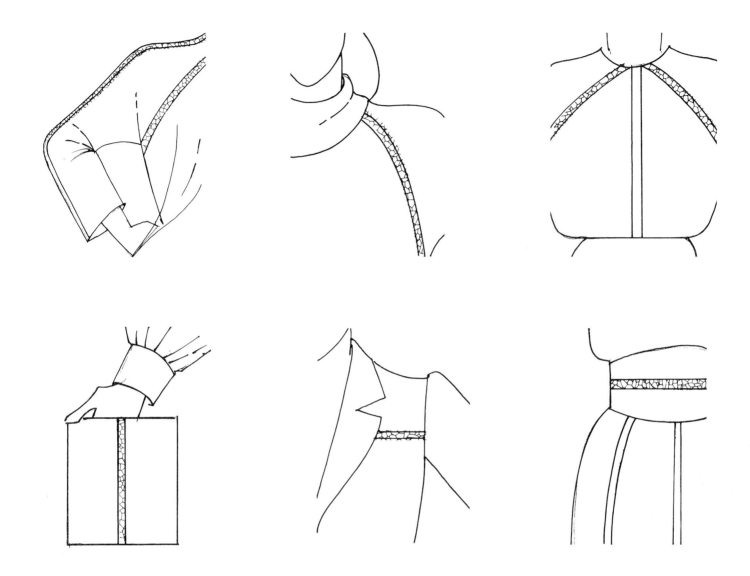

A selection of slot seams with contrasting
fabric adding a decorative effect to a design.

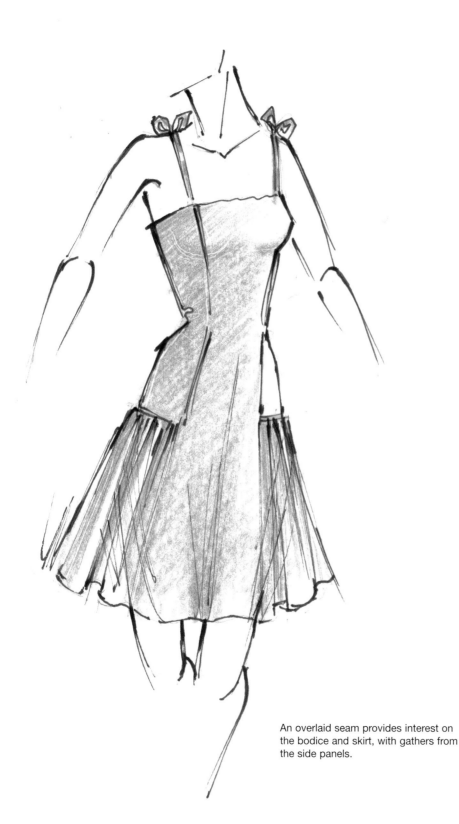

An overlaid seam provides interest on the bodice and skirt, with gathers from the side panels.

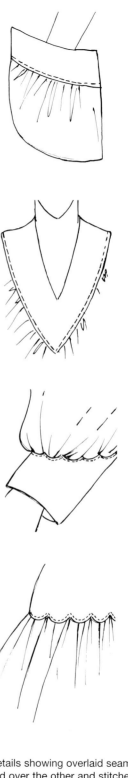

Details showing overlaid seams. One piece of fabric is laid over the other and stitched from the right side. The advantages of this seam are that the fabric always has the right side uppermost, it may be used on seams of any shape, and it is also easier when arranging gathers in a seam, enabling one to achieve the effects required by moving the gathers as necessary.

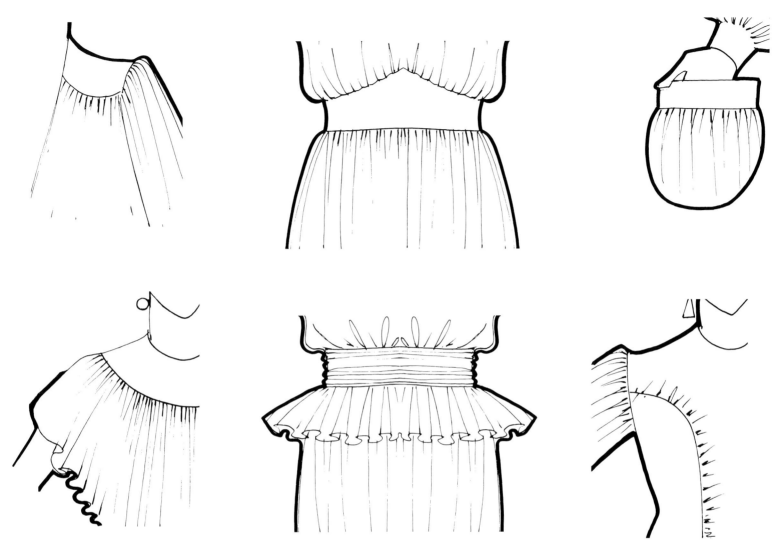

A selection of gathered effects in the detail of a design, suggesting a soft fabric, such as jersey, silk, voile or fine velvet gathered into small folds.

Gathered seam. This is a very decorative seam. The effect will vary depending on the fabric and amount of gathers used. This detail is often used on sleeves, cuffs, yokes, waistbands and panel lines.

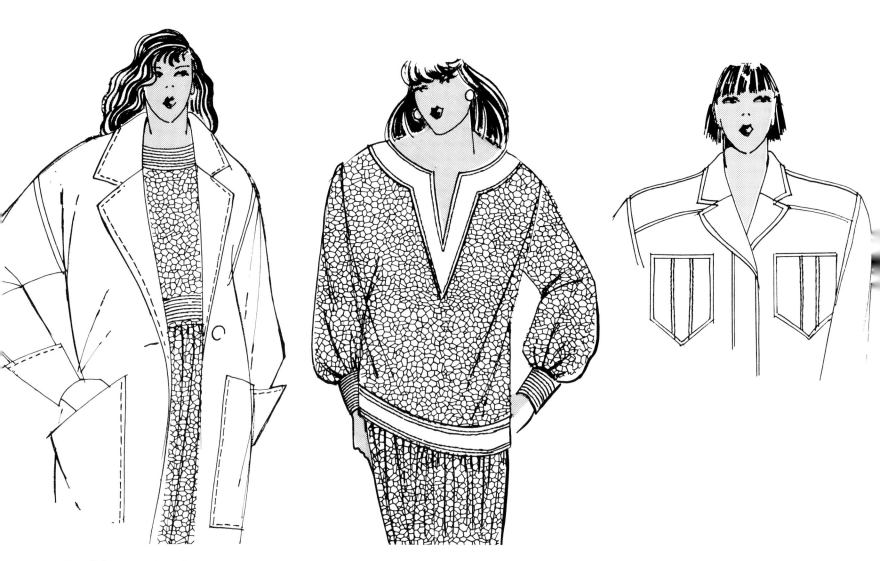

Top stitching as a decorative
feature, emphasizing seam detail.

Variations of the ruched seam.

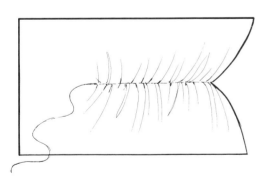

Ruched seam. This seam gives a very decorative effect used on a skirt, sleeve, bodice or shoulders. The seam is drawn up to achieve the effect of ruching.

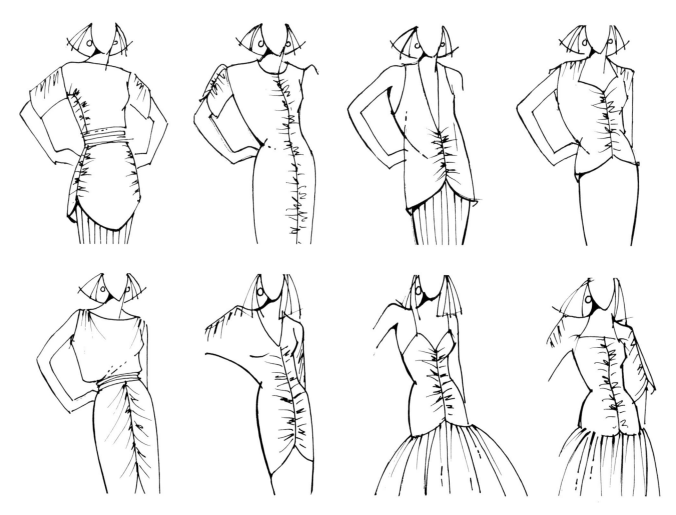

More variations of the ruched seam.

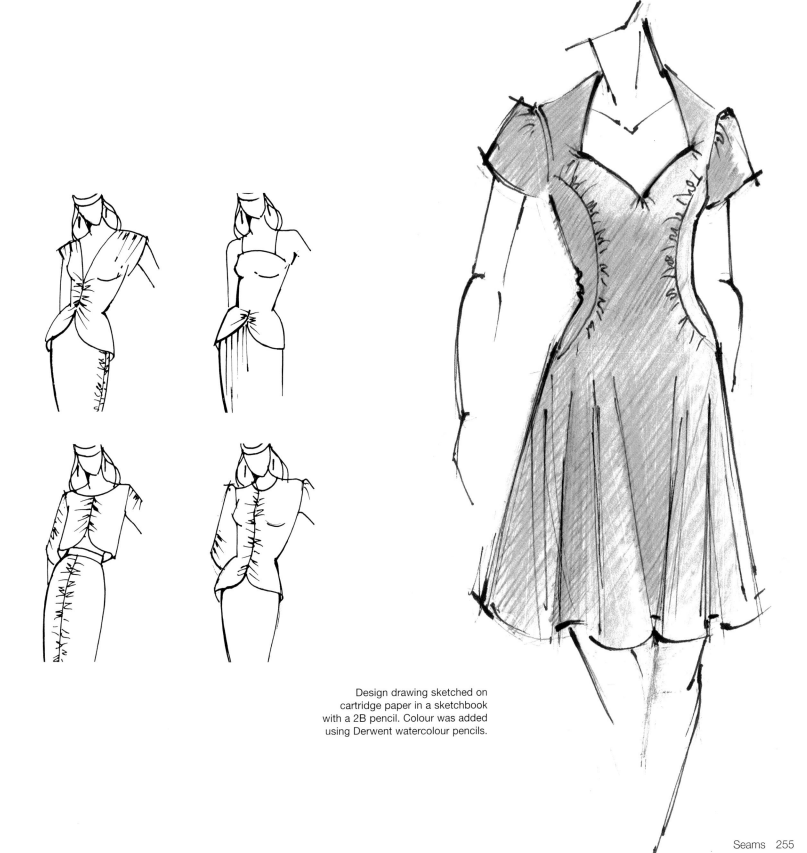

Design drawing sketched on
cartridge paper in a sketchbook
with a 2B pencil. Colour was added
using Derwent watercolour pencils.

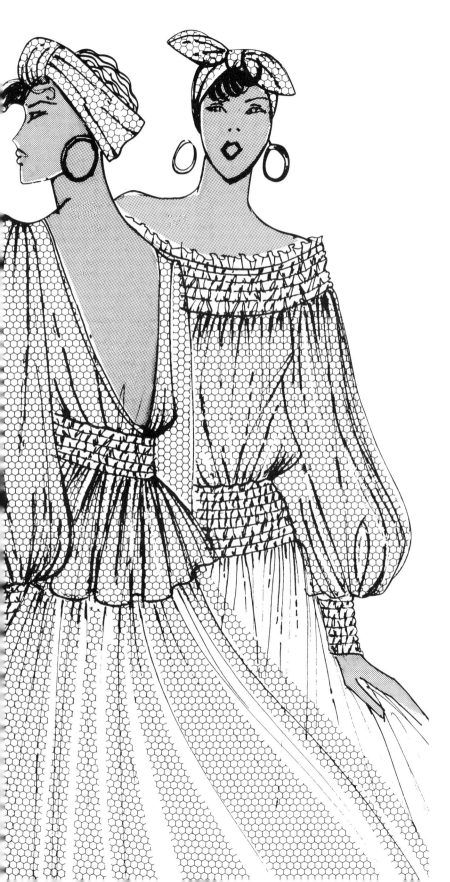

Rows of shirring elastic are used to provide a decorative way of controlling fullness over a wide area. The stretchy effect of shirring hugs the body and expands with the body movements. It may be used for the entire bodice of a garment or for just a small section on the cuff, shoulder, waist or hips. Lightweight fabrics are the most suitable.

Shirring on the neckline, cuff and waist areas.

Shirring

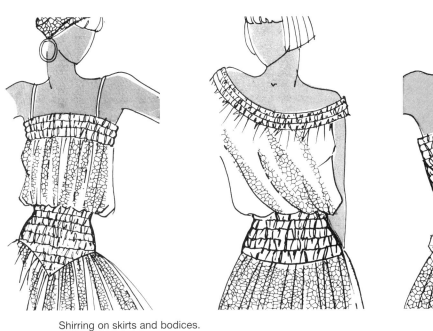
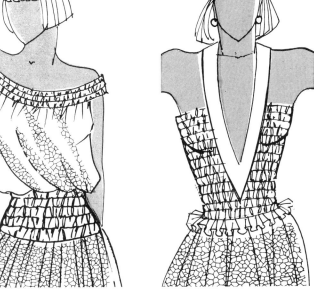
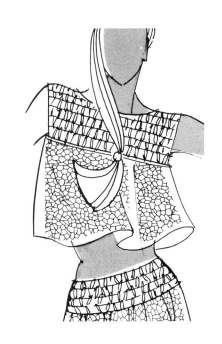

Shirring on skirts and bodices.

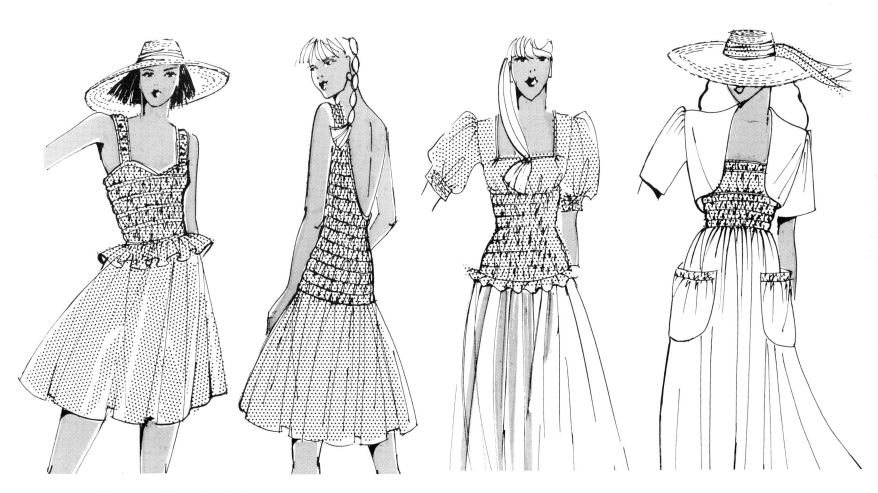

Wide areas of shirring hug the figure.

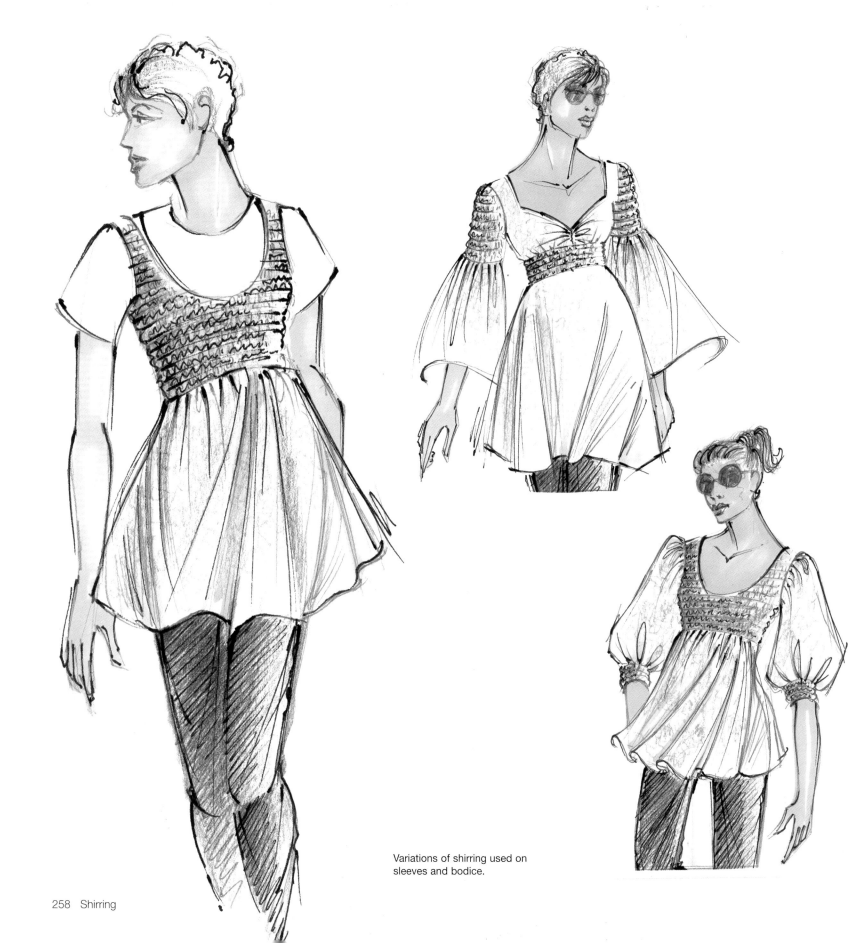

Variations of shirring used on
sleeves and bodice.

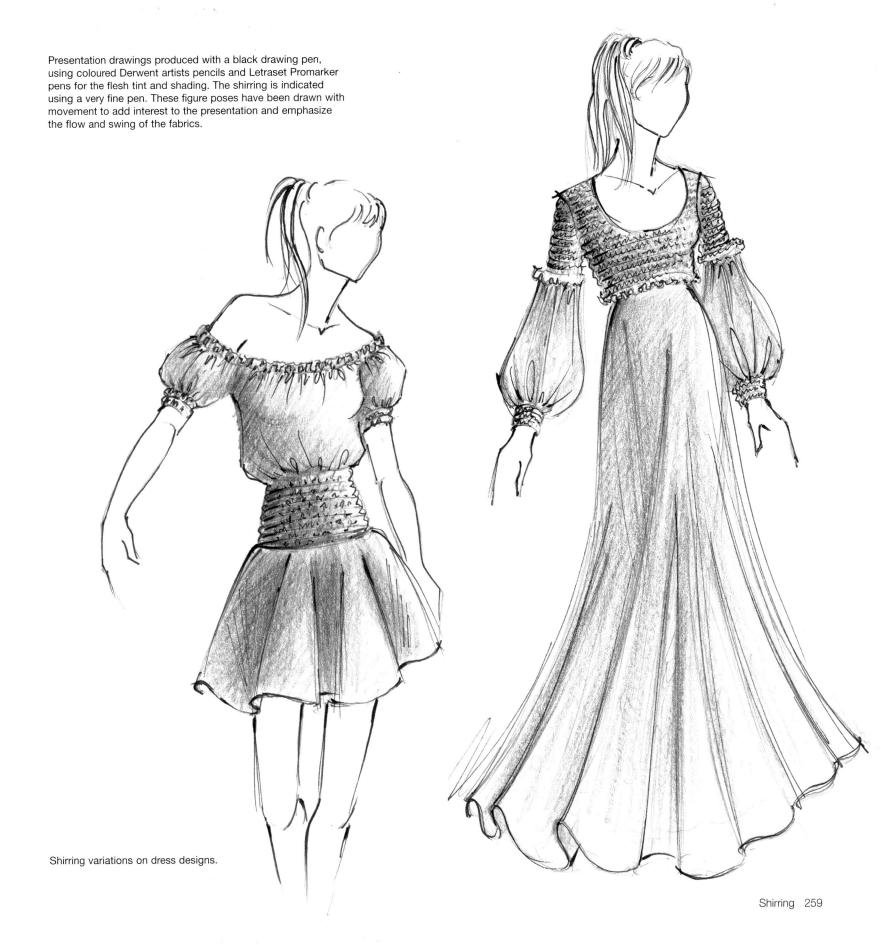

Presentation drawings produced with a black drawing pen, using coloured Derwent artists pencils and Letraset Promarker pens for the flesh tint and shading. The shirring is indicated using a very fine pen. These figure poses have been drawn with movement to add interest to the presentation and emphasize the flow and swing of the fabrics.

Shirring variations on dress designs.

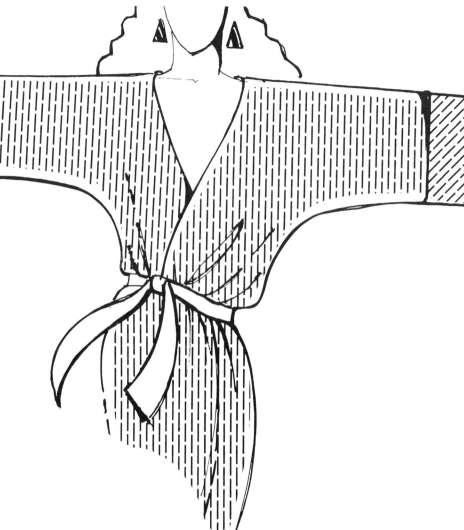

Kimono sleeves.

Sleeves

A wide selection of sleeves is illustrated throughout the book. Note the many effects achieved by adding cuffs, gathers, pleats and tucks and by varying the sleeve widths from tight-fitting sleeves to very full ones. The fabrics used give a variety of different effects to the design from the soft, flowing fabrics to the heavier rich and textured brocades. There are many variations of the sleeve:

Kimono sleeve

The classic kimono sleeve is a T-shaped garment. The T shape creates folds, producing a draped effect. The kimono sleeve can be cut with a yoke, which gives a closer fit. This sleeve is used in many areas of fashion, from casualwear to coats, jackets, dresses and eveningwear.

Raglan sleeve

This sleeve has a diagonal seamline that leads into another seam or forms part of that neckline. It can be cut on the straight or on the bias with a one- or two-piece construction. The shoulder curve is part of the sleeve shape created by a dart, gathers or a seam.

Set-in sleeve

The one-piece set-in sleeve is the most classic style of sleeve and allows the designer to created many different variations.

Cap sleeve

A very short sleeve that is simply an extension of the shoulder and not usually continued under the arm.

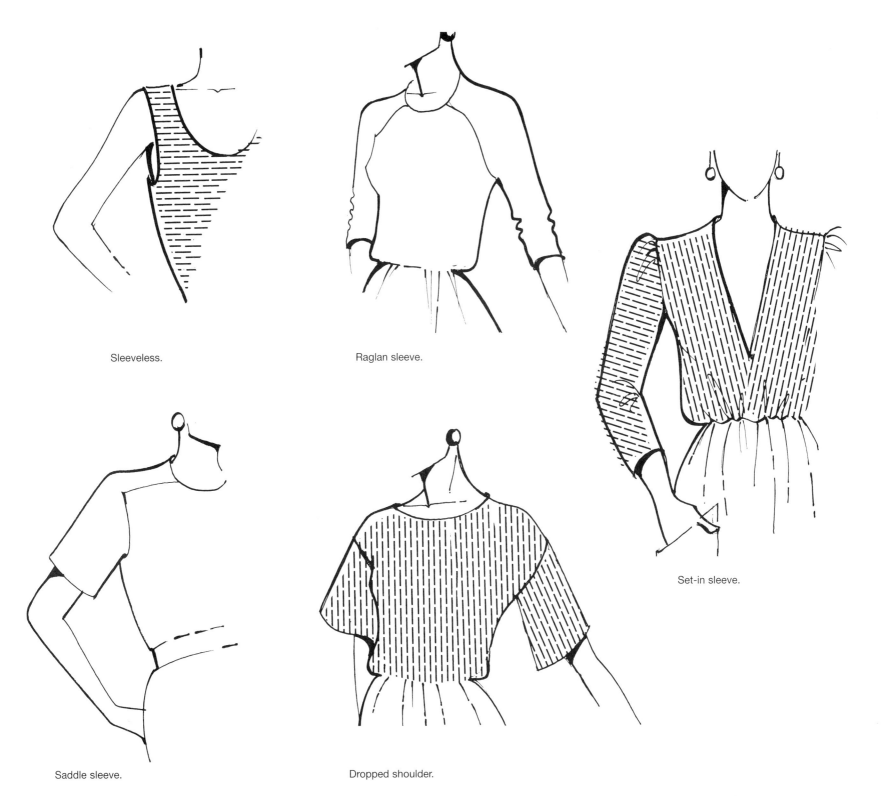

Sleeveless.

Raglan sleeve.

Set-in sleeve.

Saddle sleeve.

Dropped shoulder.

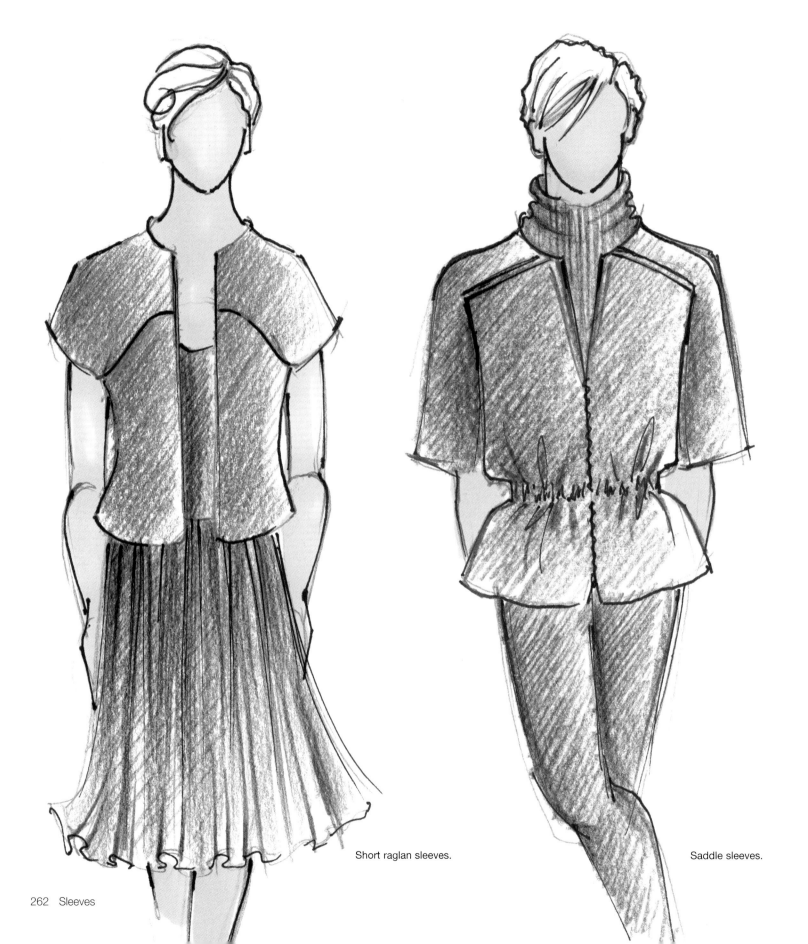

Short raglan sleeves.

Saddle sleeves.

These design sketches, or flats, demonstrate a simple and quick method of presenting ideas. They may be drawn freehand or a template could be used to produce your designs. In the early stages, this style of presenting work gives a very clear impression of the cut, seam placement and design details. The faces and hair are only suggested, and could be added later. Colour is added with coloured pencils to indicate texture and tone, leaving areas of white to highlight folds and surface textures.

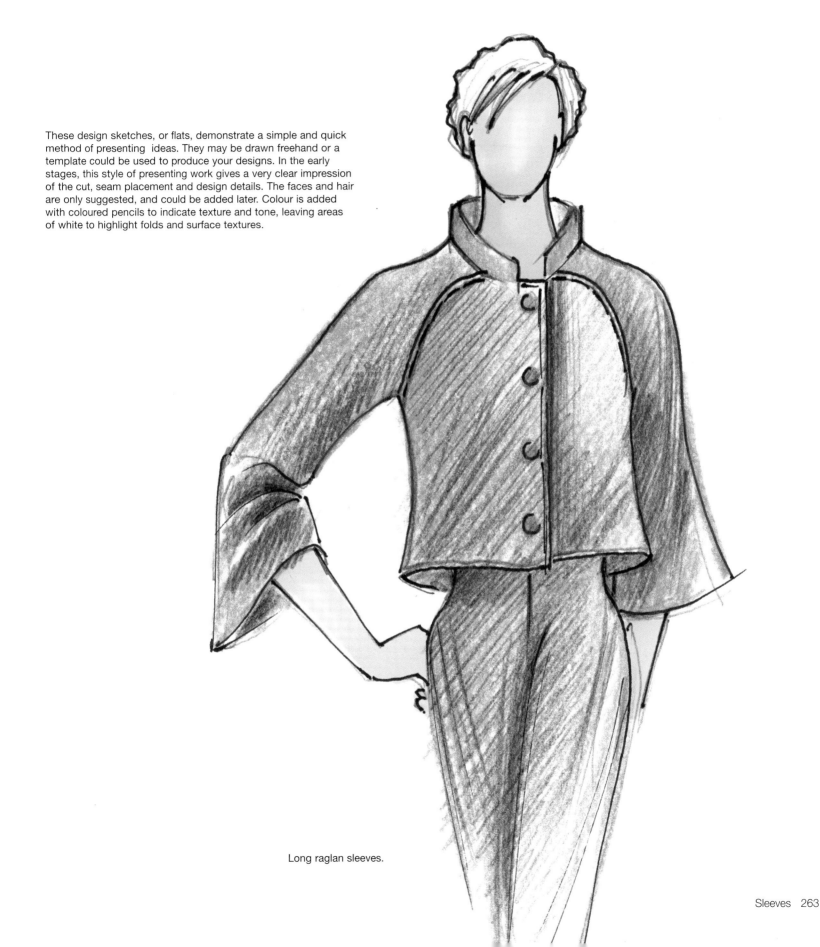

Long raglan sleeves.

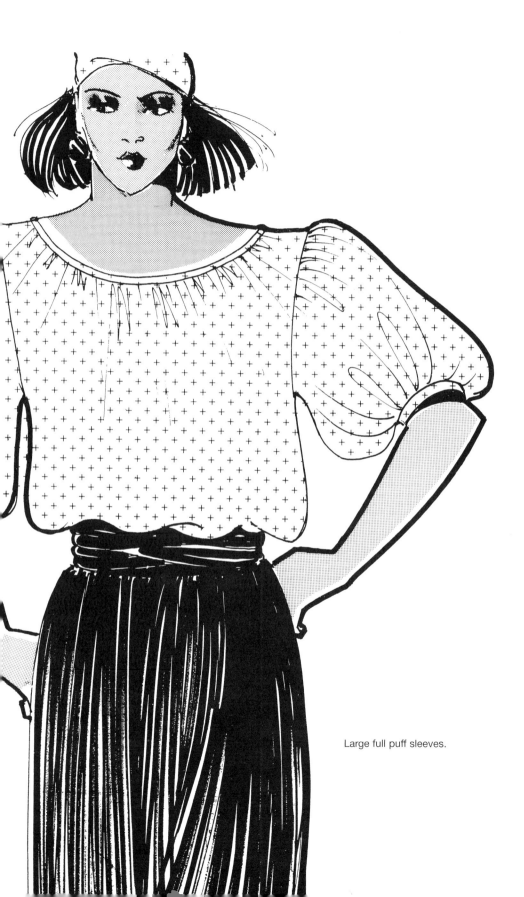

Large full puff sleeves.

Three-quarter-length sleeve.

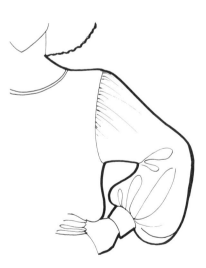

Bishop sleeve, fuller at the cuff than at the shoulder.

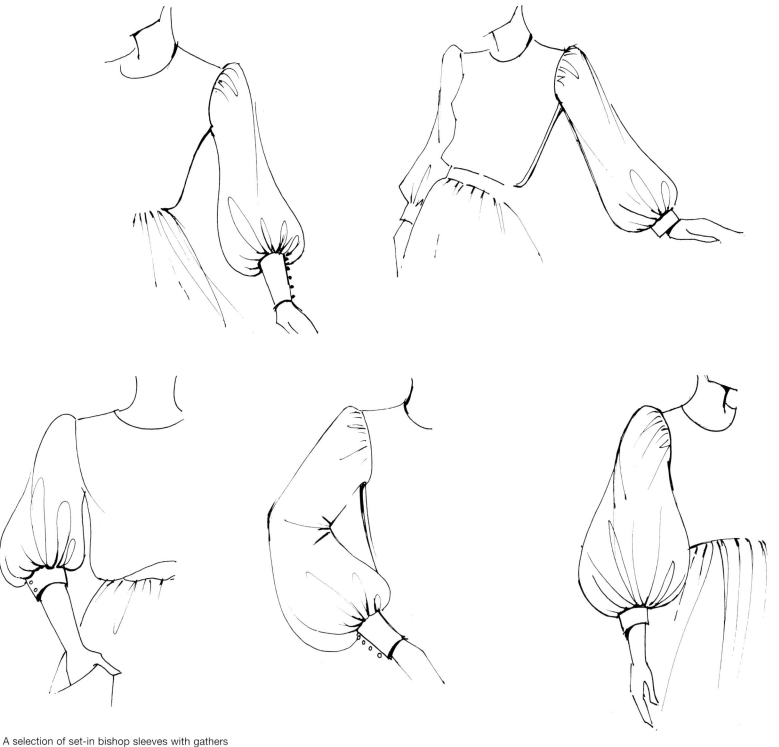

A selection of set-in bishop sleeves with gathers at the sleeve head and cuff. Note the variation of armhole shapes and fullness of the sleeve.

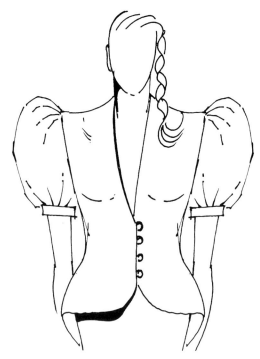

Set-in puff sleeves.

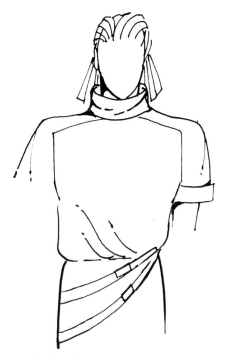

Saddle sleeves.

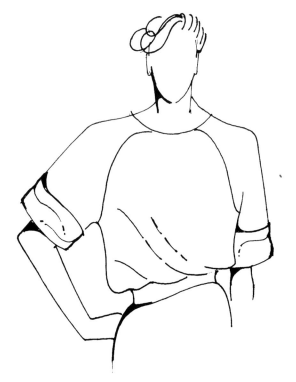

Raglan sleeves.

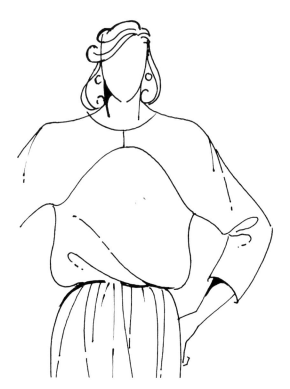

A variation of raglan sleeves.

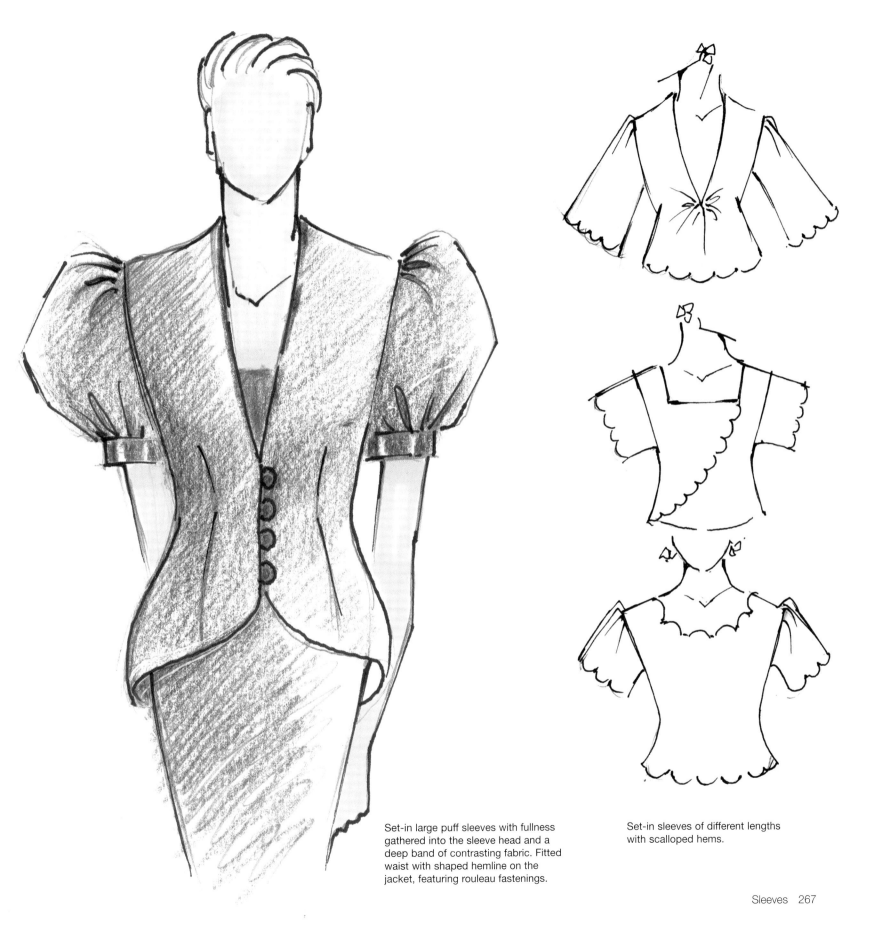

Set-in large puff sleeves with fullness gathered into the sleeve head and a deep band of contrasting fabric. Fitted waist with shaped hemline on the jacket, featuring rouleau fastenings.

Set-in sleeves of different lengths with scalloped hems.

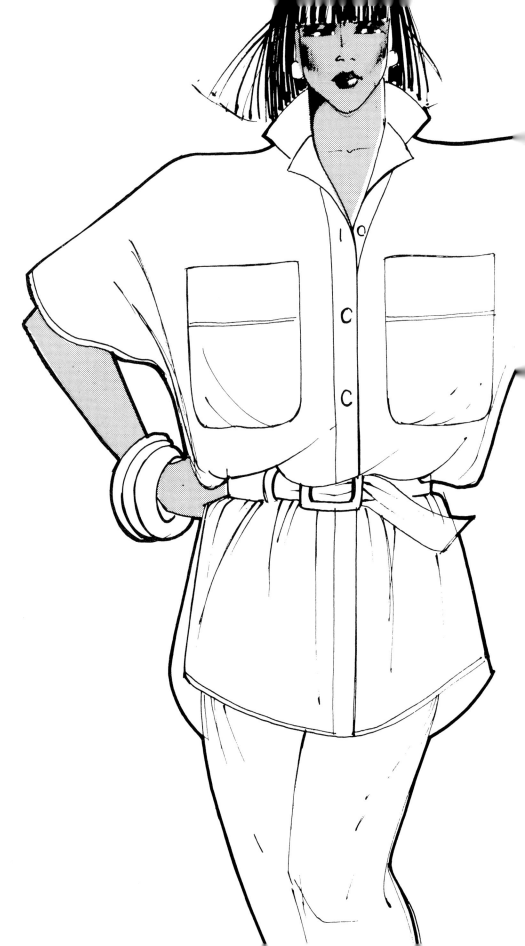

Kimono sleeves.

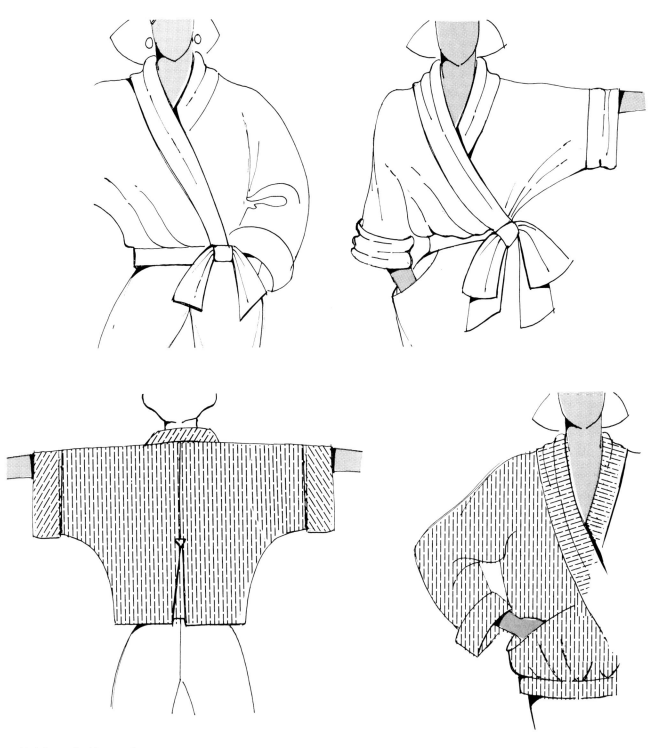

Variations of a kimono sleeve.

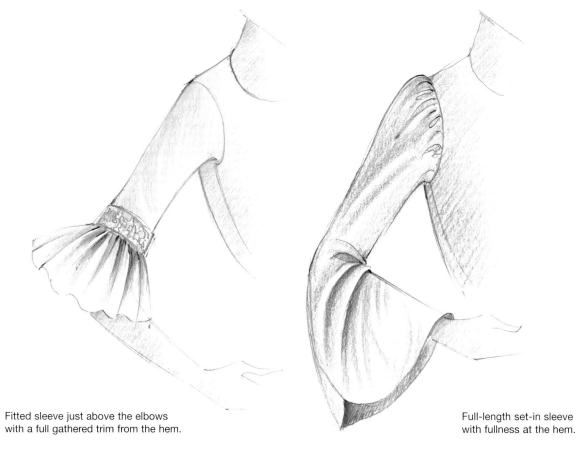

Fitted sleeve just above the elbows
with a full gathered trim from the hem.

Full-length set-in sleeve
with fullness at the hem.

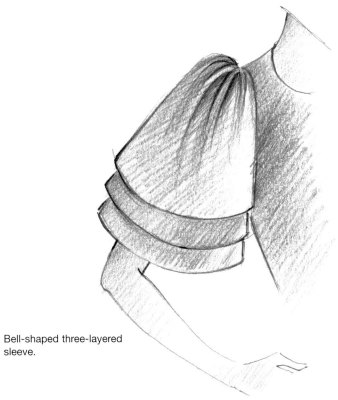

Bell-shaped three-layered
sleeve.

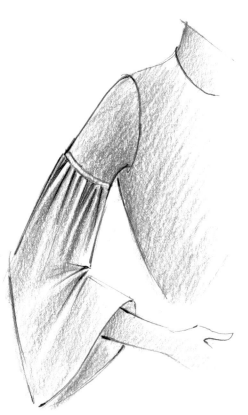

Fitted sleeve from the
shoulder, gathered and
flared from the upper arm.

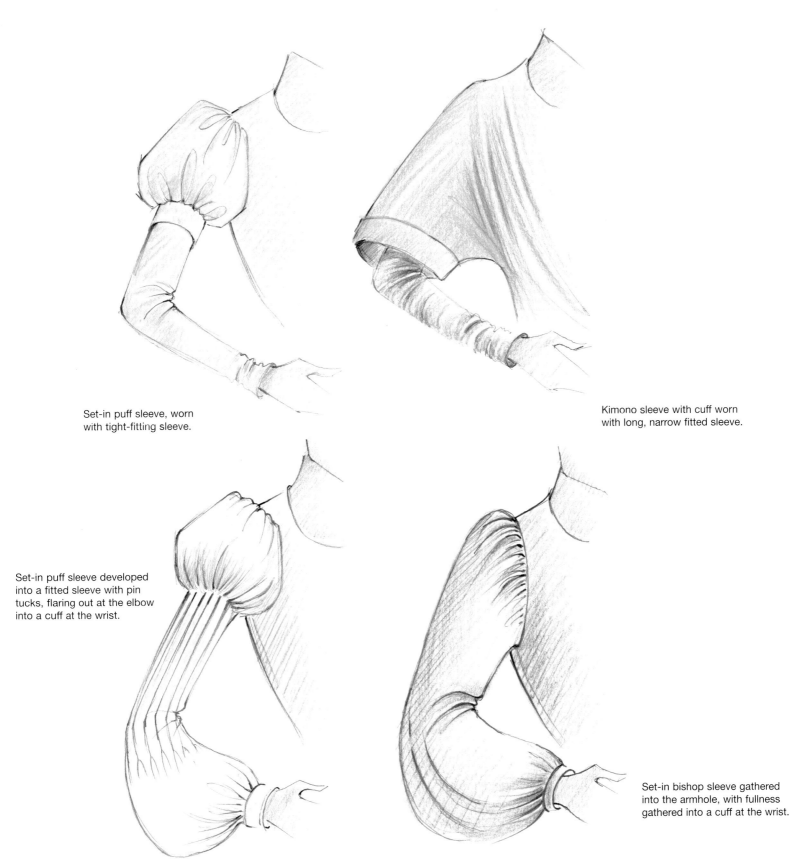

Set-in puff sleeve, worn with tight-fitting sleeve.

Kimono sleeve with cuff worn with long, narrow fitted sleeve.

Set-in puff sleeve developed into a fitted sleeve with pin tucks, flaring out at the elbow into a cuff at the wrist.

Set-in bishop sleeve gathered into the armhole, with fullness gathered into a cuff at the wrist.

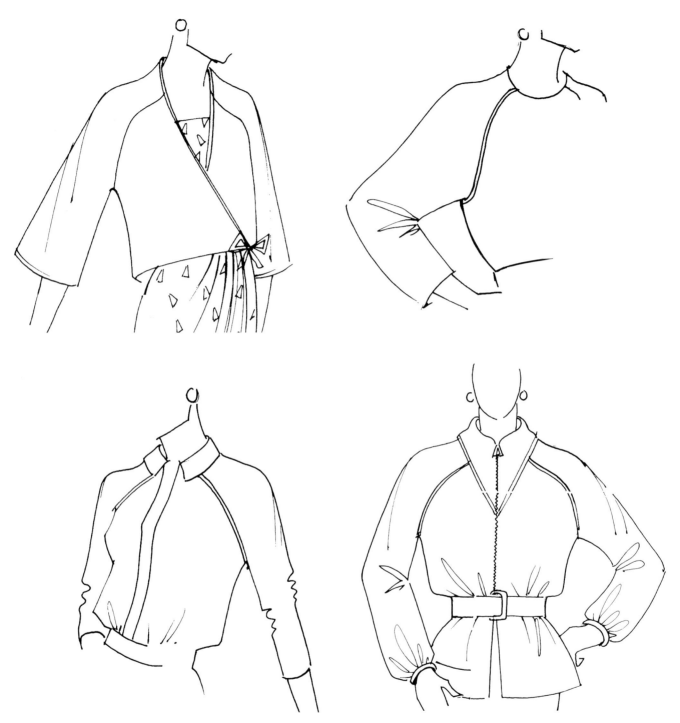

Variations of the raglan sleeve.

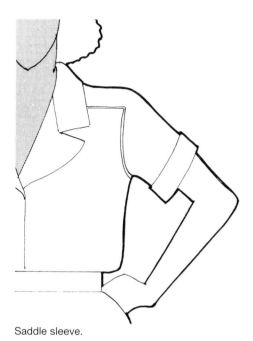

Saddle sleeve.

Deep raglan sleeve.

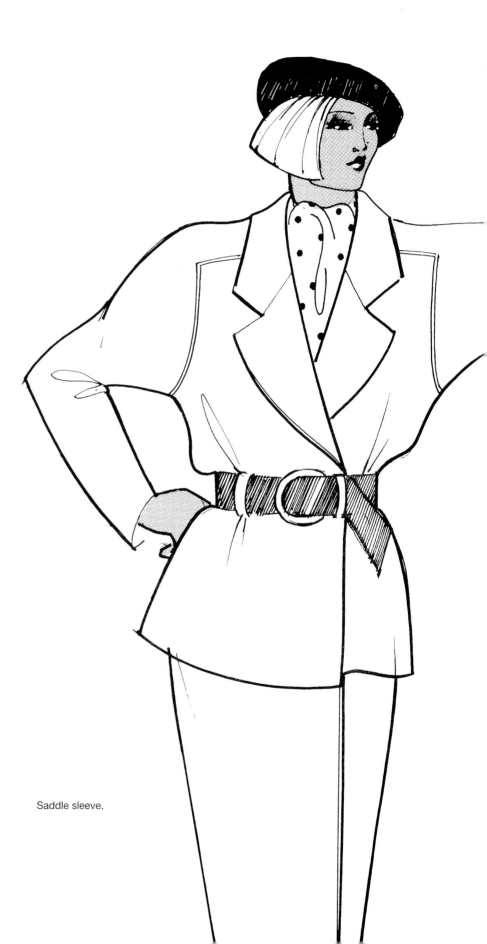

Saddle sleeve.

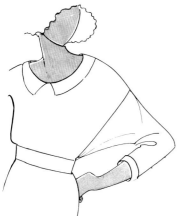
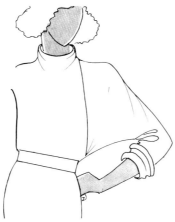
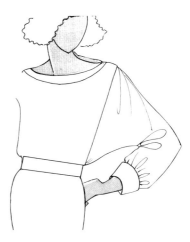

Bat wing variations.

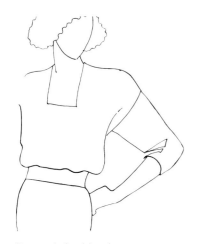
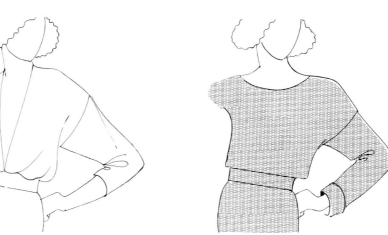

Dropped-shoulder sleeves.

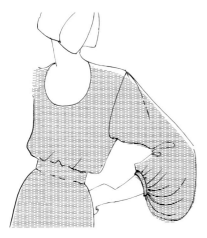
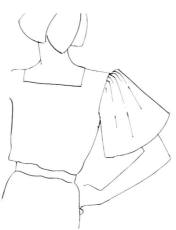
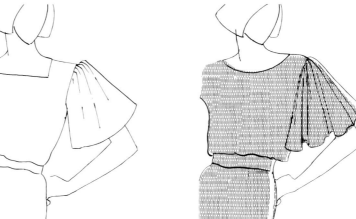

Set-in sleeves.

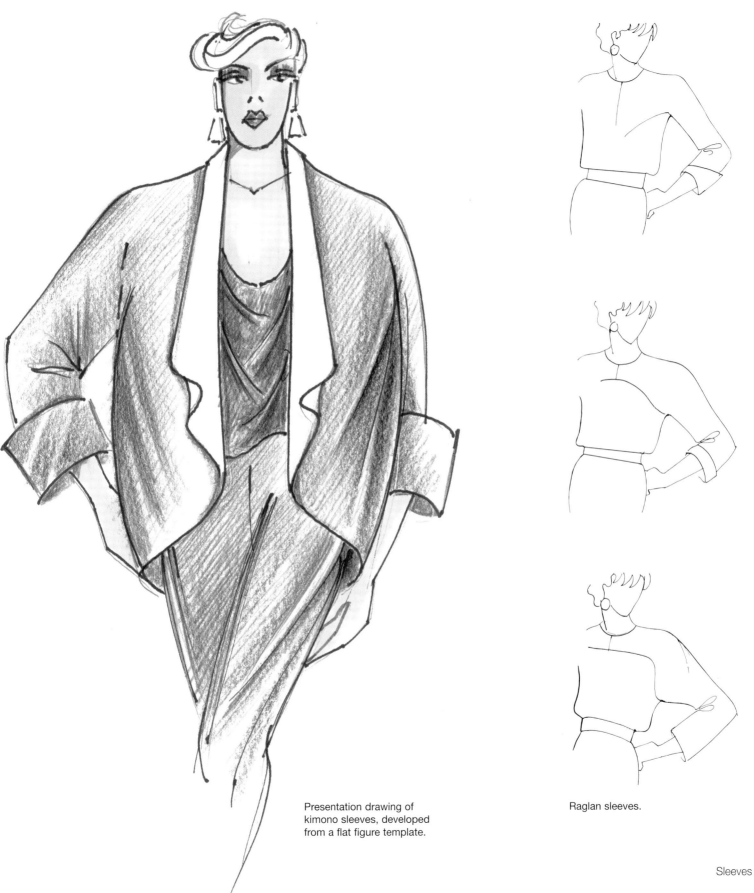

Presentation drawing of
kimono sleeves, developed
from a flat figure template.

Raglan sleeves.

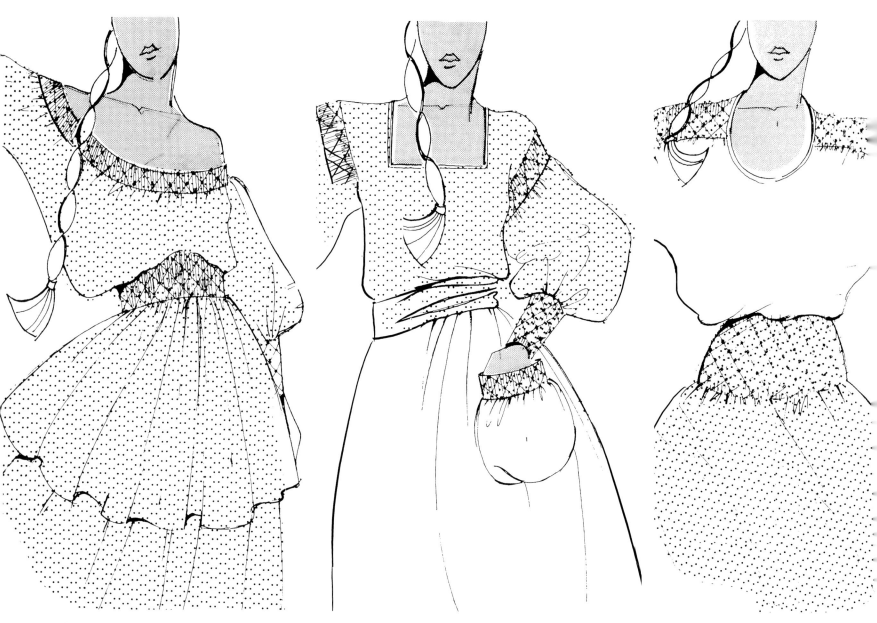

Smocking using traditional
embroidery stitches.

Smocking

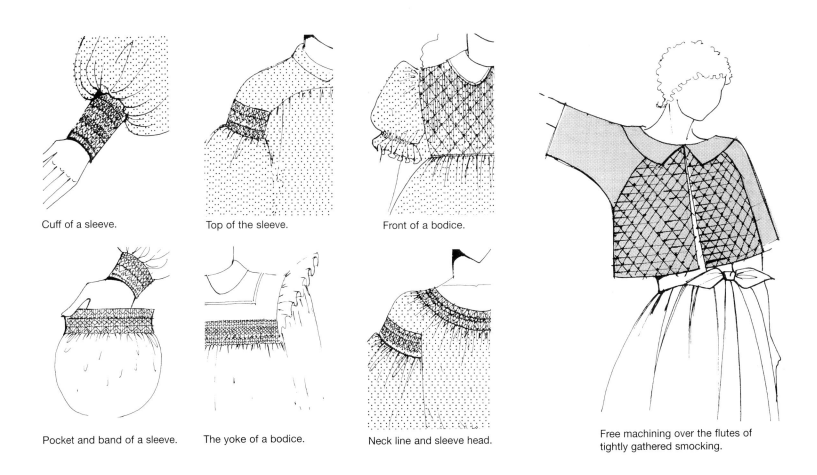

Cuff of a sleeve.

Top of the sleeve.

Front of a bodice.

Pocket and band of a sleeve.

The yoke of a bodice.

Neck line and sleeve head.

Free machining over the flutes of
tightly gathered smocking.

Smocking may be worked on many fabrics from printed cottons and ginghams
to silks, lightweight woollen fabrics and tweeds. It is a very effective decoration
used on many designs from children's garments to day and eveningwear.

Smocking is achieved with embroidery yarns, which are selected according
to the type of fabric used. It can also be introduced to give a textured effect
using fabric and yarns in the same colour, or every row of smocking may be
produced in a different colour or in a variety of colours. Once the gathering
has been done, there is a large selection of embroidery stitches from which to
form the pattern, depending on the effects required.

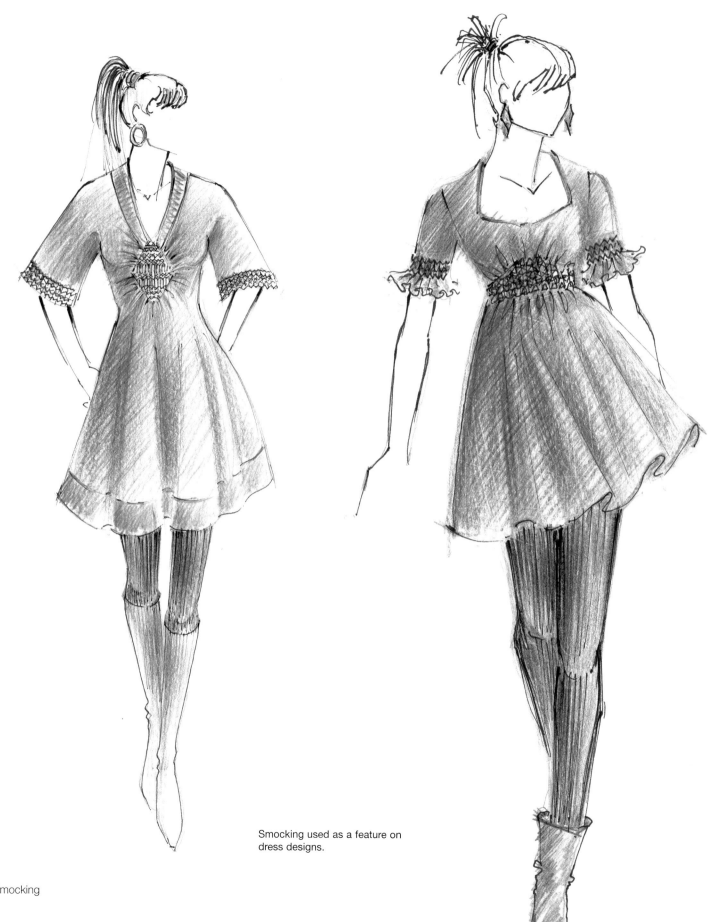

Smocking used as a feature on
dress designs.

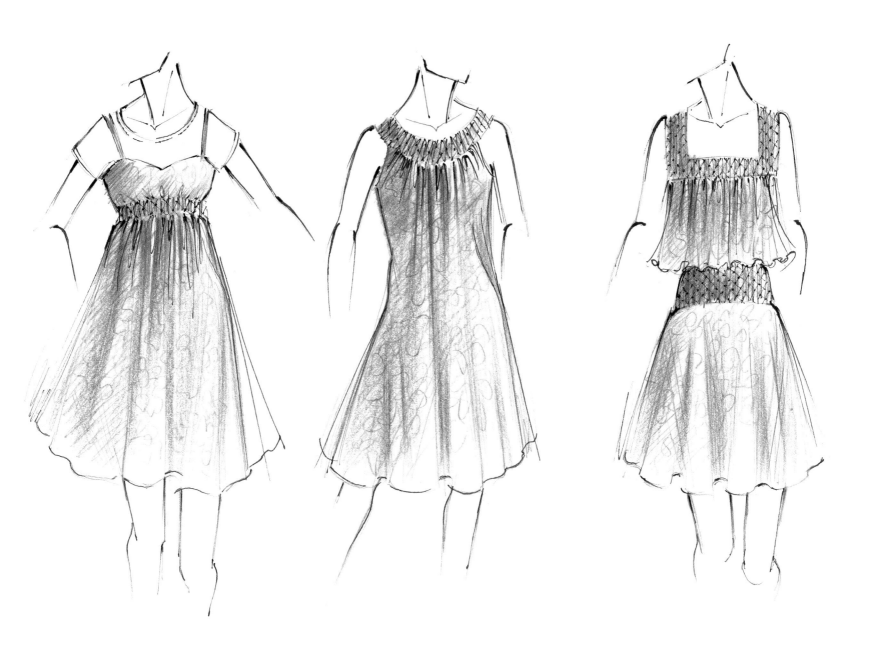

Variations of a smocking design
used at waistline, hips and neckline.

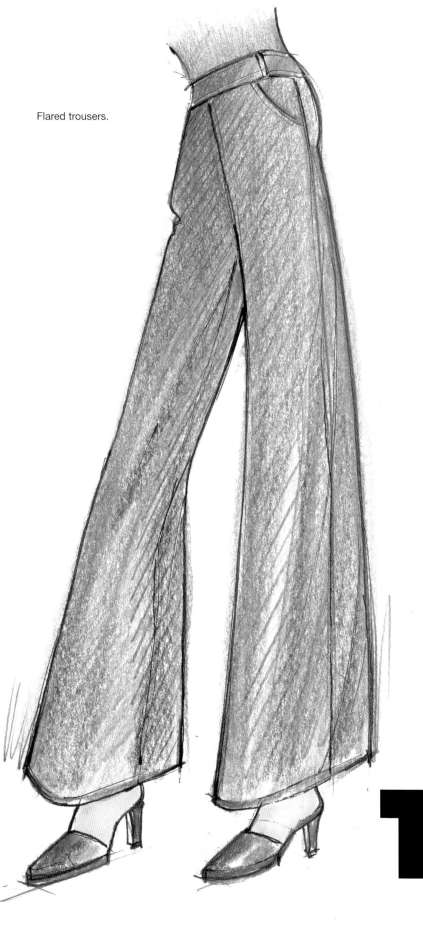

Flared trousers.

Trousers vary primarily in their length and the cut of the leg. Popular lengths include three-quarter length, as shown opposite, ankle length and floor length, while the cut can be anything from skinny cut to flared (see page 283) or even split-skirt style. Hems are usually either straight or with turn-ups, although very narrow trousers can have a split-seam detail. Other detailing can be added with pocket shaping, top stitching, embroidery or appliqué.

Trousers

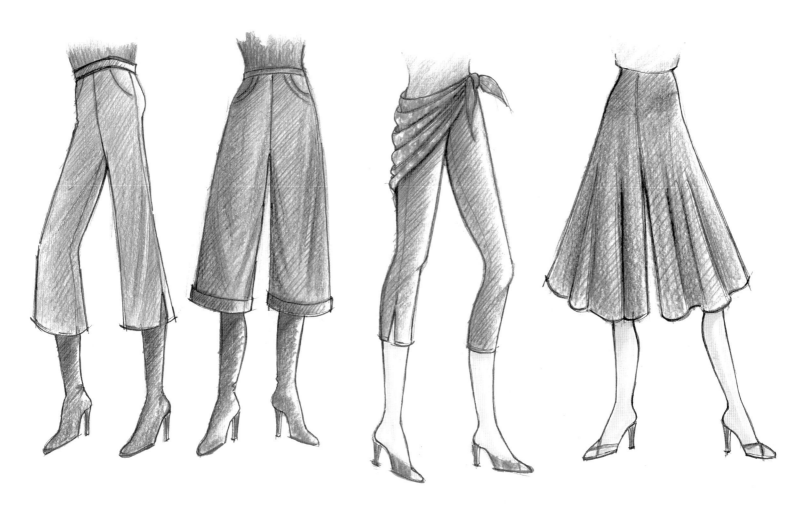

Three-quarter-length trousers with a side slit at the hem.

Three-quarter-length trousers with turn-ups.

Narrow three-quarter-length trousers.

Trousers cut to give the effect of a divided skirt.

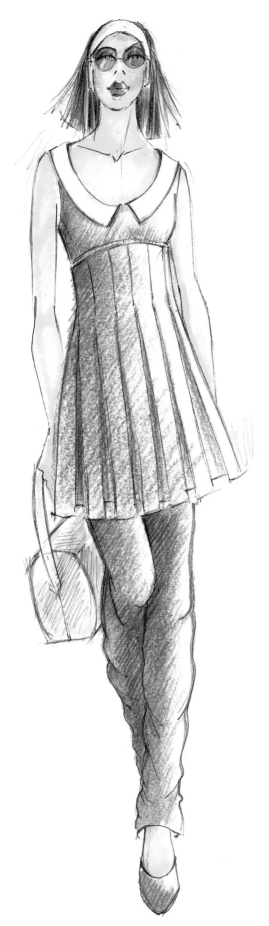

Presentation drawing on textured paper of dress worn with jeans. Derwent artists pencils used for colouring with details completed with a fine pen. Letraset Promarker blush pen used for the flesh tint.

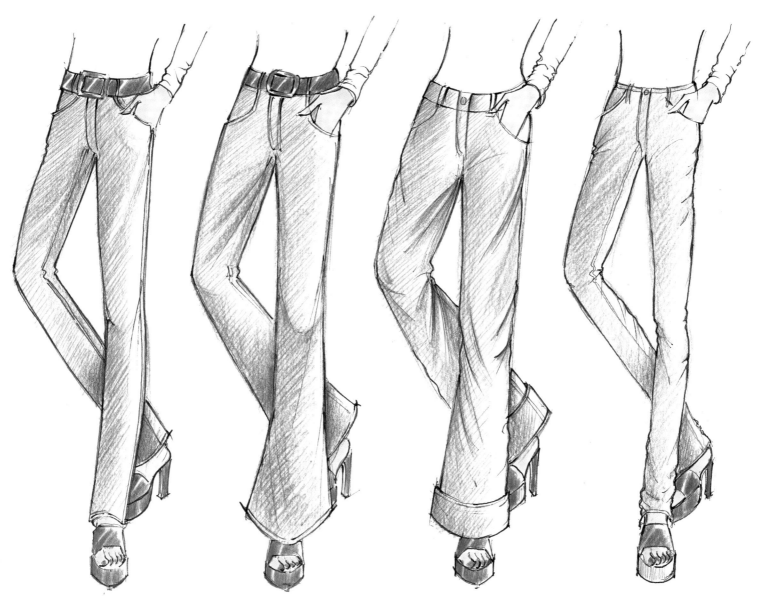

Boot cut. Flared. Flared with turn-up. Skinny cut.

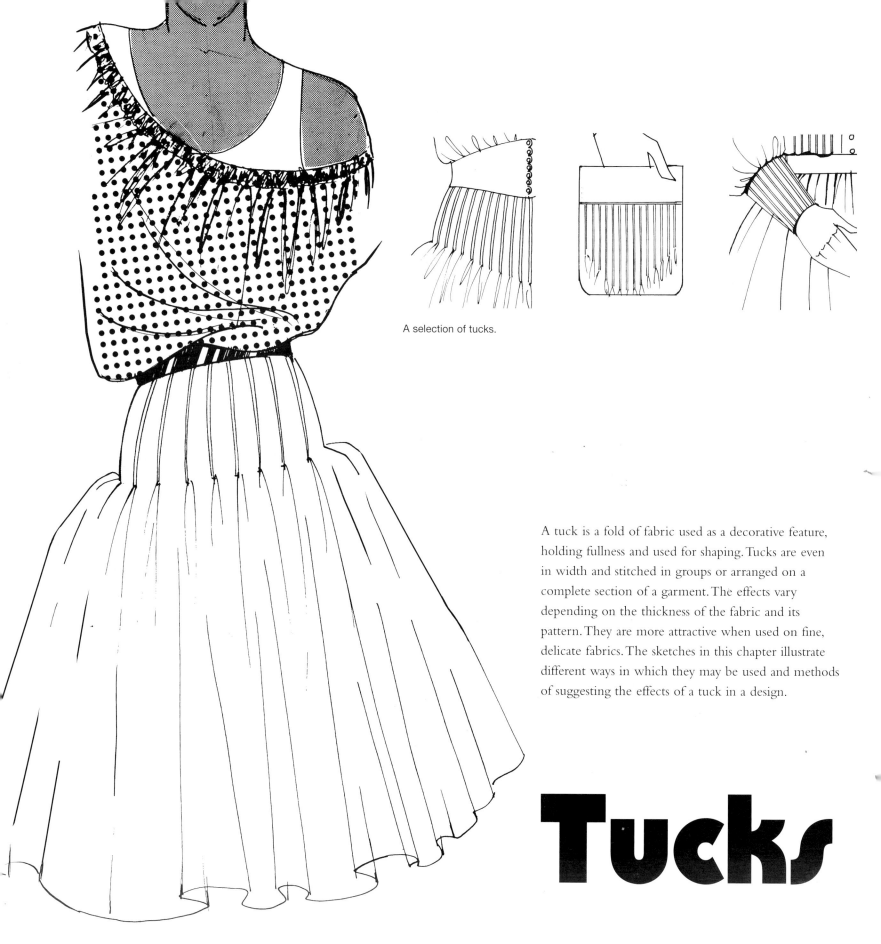

A selection of tucks.

A tuck is a fold of fabric used as a decorative feature, holding fullness and used for shaping. Tucks are even in width and stitched in groups or arranged on a complete section of a garment. The effects vary depending on the thickness of the fabric and its pattern. They are more attractive when used on fine, delicate fabrics. The sketches in this chapter illustrate different ways in which they may be used and methods of suggesting the effects of a tuck in a design.

Tucks

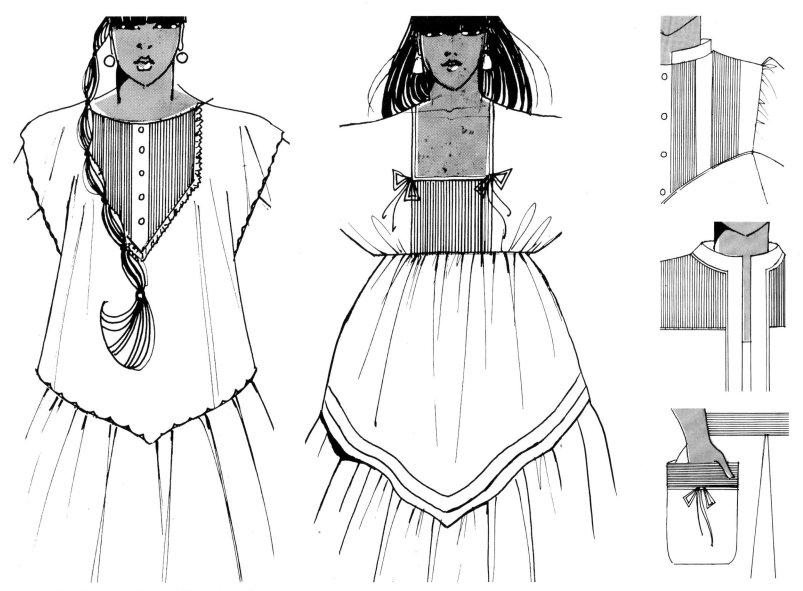

Groups of small pin tucks placed within sections of a design. The sections are edged with piping or lace.

Pin tucks. The tucks are very fine and narrow and they should be very close together. They cannot be pressed to one side so tend to stand up. They are often combined with embroidery and lace and look effective when used in a panel or on a pocket or yoke.

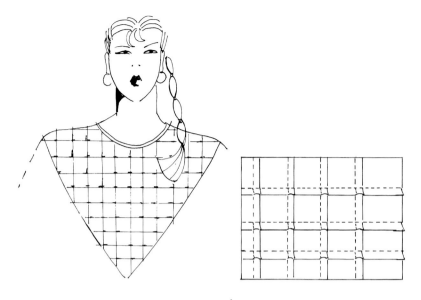

Cross tucks: The cross tuck gives a very pleasing effect when used on yokes, pockets and large areas of a garment.

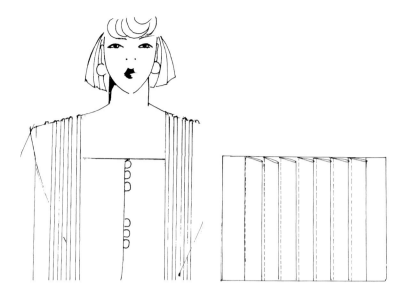

Blind tucks: Tucks that meet are called blind tucks.

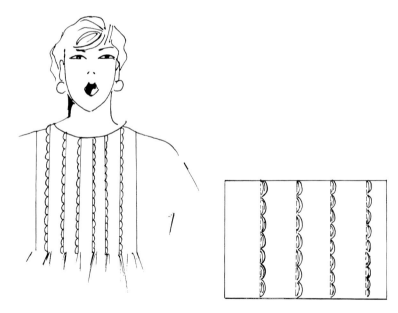

Shell tucks: The shell tuck gives a very attractive scalloped edge to a tuck. The effect is often used on delicate fabrics for eveningwear and children's designs.

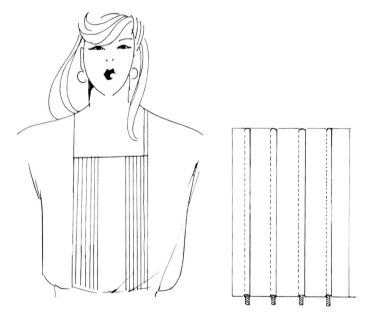

Piped tucks: Piping cord inserted into each tuck. This emphasizes the tucks.

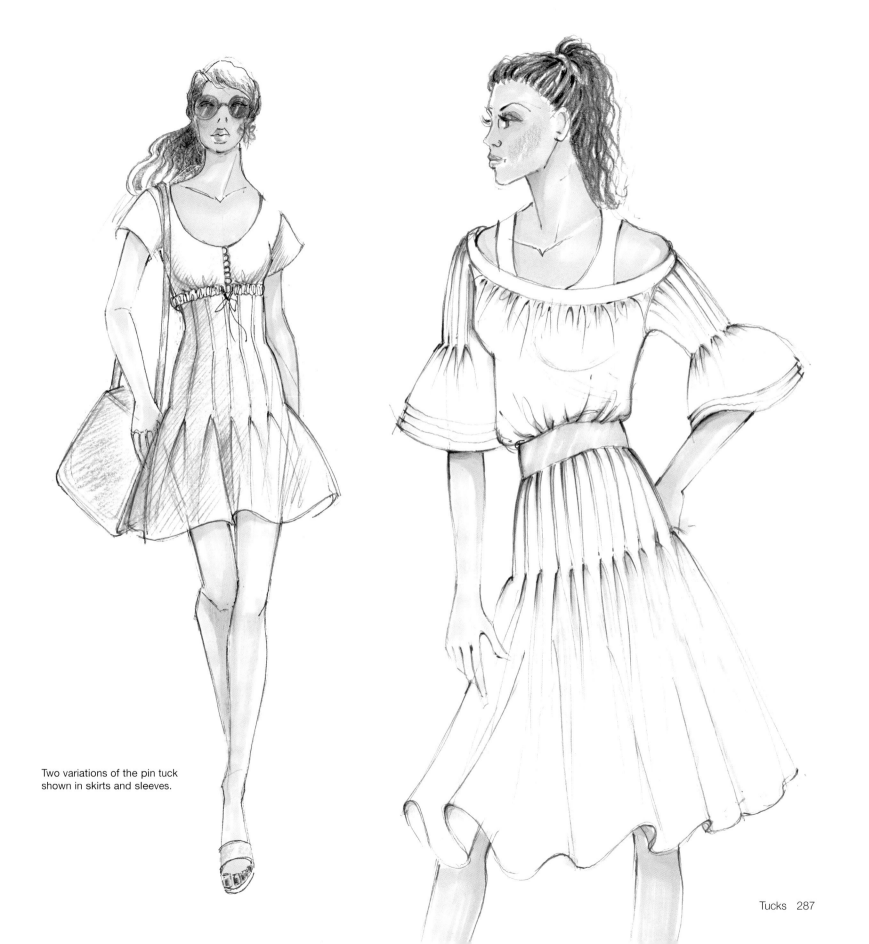

Two variations of the pin tuck
shown in skirts and sleeves.

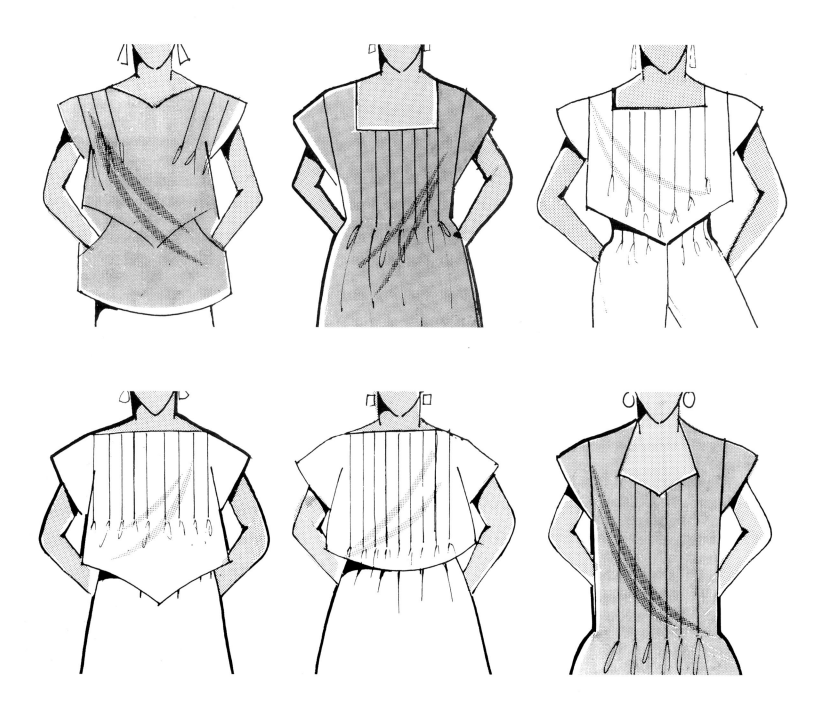

Ideas for a collection of designs using the released tucks. Released tucks are used to
control fullness and then released at a desired area on a design. The fullness may be
released at one end of a tuck or both. Dart tucks may be stitched on the straight grain.

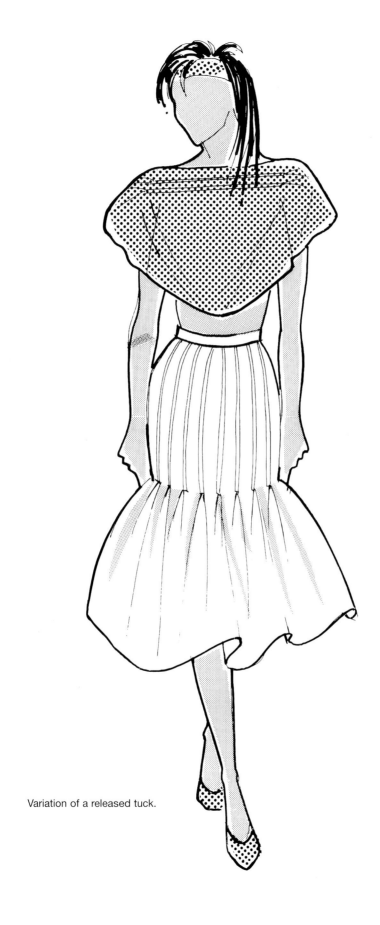

Variation of a released tuck.

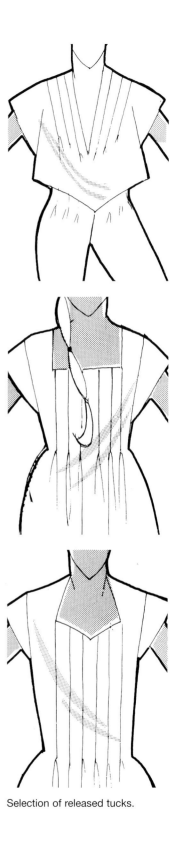

Selection of released tucks.

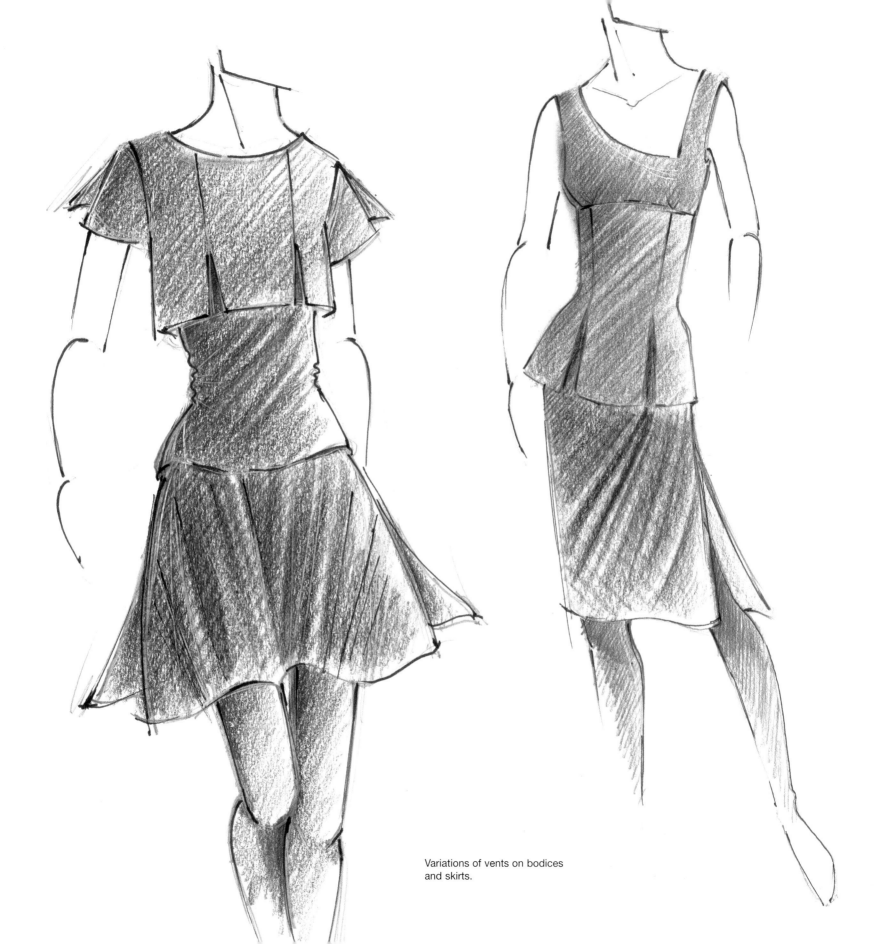

Variations of vents on bodices
and skirts.

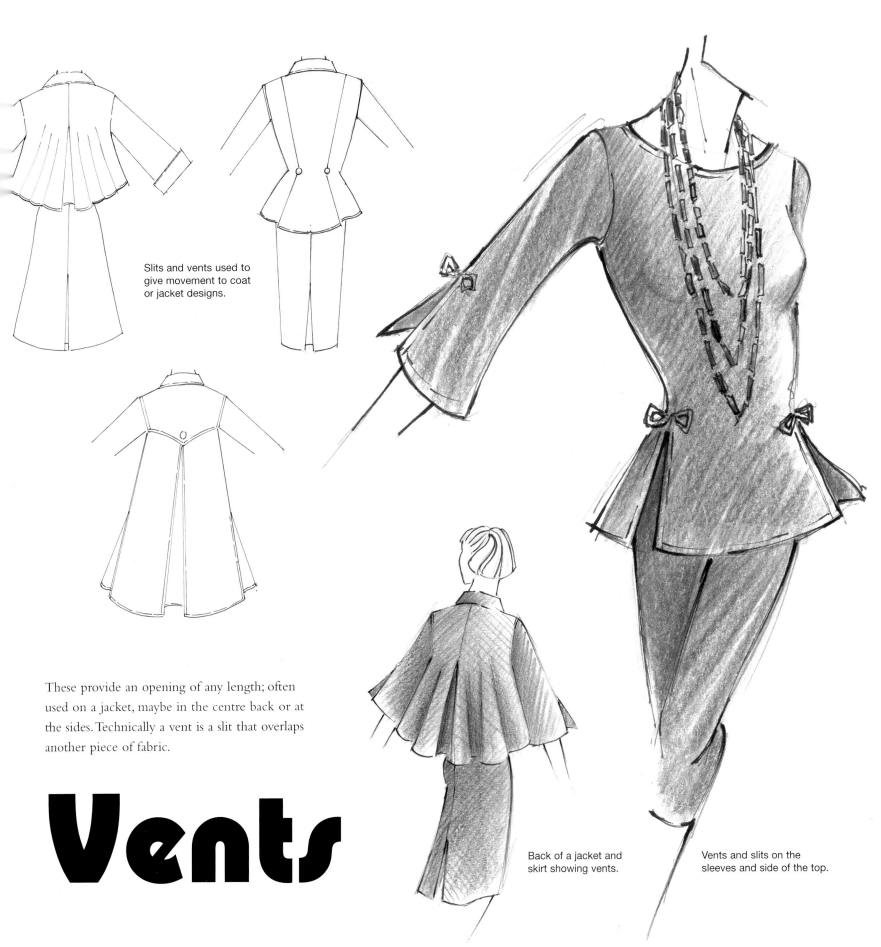

Slits and vents used to give movement to coat or jacket designs.

These provide an opening of any length; often used on a jacket, maybe in the centre back or at the sides. Technically a vent is a slit that overlaps another piece of fabric.

Vents

Back of a jacket and skirt showing vents.

Vents and slits on the sleeves and side of the top.

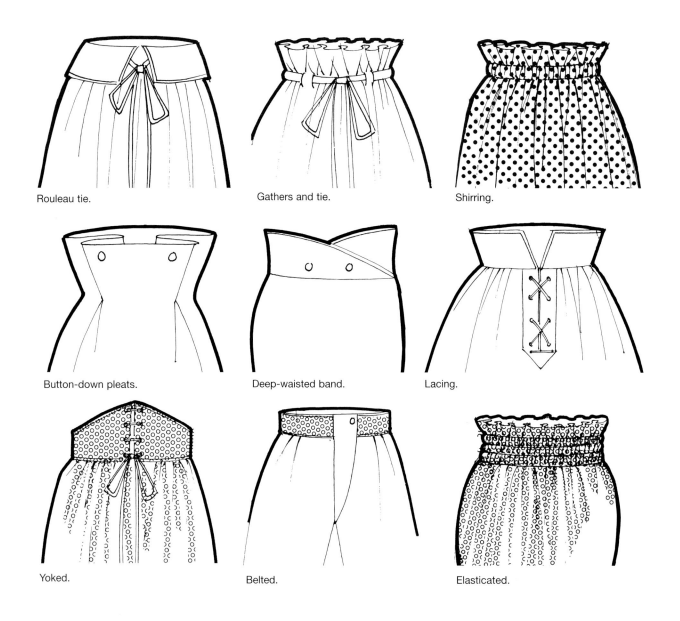

Rouleau tie.

Gathers and tie.

Shirring.

Button-down pleats.

Deep-waisted band.

Lacing.

Yoked.

Belted.

Elasticated.

The waistband has many variations from the very simple to styles that become the main feature on a design. Illustrated are a number of ideas using a varied selection of design details.

Waistbands

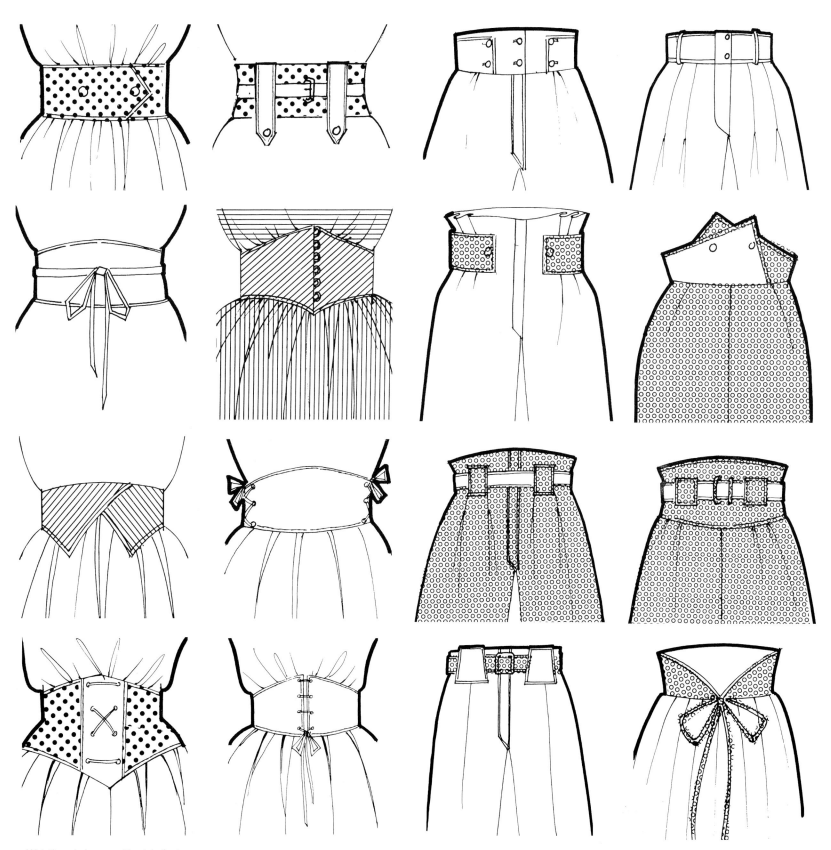

Waistband shapes with style features.

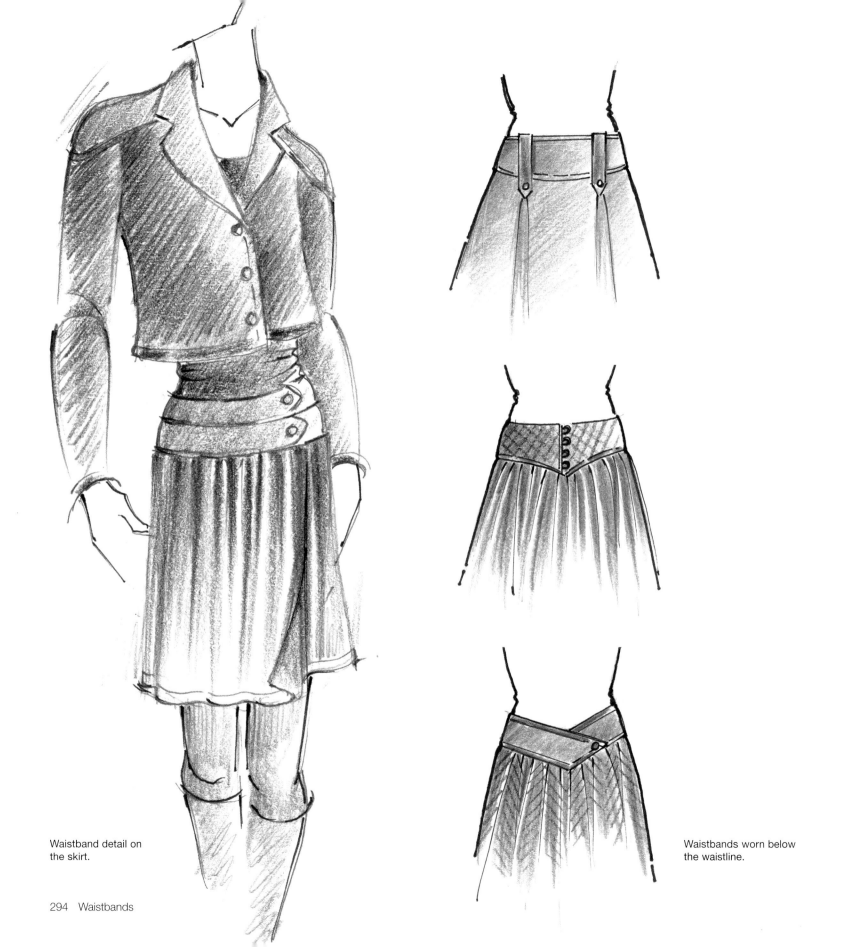

Waistband detail on
the skirt.

Waistbands worn below
the waistline.

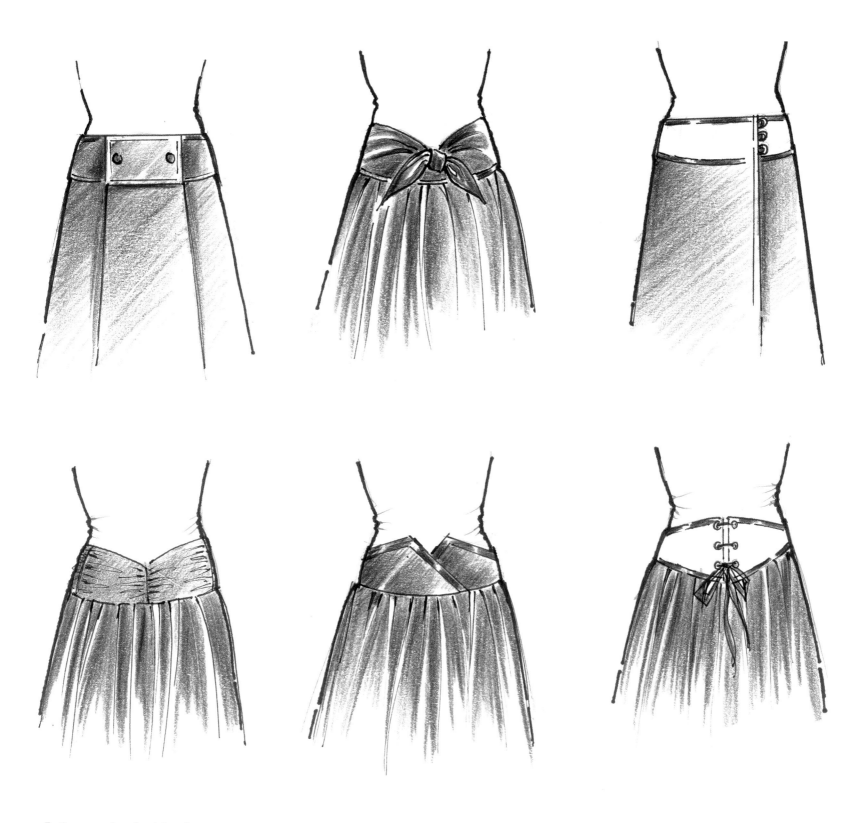

Further examples of waistbands
worn below the waistline.

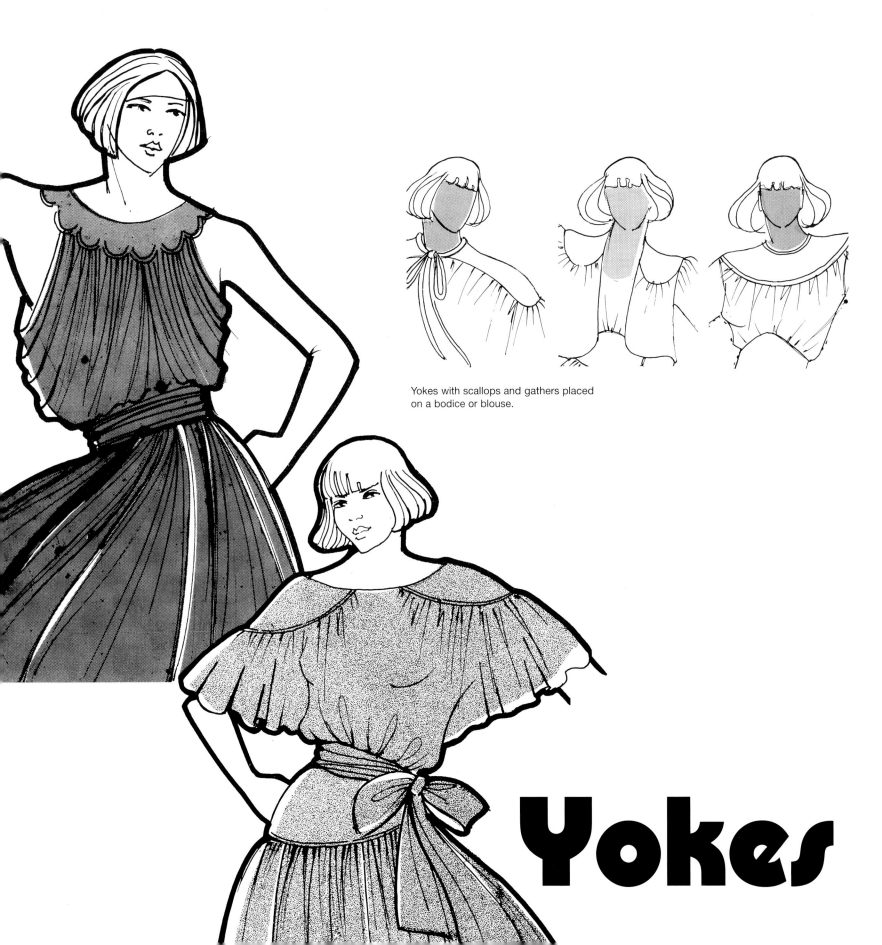

Yokes with scallops and gathers placed
on a bodice or blouse.

Yokes

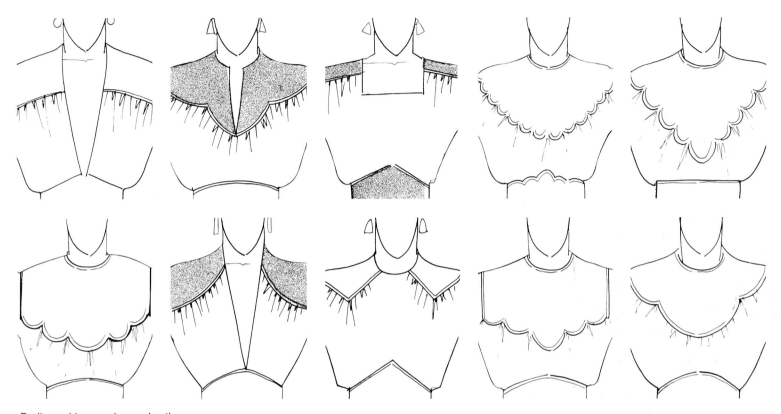

Bodice or blouse yokes and gathers.

The yoke is a flat area of a garment. It is often in contrasting material, piped to emphasize the shape, or it may incorporate quilting, embroidery, pleating, tucks, appliqué or decorative stitching. The yoke is placed on a garment to add to the design and can produce a variety of shapes based on curves and squares.

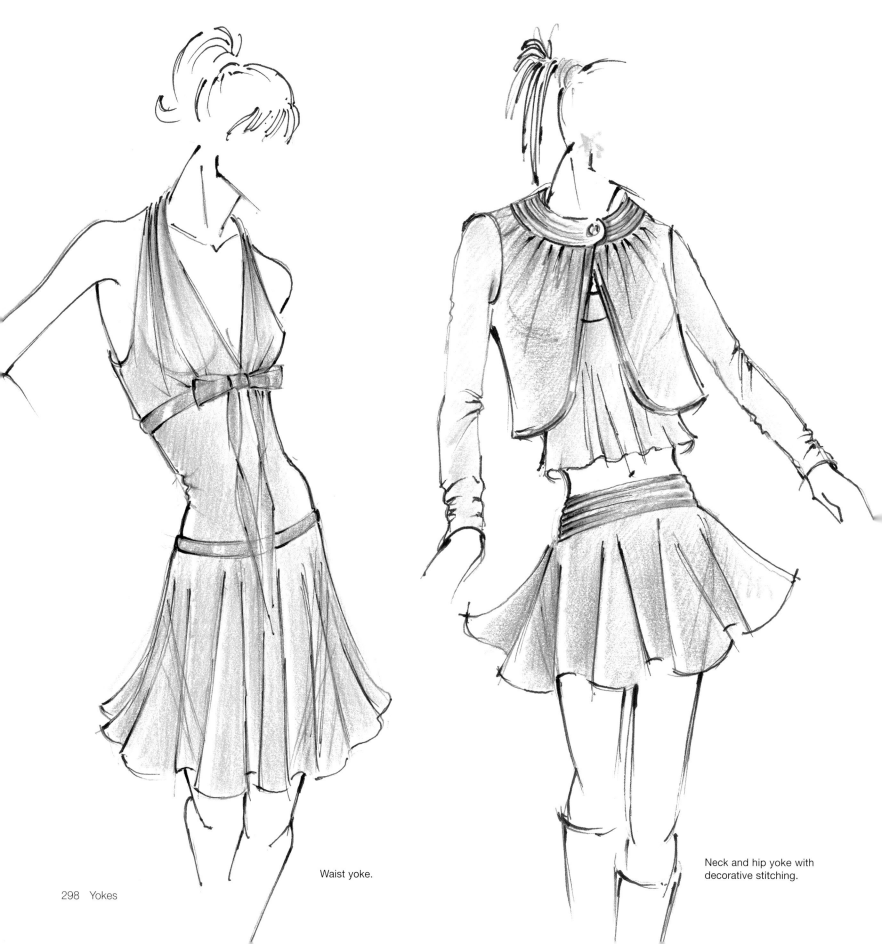

Waist yoke.

Neck and hip yoke with decorative stitching.

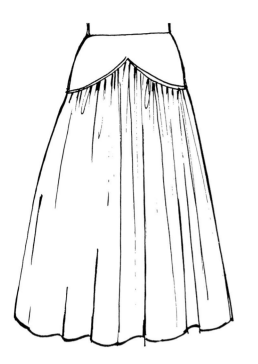 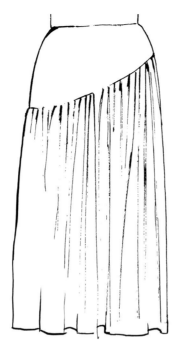 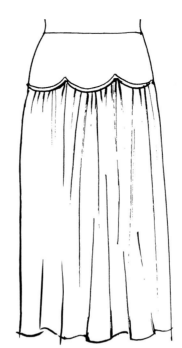 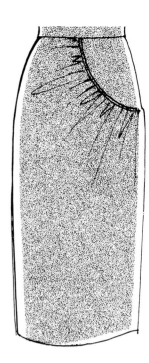

Folds and gathers from yokes on skirts based on
the curve, emphasizing the shape with piping.

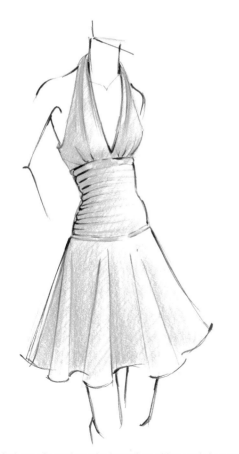 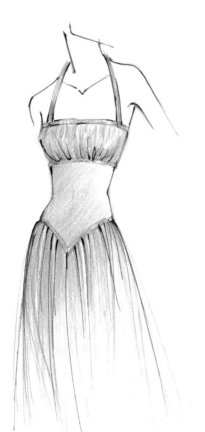

Variations of a waist yoke based on skirts and dresses.

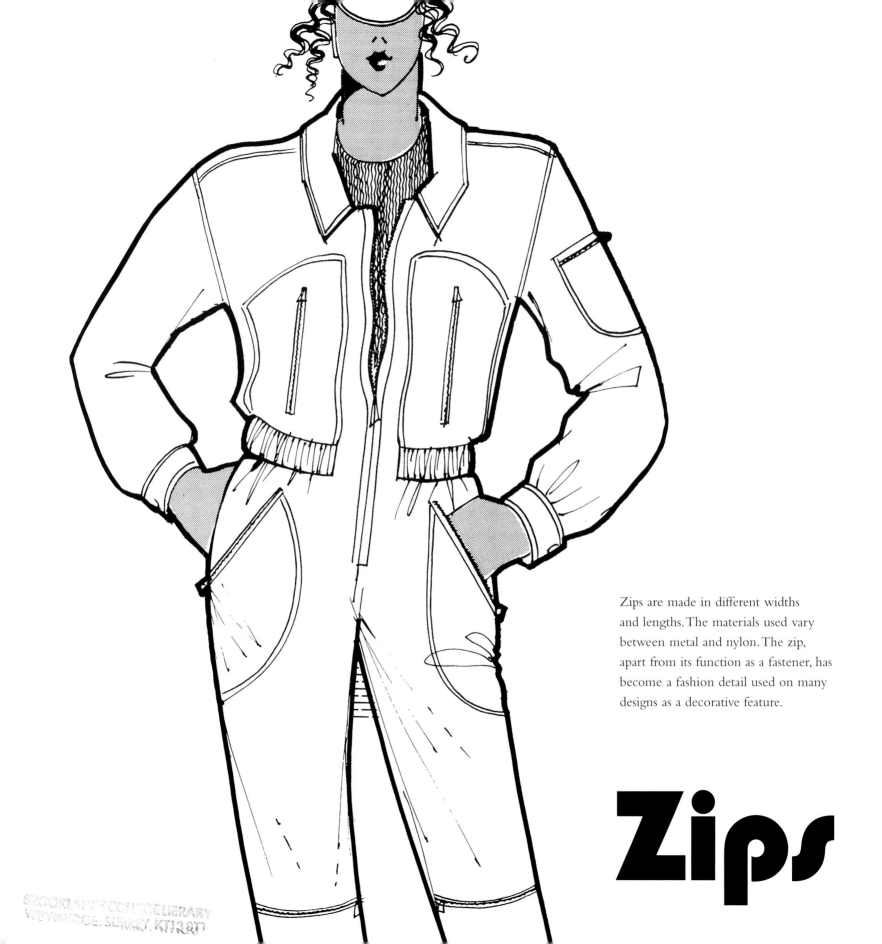

Zips are made in different widths
and lengths. The materials used vary
between metal and nylon. The zip,
apart from its function as a fastener, has
become a fashion detail used on many
designs as a decorative feature.

Zips

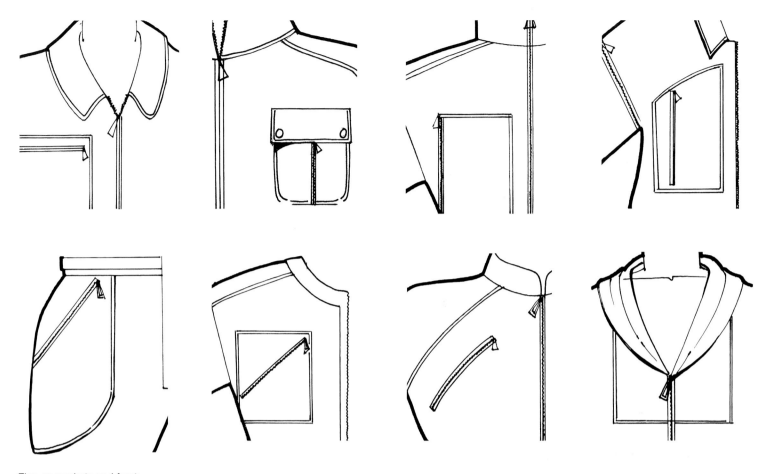

Zips on pockets and front
fastenings.

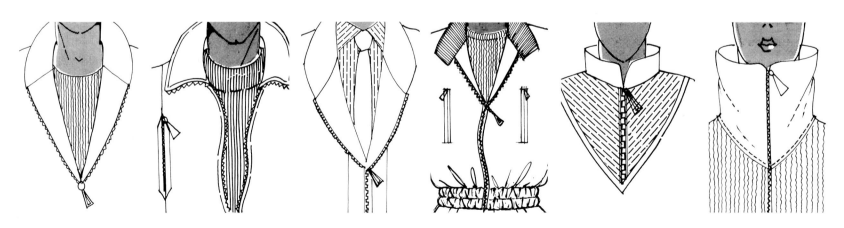

A selection of zip fasteners
used as fashion details.

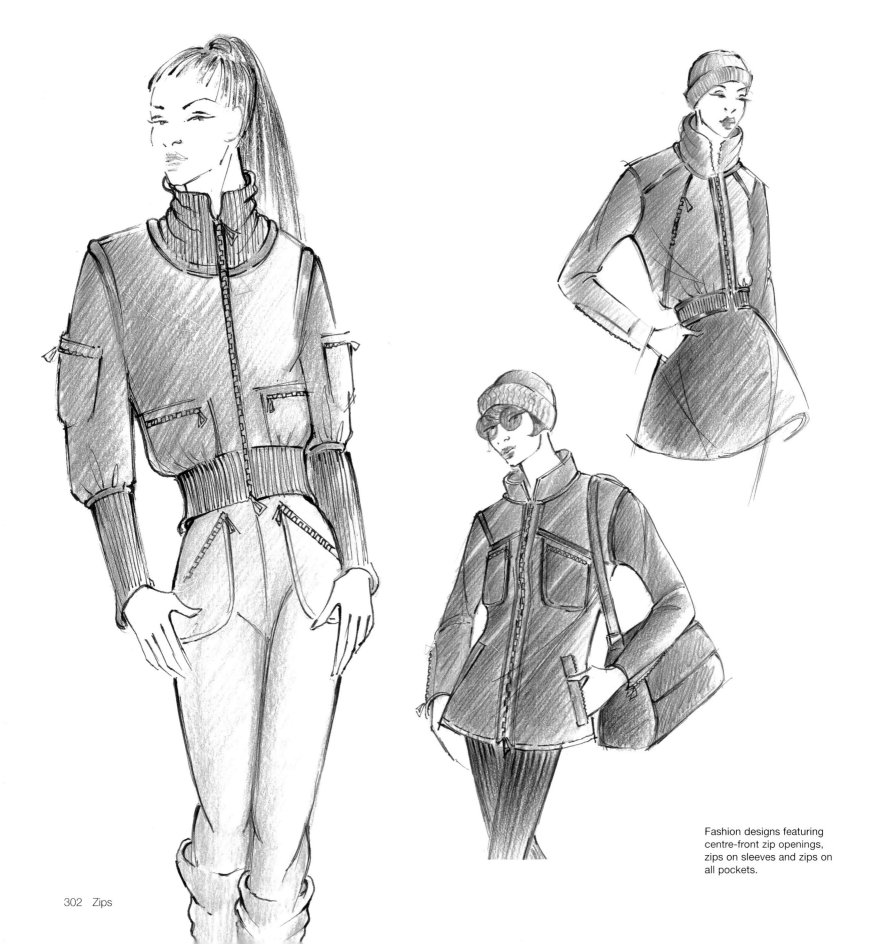

Fashion designs featuring
centre-front zip openings,
zips on sleeves and zips on
all pockets.

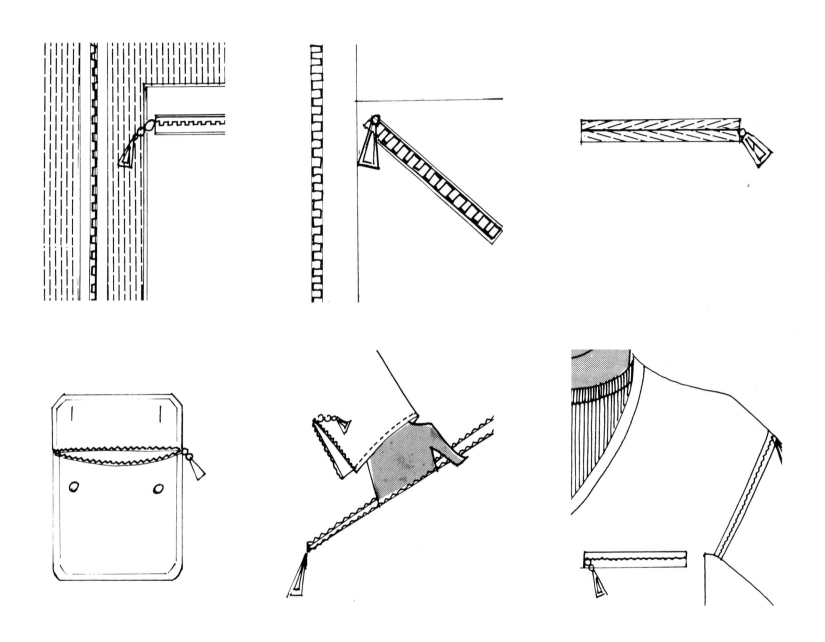

This type of sketch is used
for working drawings.

Acknowledgements

I would like to thank all the students and lecturers of the many colleges I have visited for their support in producing this book. I would also like to extend my thanks to the library of the Victoria and Albert Museum and the many costume collections I have visited, for help in aiding my research. And finally to my editors at Batsford, Tina Persaud and Kristy Richardson, and Laura Brodie in the production department, for their encouragement and patience in the preparation of this book.